Praise for
escaping the delta

"This book is amazing. Well researched, opinionated, and controversial (I'm sure a couple of barroom fistfights will occur), but written with such honesty, intelligence, and love for the music that it's difficult to sum up my feelings in a couple of sentences." —Dave Alvin, musician and songwriter

"Throughout, Wald writes better than anyone else ever has about the blues. If you read only one book about blues—maybe ever—read this one. Not just for bluesniks; this is great black history, too." —*Booklist* (starred review)

"Wald's view of American culture is wonderfully bold and bracing. . . . In the context of most writing about popular music, *Escaping the Delta* is more than a tonic. It's champagne, Muddy Waters's favorite drink."
 —Anthony Heilbut, *Los Angeles Times Book Review* (cover review)

"*Escaping the Delta* is a scholarly and fascinating addition to the growing lexicon of literature about the blues." —Bonnie Raitt

"Wald's is a story of race, to be sure, of black musicians, primarily, and black and white audiences. And he sets his history in a full social context . . . full of insight and intelligence."
 —Susan Larson, *New Orleans Times-Picayune*

"As persuasive as the lesson he imparts is, Wald never puts you in mind of the dusty academic. . . . Having disabused Johnson's admirers of their dearly held beliefs, Wald offers something richer in their stead: clear-eyed, vibrant history rather than misty fairy tale."
 —Glenn Dixon, *Washington City Paper*

"A unique approach to the story of the blues—Wald tells it as it really happened, and not as how it makes better sense in relation to the modern music business. . . . A vivid, fascinating, and valuable tale."
 —Lloyd Bradley, *Blender*

"By avoiding the unproven tales accepted by other chroniclers—and offering a broader contextual look at the strange evolution of blues, with Johnson as a case study—Wald unearths freshness and surprise from well-trodden ground." —David Beard, *Boston Globe*

"A thoughtful, impassioned historical essay. . . . The best studies inspire further study, and the best music books inspire further listening. *Escaping the Delta* could well do both." —Daniel Cooper, *Washington Post*

"Elijah Wald overturns the myths and puts Johnson's music into a broader, often surprising context. . . . Thanks to his examination and research, a new picture of Johnson emerges. . . . The performances remain singular. Robert Johnson seems familiar." —Barry Mazor, *Wall Street Journal*

"Not only a great survey for blues beginners, but a bomb that explodes all the romantic notions we have about race, class, and the creation of the blues at the crossroads." —Josh Rogers, *Portland Phoenix*

"*Escaping the Delta* flies in the face of conventional wisdom. . . . Wald tells the simple, unassailable truth about Johnson, and about the noise we call the blues. . . . Useful, well researched, and thoughtful." —Philip Martin, *Arkansas Democrat-Gazette*

"Elijah Wald makes a heroic effort to reconcile the origins of blues with its current forms, even at the cost of deconstructing his own sacred cows. The result is a book any American music lover will find enlightening." —Woody Mitchell, *Charlotte Observer*

"Elijah Wald has come to be known as a 'revisionist historian.' But *Escaping the Delta* is actually not revisionist at all. It merely looks back at Johnson . . . with context and common sense." —Steve Knopper, *Chicago Tribune*

"A highly outspoken, well-researched look at the era in which Johnson lived, his music, and the latter-day reassessment of the musician." —Bill Ellis, *Memphis Commercial Appeal*

"Fascinating . . . a crucial attempt at bringing a world of myth back to reality." —Christopher Schobert, *Buffalo News*

"Wald writes entertainingly and informatively, and often eloquently, with detailed source notes to back his contentions about how the shape of black music changed with its audiences. . . . A fascinating and knowledgeable book." —Jim White, *Pittsburgh Post-Gazette*

"Both a homage to one of the great musicians of all time and a history of American blues across color lines." —*Daily News* (New York)

"Wald's arguments are thoughtful and well researched, and blues fans who come to his book with an open mind or readers who are simply interested in learning more about Johnson will be amply rewarded." —Ted Drozdowski, *Boston Phoenix*

"Wald devotes three glorious chapters to an almost bar-for-bar discussion of Johnson's slim volume of recorded work. Wald has the ability to bring fresh

appreciation to timeless songs like 'Kind-Hearted Woman' and 'Come On in My Kitchen,' and to explain the harder-to-fathom songs, such as 'Dead Shrimp Blues' and 'They're Red Hot.'" —Mike Francis, *Portland Oregonian*

"In foregrounding the blues as the dynamic popular entertainment of its day rather than the reverential marker of authenticity it has become, *Escaping the Delta* takes the reader for a thoroughly enjoyable ride on the road that led to rock 'n 'roll and the blues revival that followed. Along the way Elijah Wald explodes a few myths, points up the absurdity of recording-industry marketing categories, illuminates the porousness of the folk-pop divide, and teaches us to appreciate Robert Johnson in a whole new light."
—Reebee Garofalo, author of *Rockin' Out: Popular Music in the USA*

"An excellent book . . . certain to stir controversy."
—Larry Cox, *Tucson Citizen*

"Elijah Wald takes a fresh look at blues history, particularly at the romantic myths that have grown up around Delta blues. The result is a thoughtful and rigorously considered account of a profoundly American musical genre that helped to define the twentieth century."
—Dick Spottswood, ethnic music scholar, writer, and editor

"Wald's precision aids him in his quest to re-analyze America's perception of the blues as well as in trying to decipher the music's murky true origins and history. Wald combines a short bio of Johnson with detailed analysis of his songs and the mysterious tales that are associated with him, giving a thorough account of Johnson's life, music, and legend." —*Publishers Weekly*

"*Escaping the Delta* does an extraordinary job of sifting through the myths in order to unearth reality." —Robert Gabriel, *Austin Chronicle*

"Agree with the author or not, most readers will find *Escaping the Delta* fascinating reading. And they're sure to learn something new on almost every page." —Joe L. White, *Jackson Clarion-Ledger*

"A major work that should find a place in the library of every blues aficionado." —Paul Garon, *Living Blues*

"Wald offers a persuasive and unconventional portrait of Johnson as a skillful, ambitious, creative artist rather than the anti-social misfit of folklore. . . . More than anything, what shines through this book is the sheer informed love of the music." —Mark Polizzotti, *New Republic*

ELIJAH WALD has been a musician since his childhood and a writer for more than twenty years. His previous books include *Josh White: Society Blues,* the award-winning biography of bluesman Josh White; and *Narcocorrido: A Journey into the Music of Drugs, Guns, and Guerrillas,* an exploration of the Mexican pop ballads of drugs and politics. He is also the co-author of *River of Song: A Musical Journey Down the Mississippi* and *Exploding the Gene Myth.* For more information, please visit his website: www.elijahwald.com.

escaping the delta

ROBERT JOHNSON AND THE INVENTION OF THE BLUES

ELIJAH WALD

Amistad
An Imprint of HarperCollinsPublishers

FIRST AMISTAD PAPERBACK EDITION 2005

Book design by Shubhani Sarkar

Printed on acid-free paper

The Library of Congress has catalogued the hardcover edition as follows:
Wald, Elijah.
 Escaping the delta: Robert Johnson and the invention of the blues / by Elijah Wald.
 p. cm.
 Includes bibliographical references and indexes.
 ISBN 0-06-052423-5
 1. Johnson, Robert, d. 1938. 2. Blues musicians—Mississippi—Biography. 3. Blues (Music)—Mississippi—History and criticism. I. Title.
 ML420.J735W35 2004
 782.421643'092—dc21
 [B] 2003052287

ISBN 0-06-052427-8 (pbk.)

13 14 15 BVG/RRD 15 14

To the memory of Dave Van Ronk,

so often my mentor in both music and writing,

whose ideas formed the foundation of this work.

contents

ACKNOWLEDGMENTS xi

INTRODUCTION xiii

one
THE WORLD THAT JOHNSON KNEW

1 WHAT IS BLUES? 3

2 RACE RECORDS: BLUES QUEENS, CROONERS,
STREET SINGERS, AND HOKUM 14

3 WHAT THE RECORDS MISSED 43

4 HOLLERS, MOANS, AND "DEEP BLUES" 70

5 THE MISSISSIPPI DELTA: LIFE AND LISTENING 83

two
ROBERT JOHNSON

6 A LIFE REMEMBERED 105

7 THE MUSIC 126

8 FIRST SESSIONS, PART ONE: GOING FOR SOME HITS 131

9 FIRST SESSIONS, PART TWO: REACHING BACK 149

10 SECOND SESSIONS: THE PROFESSIONAL 166

11 THE LEGACY 186

three
THE BLUES ROLL ON

12 JUMP SHOUTERS, SMOOTH TRIOS, AND DOWN-HOME SOUL 193

13 THE BLUES CULT: PRIMITIVE FOLK ART AND
THE ROOTS OF ROCK 220

14 FARTHER ON UP THE ROAD: WHEREFORE AND
WHITHER THE BLUES 250

AFTERTHOUGHT: SO WHAT ABOUT THE DEVIL? 265

APPENDIX 277

NOTES 281

BIBLIOGRAPHY 317

INDEX 323

acknowledgments

HAVING SPENT MOST OF MY LIFE LISTENING TO, READING ABOUT, and playing blues, I cannot begin to list all the people to whom I owe debts for what is in this book. However, some specific names must be cited:

For access to his collection of recordings, I must thank Chris Strachwitz of Arhoolie Records, and also John Tefteller for playing me his unissued test pressing of Tommy Johnson. For the chapter on musical tastes in Mississippi, I am particularly indebted to the pioneering research of Samuel Adams, and to those who made that work available to me: Evelyn Adams, the staff at Fisk University, and Robert Gordon, who alerted me to Dr. Adams's scholarship. For that chapter and others, I was greatly helped by the staff at Alan Lomax's Association for Cultural Equity, and also at the Folklife Archive of the Library of Congress.

For the chapters on Robert Johnson's recordings, I was alerted to many of his potential sources by Edward Komara's list in Gayle Dean Wardlow's *Chasin' That Devil Music*, and by Bob Groom's three articles in *Blues Unlimited*. Even where I have diverged from their suggestions, I could do so only after following the trails they blazed.

As I wrote this book I tried to seek the advice of knowledgeable critics who would catch my errors as a researcher and a historian. For reading the entire manuscript, I must thank Matthew Barton, Cheryl Devall, Peter Guralnick, and Peter Keane. For reading selected sec-

tions, often in meticulous detail, I thank Lynn Abbott, David Evans, Reebee Garofalo, Paul Rishell, and Tony Russell. All of these readers saved me from embarrassing mistakes or misjudgments, but of course must not be held responsible for any that remain. There were also various people with whom I had lengthy conversations that were indispensable at many stages of the writing. Among them, I must single out Scott Barretta, Andy Cohen, Paul Geremia, Steve James, Richard Nevins, and all the guys at Stereo Jack's record store.

Jeff McLaughlin once again stepped in as my personal editor, and once again provided his unique combination of encouragement, criticism, and close reading. Richard McDonough again found my work a good home with Dawn Davis and Amistad, and it is a pleasure to have worked again with Rene Alegria, editor of HarperCollins's Rayo imprint, who slid over to Amistad to provide appropriate advice and criticism. And many thanks to Andrea Montejo, for cheerfully fielding all my phone calls.

introduction

"Scholars love to praise the 'pure' blues artists or the ones, like
Robert Johnson, who died young and represent tragedy. It angers
me how scholars associate the blues strictly with tragedy."[1]

—B. B. KING

"Blues is not a dream. Blues is truth."[2]

—BROWNIE MCGHEE

FOR ITS FIRST FIFTY YEARS, BLUES WAS PRIMARILY BLACK POPU-
lar music. Like rappers or country-and-western stars, the top blues
singers were assumed to come from poor backgrounds and to under-
stand the problems and aspirations of folks on the street or out in the
country, but they were also expected to be professional entertainers
with nice cars and fancy clothes, admired as symbols of success.

In the 1960s, a world of white and international listeners discovered
blues, and for roughly the last forty years, the style has primarily been
played for a white cult audience. This audience has generally consid-
ered blues singers to be purveyors of a wild, soulful folk art, the antithe-
sis of glitzy pop entertainment. Even at the pinnacle of commercial
success, an artist like B. B. King is considered by the mass media to be
a "roots" musician, described in very different terms from either a Duke
Ellington or a Van Morrison. It is common to hail blues artists not for

their technical skill or broad musical knowledge, but rather for their "authenticity." By this standard an unknown genius discovered in a Louisiana or Mississippi prison is by definition a deeper and more real bluesman than a million-selling star in a silk suit and a Cadillac.

Such standards framed my own introduction to blues, and though I now consider them pure romanticism, an outsider's perception that has virtually no bearing on the realities of the music, my tastes remain largely unchanged. I am not a mainstream pop fan. If a record sounds like hundreds of other records, that diminishes my appreciation of it. I want to hear unique, personal work, and my interest is even greater if that work provides a window into a world or culture that is unfamiliar to me. That is part of what attracted me to blues, and I continue to share much of the aesthetic that drives other contemporary blues fans. We love the music as a heartfelt, handmade alternative to the plastic products of the pop scene, and when we listen to older records it is as natural for us to prefer Charley Patton or Robert Johnson to the more popular urban blues singers of their day as to prefer Lester Young to Guy Lombardo, Tom Waits to Billy Joel, or Cesaria Evora to Christina Aguilera.

Because of this, writers like myself have tended to shy away from the fact that blues was once popular music. Its evolution as a style, and the career paths of most of its significant artists, were driven not by elite, cult tastes, but by the trends of mainstream black record buyers. Hard as it is for modern blues fans to accept, the artists we most admire often shared the mass tastes we despise, and dreamed not of enduring artistic reputations but of contemporary pop stardom. Nothing we know about Robert Johnson suggests that he aspired to be a Mozart or Keats, a tortured genius dying young but leaving a timeless legacy. Everything suggests that he hoped to make it on the commercial blues scene, to be the next Leroy Carr, Kokomo Arnold, or Big Bill Broonzy. Indeed, while white fans often imagine that if he had survived into the electric era he would have been tearing off screaming Delta slide licks à la Elmore James, his black musical companions are more inclined to suggest that he would have been as slick and expert as T-Bone Walker, complete with a horn section and a zoot suit.

Instead, he died virtually unknown in a rural backwater, without

making any appreciable dent on the blues world of his day. It was only after blues had largely disappeared from the black charts and had been revived as a nostalgic adjunct to the white folk and rock scenes that he became famed as the most influential and important bluesman of all time. On purely artistic grounds, his posthumous acclaim may be deserved. The early Mississippi masters—Charley Patton, Son House, Skip James, and a handful of others—are among the greatest musicians this country has produced, and Johnson's work can be seen as summing up their tradition. Still, that does not give his fans the right to rewrite history, and the historical evidence is clear: As far as the evolution of black music goes, Robert Johnson was an extremely minor figure, and very little that happened in the decades following his death would have been affected if he had never played a note.

So why do I still take Johnson as my central figure for a book on blues history? There are two reasons:

The first is that he is the only prewar blues artist whose records are still widely owned and heard today, and therefore he is the natural starting point for modern listeners who want to delve more deeply. Because he recorded so little, most blues fans own his complete works, so I can assume that readers will have the basic source material available. His unusually broad grasp of the popular styles of his day makes these recordings a particularly good door into the larger musical world around him, and the fact that he arrived relatively late on the scene means that most of his roots and influences are accessible to us.

The second is that the odd evolution of blues and its audience is perfectly exemplified by the paradox of Johnson's reputation: that his music excited so little interest among the black blues fans of his time, and yet is now widely hailed as the greatest and most important blues ever recorded. Since all blues history was written retrospectively, this paradox has rarely been stressed. Therefore it is difficult for modern readers to understand quite how differently the music was seen in the days when it was a mainstream black pop style rather than magnificent folk art.

Due to a combination of taste and accident, Robert Johnson has served from the beginning as a unique bridge between two very different worlds. For his original fans, he was a bridge out of the Delta, a young local player who had managed to assimilate all the latest styles

from the radio and the jukeboxes, and to perform them as well as the big stars in St. Louis and Chicago. For the small group of urban white blues fans that eventually grew into a huge audience that remains largely urban and white, he was a bridge in the other direction, taking us from our world into the "deep blues" of the older Delta players. In both cases, Johnson has served as a screen on which each group of fans projected its own dream movie of the blues life. For his peers in Mississippi, he was a hip, smart adventurer who had traveled to northern cities and lived high, wide and free. For a modern audience of college students, rock musicians, and historians, he has been the dark king of a strange and haunting world, lost in the Mississippi mists and harried by demons—a legend more earthy, violent, and passionate than anything in our daily lives. Amidst all the mythologizing, it is not easy to stand back and treat Johnson as a normal human being, a talented artist who came along at a particular period in American music, and to try to understand his world and his contribution rather than getting lost in the clouds of romanticism.

I STARTED PLAYING BLUES GUITAR in my early teens, and I had been working the folk circuit for a dozen years before I first went to Mississippi. That was in 1991, and strangely enough I was there to play at the dedication of Robert Johnson's grave marker.[3] Washtub Robbie Phillips, my regular bass player, had been invited by the organizer of the ceremony and had just won a thousand dollars on the lottery, providing us with gas money. I had a car, and our friend Kenny Holladay, a slide guitarist based in New Orleans, agreed to meet us in Clarksdale. We understood that there would be some real Mississippi bluesmen performing at the ceremony, but that maybe we would be allowed to play a tune. As things turned out, none of the other musicians showed up, so we were the band.

The ceremony was held at Mount Zion Missionary Baptist Church, a small white building surrounded by fields of soybeans, on the outskirts of Morgan City, a sleepy hamlet south of Itta Bena. To us outsiders, the whole experience was like a journey into a different place and time. The congregation sang the first couple of songs a cappella,

and the harmonies and rhythms were straight out of the nineteenth century, a taste of the music Johnson himself, and Charley Patton before him, would have heard as children. Rather than the shouting, body-twisting power of later gospel, it moved with the gently insistent pulse of human breath, the singers swaying from side to side, adding harmonies and responses as the mood took them. When the pianist joined in, they settled into a slightly more modern rhythm, but it was still unlike anything I had heard in gospel churches up north.

Reverend James Ratliff, Mount Zion's pastor, delivered the sermon. He explained that he had never heard of Johnson until a few months earlier, but he could appreciate the miracle of a bunch of people coming down from New York City because a famous blues singer was buried in his cemetery, and giving him money to restore his church. Apparently some members of the congregation had been a bit dubious, especially after learning that Robert Johnson was famous not only for his music but for being involved with satanic forces, but Reverend Ratliff had sorted that out to his satisfaction: "God works in mysterious ways," he preached. "Legend says this man sold his soul to the Devil. I don't know about that. All I can say is, when he died, the members of this church had love in their hearts and gave him a resting place, and God wrote that down. Now, I don't know what Robert Johnson told the Lord. *You* don't know what Robert Johnson told the Lord. We *all* have come short of the glory of God."

After the sermon and a few words from a Greenwood city councilor, we moved out to the churchyard, where a sheet was pulled off the new stone. It was decorated with a quotation from the music historian Peter Guralnick, a picture of Johnson by R. Crumb, and a line from Johnson's "Me and the Devil": "You may bury my body down by the highway side."

Then it was our turn. Kenny had been trying to think of some songs that would be sedate enough for the church folks, but decided that Johnson's biggest hit was the obvious choice, so we played "Terraplane Blues," a racy, double-entendre number about a popular make of car. The lyric is pretty typical blues fare, but the audience's reaction was a revelation for me. While the white record executives and reporters were nodding in appreciation at the authenticity of Kenny's sound, the

local black congregation was treating us as entertainment, cracking up at lines like "when I mash down on your little starter, then your spark plug will give me fire." The song had come home, back to where it was good fun rather than a historical artifact.

For me, on that first visit, this was a huge part of the Delta's appeal. Mississippi had made hardly any attempt to preserve its musical past, and where the blues had survived, it had survived naturally, kept alive by local folks who still liked to dance to the old rhythms. It had not been embalmed or placed under glass, turned into a tourist attraction like Beale Street in Memphis or the French Quarter in New Orleans. In Clarksdale, the tourist brochures made no mention of places like the Blue Diamond Lounge, where we went later that night. Even though there was a fairly popular local blues band playing, our small group included the only white faces in the room.

The Blue Diamond was apparently the main blues club in Clarksdale, a small, crowded shack down a dark street, in which a few pool players tried to line up shots without getting bumped by the dancers. The front window was boarded up, and though it had a hole cut in it for a noisy electric fan, the atmosphere was murky with cigarette smoke. Aside from the fan, the refrigerated beer and the amplified band, the Blue Diamond seemed little removed from the rural juke joints of the 1930s: small and hot, smelling of sweat and cheap alcohol, the bands playing blues, and couples rubbing against each other in drunken, snaky dances that were rawly, exuberantly sexual.

As a music reporter, I considered all of this grist for my mill, and my pleasure was only increased by the fact that the local white people I met—as well as the more "respectable" black citizens—could be relied on to give dire warnings about the dangers of clubs like the Blue Diamond, or of hanging out at the sidewalk barbecue joint where we went later that night, or of staying at the Riverside Hotel, which I made my headquarters on several later visits to the region. The Riverside was a squat, sprawling building that had previously been the "colored" hospital, and was where Bessie Smith died in 1937 after a car accident on the road from Memphis. Its proprietor, Miz Hill, recalled seeing Smith at a local theater, though she remembered the glittering gowns and feathered headdresses better than the music. In Miz Hill's

decades running the Riverside, she had been host to much of the local blues scene: John Lee Hooker and Robert Nighthawk had lived there for extended periods, and Ike Turner arrived as a teenager and rehearsed his band in the basement. Miz Hill considered herself Turner's surrogate mother, and after his Kings of Rhythm had their first hit with "Rocket 88," she sewed the number onto ties for all his band members. By the time I got there, the Riverside's only resident musician was a young white guy who worked at a nearby record store, but the place still had plenty of local flavor. The other guests were all black Mississippians, divided pretty evenly between muscular men renting by the month and seductively dressed women renting by the hour.

I stayed for a couple of weeks, driving around the Delta to research articles on "the heartland of the blues." In Greenville, I spent an afternoon at the Playboy Club, sitting with its owner, Booba Barnes, a raw blues singer and guitarist who had modeled himself on Howlin' Wolf. Barnes was pleasant and hospitable, but obviously had heard all my questions before. Still, he had nothing better to do that afternoon, so he sat with me at a front table for a couple of hours, eating peanuts and drinking Coca-Cola. The Playboy was bigger than the Blue Diamond, but the general idea was the same. Everything was purely functional: a dozen tables, a jury-rigged stage with a cheap drum kit, a refrigerator for beer, and a jukebox stocked with blues and rap records. On one wall, someone had drawn a Playboy bunny silhouette and lettered the club's name. Outside was another crude sign, with a square hole cut out of the middle of it to make room for a fan.

Barnes was a small, wiry man, with a pointed beard and bulging eyes that made him look fearsomely Mephistophelean on his album covers. In person, he was polite and soft-spoken, and the people who dropped in during the course of the afternoon treated him as a respected businessman, showing a mild but obvious deference. The neighborhood kids addressed him as sir, and he brusquely sent them on errands to buy Cokes and cigarettes.

Barnes was probably the hottest Delta act on the touring circuit at that moment, traveling to Chicago, New York, and Europe, and he was clearly proud of the fact. At one point a young man came in and had

a whispered conversation with him, and when he had gone Barnes told me, "He wants to play with my band. He plays bass. He's good, too, but I'm gonna keep the boy I got. A few years back, that guy didn't want nothin' to do with me. He put himself above me. He was playing that disco and stuff, but I stuck with what I know, and now I ain't making nothin' but money."

As we sat there, chatting and sipping our Cokes, a man walked past the door, and Barnes jumped up and ran after him, yelling, "Get your goddamn ass inside here!" He returned alone, shaking his head, and explained, "Yeah, that guy drink in here for nothing and then when he's got some money he go drink somewhere else." The next time the guy went by, Barnes ran out and yelled after him again, then reached inside the back band of his pants and pulled out a pistol, held it up to his cheek, and sighted along it, shouting, "You give me my damn money!" He was laughing, and the customers were laughing, so I laughed along with them, guessing that this was a show put on for my benefit. Still, the gun was real.

From the Playboy, I headed across town to visit Eugene Powell. Then eighty-three years old, Powell was the only prewar blues recording artist who still made his home in Mississippi. He was sitting on his front porch with a lady friend, and invited me to join them. With little prompting, he began talking about the old days when he used to perform with the Mississippi Sheiks, the state's most popular band. After a while, we got out our guitars, and I played backup as he ran through what I gathered had become his standard set, a mix of blues, pop and country hits. The blues were mostly standards like Little Brother Montgomery's "Vicksburg Blues," Roosevelt Sykes's "44 Blues," and Tommy Johnson's "Big Road Blues," which he introduced as his own compositions, meaning that he had rearranged them and added some new verses.

When the mosquitoes started biting, we moved inside. Powell's front room was both bedroom and parlor, with a big double bed and several chairs. The walls were decorated with framed photographs of his children and of "old friends that's dead." In the center of one wall was a hand-tinted portrait of Martin Luther King, with a yellow plastic flower attached to the frame. On the wall facing the bed was a large

clock, a present from his daughter in Chicago. Its second hand carried a butterfly, revolving through a field of artificial flowers, and its case was surmounted by a golden bust of a unicorn.

I had brought a cassette that included Powell's 1936 recording of "Street Walkin'" (made under the pseudonym Sonny Boy Nelson), along with other Mississippi songs of the period, and he asked me to put it on and leave it playing. He talked through all the guitar-and-vocal selections, including his own, but stopped to listen to the Sheiks playing their biggest hit, "Sitting On Top of the World." When it was over, he laughed and said, "Now, anybody don't like that don't like ham and cheese."

After a while, Powell got off the subject of music and started talking about ghosts, or "haints." He said he had never seen any himself, but he had friends who had, and he knew a house where, if I could stay in it all night, the owner would pay me ten thousand dollars. Taking my cue, I asked him about the stories of bluesmen using supernatural powers to improve their playing. "Oh, yeah," he said, smiling. "They say if you put some rattlesnake rattles in your guitar, that'll make it sound better. I tried it, but I never did hear no difference. Then somebody told my mama that if I did that, when the rattles go melt away to dust I was gonna go blind, so she said to get those things out of there.

"They say, 'Take some graveyard dirt, you'll be a great guitar player.' Hacksaw Harney told me to try that, he said that's why he play so good. He took me along with him to get some, but I got about halfway there, and I said no. He said, 'You got to do that if you want to be a better player.' I said I guessed I was good enough."

Powell chuckled, and changed the subject, telling me about the busloads of Japanese people who come to see him every summer. I would have liked to hear more musical legends, but did not feel like pressing him.

Frankly, to a northern blues fan, the Delta still had plenty of ghosts. Every town name reminded me of an old song, and it was an almost mystical experience just to drive through the monotonous infinity of flat fields stretching out to the horizon. That first visit, the annual rains had come stronger than usual, and the whole Delta was flooded,

recalling the days before the levees were built. Lone houses stood on stilts, surrounded by sunken cars and telephone poles pushing up like reeds in a haunted lake.

I visited the Delta several times in the next two years, choosing different seasons, when the land was dry and the cotton buds shone purple, or the white bolls hung waiting to be harvested. It was a deeply moving experience to drive through those expanses of empty fields, hearing the lonesome blues whining through my tinny car speakers. A piece I wrote at that time reflects the way it captured my imagination:

> It is hardly surprising that this should have been the birthplace of the most desperate and primal of American musics. Where musicians in the cities or the more accommodating eastern seaboard states could be cheery entertainers, in the Delta there was little money left over for entertainment. Music, dancing and drinking were not casual pastimes, they were the only available escape from the difficulties of day-to-day life. The music had to serve an almost religious function, to take the listeners to another world.

I still believe some of that, but after spending more time in the Delta I began to wonder about my early reactions. Six years after that first visit, I was standing with Big Jack Johnson outside a grocery store that doubled as a juke joint in the tiny hamlet of Bobo, near Tutwiler. There was almost nothing there, just the store, a few small houses, and the big mansion of the plantation owner. It was the Delta I was used to, the grimly picturesque cradle of the raw blues, but that was not how Johnson saw it. As he looked around, he described the thriving town that Bobo had been in the 1960s. There had been houses all around, a school, a hospital, and crowds of people ready to party on Saturday night. The abandoned desolation I found so striking and romantic was astonishingly recent. Far from being the roots of the blues, it bore little relation to what had been there even thirty years earlier, much less to the thriving Delta communities of the prewar years, before the combination of new farm technologies and opportunities up North prompted a mass migration of black Mississippians to St. Louis, Chicago, and Detroit.

I got to thinking about how little my response to the region and its music matched that of the Delta artists I admired, and how much my own aesthetic differed from that of the average blues fan or musician of the 1930s. There was an obviousness to these meditations: I was born into a situation so different that it would be bizarre if I did not react differently to this world. But the more I thought about it, the more I found myself extrapolating to the broader blues field as I knew it, and being struck by the fact that virtually all the historical, musicological, or even impressionistic writing on blues has been done by people from backgrounds much more like mine than like those of the blues artists themselves. As a result, there is a tendency for even the most scholarly and well-researched pieces to be permeated with a romanticism that obscures at least as much as it illuminates.

In many cases, this has only become more true with the passage of time. The earliest books on the blues appeared in the late 1950s and early 1960s, barely twenty years after Robert Johnson made his recordings. Those early writers met many of the old musicians, drank with them, and wandered streets in neighborhoods that had hardly changed since the music's golden age. They could turn on their radios and hear Elmore James, John Lee Hooker, Muddy Waters, Jimmy Reed or Lightnin' Hopkins being played on black pop stations alongside Sam Cooke, James Brown, and the Drifters. The continuum of blues was inescapable, since it was still part of the African-American popular music mainstream. Lonnie Johnson, one of the biggest stars of the 1920s, had survived to cut "Tomorrow Night," a Nat "King" Cole–flavored R&B ballad. Big Joe Turner, a boogie-woogie shouter and disciple of Bessie Smith, had jump-started the rock revolution with "Shake, Rattle and Roll." New versions of songs like "See See Rider" and "Stagolee" were number-one hits. By the mid-1960s, one could go to a coffeehouse in Boston, New York, or Washington and see Mississippi John Hurt or Skip James.

The early writers were thus dealing not only with records but with people, and the degree to which they could impose their personal reactions on what they were hearing was more limited. They had a different background and perspective than the writers of my own generation, who came to the music after the folk-blues revival had ar-

rived along with the Rolling Stones, Paul Butterfield, Eric Clapton, and Canned Heat, and record stores had a blues section filled with reissue albums like the 1961 Columbia LP that presented Robert Johnson to the world and crowned him in its title, *King of the Delta Blues Singers.*

To us later fans, Johnson was a kind of god, and few of us questioned that title's legitimacy. His stature increased still further as his songs were covered and reworked by blues and rock players, and then with the astonishing sales of the two-CD set of his complete recordings in the 1990s. Today, he is regularly cited as the definitive figure in early blues, a musical giant whose influence was analogous to Louis Armstrong's or Charlie Parker's in jazz, to Jimmie Rodgers's or Hank Williams's in country music, to Ray Charles's, Bob Dylan's, Aretha Franklin's, or Jimi Hendrix's.

Many people will consider it shocking, or even blasphemous, to suggest that Johnson was nothing of the kind, that as far as blues history goes he was essentially a nonentity. Nonetheless, if by "blues" one means the black popular music that flourished from the jazz era to the dawn of soul and disco, that is about right. While all the other artists listed above were massively popular within their worlds, affecting admirers and detractors alike and redefining the terms of their genres, Johnson was unknown to the vast majority of the blues audience and ignored by all but a handful of his musical peers until the "blues revival" hit in the 1960s.

I am struck by how much the general perception of Johnson's place in blues history has changed since the first extended piece was written about him in 1959, as part of Samuel Charters's groundbreaking volume *The Country Blues.* Charters began as follows:

> The young Negro audience for whom the blues has been a natural emotional expression has never concerned itself with artistic pretensions. By their standards, Robert Johnson was sullen and brooding, and his records sold very poorly. It is artificial to consider him by the standards of a sophisticated audience that during his short life was not even aware of him, but by these standards he is one of the superbly creative blues singers.[4]

Charters had far more limited resources than we have today, in terms of biographical details and listenable copies of period recordings, but he touched on the central paradox of Robert Johnson's reputation, and by extension on the disjuncture between the black and the white blues audiences.

During that first trip to Mississippi, I was startled by the extent to which the blues history I had learned was out of step with what I was hearing from local black people. The white sponsors of the Johnson memorial kept repeating that Robert Johnson remains an enduring legend in the Delta, but after hearing Pastor Ratliff's sermon I had some doubts. I took to asking every black Mississippian I met—young or old, educated or illiterate, blues fan or not—whether they had heard of him. I could not come up with a single person who was familiar with Johnson's name, except a couple who had read about the memorial ceremony in the local papers and some blues musicians who had been introduced to his work by white enthusiasts. And it was not just Johnson. In my admittedly limited sample, Charley Patton's name rang almost equally few bells. Even Miz Hill at the Riverside Hotel, despite being in her eighties and considering herself a sort of den mother to the Mississippi blues world, when asked about local stars of the acoustic era, remembered only the Mississippi Sheiks. Her list of the popular artists of her youth more or less echoed the era's sales figures, whether in Clarksdale, Chicago, or Houston: Bessie Smith, Lonnie Johnson, Blind Lemon Jefferson, and Victoria Spivey.

Now, it is no criticism of an artist to say that he is without honor in his own country. The fact that Robert Johnson made little impact on the blues scene of his time, and that the vast majority of his direct musical heirs have been white players born long after his death, does not diminish the greatness of his art. Indeed, for most of his admirers, the exact opposite is true: The mystery and obscurity of his legend have only increased the fascination of his work.

Still, it seems fair to ask as we look at the picture of the handsome, smiling man in the natty suit that graces the cover of Johnson's *Complete Recordings*: Does the mystery and obscurity have anything to do with Robert Johnson as he lived and played? When he dreamed, did he see himself as the dark prince of the Delta, or did he imagine him-

self driving a Cadillac past the Empire State Building to his headlining gig at the Savoy Ballroom? Is it maybe time—at least for a moment—to cast aside the fascination with noble primitivism, and remember that the blues scene of his day was part of a popular music world that also included Fats Waller, Gene Autry and Bing Crosby? What would a century of blues look like if, for a moment, we tried to put aside the filter of rock 'n' roll and our own modern tastes?

To me, this book is largely a series of such questions. For people who are already deep into blues, it is an attempt to explore different ways of looking at familiar history and listening to familiar music. For those who know Johnson only as a root figure in the history of later, electric styles, it is an attempt to provide a guidebook to how he came to sound as he did, how those later styles developed, and how blues came to be what it is today. This is an ambitious task, and I have made no attempt to be comprehensive. Rather, I have tried to touch on the key points and figures, and to look at how they affected the music as a whole. Over the last two years, I have listened to more blues than ever before, and read everything I could get my hands on that would tell me how the players lived their lives and thought about their music. It has been a joy and a pleasure, and I can only recommend that, after reading what I have to say, others do likewise, and reach their own conclusions.

one

THE WORLD THAT JOHNSON KNEW

1

WHAT IS BLUES?

"The sorrow songs of the slaves we call Jubilee Melodies. The happy-go-lucky songs of the Southern Negro we call blues."[1]

—W. C. HANDY, IN 1919

"I never did name one of my records the blues after all. Everybody else called my sounds what I made 'the blues.' But I always just felt good behind 'em; I didn't feel like I was playin' no blues."[2]

—JIMMY REED, IN 1975

THERE HAS PROBABLY BEEN MORE ROMANTIC FOOLISHNESS written about blues in general, and Robert Johnson in particular, than about any other genre or performer of the twentieth century. As white urbanites discovered the "Race records" of the 1920s and 1930s, they reshaped the music to fit their own tastes and desires, creating a rich mythology that often bears little resemblance to the reality of the musicians they admired. Popular entertainers were reborn as primitive voices from the dark and demonic Delta, and a music notable for its professionalism and humor was recast as the heart-cry of a suffering people. The poverty and oppression of the world that created blues is undeniable, but it was the music's up-to-date power and promise, not its folkloric melancholy, that attracted black record buyers.

When did blues emerge? We have all heard variations on a mythic answer:

> The blues been here since time began
> Since the first lyin' woman met the first cheatin' man.

Which is indisputably true, if we are talking about heartache rather than music. People have always had the blues, and as far as we know they have always sung about it.[3] This is the source of Spanish flamenco, of Cape Verdean *morna*, and of country and western, all styles notable for lamenting lost and martyred love. However, if we are talking not about a universal emotion, but about the music filed in record stores as "blues," matters become both more prosaic and more complicated.

Before going into the history of blues music, we first have to confront the fact that the term has been used for a lot of different styles over the years. Like all genre names, "blues" has always been, first and foremost, a marketing term. When the market is hot, the word gets tacked onto plenty of songs that fit no musical definition of the form. When it gets cold, even the most straightforward twelve-bar blues may get classified as folk, jazz, rock, or funk. I am not going to enter the meaningless debate over what is or is not blues—I have no problem with people using whatever definition they like, as long as they grant that it is not the only one. It is worth taking a moment, though, to look at a few common definitions and provide an idea of what the word means to me.

The simplest and clearest definition of blues is the one used by musicians, as when they say, "Let's play a blues." This is a certain sequence of chords, commonly known as the twelve-bar blues, and there have been literally thousands of songs composed in this pattern. All such songs are technically "blues," though they have been played by ragtime orchestras, jazz bands, pop and rock groups, and have formed the bedrock for artists as different as Ma Rainey, Count Basie, Elvis Presley, James Brown, and Mose Allison.

While this definition has the virtue of simplicity, a lot of music that is generally considered to be blues does not fit the twelve-bar frame-

work. Much of Bessie Smith's and B. B. King's work, for example, is set to more varied and complex chord changes. As a result, folklorists and musicologists often say that the standard blues form can have twelve, eight or sixteen bars, or various other variations, and that the most important thing is a certain tonal feel created by the use of "blue notes" (in technical terms, the flatted third and seventh notes of the major scale). Such notes are common in many earlier African and African-American styles, as well as in quite a few other musics around the world, and they are usually described by Europeans and Euro-Americans as having a mournful, lonesome, minor-key sound.

The perception of this "blues feel" is to a great extent subjective, and different people hear it in different places. There is infinite argument, for example, over which jazz masters have and have not been able to get a blues feel in their music. In the wider world, some writers will argue that the Egyptian star Oum Khulthoum was a sort of blues singer, or the griots of Mali, or the Greek *rebetika* artists, while others fervently dispute the point. Even within the musics normally considered blues there is plenty of room for disagreement. I recently had a conversation with an expert who argued that most of the famous blues queens of the 1920s were not really singing blues, while white "hillbilly" artists like Dock Boggs often were.[4]

Where all the experts come together is in their irritation at the most common and influential definition of blues. This is the definition used by the true modern arbiters of genre, the people who market music and file it in record stores. Through their good offices, "blues" has come to be generally understood as the range of music found in the blues section when we go shopping for CDs. This commercial definition uses the word as a grab-bag term for all sorts of older African-American musics that cannot be filed elsewhere: The rule seems to be that if a black person played it before 1950, and it is not classifiable as jazz, classical or gospel, then it must be blues. In most record stores, fiddle hoedowns end up in the blues section if they were recorded by black players, as do work songs, children's songs, and a good deal of ragtime. Even gospel music will usually be found there if the performer was black and accompanied him- or herself on guitar.

For music recorded after 1950, things are a little different. The

rock, R&B, and soul revolutions all included a lot of performers who used blue notes and recorded songs in the twelve-bar form. Jackie Wilson, James Brown, Aretha Franklin, Mick Jagger, and Janis Joplin have all been known to flat their thirds and sevenths like crazy, but are not generally filed as blues singers. This is because, for much of the last fifty years, the term "blues" has tended to be a synonym for "not successful enough to be remembered outside the blues audience." While such stars as Ray Charles, Chuck Berry, and Dinah Washington will be found in the "soul," "rock" and "jazz" sections, less successful contemporaries like Guitar Slim, Percy Mayfield, and Ruth Brown will be filed as blues singers. Then, of course, there are all the white players who came along after the 1960s. Many of them—Eric Clapton and George Thorogood are obvious examples—played a lot of blues, but are usually filed as rockers. Others, especially after the success of Stevie Ray Vaughan, are filed as blues even though they are no bluesier than Clapton or Thorogood.

Although the record marketers' classifications make little sense from a musicological perspective, we are all fairly used to them and can usually find the records we want. And, in the end, that is what genre descriptions are good for. The jazz and classical categories are no more logical, both having long since expanded to include musics that would be unrecognizable to the earlier artists in those fields, filed together not because of shared musical characteristics but because of a shared cultural history. Rock has come to mean everything from Elvis Presley to symphonic productions, avant-garde art music, doo-wop, punk, and ska. Genres and categories are not descriptions of music, they are ways of grouping and marketing music. Or, to put it another way, such divisions do not deal with how music sounds, but how it is perceived.

I will use the word "blues" in various ways throughout this book, and while I will not be as lax as the record bin taxonomists, I will pay relatively little attention to musicological standards. That is because the musicologists and folklorists defined their terms after the fact, and their definitions would have seemed ridiculous to most blues singers and buyers. I have mentioned an expert who argues that Dock Boggs was a blues singer but that W. C. Handy's songs were ragtime and

many recordings by Bessie Smith and her peers were Tin Pan Alley pop. Musicologically, that makes sense, but historically it excludes the very music that gave us the word.

"Blues," in the parlance of the teens and early 1920s, meant the popular style purveyed by Handy and the blues queens. In succeeding years, it was expanded to include other, more or less related styles, such as those played by guitarists on the streets and farms of the deep South, but this was a marketing choice, spawned by the success of the commercial blues craze. To say that the artists who gave the music its name and established it as a familiar genre are not "real" blues artists because they do not fit later folkloric or musicological standards is flying in the face of history and common sense.

What is more, my main point in writing this book is to try to look at the blues scene from inside, as it evolved, rather than to apply the standards of modern fans, experts, or academics. Our present-day idea of blues has largely been determined by people who had little if anything to do with the culture that produced the music, and who codified their definitions after blues had ceased to be part of the mainstream black pop scene. For almost fifty years, blues history has also been filtered through the prism of rock 'n' roll, a music that is closely related but has quite different standards of quality. Because of all this, I prefer whenever possible to define the style not according to my own ears and tastes, but according to the judgments of the blues players and consumers of the times. My working definition of "blues," at least up to the 1960s, would be: "Whatever the mass of black record buyers called 'blues' in any period." I am not claiming this definition is perfect by any means, and I understand that there are plenty of situations in which it will not work. Nonetheless, it is a first step toward understanding how the idea of blues evolved through the years and, perhaps more importantly, how the musicians themselves perceived their music.

One result of applying the standards of the musicians and their original fans is that I will not assume that blues singers are deeper, better, or more authentic because of poverty, rural roots, or lack of musical training. Robert Johnson and his peers were intelligent professionals, well versed in the trends of their day and the tastes of their

audiences. Some were more sophisticated than others, but all were competent entertainers, and their music reflected the demands of a very active and critical public. Among other things, that public saw them as symbols of success, people who could flash fat rolls of banknotes and wear nice suits, and who did not have to sweat in the fields from sunrise to sunset.

The more familiar literary view—that blues was the heart-cry of poor, backcountry black folk—has its place, and it would be misleading to imply that it is totally an invention of later, mostly white writers and fans. It was part of the blues legend from the beginning, a colorful way of marketing a new style. The romantic roots of this stereotype can be seen in W. C. Handy's tale of the chance encounter that set him on the path to becoming one of America's defining pop composers. He had fallen asleep while waiting for a train in the Mississippi Delta hamlet of Tutwiler, and woke to hear music:

> A lean, loose-jointed Negro had commenced plunking a guitar beside me while I slept. His clothes were rags; his feet peeped out of his shoes. His face had on it some of the sadness of the ages. As he played, he pressed a knife on the strings of the guitar in a manner popularized by Hawaiian guitarists who used steel bars. The effect was unforgettable. His song, too, struck me instantly.
>
> Goin' where the Southern cross' the Dog.
>
> The singer repeated the line three times, accompanying himself on the guitar with the weirdest music I had ever heard.[5]

With slight variations, this picture has been conjured up again and again over the succeeding decades. Writers of all sorts have pictured a parade of ragged, downtrodden minstrels, singing their strange, personal music on ramshackle porches across the deep South. Since the coming of the folk-blues revival in the late 1950s, hundreds of middle-class white kids (and some black kids as well) have built themselves blues personas that self-consciously mimic this image, donning a work shirt or overalls, hunching over their guitars, and mumbling in their best approximation of Mississippi field inflections.

What would Robert Johnson think of that, if he were alive? Would

he be amused or annoyed, or simply baffled? It is one of the eternally unanswerable questions, but there certainly have been plenty of blues artists who resented the image. Take Little Milton, a singer and guitarist from outside Greenville, Mississippi, who has been making a good living in the blues field for half a century:

> Blues isn't all about some guy sitting on a corner, on a store porch or in a little dingy joint, with overalls on and patches on them, singing about his woman left him and took everything. You know, rich women leave rich men as well. Educated men, educated women leave each other, so I fail to see the significance of just the down and out, you know, that kind of thing. There's nothing wrong with coming onstage looking like you're somebody that's successful, smelling good, you know—the hygiene thing, the whole bit. I don't see anything wrong with that. I call that "class" of an individual; makes no difference what type music or profession they might be in.[6]

Look at that photograph of Robert Johnson, in his wide-lapel, pinstripe suit, his tie with its broad diagonal stripes and shiny metal clip, his handkerchief neatly folded in the breast pocket, and his hat cocked jauntily on his head. "There's nothing wrong with coming onstage looking like you're somebody that's successful. . . ."

In any case, however romantic the image, the guitarist Handy saw in Tutwiler would not have called his music blues. As Son House would say, "The old songs they used to sing way back yonder, weren't *none* of them pertaining to no blues."[7] That term arrived in most areas only in the teens, and even then was used not for rural back-porch moans, but for a hot new pop style, performed by professionals in fine gowns and fancy suits. The older black music that survives in the recordings of people like Mississippi John Hurt only came to be marketed as blues later on, because calling it that made it seem more up-to-date.

Blues certainly had roots in earlier Southern styles, but its trunk and many of its most fruitful branches were in Chicago and New York—and later in Los Angeles—in the recording studios and vaudeville theaters. In the 1920s, slavery was still a living memory for many

black families, and no one was feeling nostalgic for any "good old days." Black record buyers were looking forward to a "new world a-coming," in the words of the Harlem historian Roi Ottley, and blues was part of that, a down-home relative who had gone up north and made her fortune.

As Honeyboy Edwards, a friend and contemporary of Johnson's, puts it:

> When the people were slaves, they'd holler 'cause it make the day go 'long and they wouldn't worry about what they were doing, and that's what the blues come from. Then in the twenties, like, they named it the blues, with Mama Rainey and all, Ida Cox, Bessie Smith, Blind Lemon Jefferson, Lonnie Johnson. Before that come out, they just played a lot of ragtime stuff, like my father used to play. He played guitar and violin, and he played, like, "John Henry fell dead with the hammer in his hand," "Stagolee," and "Spoonful," that kind of stuff.[8]

That "ragtime stuff" made up the core repertoire of older Delta players like John Hurt and Furry Lewis, and would be recalled by bluesmen like Big Bill Broonzy, a country fiddler until he moved to Chicago and learned guitar. It was not ragtime in the sense that Scott Joplin played ragtime. Though a few hotshot guitarists in the East had the technical skill to fingerpick piano rags on guitar, and black string bands from Dallas to the Atlantic seaboard played formal, multi-section compositions like "Dallas Rag" and "St. Louis Tickle," Edwards uses the word "ragtime" much as a lot of people today use "blues": as a catchall term for older African-American rural music. Someone who grew up in the rock era would call Mississippi John Hurt's music blues. Edwards, who grew up when blues was a hot new trend, calls it ragtime. I do not know what it would have been called at the turn of the century, when ragtime itself was a flashy new pop sound— probably "reels," a term many older black people in the South were still using in the 1920s to describe any secular country music, blues included.[9] Edwards includes songs that most modern listeners would classify as blues in the "ragtime" category, because the black audience of his youth already considered them outmoded, fit only for hicks, old

people, and white folks. As he recalls, "When I was in Mississippi, a lot of white people used to give dances, they used to keep me playing a lot of places, and I played a lot of ragtime stuff then, like 'Alberta,' 'Corinna,' 'Saint Louis Blues.'" That last song, for those unaware of the fact, was W. C. Handy's biggest hit, the number that made blues an international sensation.

If Handy was the Father of the Blues—and his success in popularizing the term gives him a fair claim to the title—its mother was Ma Rainey, who may have been the first entertainer to stake her fortunes on blues singing. Gertrude Rainey was born in Georgia in 1886, and by 1904 she was touring as half of a song-and-dance team with William "Pa" Rainey. They appeared in minstrel troupes, tent shows, vaudeville theaters, and circuses throughout the southeastern United States. In her one known interview, Rainey told the folklorist John Work that she first came across what would become her trademark style in 1902, in a small town in Missouri. As Work recalled her story:

> A girl from the town . . . came to the tent one morning and began to sing about the "man" who had left her. The song was so strange and poignant that it attracted much attention. "Ma" Rainey became so interested that she learned the song from the visitor, and used it soon afterwards in her "act" as an encore.
>
> The song elicited such a response from the audiences that it won a special place in her act. Many times she was asked what kind of song it was, and one day she replied, in a moment of inspiration, "It's the *Blues.* . . ."
>
> She added that a fire destroyed some newspaper clippings which mentioned her singing of these strange songs in 1905. She added, however, that after she began to sing the blues, although they were not so named then, she frequently heard similar songs in the course of her travels.[10]

Rainey became a popular star on the Southern circuit, and by the early teens she and her husband were traveling with a circus and billing themselves as "Rainey and Rainey, Assassinators of the Blues." It is worth noting that this billing uses the word "blues" not for a

musical style, but in the old sense of misery, which their act would wipe out. It is not clear at what point she began calling her songs blues, and there is no evidence that she used the term any earlier than Handy did. Whether or not she gave the music its name, though, she did a great deal to put it on the map.

It is often argued that Rainey's girl in Missouri and Handy's railroad station guitarist are examples of the original blues singers, and that the professionals were just elaborating on and jazzing up a common rural style. Certainly, Handy and Rainey were building on earlier folk forms, and gave the credit where it was due. But they also created something new, a vibrant, theatrical expansion of the older moans and hollers, and it was this new creation that swept the country under the name "blues." They were so popular and influential that, since recordings of black rural musicians would not be made until well into the blues era, we can never have a clear idea of what the music sounded like before the professionals came on the scene. A handful of amateur folklorists in earlier years had transcribed scattered lines that seem like proto-blues lyrics, and it is possible that by the dawn of the twentieth century the deep South was full of people playing something that sounded more or less like what would come to be called blues. It is at least equally likely that such songs were rare, regional, and followed no set structures until Rainey and her peers shaped them, polished them, and made them into showstoppers.

It is also far from clear that even these pre-blues styles were ancient, rural creations. There has always been a coterie of New Orleans patriots who claim that blues arose in that city's red-light district. Jelly Roll Morton, who was born there in 1885, said that the style was already common in his childhood. Introducing his recording of "2:19 Blues," he recalled that it was the signature song of a whorehouse singer named Mamie Desdumes: "She hardly could play anything else more, but she really could play this number. Of course, to get in on it, to try to learn it, I made myself the can-rusher [the kid who would carry a bucket down to the corner bar to buy beer]."[11] This suggests that the style was already established in New Orleans almost a decade before Handy or Rainey came across it farther north. Since the city functioned as the main shipping center for the South and Midwest,

and especially for river states like Mississippi and Missouri, it is possible that a New Orleans style went feral in the countryside, and Handy and Rainey would have been in just the right places to rediscover it as rural folk music.[12]

Whatever the music's origins, by the time the first rural guitarists and singers began recording in the mid-1920s, blues had been a major pop style for over a decade, and all of them would have heard and been influenced by the polished work of the vaudeville and tent-show singers. When the record companies called their music blues, it was a commercial choice designed to link them to the popular recordings of the blues queens. The newspaper ads for their records might show an old man riding down a dirt road on a tired mule, or a wide-mouthed minstrel caricature, but to a young player trying to make a name in the entertainment world, the word conjured up pictures of good jobs, big money, and shiny cars. If someone had suggested to the major blues stars that they were old-fashioned folk musicians carrying on a culture handed down from slavery times, most would probably have been insulted.

2

RACE RECORDS: BLUES QUEENS, CROONERS, STREET SINGERS, AND HOKUM

WHEN WE TRY TO SORT OUT THE EARLY HISTORY OF BLUES, WE have to rely on the information available to us, but we need to keep in mind that this information is limited and potentially misleading. As Lewis Mumford wrote in *The Myth of the Machine*, "Material artifacts may stubbornly defy time, but what they tell about man's history is a good deal less than the truth, the whole truth, and nothing but the truth."[1] He was pointing out that simply because all we can dig up in an archeological site are durable artifacts, this does not mean that these artifacts were especially important to the civilizations that produced them. All that has survived intact from the dawn of humanity are a few primitive stone tools, but that does not mean that the societies that produced those tools did not have elaborate social or religious structures that may have contributed far more to our ancestors' development and survival than the advance from unshaped pounding stones to sharpened flints.

Likewise, we are making a serious mistake if we assume that the recordings made during the first great blues era give us a good idea of what was played by Robert Johnson and his contemporaries. Records and sheet music give us an excellent idea of what was being sold in the commercial market for records and sheet music, but in many cases that would have had little to do with what musicians were playing at live performances.

Before discussing these limitations, though, it is necessary to have

some idea of what does survive, and of what the mainstream commercial blues world looked like over the years. This is particularly true because the popular perception of the early blues boom is so flagrantly out of sync with the facts. Over and over again, the most influential and acclaimed stars of the period have been belittled or ignored by later writers and fans who happen to find them boring. As a result, the popular notion of a typical prewar blues artist is a ragged guitarist wandering the dirt roads of the deep South, rather than the savvy, urban, smartly dressed vaudeville queens and piano-guitar duos that generally dominated the market and set the trends. Not only is this unfair to these successful stars, but it also obscures the motivations and influences of the lesser-known, folkier players who today are most admired.

Much as we moderns may enjoy concentrating on those artists we consider to be unique geniuses, we must not forget that they were part of a larger pop scene, driven by commercial fads and fashions. It was often bedeviled by formulas, conservatism and mediocrity, just like any later pop scene. Bessie Smith and Leroy Carr, as much as Elvis, the Beatles, or Britney Spears, were quickly followed by a horde of sound-alike imitators churning out repetitive variations on their hits. These imitators were not great creative artists, but that was irrelevant at the time. No one involved in the blues world was calling this music art. It was working-class pop music, and its purveyors were looking for immediate sales, with no expectation that their songs would be remembered once the blues vogue had passed. And yet, out of this money-grubbing, hit-centered world came a lot of superb music, as well as sources for all the African-American popular styles that have followed. To the mainstream black audience, this was the blues boom, and it is worth taking a chapter to follow its evolution, tracking its main trends and stars.

As I have already outlined, the word "blues" became current as a musical term in the early teens, largely spread by sheet music and vaudeville performers. Recording was still in its infancy at that time, so printed music remained the main way of disseminating new compositions, and the first published blues was a song called "I Got

the Blues," which appeared in New Orleans in 1908. Its composer was an Italian American named Antonio Maggio, and it began with a twelve-bar section using a melody that is a clear predecessor of W. C. Handy's "St. Louis Blues." It was described on its cover as "An Up-to-Date Rag," which neatly places it in its historical context, on the cusp of the evolution from the ragtime era to the age of blues and jazz.[2]

This was an exciting period for African-American popular culture, and the musical evolutions are part of a larger picture. In 1905, the Pekin Theater opened in Chicago as the first major house owned and managed by African Americans and dedicated to presenting black performers in front of a mixed audience.[3] Soon, such theaters were popping up throughout the South and Midwest, and a vibrant black vaudeville circuit developed. For black performers, this was an important breakthrough, because it meant that solo artists or small bands could tour nationally without having to organize and promote their own concerts or be members of minstrel troupes. This freedom encouraged innovation, as performers tried to come up with unique routines that would set them apart from the competition, and blues songs at first seem to have been presented as a sort of musical novelty. Indeed, it is an odd fact that the earliest surviving mention of blues being performed onstage is in a 1910 newspaper review of a ventriloquist's act that included a blues-singing dummy.[4]

The ascendance of blues on the commercial music scene is usually dated to the fall of 1912, when "Dallas Blues," "Baby Seals Blues," and "The Memphis Blues (Mr. Crump)" all hit the sheet-music market. "Memphis Blues," in particular, was picked up by bands across the country, and it launched the career of W. C. Handy, who would be dubbed the "Father of the Blues." Handy had been born in Florence, Alabama, in 1873, and worked for many years as a cornet player, music teacher, and minstrel-show musician before becoming a bandleader in Memphis, Tennessee. In his autobiography, he recalls that in 1909 his band was hired to drum up votes for E. H. Crump, a candidate for mayor, and Handy came up with a unique campaign song. It was based on the melody he remembered hearing at that railroad station in Tutwiler, including two twelve-bar blues sections and occa-

sional blue notes, "attempting to suggest the typical slurs of the Negro voice."[5]

Handy followed "Memphis Blues" with "St. Louis Blues" in 1914, which remains his most enduring composition. Then came "Yellow Dog Blues" (originally titled "Yellow Dog Rag," an indication of how little these terms meant, except as eye-catching commercial rubrics),[6] "Beale Street Blues," and many more. Other composers leapt on the bandwagon, and soon every dance or vaudeville orchestra had to have its moaning novelty number in the new style.

It has been common for historians to mention this early blues craze, then jump directly to 1920, when Mamie Smith's "Crazy Blues" became the first major vocal hit by a black singer selling principally to black record buyers.[7] This seems quite natural to those of us raised on the fiction that tastes evolved more slowly in the past than they do now, but not even the rock 'n' roll era saw faster and more dramatic changes in American music than the period from the teens to the thirties. This was the height of the modernist wave, with the world shaken by World War I, the Russian Revolution, and the Great Depression. Fashions changed at a dazzling clip, and musical styles swept in and out, or underwent complete transformations at a pace that makes five or six years a significant stretch of time.

The jump from Handy's sheet music to Smith's recording is particularly misleading, as is the frequent listing of "Crazy Blues" as the first blues record. As far as I can tell, this mistake grew out of the fact that so much of the early historical writing on blues was done by people with progressive political views, who were celebrating the music as a vital cultural expression of black Americans. Obviously, this approach is valid in many contexts, and blues has deep roots in black culture, but the story is more complicated than that. Blues was pop music, and pop music rarely fits a simple political or cultural agenda.

When the blues craze hit, the record companies were quick to react. The first recording of a blues composition was made in 1914, when the Victor Military Band cut a version of Handy's "Memphis Blues." This was not a particularly innovative record, owing more to the Sousa ragtime march tradition than anything else, but it broke the

ice and was soon followed by more interesting performances. Many were instrumentals, and Handy himself traveled to New York to make his studio debut in 1917, with a twelve-piece band that included three violins and a xylophone.[8]

The first blues to be sung on record was also "Memphis Blues," performed by a fellow named Morton Harvey in 1915.[9] By the end of the decade there were dozens of vocal blues on the market, and a couple of artists were even making a specialty of the style. Al Bernard ("The Boy from Dixie") was known for his interpretations of W. C. Handy numbers, and Marion Harris led off the long line of performers who have been billed as "Queen of the Blues." What sets these singers apart from those enshrined in the history books is that all of them were white.[10]

Considering the number of white blues singers who have come along since the 1950s, and their influence on the modern audience, it is surprising that so little attention has been devoted to these pioneers. I would not overstate their importance, but they were significant figures in their time, and certainly are part of the larger story. It is true that their records are fairly unexceptional pop productions, and one could argue that they fit more into the novelty category than in a discussion of the music as a serious art form. Harris and Bernard made blues-inflected songs a mainstay of their careers, but performers like Norah Bayes and Marie Cahill recorded "Negro" material as part of broader careers as ethnic impersonators, alongside numbers like "How Can They Tell That Oi'm Irish?" and "Has Anybody Here Seen Kelly? (From the Emerald Isle)." Such mimicry was a mainstay of early-twentieth-century vaudeville, both black and white, and it is difficult to sort out the degree to which blues in this context was treated as engrossing music rather than amusing theater.[11]

Even Bernard and Harris were often described in the contemporary press as clever impressionists, celebrated for their mastery of "Negro dialect songs." Given this, it is easy to dismiss the early white blues singers as holdovers from the blackface minstrel tradition rather than heralds of a new era. Certainly, in some cases their presentation overlapped the older minstrel style. Marie Cahill's 1917 recording of "The

Dallas Blues," one of the first pure twelve-bar blues on record, begins with the following spoken segment:

> I want to sing to you all a blues song I heard a darky sing down in Dallas, Texas. He was a quaint character, this Mose, and incidentally an inveterate poker player, until one day at a big revival, he got religion, and a day was set aside for his baptism. When he took the preacher's hand and waded out into the water, he looked like a changed man. But unfortunately he hadn't changed his sinful suit of clothes, and when he got in about waist deep, a card floated out of his pocket and turned face up on the water. It was the ace of hearts. A little farther out, and another card floated out of his pocket and turned face up on the water. It was the king of hearts. Still a little farther out, and another card floated out of his pocket and turned face up on the water. It was the queen of hearts. Then came the jack of hearts, and then the ten of hearts. And then the preacher threw up his hands and said, "Good Lord, brother! If that hand don't save you, there ain't no use to baptize you."
>
> So there was Mose, too hurt to laugh and ashamed to cry. Ducked, but not baptized. And then his girl ducked too. And that's when I heard him say:

> I've got the Dallas blues and I'm a-feeling mighty, I said mighty,
> I mean sad,
> I've got the Dallas blues and I'm a-feeling mighty sad.
> But the blues ain't nothing but a good man feeling bad.[12]

It is an open question whether Cahill was a blues enthusiast who framed the music with minstrel touches in order to bring it to a wider audience, or a vaudeville minstrel latching on to the new fad. Either way, her work gives an idea of how blues first came into many homes. What is more, one might suggest that her description of the song as something she had heard from a "quaint . . . darky" in Dallas is only a little more removed and superior than Handy's description of the ragged Negro, with feet peeping out of his shoes, who sang "the weirdest music I had ever heard."

Handy himself was very appreciative of the white blues singers, numbering them among his earliest supporters. He writes that, in fact, white bands were often more receptive to his work than their black counterparts:

> The Negro musicians simply played the hits of the day, whether composed by me or someone else. They followed the parade. Many white bands and orchestra leaders, on the other hand, were on the alert for novelties. They were therefore the ones most ready to introduce our numbers.[13]

He immediately adds that "with Negro vaudeville artists it was different," that they were always on the lookout for striking material and "these performers became our most effective pluggers," but adds that he also hired a Greek and an Armenian singer to promote his songs and those of the other songwriters he published. Handy regarded Al Bernard with special affection, struck by the young singer's "good looks and his soft Southern accent as well as by the fact that . . . he could sing all my Blues." Handy recommended Bernard to Thomas Edison as a recording artist, and also published many of Bernard's own compositions.

Of Marion Harris, Handy wrote that "she sang blues so well that people hearing her records sometimes thought that the singer was colored."[14] Harris's best-known hit, "I Ain't Got Nobody,"[15] was covered by an array of African-American blues queens, including Bessie Smith, and she continued to be popular throughout the 1920s, though her ethnicity has robbed her of a place in the history books and blues discographies. What makes this omission particularly silly is that Mamie Smith, generally hailed as the pioneer of vocal blues recording, must have been equally hard for a lot of listeners to place by race. Like Harris or Bayes, Smith was a polished vaudeville performer, and her diction was at least as "white" as that of the white singers who specialized in blues or "Negro" songs. She made her recording debut on the heels of her starring role in a musical revue called *Maid of Harlem*, and her first record had her singing a pair of standard Tin Pan Alley songs, backed by an all-white orchestra. It was precisely because of

her mainstream, relatively bland style that the composer Perry Brad-
ford chose her to break down the color bar and become the first black
blues singer on record.[16]

As for "Crazy Blues," the song that opened up the Race record mar-
ket and pushed the blues recording boom into high gear, it was typical
of the sophisticated vaudeville style. While Cahill's "Dallas Blues" and
Handy's early compositions were largely based on folk sources, "Crazy
Blues" was well along the path to the sort of material that, aside from
using the word "blues" in the title, had little to distinguish it from
other Tin Pan Alley torch songs. This is not to say that it was a less
genuine blues than the folkier songs, but only to reemphasize the fact
that such categories are infinitely mutable, arbitrary divisions of a con-
tinuum that can be followed smoothly from "St. Louis Blues" through
"Crazy Blues" to "Body and Soul."

"Crazy Blues" was nonetheless an important breakthrough. Mamie
Smith was a fine singer, she was backed by a hot band of black jazz
players, and her success began a revolution that continues to this day.
As the first African-American recording artist to be marketed specifi-
cally to a market of black consumers, she made an immediate, aston-
ishing hit, and is rightfully hailed as a pioneer who forever changed the
recording industry. My points are only that the history of blues as pop-
ular music is not the same as its history as black cultural expression,
and that the evolution preserved on recordings is not representative
of the music's evolution in live performance. Live, the music first
emerged as a black, Southern style. On record, Mamie Smith followed
a wave of white blues singers, and her style was closer to the white-
dominated Northern vaudeville tradition than to the tent-show style of
Ma Rainey.

Indeed, all of the black singers who recorded during the two years
after Smith's breakthrough were established vaudeville artists, per-
forming blues because the record companies demanded it. When
"Crazy Blues" became a hit, there was a rush to follow up its success,
and such African-American entertainers as Ethel Waters, Edith Wil-
son, Sara Martin, Lucille Hegamin, and Alberta Hunter cut hundreds
of blues songs. This resulted in some excellent records, but there is
no reason to think that these singers had specialized in blues before

this time, or chose to specialize in them now except for commercial reasons. In a pattern that has been repeated ad infinitum, black performers were ghettoized, and their access to the recording world was dependent on their singing "black" music, whatever their own tastes or the repertoire they may have featured in their live shows. In person, black vaudeville stars were performing as wide a range of material as their white counterparts, and it was racism and the vagaries of the recording industry that kept more of this from being preserved on wax.[17]

Vaudeville singers, black and white, continued to have the blues record market to themselves until early in 1923, when Bessie Smith cut her first sides. Smith had also worked in vaudeville, and had first been known as a dancer, but her success had been largely in the South, and she was regarded as a Ma Rainey disciple as early as her teens. She sang Tin Pan Alley pop songs on occasion, but blues formed the cornerstone of her performances, and she was clearly most at home with that style.

Smith's first release, "Down Hearted Blues," was an immediate sensation and opened the door to a new wave of Southern singers. And yet, as with "Crazy Blues," its importance has sometimes been overstated, or at least described in misleading ways. The song was already an established hit, having been recorded with immense success the previous summer by Alberta Hunter (its cocomposer), and covered by Monette Moore and Eva Taylor. While Smith's version is usually described as a major breakthrough for "true" blues singing, a comparison of her record with Hunter's reveals a more complicated picture: Though Hunter's style can strike modern blues fans as overtrained and sophisticated, she sounds a good deal more comfortable than Smith did in this first outing. Smith has a magnificent voice, but she is a little tentative and lacks Hunter's eloquent command of the lyric. Furthermore, while Smith was a more distinctive singer than Hunter and would be far more influential, she clearly appreciated Hunter's work—at least if we can judge by the fact that she covered three of Hunter's hits among her first ten recordings, including the classic "Tain't Nobody's Business if I Do."

Just as I suspect that there were record buyers who did not know

that Mamie Smith was black and Marion Harris was white, there is no reason to think that the average listener in 1923 drew the clear division that I and other historians have made between Bessie Smith's work and that of singers like Hunter and Ethel Waters. Smith was quickly elevated to the top of the blues pantheon, but this does not mean that listeners considered her a revolutionary or rejected the more urbane blues queens. Smith's material was similar—when it was not identical—to that of her competitors, and plenty of people continued to prefer the more sophisticated styles. Mamie Smith, dismissed in some blues histories as a minor artist who was briefly popular before the arrival of the "real" blues queens, continued to fill theaters throughout black America well into the 1930s, and was being described as "Still the South's Favorite Singer."[18] In the Northeast especially, many people thought of the more "down-home" blues queens as old-fashioned, and even at the peak of her popularity, Ma Rainey rarely if ever appeared in New York.[19]

Bessie Smith herself had been rejected by the first African-American-owned record label, Black Swan, as too "nitty gritty," and even after she became a star, the Philadelphia-born jazz pianist Sam Wooding would say that she "didn't go over too big with New York musicians," because they found her style lugubrious: "She would sing something like 'Baby I love you, love you mo' and mo'.' I'd go to the bathroom, come back and catch the rest of the verse, 'I hope you never leave me, 'cause I don't wanna see you go.' She had dragged out each word so that I hadn't missed a thing."[20]

On the whole, though, audiences hailed Bessie Smith as "Empress of the Blues" in North and South alike. Her singing had a depth and soul that had not been heard before on record, and when it came to serious blues "moaning," the Northern vaudeville singers sounded pale and cute by comparison. Her sales were so impressive that record companies immediately dispatched talent scouts to comb the South in search of other deep blues specialists, opening the door to such artists as Clara Smith, Ida Cox, and Sippie Wallace. By the end of 1923, things had come full circle, and Ma Rainey finally got a chance to record the music she had pioneered.[21]

While what survives on record is the awesome power of their

singing, to understand the appeal of artists like Smith and Rainey it is important to remember that they were practiced professionals with many years of stage experience, and that they presented themselves not as pure, down-home blueswomen, but as successful stars. Their costumes were famously gaudy, and they were known for having uncanny control over their audiences. The mix of showbiz and soulfulness is nicely captured in the recollections of Thomas "Georgia Tom" Dorsey, who became Rainey's bandleader when her records catapulted her to a new level of stardom. On the one hand, Dorsey recalls the theatricality of Rainey's entrance:

> Ma was hidden in a big box-like affair built like a Victrola [the most popular phonograph of this period]. . . . A girl came out and put a big record on it. The band picked up "Moonshine Blues"; Ma sang a few bars inside the big Victrola, then she opened the door and stepped out into the spotlight with her glittering gown that weighed twenty pounds, wearing a necklace of $5, $10, and $20 gold pieces. The house went wild. . . . Her diamonds flashed like sparks of fire falling from her fingers. The gold piece necklace lay like golden armor covering her chest.[22]

On the other hand, Dorsey, who would go on to become the "Father of Gospel Music," describes Rainey's effect on the audience as far more than mere entertainment. He considered her a sort of secular high priestess, inspiring deep spiritual fervor:

> She possessed her listeners; they swayed, they rocked, they moaned and groaned, as they felt the blues with her. A woman swooned who had lost her man. Men groaned who had given their week's pay to some woman who promised to be nice, but slipped away and couldn't be found at the appointed time. By this time she was just about at the end of her song. She was "in her sins" as she bellowed out. The bass drum rolled like thunders and the stage lights flickered like forked lightning:

> > *I see the lightning flashing, I see the waves a-dashing*
> > *I got to spread the news; I feel this boat a-crashing*

I got to spread the news; my man is gone and left me
Now I got the stormy seas blues. . . .

The applause thunders for one more number. Some woman screams out with a shrill cry of agony as the blues recalls sorrow because some man trifled on her and wounded her to the bone. [Rainey] is ready now to take the encore as her closing song. Here she is tired, sweaty, swaying from side to side, fatigued but happy.[23]

Anyone who has seen a great gospel show in a black church will feel the shock of recognition, not only at the power of the performer to move and speak for her audience, but at the way the truth and soulfulness is supported by broad, self-conscious theater. Working for a public that still has its roots in the world where Rainey held court, gospel stars continue to surround themselves with the flashing lights and rolling bass drums, and the gaudy array of gold and diamonds, which a more urbane performer might consider "cheap."

The blues queens dressed like their audience's wildest fantasies— a tradition carried on by Little Richard and James Brown, Patti La-Belle and Dolly Parton—never fearing that the fans would mistake the rich trappings for an inappropriate sophistication. The message was that they were "country" but had made good. And that country sensibility was a big part of what set the second wave of black blues queens apart from the New York crowd. Rainey, in particular, had spent her life playing in tents across the rural South. She was no untrained hick, but country flavor was evident in much of her work. Her first sessions included songs about boll weevils and moonshine liquor (both shortly covered by Bessie Smith), and rather than relying on composers like Handy, Bradford, and Williams, she arrived with a proven personal repertoire honed over two decades. Younger singers like Bessie Smith occasionally wrote their own songs, but Rainey's material had deeper roots, and some of it almost certainly predates the earliest of Handy's compositions.

The rural orientation of Rainey's work was also reflected in her choice of instrumentation, and in this she helped pave the way for the singer-guitarists who would be the next wave of blues recording stars.

While she often used jazz bands, she also recorded two sides in the spring of 1924 with the Pruitt Twins, a guitar-and-banjo duo. A few months earlier, Sara Martin had recorded some songs with the guitarist Sylvester Weaver (one of which was advertised as "the first blue guitar record"),[24] but piano and trumpet were still the norm for blues accompaniments. Rainey continued to record with guitarists throughout her career, including sides with Blind Blake and Tampa Red, and she clearly understood that there was an audience that favored such down-home, country sounds.

Before moving on to the male street singers who began recording in the mid-1920s, I want to emphasize yet again the extent to which blues history has been skewed in the popular imagination. Anyone hoping to understand the blues era must keep in mind that during the period when blues was at its peak of popularity, transcending all other black styles, the female singers I have been discussing were always the music's biggest stars. A glance through the *Chicago Defender*'s record advertising in the early 1920s shows that jazzmen like King Oliver and Jelly Roll Morton were considered minor figures compared to them. When the male guitarists arrived on the scene, some would match the queens in terms of record sales, but they never approached the same heights of the entertainment world. Ida Cox, Sara Martin and the various Smiths headlined large shows, often including two dozen musicians, dancers, singers, comedians, and assorted novelty acts.[25] For many listeners, they continued to define the blues field right up to World War II. As far as I can find, New York's foremost black newspaper, *The Amsterdam News*, never so much as mentioned a blues singer who was not female and fronting a band until the 1940s, and any black person I have spoken with who was listening to music at this time, if asked to name the top names in blues, has reeled off a list of women, plus maybe one or two men. Obviously, there were some record buyers who would have produced a different list, but in my experience the one I heard from Honeyboy Edwards is typical: Ma Rainey, Ida Cox, Bessie Smith, Blind Lemon Jefferson, and Lonnie Johnson.[26]

Today, going through the record bins, one finds that this situation has been turned on its head. Relatively few CDs attest to the dominance of the blues queens, while there are hundreds of overlapping

reissues of their male contemporaries. Even among the male perform-
ers, it often seems that modern-day acclaim is granted in inverse ratio
to prewar popularity. I share many of the tastes and predilections that
have led to this state of affairs, and am not protesting it, but it is vital
to remember that the tastes of white blues revivalists do not in any way
mirror those of black record buyers in the 1920s or 1930s, or even
those of the early blues artists who are most admired by modern fans.
As for white performers like Bernard and Harris, there has not been
even the most cursory study of their work, and this leaves a funda-
mental gap in any understanding of early blues history, since they
paved the way for Mamie Smith and Alberta Hunter as surely as Smith
and Hunter paved the way for Bessie Smith and all that followed.

In any case, the next trend in blues recording introduced the male
performers whom most people today think of as the music's
originators—though it took a couple of years and happened in fits and
starts. By 1924, the basic style of the blues queens was thoroughly es-
tablished, and the record companies were hunting around for novel-
ties that might set their products apart. Okeh Records, which had
pioneered the white "hillbilly" recording boom the previous year, was
the first to explore a more countrified blues style, releasing a record of
Sara Martin with Sylvester Weaver's "big, mean, blue guitar" in Janu-
ary, and making an abortive attempt to promote an Atlanta street
singer and guitarist named Ed Andrews that summer.[27]

Martin's record did well enough that she was soon traveling to At-
lanta to cut further sides with Weaver, and by the fall she was record-
ing regularly with the fiddler Clifford Hayes and his Louisville Jug
Band. Still, she remained essentially a blues queen of the old style,
and it was the Chicago-based Paramount label that found the first real
country-style blues star—though he was a long way from fitting any
modern stereotypes.

Papa Charlie Jackson was an anomalous character, as much an old-
time minstrel or medicine-show man as a blues pioneer.[28] Originally
from New Orleans, he was a journeyman singer and banjo player who
could do everything from playing rhythm in jazz bands to picking out
finger-style arrangements of ragtime numbers. By the early 1920s, he
had settled in Chicago and was earning his living as a street musician,

and the fact that he was based in an important recording center must have been a key factor in his getting the opportunity to make records.[29] Jackson's main strength may well have been his crossover appeal. While he sang blues from his first records on, his most enduring number was "Salty Dog Blues," a comic ragtime piece that sold not only to blues fans, but also to lovers of minstrel novelties. The song would become a standard in the white country and bluegrass repertoire, and if our usual views of music history were not so deeply colored by race, Jackson might be considered a pioneering "hillbilly" performer as much as a bluesman.

Paramount promoted Jackson as a blues singer, introducing his debut with the claim that "this man can sing and play the Blues even better than a woman can,"[30] and many fans undoubtedly placed him right alongside Rainey and Ida Cox. Still, even on his most straightforward blues songs, his style of singing and his approach to the banjo—an instrument already falling out of favor on the black pop scene—always had an archaic, ragtime feel. His most widely imitated record among black performers was "Shake That Thing," a risqué twelve-bar novelty with a jaunty rhythm that sounded like nothing else on the blues market of the time—though it presaged the double-entendre Chicago style that would come to be known as "hokum."

The idea that Jackson was regarded as a unique novelty is supported by the fact that his success did not provoke any rush to record other black banjo players or street singers. Though he hit in August of 1924, it was not until 1926 that the next self-accompanied male singers made a dent in the market, and the first of these could not have been further from Jackson's down-home minstrel persona.

Like Jackson, Alonzo "Lonnie" Johnson was from New Orleans, but he was one of the most sophisticated and forward-looking instrumentalists of the period, a virtuoso guitarist who also played creditable violin and piano. As a singer, his hallmark was a suave delivery tinged with both humor and gentle melancholy—B. B. King, who cites him as a defining influence, describes his style as "dreamy"—and musically he was closer to the blues queens than to most of the other male artists who would appear in the next few years, though historians have tended to emphasize not his mellow vocals but his astonishing guitar work.

Johnson had grown up working the streets and bars of New Orleans with a family string band, then spent several years as a jazzman on the Mississippi riverboats, and he was comfortable playing in the most modern instrumental ensembles. Even after becoming a best-selling vocalist, he continued to play jazz dates, recording guitar solos with the Louis Armstrong and Duke Ellington bands and a ground-breaking series of duets with the white New York guitarist Eddie Lang. He is widely considered the father of jazz guitar, and his dazzling, vibrato-laden solos laid the groundwork for all the electric lead styles to come. It is this instrumental virtuosity that has kept his name alive among blues revivalists, many of whom consider his singing too urbane and smooth. By contrast, in the 1920s and 1930s he was best known as a singer. Of the forty ads for his records that appeared in the *Chicago Defender* between 1926 and 1931, not one even mentioned that he played guitar.[31]

That being the case—and considering the fact that he recorded numerous duets with female vocalists like Victoria Spivey—it might be more appropriate to regard Johnson as a sort of male blues queen than to class him with Jackson and the "down-home" street singers that would shortly flood the blues market.[32] These artists were a complete departure from the previous black recording stars, and were intended to reach a different market. In 1924, Paramount records had included a paragraph in its catalog, accompanying a photograph of its one African-American recording manager, J. Mayo "Ink" Williams, which expressly solicited consumer input: "What will you have? If your preferences are not listed in our catalog, we will make them for you, as Paramount must please the buying public. There is always room for more good material and more talented artists. Any suggestions or recommendations that you may have to offer will be greatly appreciated by J. Mayo Williams, Manager of the 'Race Artists Series.'"[33] How many responses Paramount received is unknown, but one of them would change the course of the Race record industry. In 1925, Williams got a letter from a music store in Dallas, recommending that he record a blind street singer and guitarist named Lemon Jefferson.[34]

Blind Lemon Jefferson—as he would be billed throughout his career—was a new kind of blues singer. He had a rough-hewn,

intensely personal style, and no one could have mistaken him for a vaudevillian or minstrel showman. Indeed, he must have struck some of the Paramount executives as a pretty risky proposition, since no similarly raw artist had so far had any success on the Race scene, but the gamble paid off with astonishing speed. Jefferson was a sensation, selling not only in the rural South but also in northern cities, and this time the record companies did not treat these sales as a fluke. Within months, the Race catalogs filled with a varied panoply of Southern street-corner players. Many were blind men, and the more romantic historians link them to the long tradition of blind bards reaching back to Homer, but it is worth remembering that a lot of people in their home communities regarded them as essentially musical beggars, and one can only imagine how surprised these folks must have been to see them suddenly advertised as national stars. Even the people who crowded around Jefferson when he performed on the Dallas streets and who considered him a musical prodigy must have been startled to see him buying a car and hiring a chauffeur to bring him to his recording dates.

Jefferson's arrival not only heralded a new era in blues, but was part of a broader movement that would reshape the entertainment business. Until the mid-1920s, records had tended simply to duplicate popular show-business successes. There were some widely recorded artists who had no great reputation as live performers, but they were performing in mainstream pop styles, providing recorded versions of Broadway and vaudeville hits, light classics, or old parlor and minstrel favorites. In the 1920s, the record companies gradually became aware that there were huge profits to be made off niche and regional markets. It turned out that a lot of folks were not only hungry for the latest hits from New York, but could be even more excited to hear a record of someone who sounded like them or their favorite local entertainers.

The first sign that recording would create a new set of rules came in 1923. That was the year that Bessie Smith hit, directing attention toward the rougher-voiced Southern blues singers, and it also saw the first Southern "field trip" by a recording scout for the Okeh record label. Okeh's Atlanta-area distributor, Polk Brockman, wanted the com-

pany to record a white "hillbilly" musician named Fiddlin' John Carson, who had a regular local radio spot. Okeh's scout, Ralph Peer, thought Carson sounded too screechy and unprofessional, but Brockman promised to order five hundred copies of the first release, so Peer recorded Carson doing a sentimental nineteenth-century minstrel number, "The Little Old Log Cabin in the Lane." The song had already been recorded by everyone from the black concert artist Carroll Clark to the white opera singer Alma Gluck, but Carson's version was entirely different.[35] He sang in a halting, nasal voice, with no accompaniment aside from his fiddle, and sounded straight out of the backwoods. It is easy to see why Peer was dubious, but Carson's music turned out to be exactly what a lot of country people were waiting to hear. The record was an immediate hit, and Carson went on to record almost two hundred pieces—more than all but a couple of blues singers.[36]

With Carson's success, record companies began sending mobile units south in search of other quirky, regional players, though it was two more years before Jefferson's success set off a similar boom in black rural recordings. As with vaudeville blues, many of the first country blues records were made by white "hillbilly" musicians. Even before Carson's success, the white Virginia guitarist and harmonica player Henry Whitter had cut four "blues" songs, including the influential "Lonesome Road Blues," and Carson recorded a song he called "Tom Watson Special," which was a variation of the piece W. C. Handy called "Hesitating Blues."

In this case, though, there was a fundamental difference between the markets served by the early white country musicians and by the black street singers who followed. The white rural recordings were released in series labeled "Old Time Tunes" or "Old Fashioned Tunes," reflecting the perception that their music was a treasured relic of past times. Many white Southerners had a fond attachment to the good old days "before the war," and the nostalgic advertising rubrics were designed to appeal to such feelings. This appeal would remain a commonplace of country-and-western music, and is still routinely invoked by Nashville stars in the twenty-first century.

African Americans, by contrast, were anything but nostalgic for the

old South. As a result, records by black rural artists were marketed not in separate black country series, but in the regular Race catalogs, alongside the hottest singers on the contemporary pop scene. While advertisements often described Jefferson as "down home," and his records certainly appealed to a regional market, he was not in any way a nostalgia act. Indeed, his greatest strength was his originality. His style was dazzlingly idiosyncratic, and most of his songs were entirely new compositions. Even when he recycled older verses, he tended to shape them into novel and unique configurations. He usually stuck to the twelve-bar form—though he did not hesitate to expand or contract a bar if he happened to be in the mood—and indeed was probably more dedicated to it than any previous blues star. He could play other styles, from gospel to ragtime, but the twelve-bar blues was where he felt most at home, and almost all of his own compositions were in that pattern.

This raises an interesting question. Jefferson was born in the mid-1890s, so he would have been in his teens when the blues craze hit.[37] As many of us can testify from personal experience, that is a particularly susceptible age for forming musical tastes, and it would not be at all surprising if he was caught up in the spirit of the blues boom, and derived much of his style from the popular hits of his youth. On the other hand, he was from the area around Dallas, and "Dallas Blues" was one of the first published blues numbers, providing circumstantial evidence for an earlier folk-blues tradition in the region. Hence the great mystery: Does Jefferson represent the survival of a root style that preceded and influenced the work of singers like Rainey, or was his style a brilliant reshaping of the pop form Rainey pioneered, tailored to fit his own tastes and talents?

The fact that Jefferson's music was marketed as blues was due to its resemblance to the pop style, but that tells us nothing about which came first. Most likely it was a chicken-or-egg situation, with pop and folk artists nurturing one another and neither having primacy. The music played by Jefferson and the wave of black street musicians who followed him into the studios in the mid-1920s retained traces of regional styles that predated and influenced the blues composers, but

such styles may well have gelled into a uniform "blues" pattern under the influence of the national hits.

I am emphasizing this question because it is often assumed that the styles played by Jefferson and the other guitarists were the roots of Handy's and Rainey's music, despite the lack of any recorded evidence to support such an assumption. It would be ridiculous to accept the evolution preserved on record—white vaudevillians to black vaudevillians to black Southern female blues specialists to idiosyncratic guitarists—but it is only slightly less absurd to suggest that the evolution progressed cleanly and precisely in the opposite direction. There were certainly black rural guitarists before there was a blues boom, but there is no reason to think that they were playing anything much like Jefferson's repertoire before Rainey and her followers made blues one of the most popular styles in black America.

In fact, if we listen to the first wave of records by black guitarists, it is striking how much of their repertoire consists of non-blues material, even though blues was the hot sound of the moment. The success of Carson's and Jefferson's records persuaded most of the major companies to send field outfits to hold auditions in Southern centers like Atlanta and Dallas (and secondarily in Memphis and New Orleans). At first, since their early successes had been so unexpected, they were open to recording pretty much any rural-sounding entertainer who had some local fans, and these early outings preserved a variety of music that is still astonishing. Blind Blake, a Florida-Georgia guitarist who became the next big name after Jefferson, played a virtuosic ragtime dance style, and if the exuberance of his performances is any guide, he favored minstrel and ragtime tunes over his more stolid blues material. Atlanta street singers like Blind Willie McTell and Peg Leg Howell performed everything from blues to minstrel, ragtime, hillbilly, and gospel.[38]

Given their rural roots and the breadth of their non-blues repertoires, it is natural to refer to these artists as "folk" or "country" bluesmen, but it is important to remember that most of the successful ones were professional musicians, not farmers who played guitar on the side. As commercial entertainers, they were keenly aware of the

current trends, and once they became established as recording stars they used many of the same sorts of sales gimmicks as the vaudevillians who had preceded them. Unique and idiosyncratic as Jefferson was, he was not above recording sequels and holiday records that were as formulaic as anything on the Tin Pan Alley pop scene. Nor was he by any means alone in this. While he was the first male blues star to make a Christmas record, 1928's "Christmas Eve Blues" (backed with "Happy New Year Blues"), December of 1929 would find Blind Blake singing "Lonesome Christmas Blues" and Leroy Carr doing "Christmas in Jail."[39]

A more typical example of the way Jefferson and his peers fit into the larger black music world of their time is the cycle of "Black Snake" songs. The first of these, "Black Snake Blues," was recorded in May of 1926 by Victoria Spivey, a young singer, pianist, and songwriter who had known Jefferson in their native Texas. It was quickly covered by a vaudevillian named Martha Copeland, and then Jefferson weighed in with "That Black Snake Moan," apparently an even bigger hit than Spivey's record. Within the next year there were at least ten more "Black Snake" records, most by blues queens but including instrumental versions by the jazzmen King Oliver and Clarence Williams. A pianist named Lew Jackson even produced a player-piano roll of the song, with printed lyrics included—that era's equivalent of karaoke. Jefferson took full advantage of this vogue, first rerecording his original version for another label, then cutting a sequel called "Black Snake Dream Blues." Though this was advertised as "another of the same kind of Blues as 'Black Snake Moan,'"[40] it was written not by Jefferson but by a pianist named George Perkins, and Jefferson sang it over Perkins's accompaniment, proving his ability to meet the blues queens on their home turf. A year and a half later, when Spivey teamed up with Lonnie Johnson to cut a "New Black Snake Blues," Jefferson responded with "That Black Snake Moan Number 2."

This interchange between the more countrified singers and the vaudeville and dance-hall artists continued throughout the blues era. Texas Alexander, as raw a blues singer as ever recorded, used a range of accompanists that included Lonnie Johnson, the Mississippi Sheiks string band, and a King Oliver jazz trio, and there are numerous ex-

amples of "country" bluesmen using songs or verses they had learned off records by the vaudevillians, and vaudevillians adapting rural material. While the street singers and the theater stars lived and worked in very different worlds, recording was the great equalizer. The last record ad to appear in the *Chicago Defender*, before Depression-era belt-tightening put an end to such expenses, was evenly divided between Louis Armstrong's version of "Stardust" and a double-entendre blues by the Mississippi guitarist Bo Carter.[41]

That said, there were also vibrant regional styles, and musicians whose local importance was far out of proportion with their success on the national scene. No other country-style guitarist matched Jefferson's overall impact, especially when it came to reaching listeners in the urban North, but many did very well in their home areas, and some—Blind Blake, Barbecue Bob, Jim Jackson—were hot sellers throughout the South. Dozens of great players were recorded between 1926 and 1930, and this is the period that is generally considered most exciting by present-day acoustic blues fans. If I mention only a handful of these artists, that is because they have been abundantly covered by other writers, and because I am trying to balance their importance against that of the blues queens who preceded them and the urban piano-guitar duos who would shortly come to dominate the scene. I must mention one further name, though, if only because it has been common to find him described as "one of the most important musicians twentieth-century America has produced," and "the first blues superstar."[42]

Charley Patton was one of the last recording artists in the wave of Jeffersonian lone rangers, the older players who accompanied themselves and were adept at playing hoedowns, ballads, and minstrel songs along with their more recent blues numbers. Born in rural Mississippi, he had developed a strong local reputation in the mid-Delta region and was in demand at both black juke joints and white picnics, prized for his flashy showmanship as much as for his music.[43] Though now regularly hailed as *the* seminal figure in blues history—based on the notion that his corner of the Delta is the music's unique heartland—Patton had little success on the national market, and even in Mississippi his records were less broadly influential than those of the

younger, slicker musicians who recorded in the next few years as members of the Mississippi Sheiks and a variety of associated groups. Still, he is an outstanding example of the sort of little-known regional genius who briefly received some national attention in Jefferson's wake, a guitarist and singer with a varied, deeply personal style that encompassed a huge range of musics and reshaped them into something unique and timeless.

Unfortunately for those of us who enjoy such magnificent individualists, the record companies quickly outgrew the period of experimentation that had led to their exposure. For a moment, the talent scouts had been stumbling in the dark, recording almost anything they came across, in hopes of bumping into another hit style. By the late 1920s, they had worked out how to produce reliable sales, and no longer cared to waste their energy auditioning unpolished country eccentrics. (Patton was the exception that proved the rule, recorded in 1929 because a Jackson record dealer contacted Paramount and guaranteed a local market for his work.)[44] The next generation of blues stars would be hip, urbane soloists or duos who sang clever twelve- and eight-bar compositions in a casually assured barroom manner. The two defining hits in this new style appeared in 1928, and made their performers into instant stars: "How Long—How Long Blues," by the Indianapolis-based pianist Leroy Carr, and "It's Tight Like That," by the Chicago-based guitar-and-piano duo of Tampa Red and Georgia Tom.

Virtually all popular blues for the next twenty years can be seen as flowing directly from these two records, though it is rare for these performers to be given anything like their due. It is not that they are unrecognized, exactly, but rather that the tastes of white musicians, collectors, fans, and blues historians have favored the more countrified players. As a result, although anyone who is knowledgeable about this period will grant that Carr was important, few have emphasized his unique and overarching influence. Simply put, he was the blues world's most influential male singer, at least until the 1950s, and his impact extended well beyond the boundaries of what is normally considered blues. Nat "King" Cole owed him a debt, and Ray Charles (who recorded two Carr pieces among his early sides) even more so.

As for Sam Cooke—who set the pattern for everything from the 1960s soul shout to today's smooth R&B—the R&B historian Arnold Shaw traced the following line of descent: "Cooke, who influenced Otis Redding, David Ruffin, and Jerry Butler . . . , was himself the culmination of a blues-ballad tradition that had its inception with Leroy Carr and numbered Cecil Gant, Charles Brown, and Dinah Washington among its celebrated exponents."[45] The same connection could have been traced by a different route: Cooke started out in the gospel world, as understudy to R. H. Harris of the Soul Stirrers, and Harris listed Carr among his most important models, saying, "He was my man. I just wished he'd been in the spiritual field."[46]

Carr was born in Nashville, Tennessee, probably in 1899, but most of his performing life was spent in Indianapolis. He was a beautiful singer and a tasteful pianist, and was accompanied on almost all of his records by the guitarist Scrapper Blackwell.[47] In a parallel to what was happening in the mainstream pop scene, he was the first blues "crooner," a twelve-bar Bing Crosby. Unlike either the blues queens, whose voices had to be powerful enough to be heard over a band in a crowded theater, or the sidewalk singers, who needed to project over a busy street, Carr sang in a conversational tone. His work had a new intimacy, which was perfectly matched by the relaxed eloquence of his songwriting. Records like "Midnight Hour Blues" and "(In the Evening) When the Sun Goes Down" were covered by everyone from Count Basie to the Ink Spots and the Dominoes, and Carr's smoothly soulful phrasing formed the template followed by virtually every blues balladeer to follow. "How Long—How Long" was his breakthrough hit, a gentle eight-bar blues that became one of the genre's first ubiquitous standards. It is unlikely that there was any blues singer in the next twenty years who could not have managed a version of this song, and its lilting melody inspired hundreds of later compositions.[48]

Tampa Red and Georgia Tom were also a piano-and-guitar duo, and recorded quite a few ballads in the Carr style, but their trademark was the upbeat, risqué music that would come to be known as "hokum."[49] Georgia Tom had been Ma Rainey's pianist and a composer of vaudeville blues songs since the early 1920s. He had recently taken time off from the secular world to write religious music, and as Thomas A.

Dorsey would go on to be the "Father of Gospel Music," writing dozens of gospel standards and acting as mentor to Mahalia Jackson. Tampa Red, meanwhile, was a slide guitar virtuoso with a thin, distinctive voice and a fondness for the kazoo. Together and separately, under their own names and various noms de guerre, they redefined blues as light, sexy party music. "Tight Like That" was basically a reworking of Papa Charlie Jackson's "Shake That Thing," but they played it in a modern, uptown style, and followed its success with a string of hot double-entendre numbers. They even did a raunchy cover of "How Long—How Long Blues," with the vaudeville comic and female impersonator Frankie "Half Pint" Jaxon ecstatically moaning the words "how long, daddy, how long!" over and over, and eventually faking an orgasm. The record also included the immortal interchange:

Tampa Red: "Woman, you reading the Lady's Home Journal."
Jaxon (in falsetto): "Yes, Daddy, but I want that Saturday Evening Post!"

It was a long way from Ma Rainey holding church in the black vaudeville theaters, but Carr-style ballads and hokum party music would dominate the blues scene until the arrival of R&B.

This musical shift reflected changes both in entertainment technologies and in the lifestyles of African-American consumers. Ever since the Civil War, black Southerners had been leaving the countryside and heading for urban areas, crowding the booming black districts of Dallas, Memphis and Atlanta. After World War I, this trend was greatly accelerated, and by the 1930s most of these emigrants were heading for industrial centers farther north: St. Louis, Detroit, Chicago, and New York. City life called for a hipper, more streamlined sound track. Dorsey would explain that the sparer musical approach, with just piano and guitar, was better suited to the urban environment than the big, horn-powered sound of the blues queens: The most frequent performing venues were now "rent parties" held in apartment buildings, and neighbors would get annoyed and call the cops if things got too loud.

Blues was also experiencing the same technological transformation that was affecting mainstream pop styles. The arrival of electronic

amplification meant that even in clubs and theaters it was no longer necessary to have a voice that could be heard over a full orchestra or cut through a crowded, noisy room. What was happening in blues was to a great extent part of the wider revolution in which Crosby-style crooners were replacing big-voiced stars like Al Jolson.

By the fall of 1929, there was also the Depression, which closed down a lot of the large touring shows and theaters. Record companies went bankrupt as sales plummeted, and for a while it seemed as if the blues boom might be finished.[50] Instead, it became clear over the next few years that the hard times had only increased some people's yearning for music, and by 1937 there were almost as many new blues records being issued as in the peak years of the 1920s. Still, cost cutting was the order of the day, and few companies were prepared to spend money on Southern field trips, or to take chances on new and untried artists. For the next decade, the blues market would be overwhelmingly dominated by piano-and-guitar duets, sometimes fleshed out with a bass, harmonica, kazoo, or washboard, recorded by a small circle of professionals. These musicians routinely played on one another's sessions, and the resulting records would be released under the name of whoever happened to be singing. It was during this period that Chicago cemented its reputation as the capital of the blues, home to a crop of reliable players who ground out records as efficiently as the local slaughterhouses processed hogs into sausage.

I like sausage, and I like the Chicago blues sound of the 1930s, but one cannot deny its homogeneity. The studio-band system had no room for idiosyncratic artists like Lemon Jefferson, nor did it spawn the variety of writers, arrangers, and musicians that had dabbled in blues during the heyday of the vaudeville queens. Big Bill Broonzy, for example, played guitar on hundreds if not thousands of records, and had 224 sides released under his own name or pseudonyms. He was an expert player, singer, and songwriter, but even his most diehard fans will grant that he repeated himself a lot, and that a well-chosen forty or fifty songs would be enough to effectively sum up his work in this period. What is more, apart from a few exceptional sides, little distinguishes these records from others being recorded by the mix-and-match Chicago studio groups, aside from the shifting vocalists—Bumble Bee Slim, Sonny

Boy Williamson, Jazz Gillum, Washboard Sam, and on the women's side Memphis Minnie, Georgia White and Lil Johnson—and even the vocals tend to have a lot in common.

A similar scene existed in St. Louis, also heavily weighted to piano-guitar duos and post-Carr vocalists like Walter Davis and Peetie Wheatstraw, and most of the main blues recording stars of the period seem to have been prized as much for their consistency and reliability as for any uniqueness of talent or approach. (Uniqueness, hell: One of the most popular singers of the 1930s was Bill Gaither, who was so obviously a second-string Leroy Carr that, instead of using his own name, he recorded as "Leroy's Buddy.") These players would make the vast mass of blues recordings in the 1930s, their reign only occasionally interrupted by an oddity like Blind Boy Fuller or Bo Carter, whose imaginatively obscene lyrics compensated for a relatively rural-sounding solo guitar accompaniment.

Of course, records are not the whole story, and there was a lot of other music being played that was not considered salable enough to be captured for posterity, whether in city apartments or at backcountry dances. In the next chapter, I will attempt to flesh out the picture, exploring what the records may have missed. However, to complete the saga of the early blues boom, I want to give a list of its top recording stars. This is necessary, because many histories have left readers with severe misimpressions about the period. Writers typically give disproportionate space to Charley Patton, Robert Johnson, and other rural players, and though they may mention the greater sales of blues queens like Clara Smith and Sara Martin, and uptown pianist-singers like Walter Davis and Peetie Wheatstraw, it is natural for readers to lose any sense of scale.

To be fair, this list is not an absolute indicator of popularity. It does not convey the importance of Blind Lemon Jefferson and Leroy Carr, who died at the peaks of their careers, and since it tabulates only numbers of recordings, rather than sales per record, it also understates the impact of "one-hit wonders" like Jim Jackson. Meanwhile, some of the Chicago and St. Louis players of the 1930s may be overrepresented, since their proximity to the recording studios gave them an advantage over their rural peers. (Though, to balance that, the entries for studio

stalwarts like Big Bill Broonzy and Tampa Red do not include the many cuts that featured their vocals but were released under group names like the Hokum Boys.)

On the whole, though, I believe that this list gives an accurate picture of what was being sold on the blues scene of the 1920s and 1930s, and it generally matches the recollections of people I have interviewed who were playing and listening during that period. Certainly, every artist included here was popular enough to record again and again, and the top twenty names would have been known to anyone even faintly interested in the style. If many of them are unfamiliar to most present-day blues fans, that indicates how much our view of the scene has been influenced by the intervening years, and how little it resembles the views of listeners at the time.

Here, then, are the blues artists who had more than a hundred sides released under their names between 1920 and 1942:

Tampa Red—251 sides, between 1928 and1942
Big Bill Broonzy —224 sides, between 1927 and 1942
Lonnie Johnson—191 sides, between 1925 and 1942
Bumble Bee Slim—174 sides, between 1931 and 1937
Peetie Wheatstraw—161 sides, between 1930 and 1941
Bessie Smith—160 sides, between 1923 and 1933
Walter Davis—160 sides, between 1930 and 1941
Memphis Minnie—158 sides, between 1929 and 1941
Washboard Sam—141 sides, between 1935 and 1942
Roosevelt Sykes—132 sides, between 1929 and 1942
Blind Boy Fuller—129 sides, between 1935 and 1940
Sara Martin—128 sides, between 1922 and 1928
Clara Smith—124 sides, between 1923 and 1932
Leroy Carr—120 sides, between 1928 and 1935
Bo Carter—109 sides, between 1928 and 1936
Bill "Leroy's Buddy" Gaither—109 sides, between 1931 and 1941

The runners-up are Ethel Waters with 97 sides (though her position would be far higher if I included the many pop-jazz recordings she made in the 1930s after abandoning the blues scene, and lower if I

removed the pop songs she did during her blues phase); Ida Cox with 96; Rosa Henderson and Ma Rainey with 94 each; Georgia White with 91; John Lee "Sonny Boy" Williamson with 89; Lemon Jefferson with 86; Georgia Tom Dorsey with 85; the Mississippi Sheiks with 84; Blind Blake, Alberta Hunter and the Harlem Hamfats with 79 each; Kokomo Arnold and Eva Taylor with 78 each; Kansas Joe McCoy and Victoria Spivey with 77 each; Mamie Smith with 75; Curtis Jones with 74; Lucille Hegamin and the Memphis Jug Band with 73 each; the Yas Yas Girl with 71; and the Hokum Boys, Papa Charlie Jackson and Josh White with 69 each (not counting the records White made in the early 1940s for the white folk market, which would bring him up to 109).[51]

Barely a half dozen of these forty entries are the sort of rural, street-corner or juke-joint players that most present-day listeners associate with the golden age of acoustic blues. These were the stars, the popular professionals who had the hits that the rural players learned, imitated, and reworked for local fans. They are not the whole story of the blues era, but they were by far the most visible and influential figures, and the ones who defined the style for the vast majority of its audience.

3

WHAT THE RECORDS MISSED

"So far as what was called blues, that didn't come till 'round 1917. . . . What we had in my coming up days was music for dancing, and it was of all different sorts."[1]

— MANCE LIPSCOMB, TEXAS GUITARIST AND SINGER

As I tried to emphasize in the previous chapter, the main purveyors of blues music were professional musicians. I need to stress this, because blues has so often been trumpeted as a black folk style, in the sense of being a "music of the people," played by farmers and laborers as a form of relaxation from their harsh daily grind. Of course, plenty of people did play blues at home to relax after a day's work— just as people today may get together to play blues, jazz, country, or classical string quartets—and this kind of informal music making was far more common before phonographs, radio, and television made professional entertainment accessible in every living room. However, the vast majority of the music that got recorded and that influenced amateurs and professionals alike was made by people who played for a living. Some had other jobs as well, but even these performed for a paying public and were not just enthusiastic amateurs.

These musicians worked in all sorts of settings, from formal concert halls to street corners, to places that few of us would think of as performance venues. A good example is the local barbershop. Despite

the survival of the term "barbershop quartet," most people have forgotten how much music was played in barbershops, which were a common place for men to gather in idle moments. Frequently, the barber would keep a guitar or mandolin hanging on the wall, handy for any musician who happened to wander in. Nonprofessionals might while away their time harmonizing on favorite songs, but professionals would also stop in and play for tips, or to demonstrate their expertise for potential customers. After all, until recording came along, an event that wanted to have music had to have live musicians. Be it a picnic, a bar, or any kind of dance or social occasion, no music was available unless there was someone to play it.[2]

As a result, musicians of that time had a degree of versatility that is now extremely rare. Or maybe that is the wrong way to phrase it. Our idea of musical versatility is largely based on a system of taxonomy that did not even exist before the recording era. The idea of genres and categories, which most of us now take for granted, was invented as a means of filing and marketing records. Before the twentieth century, while one heard very different styles in different settings, they were not neatly classified, and the divisions were generally based on performance style rather than types of music. For example, European concert virtuosos who toured the United States would routinely work up an arrangement of "Yankee Doodle" as a crowd-pleasing adjunct to the more highfalutin German or Italian compositions. There were any number of pieces that would have been equally likely to show up in the repertoires of players at minstrel shows, rural picnics, brass band concerts, and Carnegie Hall, catchy tunes like "Blue Bells of Scotland" and "Over the Waves."[3]

Of course, some audiences preferred one style and others another, but these styles were not yet codified and there was a good deal of shading and overlap. Any working musician was thus expected to play a range of music that would surprise modern listeners, who are used to the idea that classical musicians play classical, country musicians play country, and jazz musicians play jazz. This was especially true in rural backwaters where audiences were lucky if they heard a touring band every few months. Hillbilly groups like the Carolina Tarheels, far from sticking to fiddle breakdowns, would advertise their shows as

consisting of "old time Southern Songs mingled with the latest Broadway Hits."[4]

When it came to blues, there were probably very few musicians working in the 1920s or 1930s who restricted themselves to that style. What survives in the Race record catalogs may imply that certain artists could play only the most basic twelve-bar blues pattern, but that has far more to do with what the companies wanted than what the musicians were capable of providing. As we will see in this and ensuing chapters, a performer whose entire recorded repertoire consists of blues might have been making his or her day-to-day money playing in a jazz group or a country hoedown band, or even plinking out Neapolitan mandolin melodies in Italian restaurants.

As Johnny Shines, one of the great Delta blues artists, explained:

> When you went into a place, you'd hit on different numbers till you find out what they really liked, and whatsoever they liked, that's what you played. See, different places, different areas throughout the country liked different things. . . . Now, when you get back on the farms and places like that, you didn't have to play nothing but the blues. You could play the same number all night, as far as that's concerned—as long as you played it fast and slow, just change the tempo, it didn't make no difference. In those little towns, though, you had to be on your P's and Q's, play what they liked. [Shines recalled Earl Hines and Duke Ellington as particular favorites.] Mostly you played for the dancers . . . They were doing two-steps and quite a few waltzes in those days.[5]

Shines was comfortable with this broader repertoire, but recorded only blues, and this was typical of a lot of black musicians of his time. As a result, if we want to understand such musicians and try to form a full idea of their musical world, we have to look beyond what survives on their records. This is not an easy process, but we can certainly paint a far broader, more inclusive picture of black vernacular music than is commonly accepted. We cannot say exactly how some unrecorded music would have sounded, but we can at least insist that it existed and remember that the people we think of as blues artists were playing and listening to it.

The most obvious gap in blues history, or the history of African-American music in general, is all the material that went unrecorded before the 1920s. Many scholars have attempted to extrapolate earlier styles from recordings of the oldest black players, and of white artists who showed clear affinities with common black styles. This approach provides a lot of information, especially about the string band tradition, but we will never know for sure how accurate a picture it has given us. Times and styles change, among vernacular country players as well as among trendy urbanites, and this was particularly true in this period, due to the arrival of the phonograph. For some twenty years before rural Southern artists or black players of almost any kind began to be recorded, such artists could sit at home and listen to Caruso, John Phillip Sousa, Al Jolson, and a lot of minstrel comedy. Even in the most isolated mountain areas, peddlers carried sheet music and phonographs, and wandering musicians brought news of the latest innovations.

Because of this, we will never know exactly what music the parents and grandparents of the blues stars would have played, or how they would have played it. Nonetheless, I can say with absolute security that they played a much, much more varied repertoire than is usually assumed by people who have not made a study of early rural music-making. The common stereotype of black music in the slave and Reconstruction eras is of somber, African-inflected spirituals and field songs, leavened with ecstatic religious pieces that may be hailed as coded celebrations of future freedom. This is accurate up to a point, but obscures the fact that African Americans played every sort of music in the South, and made up the majority of full-time musicians. When white plantation society fell in love with the waltz, the schottische, or the latest French ballroom fad during the antebellum years, its dance orchestra would typically be made up of black slaves. Some of these slave musicians were perforce skilled music readers, and a few became highly skilled classical artists. (Black classical musicians are rarely mentioned in blues histories, but it should be noted that the most sophisticated American guitarist of the nineteenth century was a black man from Virginia, Justin Holland, who introduced the European techniques of Sor and Carcassi to the United States.) The clas-

sical influence was not restricted to a tiny elite, but seeped down to a lot of people who did not have access to formal training. After the guitar became widespread in the 1890s (when Sears-Roebuck made inexpensive mail-order instruments available), one of the instrumental numbers most frequently found among rural players was "Spanish Fandango," a standard beginner piece in the formal instruction manuals, which was so popular that many blues players continued to refer to its trademark "open G" tuning as "Spanish."[6]

Meanwhile, the slaves themselves held dances, and much of what we now think of as "old-time" or "hillbilly" music derives from their so-called jigs and reels (terms that were routinely used for any dance that struck respectable people as wild and unrestrained, whether Irish or African). Our view of this music has been forever slanted by the vagaries of the record scouts who arrived in the 1920s and, having learned that such pieces sold much better to white customers than black, discouraged black musicians from playing them. This is why all but a tiny sample of the rural fiddle music recorded during this period and afterward comes from white players.

Up through the first years of the twentieth century, the fiddle was by far the most common and popular instrument among Southern musicians, regardless of race, and older white musicians have regularly credited tunes and styles to black players. Whether or not their reproductions of such pieces exactly duplicate the way their black forebears played, they provide a glimpse of an extremely vibrant African-American hoedown tradition, and one that has profoundly affected what is now thought of as white country music. Most experts agree that between a third and a half of the standard Southern fiddle repertoire is drawn from black tradition, including such favorites as "Old Joe Clark," "Cindy," and "Cripple Creek."[7] What is more, this tradition was still very much alive during the blues era. Even in 1975, the *Grand Ole Opry* guitarist Kirk McGhee could name a dozen black fiddlers living in his home county of Franklin, Tennessee, so one can only imagine how many must have been there fifty years earlier.[8]

It is worth taking a couple of paragraphs here to explore the overlap of black and white music making in the rural South, a subject that has only recently begun to receive anything like its due from either

blues or hillbilly scholars. I once put together a talk called "Before Music Was Segregated" and, while the title was consciously provocative, I do not think it was on the whole inaccurate. It reflected the reality that most Southern music came out of a brutally unequal but broadly overlapping culture. Even in the midst of the Civil War, the Confederate General J.E.B. Stuart traveled with a personal string band that included both black and white players, and such "mixed" groups continued to play for dances throughout the South, despite the segregation common in other aspects of the players' lives.[9] (Furthermore, that segregation cannot be taken for granted, especially in the mountain areas where there were no large plantations and hence relatively few African Americans. Virulent racism did exist in many mountain communities, but there were also pockets where, as the black Virginia guitarist Turner Foddrell recalled, "We all danced together and drank out of the same jug.")[10]

Several interracial string bands recorded in the 1920s. Taylor's Kentucky Boys featured white musicians supporting the expert fiddling of Jim Booker, born in 1872 and considered one of the greatest old-time "hillbilly" players in central Kentucky, and the white Georgia Yellowhammers recorded with the black fiddler Andrew Baxter. Both Bill Monroe and Merle Travis traced their music back to a black fiddler and guitarist, Arnold Schultz, who had regularly played in their region of Kentucky, often supported by white musicians. While these examples might suggest a sort of exceptionalism—that white musicians would work with a black player, but only if he was the greatest fiddler in the region—Mississippi John Hurt came to the attention of Okeh Records scouts through his association with the white fiddler William T. Narmour, who used him as an accompanist whenever his regular guitarist could not make a gig. Meanwhile, over in Tennessee, Brownie McGhee's father played blues guitar but also worked regularly with a mixed hillbilly band.[11]

Some scholars insist that such interracial groupings were a rarity, but there is little or no evidence to support this assertion. Across the South, if one bothers to ask, one finds reports of black and white musicians working together. The fact is that most rural areas had only a limited number of skilled players available for dances, and often ended

up using mix-and-match groups of whoever could make it that night. Even in the most racist areas, white dancers rarely objected to blacks providing the music, as long as the musicians "stayed in their place," playing but not mixing socially, and a lot of white musicians developed their tastes and techniques at these events. Interracial jamming was far more common than is generally suggested, though I do not want to overstate this case, and would take the rarity of mixed groups on record to indicate that, when a group of musicians considered themselves a serious band rather than just whoever had showed up for a dance, they tended to group along racial lines.[12]

Even when musicians were segregated by race, there was no barrier preventing them from adopting each other's tunes and playing styles. The bulk of Southern fiddling sounds quite unlike anything to be found in either Europe or Africa, and that can be laid squarely on the pressures and inspiration that the black and white musical traditions exercised on each other.[13] As for other instruments, the banjo originally came from West Africa, and the percussive "frailing" or "rapping" style we hear on the records of white players like Uncle Dave Macon is a survival of an African-American technique. An interesting anecdote on this theme comes from the Virginia blues and country player John Jackson: Shortly after he was "discovered" by the white folk crowd, a folklorist was talking with Jackson about the harmonica master DeFord Bailey, and described Bailey as the only black star of the *Grand Ole Opry*. Jackson startled the folklorist by asking, "What about Uncle Dave Macon?" He had simply assumed that the old banjo player, with his repertoire of plantation tunes and the "Uncle" sobriquet—as in Uncle Ben, Uncle Tom, Aunt Jemima—was black.

Jackson's reaction makes instant sense if one watches a short film made in 1928 of the black banjo player Uncle John Scruggs.[14] Sitting outside his cabin, Scruggs performs "Little Old Log Cabin in the Lane," the same song with which Fiddlin' John Carson ignited the hillbilly recording boom. He is blind and looks to be around seventy, which could mean he was alive in slavery times, and he sings the lyric just as it was written in 1871, full of nostalgic parlor-minstrel lines about how "de darkies are all gone, I'll neber hear dem singin' in de cane." There may be experts who, blindfolded, could tell that Scruggs

was black and Uncle Dave Macon was white, but it would be no easy feat. Indeed, despite exhaustive research, there are a number of early string-band recordings that have had to be classified as racially ambiguous.

Scruggs never recorded, though the phonograph era found him still in fine fettle and popular enough to attract a film crew, so it is no surprise that a lot of other black banjo and fiddle players failed to leave any trace of their music on discs. Even in the 1970s, a survey of old-time musicians in southern Virginia turned up quite a few black banjo players (at least one still calling himself "Uncle"), none of whom had previously recorded.[15] Which is to say the perception that by the 1920s the "old-time" or "hillbilly" tradition of fiddle and banjo playing had pretty much died out in black communities is simply wrong. There were black square dances in Virginia at least up into the 1950s, and in the 1920s they were still being held in many areas of the South.

The same holds true for minstrel shows. Minstrelsy is often given short shrift in discussions of African-American music due to its racist associations—the shows relied on demeaning stereotypes and black-face makeup, and it was common for the performers, whatever their race, to be referred to as "nigger minstrels." Nonetheless, the minstrel craze swept both black and white communities, and minstrel troupes nurtured generations of black artists, from banjo players and comedians to opera singers. As W. C. Handy recalled:

> It goes without saying that minstrels were a disreputable lot in the eyes of a large section of upper-crust Negroes . . . but it was also true that all the best talent of that generation came down the same drain. The composers, the singers, the musicians, the speakers, the stage performers—the minstrel shows got them all.[16]

Minstrel shows remained common well into the 1950s, and—despite growing opposition to blackface stereotypes—their popularity was by no means restricted to white racists.[17] A scan of the entertainment pages of the *Chicago Defender*, America's most widely circulated black newspaper, shows that minstrel troupes were covered far more frequently than blues singers and, though most of the music played at

these shows probably kept pace with changing fashion, the comedy still had a lot of classic minstrel elements. Indeed, Pigmeat Markham and other comedians were still "blacking up" for shows at Harlem's Apollo Theater in the 1940s. (Now that this practice has essentially disappeared, the question remains: What color makeup *should* a black clown wear?)

The most successful minstrel shows were major theatrical events, performed by large troupes with impressive sets and an orchestra, but blackface makeup and comic "coon" songs were also a staple of informal family and school groups,[18] and of performers in touring "medicine shows." These medicine shows were short collations of songs and skits designed to draw a crowd for a pitchman selling snake oil or other questionable vade mecums. They visited out-of-the-way areas, and provided work for all sorts of rural musicians, including many who are remembered as blues pioneers. Such shows employed both black and white performers, often doing virtually identical acts, and the basic style outlived both the medicine and the makeup. Spence Moore, a white guitarist who spent several years on the medicine-show circuit, explained that after blackface went out of fashion, he and his partners would dot their cheeks with exaggerated freckles, black out a tooth, wear old overalls with "one gallus unfastened," and do the old "coon" routines as white hillbilly rubes. Which is to say that the sort of comedy featured on *Hee Haw* and the *Grand Ole Opry* is simply a minstrel survival with a new coat of paint.

As for black audiences, they were not as universally sensitive to the horrors of minstrelsy as some people like to believe. For example, numerous writers have stated that the banjo fell out of favor with black musicians because of its racist, minstrel associations, but this makes little sense when one considers that the most sophisticated black groups of the period, the orchestras of Louis Armstrong, Duke Ellington, and Jelly Roll Morton, continued to use banjos until amplification made the guitar viable in a bigger band setting. Likewise, a lot of the musicians now classified as bluesmen continued to play pieces that had originally been written as "coon songs," and while some edited the lyrics, others continued to sing the lines just as they had been written in the 1890s. (White musicians also varied in this respect. The choice

to edit had to do with racial consciousness and pride in some cases, but in others it was simply a matter of bringing the songs up to date. Acting the part of a comic "coon" was not only racist but old-fashioned.)

All in all, the fact that so few black banjo players—or fiddlers, or accordionists—were recorded had less to do with what was available than with the perceptions of the "record men." Having found that there was a large market for nostalgic "Old Fashioned Tunes" among white rural buyers, but that black consumers tended to prefer newer styles, the recording scouts made their choices accordingly. This left black string bands in a double bind: They were banned from the hillbilly catalogs because they were black, and from the Race catalogs because they played hillbilly music. The exceptions were those like the Mississippi Sheiks, who developed a large repertoire of straight-ahead blues songs for recording, while continuing to play hoedowns, pop songs, and other music in live performances.

One could argue that the record companies' policies were designed less to segregate the musicians than to provide uniform product lines. Indeed, in the few cases where black fiddlers recorded old-time hoedown numbers, these records tended to be issued in the hillbilly rather than the Race series. After all, there were no pictures on the record labels, so consumers would not know the difference.[19] The practice was not common, though, and by the end of the 1920s the chance to work both sides of the color line had pretty much disappeared. For example, James Cole and Tommie Bradley, a black fiddle-and-guitar duo, made their recording debut in 1928 with a hoedown pairing released in Vocalion's "Old Time Tunes" series, and this was probably pretty typical of their repertoire, but after 1930 all of their records were blues and pop-blues tunes, released in Champion's Race line.

The record companies not only prevented black bands from playing what was perceived as "white" music, but limited both white and black musicians in all sorts of ways. For instance, despite the fact that rural players were regularly performing the latest Tin Pan Alley favorites, almost none of this material was recorded on the Southern field trips. From the companies' point of view, this was an obvious choice, since the average country fiddler or barrelhouse pianist lacked

the musical sophistication of the top New York jazz orchestras or Broadway pit bands. Such artists could play the uptown pop hits well enough to satisfy folks in a neighborhood saloon or at a country dance, but not many record buyers, even in rural areas, cared to hear a bunch of hicks playing "I'm Coming Virginia" when it was just as easy to get the Bing Crosby record.[20]

In this case, the commercial scouts were abetted by the folklorists who provide our only other documentation for this period. While some of these folklorists took care to preserve examples of black fiddle and banjo music, they had no interest whatsoever in hearing their informants perform pop hits. The more dedicated chroniclers at least made note of the fact that these informants knew pop material, but in general they viewed such matters as "contamination" of the pure folk tradition, and avoided the subject. As a result, we can never know the extent to which Race and hillbilly artists of the 1920s and 1930s were also adept at playing the latest urban exports, or how they reshaped this material to fit their tastes and instrumentation.

I am particularly conscious of this lack because I spent a couple of years as accompanist to Howard "Louie Bluie" Armstrong, the last of the great African-American string-band masters. Howard is a fiddle and mandolin player from outside Knoxville, Tennessee, who first recorded as a member of the Tennessee Chocolate Drops in 1930. All of his prewar recordings were in the countrified ragtime-blues genre, and if he and his playing partners had died before the 1970s it would be easy to assume that this was their basic repertoire. However, as I write, Howard is still alive and playing at age ninety-three, and he has spent the last thirty years demonstrating just how wrong that assumption would have been. It turns out that, even back when they were recording, his group's theme song was "Lady Be Good," and their pop repertoire included pretty much any hit of the period, including a version of "Chinatown, My Chinatown" with a verse in what he swears is Mandarin Chinese. And that is just the tip of the iceberg. He always prided himself on being able to play whatever job came along, which meant that he mastered the whole square-dance repertoire, plus a full night's worth of Italian or Polish favorites, since his corner of eastern Tennessee had a large immigrant population from those countries. He

can sing sentimental Gene Autry numbers, play an elegant guitar arrangement of "Stardust" with all the fancy jazz chords in all the right places, and toss off a handful of Hawaiian and Mexican songs.

Now, Howard is not exactly typical—he is an accomplished painter, speaks several languages, and remarried at age ninety—but he worked as a professional musician for many decades, in Knoxville, Chicago, and Detroit, and always found other black players who knew a similar repertoire, or at least were expert enough to follow his lead. This was simply what was required of any musician who wanted to make a good living and take the variety of jobs that might be available. The same guy who was recording guitar blues on Saturday morning might go on to play in a minstrel theater band that night, provide the rhythm for a jazzy horn outfit at an after-hours juke joint, and play for a white country picnic on Sunday afternoon. Lonnie Johnson—able to play comfortably with a rough rural singer like Texas Alexander or the uptown swing orchestra of Duke Ellington, and to switch to piano or violin if necessary—was a particularly sophisticated example, but the country was full of adept journeymen who could hold down whatever chair was needed.

If some of these artists are now remembered purely as blues players, that is once again due to the commercial strictures of the record scouts. The Mississippi Sheiks, being black string musicians from Mississippi, were expected to stick to blues in the studio, but it is only this accident of recording fashion that makes us classify them as bluesmen. The band's leader and usual fiddler, Lonnie Chatmon, could read standard notation and taught the other players the latest hits off sheet music. His brother Bo recorded a long string of double-entendre blues under the name Bo Carter, but also filled in as alternate violin player, both with the Sheiks and with various mix-and-match aggregations of Chatmons and such other local musicians as Joe and Charlie McCoy. Scattered among the recordings of these Mississippi string players, one can find a typical assemblage of rural music of the time, from fiddle tunes to romantic waltzes and cowboy yodeling.

There are also some sides that force us to reassess any division between "country" and vaudeville styles. On one session, Carter and the McCoys back a minstrel singer named Alec Johnson, and in this con-

text their playing shows no sign of country roots. Carter on fiddle and Charlie McCoy on mandolin play carefully arranged parts, with all the eerie, minor-key effects and flawless arpeggios one would expect of a well-rehearsed theater orchestra. Had recording fashions been different, we might well remember them as minstrel masters, and their blues work might have been heard only at live shows in juke joints and now be forgotten. It is an accident of timing that during the brief period when black Mississippi players were being recorded, blues was what was hot.

Some people might suggest that I am picking extreme examples, but plenty of artists who are regularly listed among the "deeper" bluesmen did their share of minstrel performance. Big Joe Williams was a hard-core Mississippi guitarist and singer, with a tough, fierce sound that has no trace of string-band lightness or versatility. His records, whether cut for the Race market of the 1930s or the revivalist scene of the 1960s, were all fairly straight-ahead blues. And yet, he started out with minstrel and medicine shows, and his memories of that time carry no suggestion of his later musical taste: "They had dancing, cracking jokes, blackface comedians—we all used to do that. Take flour and soot to make you dark; we had wigs we wore sometimes; we had them old high hats and them long coats and a walking cane and them button-type spats."[21] Had the record scouts happened on Williams a few years earlier, he would be remembered not as a bluesman but as a minstrel comedian. (Or rather, since minstrelsy has largely been ignored, he would not be remembered at all, and the blues fans who "rediscovered" him in the early 1960s would have gone after someone else who happened to record during the blues boom.)

Now, the normal way this subject is addressed in blues histories is to say that, on the one hand, some blues players could also play non-blues material, and on the other hand, there were also a lot of black guitarists and singers who were not bluesmen but "songsters"—Mississippi John Hurt, Henry "Ragtime Texas" Thomas, and Mance Lipscomb are typical examples—who performed a huge range of material including some blues. This distinction is utterly modern and artificial, and has no bearing on the way musicians thought of themselves in the 1920s or 1930s. Rural Southerners often said "song-

ster" for "singer," as they said "musicianer" for "musician," but they used these terms equally for players who are mostly known for their blues work and for those who are not. Indeed, everything I have heard suggests that if they had happened upon some classical records and liked them, they would have described Caruso as an expert songster and Segovia as a fine musicianer.[22] And this is not just a matter of semantics. Genre distinctions were simply not part of most people's musical lives. A prewar "bluesman" like Jesse Thomas, in Shreveport, Louisiana, did not find anything strange about the fact that in the 1970s he was leading a hotel band that played "Tie a Yellow Ribbon Round the Old Oak Tree." His choice of material surprised and disappointed the young blues fan who found him there, but to him it was as logical to play Tony Orlando and Dawn in the 1970s as it had been to play Lonnie Johnson in the 1920s.[23]

Pretty much all the blues artists of the early era could fill requests for non-blues repertoire if asked, and it was due to the commercial trajectory of the record industry that they were so rarely asked during studio sessions. In this sense, the companies invented the concept of the "bluesman"—though this term was not current at the time—by always requesting blues from black rural performers. If black singers had no blues repertoire, they stood little chance of being recorded, while if they did, that repertoire tended to make up the vast majority of what got preserved, irrespective of what else they might know or what they performed most frequently at dances or on street corners.

A recently discovered Paramount "test pressing" proves that this could be true of even the deepest Mississippi masters. Tommy Johnson's records are considered to be among the bedrock documents of the classic Delta style, alongside those of Charley Patton and Son House.[24] However, the unissued pressing reveals that Johnson began his first session for Paramount Records by trying out two versions of a yodeling cowboy number, complete with Jimmie Rodgers–flavored guitar strumming. Johnson's blues work was always noted for its lovely falsetto passages, and his yodeling has a similar feel, but the song is still a world away from his familiar repertoire. Listening to it, one cannot doubt that he was quite comfortable with the Rodgers approach, and could have come up with more of this material had it been in de-

mand. Clearly, though, it was not what the record producers wanted from him, since it remained unheard for the next seventy years. As a result, Johnson was typed by everyone as a brilliant but limited exponent of the Patton style of hard Delta blues.[25]

As I have already suggested, the few folklorists who went into the South in those early years would only partially balance this picture. Though their motives were different from those of the commercial record scouts, they also had a specific agenda, which was to find survivals of older traditions and "typical" examples of regional and ethnic styles. Thus, they were uninterested when their informants, whether white or black, sang current hits or anything learned off records, and they often sought out "white" material such as the British ballads from their Euro-American sources, while mining Afro-Americans for songs that might reveal African or slavery-era connections.[26] As a result, their recordings often reinforce the impression that Southern music could be split along racial lines. There were exceptions to this rule—John Lomax collected his canonical version of "Home on the Range" from a black cow-camp cook—but overall the recordings left to us by the folklorists and the commercial companies both tend to give a skewed view of the racial divide in the music of early rural performers, and reinforce the impression that such players were limited to a distinct "country" repertoire.

It is hard to blame anyone for this. In those days before tape recording, both folklorists and record company men were using metal or acetate discs, which were relatively expensive and in most cases could hold only between three and four and a half minutes of music or talk. (By 1940, Alan Lomax had large discs that ran at 33⅓ and could hold fifteen minutes, but wartime rationing meant that he had a very limited supply of them.) The folklorists would certainly have liked to record far more than they did, but had to concentrate on what was most distinctive in each artist's repertoire. The most responsible ones tried to flesh out their recordings with other data, an example of which will help me make my broader point:

Any serious blues fan is aware of the recordings Muddy Waters made for Alan Lomax, John Work, and the Library of Congress in 1941 and 1942. These are precious documents, both because they are

excellent in themselves and because they provide a glimpse of one of the seminal electric blues artists near the beginning of his career. However, they include few surprises. Aside from the fact that on some tracks Waters is working with a fiddler, they are pretty much what one would expect, knowing the roots of his music and his later evolution. He has his own style, but is clearly a bluesman in what is now considered the mainstream Mississippi Delta tradition.

But what is not on the records, and how did Waters think of himself? In this case, Lomax and Work have provided the beginnings of an answer, and it is very revealing. Along with recording music, they conducted interviews and filled out a standard form on each of their informants. When asked to identify himself, Waters did not mention blues, but instead described himself as "Stovall [Farm]'s famous guitar picker." Along with explaining that the first song he learned to play was "How Long—How Long Blues," off the Leroy Carr record, Waters gave a list of the songs in his working repertoire, and it is not at all what one would expect from hearing his recordings.

Less than half the songs Waters mentioned were blues, and of the fifteen that were, one was "St. Louis Blues" (which Lomax classified as pop rather than blues) and six were learned off records by currently popular singers from Chicago and St. Louis. Meanwhile, Waters listed seven recent Gene Autry hits, including "Missouri Waltz," "Deep in the Heart of Texas," and "Take Me Back to My Boots and Saddle," and a dozen mainstream pop songs, including "Chattanooga Choo-Choo," "Darktown Strutters Ball," "Blues in the Night," "Red Sails in the Sunset," and "Whatcha Know Joe?"[27]

Waters told Lomax that his most popular pieces at local dances included many of these blues and pop songs, as well as "Corinna" and "Down by the Riverside." In another interview, he would recall: "We had pretty dances then. We was black bottoming, Charleston, two-step, waltz, and one-step."[28]

Among the things worth noting here are that blues was part of a broader mix of pop music at Delta dances, even when the band featured Muddy Waters, and that all of the nonoriginal blues songs Waters mentioned were learned off records, most of them by current hit-makers like Walter Davis and Sonny Boy Williamson. When asked

about his favorite musicians, Waters named Davis as his favorite blues recording artist and Fats Waller as his favorite radio star.

Lomax also noted that Waters had a wind-up Victrola in his house, but only seven records. Four of these had been issued within the year, including two by the Mississippi bluesman Arthur "Big Boy" Crudup and one by Jay McShann and his Kansas City orchestra. The remaining three were a gospel preaching record and older discs by Peetie Wheatstraw and Sonny Boy Williamson.[29] Unsurprisingly, Waters told Lomax that his favorite instrument was guitar, followed by piano and harmonica, but in other interviews he would add that his first instrument had been an accordion. (Only one black Mississippian recorded on accordion during the prewar era —Walter Rhodes, who cut a set of blues in 1927 accompanied by the legendary Delta guitarist Hacksaw Harney—but the instrument was not particularly rare. Henry Townsend, a sometime associate of Robert Johnson's, recalls that his father played one, and Charley Patton sometimes worked with an accordionist named Homer Lewis.)[30]

I cite all of this information to show what a limited and inaccurate picture we would have if all we knew about Muddy Waters's musical range was what survives on recordings. Without this additional material, it would be natural to classify him simply as a blues artist, firmly in the regional Delta tradition—indeed, that is how he has been remembered in every music history I know. Though Waters went on to become a major star, the defining figure in the evolution of acoustic Mississippi styles into the electric Chicago sound, all of the hundreds of sides he recorded over the years were chosen for their appeal to a blues-buying public. As a result, we will never know how he approached "Chattanooga Choo-Choo" or "Deep in the Heart of Texas," whether he expertly reworked the Autry and big-band numbers to suit his style or just played pedestrian cover versions. Furthermore, we cannot judge how his experience with these other musics affected his blues style.

Since Lomax interviewed only a handful of musicians, it is also difficult to judge how closely Waters's repertoire matched that of his Mississippi peers. There are a few clues, though. Skip James, when he began playing on the folk circuit in the 1960s, would occasionally sit

down at a piano and perform Hoagy Carmichael's "Lazybones," and his biographer wrote of him playing the Tin Pan Alley torch song "Am I Blue," complete with a kazoo solo.[31] Or take Johnny Shines, Robert Johnson's sometime traveling partner. Though his records all hew close to the standard blues forms, he took pride in his versatility, and enjoyed talking of his apprenticeship to a jazz piano player he knew only as W.J.:

> He'd play all of Earl Hines's stuff and Duke Ellington's. He was one of those fancy piano players and he taught me how to follow him with the guitar. That's how I began to exceed the rest of the boys on the corner, because I learned to play the better type of stuff. . . . We used to do things like "Everything I Do Is Wrong," "What's the Reason I'm Not Pleasing You" and things like that, popular songs. I was interested in learning anything then, anything, it didn't make no difference what it was. I always felt the more I learned, the better off I would be, the more chances I'd have of playing for the people.[32]

Honeyboy Edwards, another of Johnson's associates, would recall working with a sax player and performing songs like "Sophisticated Lady" and "Blue Moon."[33] All in all, it seems fair to assume that most players who were regularly working at dances in any but the most re-mote rural locations could at least make a fair stab at this sort of pop material, just as those who played out in the country would generally have been able to include at least a few hoedowns and waltzes.

This was, if anything, more true in other regions of the South. The surviving recordings of black players from Atlanta and the Carolinas show a greater tendency to include non-blues material than in Missis-sippi. (Though this may be due as much to the tastes of the talent scouts in each region as to the repertoires of the players themselves.) Overall, it is probable that no one outside vaudeville made a living dur-ing this period as purely a "blues" player. All were dance players, party players, street-corner players—songsters and musicianers, if you will—who included blues because it was one of the hot sounds of their time. In vaudeville or minstrel troupes, things might be a bit dif-

ferent. There, where a blues singer was just one of multiple acts and often performed only two or three songs, she might limit herself to blues. Even in the case of the blues queens, though, the earliest report of Bessie Smith describes her as a teenager singing "Won't You Come Home, Bill Bailey," she recorded several Tin Pan Alley pieces, and by the end of her career she had abandoned her old-fashioned blues style for a more commercial swing sound.[34]

As for the city-based piano-guitar stars who followed Carr and Tampa Red, they were working a lot of all-night gigs at rent parties and clubs, and would frequently have to reach beyond their blues repertoire. Paradoxically, they were even less likely to get this repertoire onto records than a lot of their rural street-corner peers. While a more countrified player like Peg Leg Howell was assumed to be a musical primitive who would play a whole mess of different stuff, the urban professionals were expected to come into the studio with polished, salable material in the current commercial style. The result is that someone like Lonnie Johnson, who could croon a song like "Old Rocking Chair" or "How Deep Is the Ocean" as smoothly as the most adept band singer, recorded only a couple of non-blues vocals among his 191 prewar sides. This was by no means his own choice. He was a professional, and took pride in being able to handle whatever styles came his way. "We played anything they wanted to hear," he once said, recalling his early days in New Orleans. "Ragtime melodies, sweet songs, waltzes . . . A lot of people liked opera, so we did some of that too." He became a blues singer because that was his only route to recording. He was living in St. Louis in 1925, and entered a blues contest that offered an Okeh recording contract as first prize. "I guess I would have done anything to get recorded," he recalled. "It just happened to be a blues contest, so I sang blues."[35]

Johnson had a light, crooner's voice, and could easily have become a proto–Nat "King" Cole, but in 1928 there was no interest in that—or at least none perceived by the recording companies. As a result, he earned his place in history as a pioneering male blues star. He never lost his taste for smoother pop material, though, and when he was "rediscovered" in the 1960s, despite pressure from folk-blues enthusiasts

to maintain his 1920s persona, he chose to play an electric guitar and to sing a mix of pop-blues, Tin Pan Alley standards, and Frank Sinatra hits.

Likewise, a thorough survey of what was recorded by the Chicago-based blues stars of the 1930s turns up a number of examples that show how comfortable they were with other kinds of pop music. Georgia White, though known for her racy blues songs in the Broonzy style, first recorded as vocalist for Jimmy Noone's Apex Club Orchestra, singing a version of "When You're Smiling (The Whole World Smiles with You)" that shows fine jazz chops and an obvious debt to Louis Armstrong. Merline Johnson, "the Yas Yas Girl," cut an exuberant version of Armstrong's hit "Old Man Mose," accompanied by a racially mixed jazz band that included the teenaged George Barnes playing one of the earliest electric guitar solos on record. Casey Bill Weldon, a slide guitar virtuoso associated with the Memphis blues crowd, turned in a dazzling number aptly titled "Guitar Swing," and his hokum outfit, the Washboard Rhythm Kings, cut an upbeat pop ballad called "Arlena."[36] In each of these cases, the recordings were unique and, if they did not exist, one would have no evidence that these artists were comfortable doing non-blues material. It is logical to assume that other Chicago "blues singers" were equally versatile but that the recording patterns of the period obscured this fact.

In support of this assumption, there is a surviving songlist from Memphis Minnie, provided to let customers at her shows know what numbers she could perform on request. Though she recorded only blues during her peak period, this list includes titles like "How High the Moon," "Lady Be Good," "Jersey Bounce," "When My Dream Boat Comes Home," and "I Love You for Sentimental Reasons."[37] Big Bill Broonzy was similarly versatile. Once again, he recorded only blues and hokum in the 1930s, but after connecting with white revivalist audiences in the 1940s he cut several Tin Pan Alley songs, including hot versions of "Who's Sorry Now" and "I'm Looking Over a Four-Leaf Clover," accompanied by Australian and English jazz bands.[38]

In fact, there was no neat divide between blues and jazz. All early jazz musicians could play blues, as witness the accompaniments Armstrong, King Oliver, Fletcher Henderson, and hundreds of other jazz-

identified artists provided for various blues queens. What is less widely acknowledged is that a lot of the musicians placed in the blues category were making at least some of their living with combos that would more logically fit into the jazz bag. Basically, it tended to be a question of instrumentation: If a blues artist ended up at a gig with some horn players, the result was likely to fit our modern idea of "good-time jazz," the sort of music heard on records by Clarence Williams's Washboard Band or the Louisville Jug Band's sessions with Johnny Dodds and Earl Hines.[39]

The outstanding example of this overlap was the Harlem Hamfats, a Chicago band led by the Mississippi guitarist Kansas Joe McCoy, with his brother Charlie on mandolin and two New Orleans–style jazzmen, trumpeter Herb Morand and clarinetist Odell Rand. The McCoys, whom I already mentioned in connection with the Mississippi string bands, had impeccable blues credentials. Joe was most famous for the duets he cut with his wife, Memphis Minnie, and Charlie supplemented his solo career by recording as accompanist to Tommy Johnson, Peetie Wheatstraw, Sonny Boy Williamson, and dozens of other blues singers. Nonetheless, the McCoys' work with the Hamfats has a hip jazziness that cannot simply be credited to the influence of Morand and Rand. Joe wrote virtually all of the group's material, starting with "Oh! Red" in 1936, a song that was popular enough to be covered by Count Basie and the Ink Spots—as well as by Blind Willie McTell and Howlin' Wolf. The Hamfat sound was an influential precursor to the "jive" style that would be popularized by artists like Slim Gaillard and Louis Jordan, and McCoy would later reshape the Hamfats' "Weed Smoker's Dream" into a minor-keyed blues ballad, "Why Don't You Do Right," which was a blues hit for Lil Green and launched Peggy Lee's career with the Benny Goodman Orchestra.

It should come as no surprise that Tampa Red and Leroy Carr, the defining pop-blues stars of the 1930s, were also adept at more mainstream styles. Red, in particular, was anything but a blues purist. He loved to play kazoo, blatting out rambunctious recaps of jazz horn lines, and one of the Hamfats' few nonoriginal songs was a cover of his uptown jive number, "Let's Get Drunk and Truck"—which he had recorded in 1936 alongside a kitschy rhumba, "When You Were a Girl

of Seven (and I Was a Boy of Nine)." By that time, his recordings already included a nice version of the pop standard "Nobody's Sweetheart," and a jaunty tribute to Duke Ellington and Cab Calloway, titled "When I Take My Vacation in Harlem":

> When old Duke sits down to the old piano,
> And old Cab shakes his wicked hi-de-ho,
> I'll be there with an armful of heaven,
> When I take my vacation in Harlem.

Carr never got into anything quite that flamboyant, but he showed an equal affection for material that would startle those who think of him as a straight blues singer. It is very rare, however, for any of these songs to turn up on compilations of his work. A survey of Carr's familiar recordings would suggest that he was a fine but quite limited artist. His greatest success was with slow blues numbers, and while he was a superlative lyricist and sang with soulful grace, his piano accompaniments are very much of a piece—basic three-chord patterns, many played in the same key. This is why some of the more hard-core "country blues" fans have criticized him and his followers as facile hacks who churned out repetitive, assembly-line product.

I am a great admirer of Carr's blues ballads, but when one hears a dozen of them back-to-back they begin to get monotonous—which is why it is only fair to stress that they were never intended to be heard that way. They were singles, destined for home phonographs or jukeboxes where they would alternate with other selections. In live performance, Carr would presumably have interpolated a lot of other material to break up the evening, and when one searches more deeply into his discography, there are quite a few clues as to what it might have included. Along with upbeat hokum numbers like "Papa's on the Housetop" and "Gettin' All Wet," which have been sparingly reissued on the ballad albums, there are a few sides that show Carr to have been a creditable Tin Pan Alley crooner.

To the best of my knowledge, only one such performance has been included in any blues compilation, and I can still recall my astonishment when I heard it for the first time. Back in the 1970s, Yazoo

Records issued an LP of Carr and Scrapper Blackwell, which along with the expected blues cuts had a lovely version of Irving Berlin's sentimental ballad "How About Me." Had I not heard it in this context, I would not have even recognized the performers. Carr's voice is pitched in a higher tenor range than usual, and has a lilting, almost overrefined flavor, very different from the deeper and more conversational style of his blues work. His piano playing is light and swinging, and Blackwell adeptly negotiates the more sophisticated chord changes. For years, I played this song to people as an example of Carr's versatility, suggesting that the reason he had become the blues world's counterpart to Bing Crosby was because he was himself part of the wave of pop crooners. Believing it to be unique, I also put it forward as an example of the limitations of the historical record. It was only while working on this book that I finally listened to Carr's complete recordings, and found that he had cut a half dozen similar pieces.[40]

It is an open question whether, given orchestral arrangements and first-rate material, Carr could have done as well crooning Tin Pan Alley ballads as he did singing blues. Judging by what survives on record, he would not have been a serious threat to Bing Crosby and Rudy Vallee, but the playing field was anything but level. In any case, he handled this material more than competently, obviously enjoyed it, and would undoubtedly have recorded a lot more of it had the opportunity been available. However, blues artists were explicitly discouraged from broadening their range in this way. As Little Brother Montgomery recalled:

> If I could record whatever I want to play, I would have recorded some great numbers. Ballads and things like that. But they have had us in a bracket: If you wasn't no great blues player, or played some hell of a boogies or somethin', they wasn't gonna let us record no way. . . . They didn't want you bringin' no [sheet] music up in there either. They wanted original things, from you. . . . They'd tell you, "Well, we can read all that music and stuff." But they wouldn't let us. I guess them whites'd carry everything else in there. I don't think anybody ever get a chance to record what they wanted to record nohow. Especially colored people."[41]

Paramount's Mayo Williams made no bones about the limitations he placed on the artists he considered to be blues singers. He explained that when they came in with pop-style ballads, "I would very quickly say: 'Well, we can't use it. Write me a blues.' In doing it that way I'd save a lot of embarrassment for myself, the company, and the person."[42]

Because of such strictures, I can produce no proof that blues balladeers like Peetie Wheatstraw or Bumble Bee Slim ever sang pop, but it certainly seems probable. Being more limited musicians than Carr or Lonnie Johnson, they may have been less expert at it, but that would have been irrelevant if they were the only musicians available at a particular party and the crowd wanted a break from twelve-bar repetition. Or, perhaps more to the point, if the musician himself needed a break. Over the years, I have heard any number of black blues stars complain about always being ghettoized in that category, and insist that they were comfortable with a lot more than what they were typically allowed to perform on record or onstage. As Little Milton, who continues to be classed as a bluesman despite several soul hits, told me, "I would get totally bored if I just sat around from night after night and I could only play the twelve-bar blues stuff. I would always want to venture off into the T-Bone Walkers, the Roy Browns, Big Joe Turners and people that were doing different kind of stuff—even Nat 'King' Cole, a little Sammy Davis, a little Frank Sinatra. I always had the versatile-type thing in my mind."

Before moving on, two further points should be made. The first is that, along with barring blues players from performing the latest Bing Crosby numbers, record producers also tended to discourage them from simply covering Leroy Carr or Lonnie Johnson songs (except in situations where one company wanted to rush out a cover of another company's hit).[43] One of the basic requirements in the blues recording field, at least by the late 1920s, was that the artists must have new material. Mississippi bluesmen have recalled that H. C. Speir, the Jackson furniture store owner who acted as a local talent scout, would tell them that they needed a minimum of four original songs in order to do a session, and that was probably typical of the field as a whole.

This demand for original material was the exact opposite of what

was expected of musicians at clubs or dances. As I have mentioned, even the best-known live entertainers in the days before jukeboxes were expected to perform a range of contemporary hits, and that was as true in the blues world as anywhere else. Just as Duke Ellington covered the latest pop products along with his own compositions, anyone known as a blues singer would be asked to play "How Long," "Tight Like That," and similar standards. Most crowds have always preferred hearing the hot favorites to exploring unfamiliar material, and in this way the juke joints and rent parties were much like the modern bar scene, where blues bands—like country, soul, or classic rock bands—still devote the majority of their stage time to covering other people's songs, only pulling out original material when they are feeling adventurous or trying to impress a record company scout.

The songs that blues artists played in the studio not only failed to represent their day-to-day repertoires, but were often created specifically for the recording session and never performed before or since. In the 1960s, revivalist fans were often astonished to find that their idols did not remember songs recorded thirty or forty years earlier, not understanding that in many cases the singers had only learned those songs for an afternoon session and would not have been able to sing them even the following week. (And that is assuming they knew them at all. Blues singers, like other people in commercial pop, often used lyric sheets at their sessions—or if they were illiterate, had lyrics read to them—and did not necessarily memorize a song unless it became a hit and needed to be performed at live shows.) This was true not only of the more uptown, formulaic performers. Blind Willie McTell has a record called "Georgia Rag," which was a studio reworking of Blind Blake's "Wabash Rag." He may have rehearsed it for a few days previous to recording, but was obviously more accustomed to just singing the original Blake version, since at one point he slips up and sings "Doin' that Wa-Georgia Rag." Likewise, Skip James told of the producer asking him for a reworking of Roosevelt Sykes's hit "44 Blues," and on the resulting record, which he called "22-20 Blues," he slips near the end and goes back to Sykes's original caliber.[44]

I am not suggesting that bluesmen created original material only for recording purposes. The blues style has always put a certain value on

personal expression, and lots of people came up with original songs that were never recorded. My point is only that every blues performer had a solid repertoire of other people's songs, and these were often their most popular and requested numbers, but this fact is not reflected by their recordings.

The final matter to be addressed here is the argument made by some blues experts that, although blues singers did indeed perform non-blues material, this was done only to please white audiences. It is true that white and black audiences often had different tastes, and that in some regions, at some times, black dancers were happy with a full evening of blues while white dancers demanded other styles. However, it is equally true that, even in the small towns of the Mississippi Delta, there have always been plenty of black dancers who wanted to hear the latest hit sounds—whether those were brass band ragtime, Ellingtonian swing, Louis Jordan, or James Brown—and plenty of white folks who demanded the rawest, raunchiest, most primitive blues. White fans may have been a factor in keeping the black fiddle tradition alive, but they were hardly the main catalyst in making black rural musicians cover the hits of Louis Armstrong and Earl Hines. Even in areas where such musicians have recalled that they played more non-blues material for whites than for blacks, this seems to have been a matter of proportion, not exclusivity.

Meanwhile, the more thoughtful white blues researchers have long been aware that they are themselves an audience, and that black musicians have often tailored both performances and interviews to their tastes. If an older artist knew that his interviewer loved the early acoustic styles, he might emphasize his own affection for old-fashioned blues playing, even if at home he preferred to listen to Lawrence Welk. I once had a Mississippi blues expert insist that Eugene Powell, who had spent an afternoon proudly showing me the sophisticated chord changes he had mastered, played pop and country songs only to please white visitors. I could not help thinking that this implied a striking contempt for Powell's intelligence, since for at least thirty years all the white people who had come to see him were blues fans, and they wanted to hear him sing "Street Walkin' Blues," not his versions of "Five Foot Two, Eyes of Blue" or "Tennessee Waltz."[45]

The fact is that all entertainers try to please their audiences, and the successful ones are expert at figuring out what an audience wants. The great blues singers were pros, not primitives. While most had very limited formal schooling, they were often well traveled, had performed for a wide range of people in widely varied situations, and were smart, sophisticated men and women. Many were adept at "reading" their listeners—and revivalist blues fans, whether scholarly or not, are a pretty easy audience to read. Such fans want to hear "deep," "authentic" black music, and the musicians generally understand that. Which is to say, when an old black man at a blues festival chooses to play a prison song rather than "Tennessee Waltz," that is not necessarily because he prefers it or finds it more personally expressive. Charley Pride is not the only African American who ever loved country-and-western music. When Mississippi John Hurt and Skip James got together in the 1960s, they would sometimes trade yodels on Jimmie Rodgers's "Waiting for a Train." Just as in the 1920s, no one saw fit to record this duet, since it was not what the public expected of them. So Hurt and James sang the hillbilly harmonies for their own pleasure, then went onstage and played the blues songs that their audience wanted to hear. *Plus ça change, plus c'est la même chose. . . .*

4

HOLLERS, MOANS, AND "DEEP BLUES"

IN THE PRECEDING CHAPTERS, I HAVE CONCENTRATED ON styles played by professional musicians, but that was by no means the only music familiar to African Americans in the rural South. Throughout history, the vast majority of people have first heard music in and around their own homes, sung by their parents, siblings, and playmates. Unlike professional styles, this "folk" music need follow no trends or tastes beyond those of the singer, and can include everything from the barely formed tunes a parent hums to lull a baby to sleep to jump-roping chants and obscene doggerel—or snatches of pop music or opera. While some of these songs may be indigenous to a region or a particular group of people, and these tend to be the ones of most interest to folklorists, private singing knows no limits. People sing whatever they like, or what happens to stick in their heads, be it an ancient ballad or an advertising jingle.

In my own home, I grew up hearing my father sing the Tin Pan Alley hits of his youth, songs like "When Francis Dances with Me" and "The Sheik of Araby." This was my home folk music and, as with most people, I did not take it seriously. It was not music, it was just my dad. The music I valued was sung by Woody Guthrie, Cisco Houston, and Pete Seeger, and later by Skip James and the Reverend Gary Davis. I called this music "folk," but in my own life all the cowboy songs, blues, and gospel arrived as commercial imports, heard only at formal concerts and on recordings. In the same way, a black child in the South in

1925 could have heard his grandmother humming old minstrel or par-
lor hits and thought of that as the music of the local old folks, while
regarding blues as something that arrived on records from up north,
fraught with all the magic of Chicago and Harlem.

Around a lot of households, or in the surrounding fields, there was
other music as well, though, and some of it predated either the blues
or the minstrel shows. Black Southerners had a deep tradition of pri-
vate and communal singing, much of it with roots reaching back to
Africa. Histories of blues frequently begin with a discussion of this
music, the "work songs," "moans," and "field hollers," and treat the
commercial blues compositions as an outgrowth of this folk tradition,
the natural extension of a shared cultural heritage. There is a great
deal of truth in this. Blues was unquestionably influenced by older
styles, and there is no mistaking the traces of traditional moans and
hollers in popular blues songs, and still more so in the performance
styles of many, if not most of the singers. These ancient, intricate
singing techniques gave blues music the flavor that Robert Palmer ex-
plored in his influential book *Deep Blues*, and are often regarded as its
most distinctive and emotionally powerful characteristic.

It is impossible to trace the history of blues without taking note of
these older black singing traditions, but one must also remember that
blues was something quite new and different. Just as one can say that
all the fundamental ballet steps are derived from Western European
folk dances, one can argue that all early blues and jazz performances
are extensions of African-rooted folk forms, but in none of these cases
is that anything like the whole story.[1] The blues that was sold on sheet
music and recordings, and performed on street corners, in theaters,
and at rent parties or picnics was not simply a commercialization of
the styles that black Southerners had sung to ease the burdens of
work, sorrow, or boredom, or shared in a group, swaying and breathing
together in ceremonial communion that might or might not involve the
formality of a church service.

I am going out of my way to stress this difference, in part, because
many of the most influential and successful blues stars had relatively
little "deep" flavor in their work, and this has often caused these artists
to be shunted aside by fans and historians who want to define blues

according to their own tastes rather than the tastes of the black audiences who originally supported the music. One can read over and over how the deep blues style traveled from Africa and was nurtured in the fields of the South, then served as the roots of the blues boom, of jazz, of soul, indeed of virtually all that is unique and great in American music. Very rarely does one read about the influences that traveled in the other direction, the extent to which rural African Americans in the deep South were consumers and fans of pop music coming to them from the cities. White urbanites, for obvious reasons, are fascinated by a creation myth in which genius blossomed, wild and untamed, from the Delta mud, and are less interested in the unromantic picture of Muddy Waters sitting by the radio and listening to Fats Waller, or a sharecropper singing Broadway show tunes as he followed his mule along the levee.

White people were commenting on the unusual and moving songs of black Americans long before the blues boom. A visitor to South Carolina in 1777 wrote of the "plaintive African songs" sung by slaves as they paddled a canoe, and a visitor to North Carolina in 1853 gave an early description of a "field holler," writing of a black man who "raised such a sound as I never heard before: a long, loud, musical shout, rising and falling and breaking into falsetto."[2] When folklorists headed into the rural South with portable disc cutters in the 1930s, such hollers were among the styles they were anxious to document, and they recorded some magnificent examples of the form. It is an odd historical fact, and one that may create a thoroughly misleading impression of black folk music, that a very high proportion of this recording was done in penitentiaries like Mississippi's notorious Parchman Farm. This was in part because folklorists were always interested in finding the oldest possible material, and thought that places like Parchman, with their isolated populations and harsh conditions of forced labor, were the most likely place to find songs still surviving from slavery times. The main advantage of the prisons, though, was that they gathered a lot of black men together in an environment where they were eager to sing for folklorists. In the outside world, many people were suspicious of strangers with recording machines— or simply did not care to waste time singing for them—and plantation

owners and local lawmen were openly hostile to white northerners interviewing "their" black folk. In the prisons, a recording session would provide convicts with a welcome break from work, and everything was approved in advance by the relevant authorities.

The concentration on prisons, though, had its downsides. Combined with the fact that so much of early folk collecting was done by white men, it meant that a disproportionate number of the recorded moans and hollers come from male singers. (There was no comparable population of female prisoners, though a few were recorded.) In normal life, women sang to themselves at least as much as men did, but this singing was generally less public. Much of their work was solitary, and it is a commonplace of blues memoirs that the first music a young artist heard was his or her mother singing while sewing, cooking, cleaning or doing the washing around the house. The fact that so much of the singing of Southern black people was collected in places like Parchman has also encouraged a linkage in many white fans' minds between prisons and blues music. Of course, prisons have been mentioned in quite a few blues songs, just as they have become a country-and-western cliché. However, no one imagining the roots of white hillbilly music thinks instantly of a line of chain-gang convicts, while such pictures are ubiquitous in documentaries and books on blues. After years of hearing prison recordings played as examples of the earliest African-American song styles, it is easy to forget that most of the people singing field hollers had never been to prison in their lives, nor was the style in any way tied to that environment.

Work songs, the rhythmic call-and-response pieces designed to keep a crew moving in unison, were a somewhat different story. These had been common throughout the South, part of the same tradition as the Anglo-American sea chanteys. (Which, though the fact is rarely pointed out, arose largely from African styles.) By the time John and Alan Lomax and other folklorists began recording in the 1930s, these songs were dying out, and the prison farms were one of the few places where they remained common and vibrant. However, while these group songs are often cited alongside the hollers, and given equal space in discussions of blues roots, they were quite different, and in very few cases have any direct connection with what was recorded by

commercial blues artists. In fact, when I try to think of examples of rural Southern musicians who reshaped such work songs into professional performance pieces, I come up with as many white banjo players as black blues singers.[3]

The field hollers (also called "corn songs" or "cornfield songs") were quite unlike the tightly structured, heavily rhythmic work-gang chants. As Alan Lomax, who recorded many of them over the years, has written:

> They have a shape different from the majority of black folk songs, which tend to be short-phrased, to conform to a steady beat, and to be performed by groups. By contrast, Delta hollers are usually minory solos, sung recitative-style in free rhythms, with long embellished phrases, many long-held notes, lots of slides and blue notes, and an emphasis on shifts of vocal color. They are impossible to notate and very difficult to sing.[4]

The hollers were not performance music, in the way that blues or jazz is, nor were they communal music like the work-gang chants or church singing. They were more like a musical way of talking to oneself, and often were sung by people alone in the fields, driving a mule, tending cattle, or doing other isolated work. As Lomax wrote:

> You could hear these personal songs—sometimes no more than a few notes long—coming from far away across the fields. These . . . were pitched high out of a wide-open throat, to be heard from far off. . . . [A convict's] signature song voiced his individual sorrows and feelings. By this means, he located himself in the vast fields of the penitentiary, where the rows were often a mile long and a gang of men looked like insects crawling over the green carpet of the crops. Listening to a holler, some con would say, "Lissen at ol Bull bellerin over there—he must be fixin to run," or "That's old Tangle Eye yonder. He's callin on his woman again."[5]

Hollers could be very simple, and of little interest to anyone but the singer, but in the hands of a virtuoso they are among the most brilliant

and intense sounds in American music. Of the few that were captured on record, the outstanding example is a freely improvised song by a man nicknamed Tangle Eye, a black convict whom Lomax recorded at Parchman in 1947. Tangle Eye's holler was preserved more or less by accident: Lomax was recording him along with a group of other convicts who were demonstrating the work songs they used to keep time while "double-cutting" a tree. Four men would stand around the tree trunk, and would let their axes fall in pairs, with the music keeping anyone from getting confused and making an ill-timed stroke that could maim the next man over. As the tree fell, they finished the song and paused to catch their breath. It was then that Tangle Eye began to sing by himself, "looking wistfully across the Delta plain."

Lomax would title this piece "Tangle Eye Blues," but it is a blues only by the loose definition that applies that word to any sad Delta song. It has no blues structure, or indeed any structure at all. Tangle Eye starts off with a long, wordless, vibrato-laden moan, a hmmmmm-mmmm that rises a moment, then sinks and trails off in a wisp of melisma. He pauses, as if wondering whether to continue, then starts up again, the hmmmm-mmm this time easing into a softly murmured "hoh-hoh-oh-oh, Lord." Then he begins to sing words: "Well I wonder will I ever get back home, hey, hey-ey-ey . . ." For the next three minutes, he blends stanzas of lonesome nostalgia—for his woman and baby, for all the time he has been on "the farm," for the friends who no longer come to see him and his mother who is dead and gone—with wordless moans and cries, sometimes floating in mellow falsetto, sometimes rumbling like underground lava. He never raises his voice, and there is something almost painfully delicate in the way he tastes and mulls over each phrase, turning it one way then another before letting it go and moving on to the next. There is no growl, no roughness, just a meditative melancholy, as if he had far too much time for thinking, and no other outlet than shaping and reshaping a personal masterpiece that will probably mean nothing to anyone else.

Such hollers are particularly interesting to folklorists, because of their clear relationship to African singing. In the 1970s, Lomax demonstrated this affinity by issuing a recording of a Mississippi holler interwoven with a song recorded in Senegal, the two singers sounding

so similar that the result feels like a single, cohesive performance.[6] While African music is associated in many people's minds with a drum-driven, rhythmic dance beat, these songs are part of a quite different tradition, the sort of vocal improvisations that herdsmen use to keep their flocks aware of their comforting presence, to warn off predators, and to while away long days alone with animals and spirits. This is the sound that links the Malian guitarist Ali Farka Toure with John Lee Hooker, and is perhaps the oldest strain in blues.[7]

When prompted by folklorists, several bluesmen have demonstrated how they reshaped and streamlined hollers into blues numbers, and the holler style permeates the singing of many of the greatest blues artists.[8] This is most obvious in songs like Blind Lemon Jefferson's "Black Snake Moan," Skip James's "Devil Got My Woman," or Tommy Johnson's "Cool Drink of Water," but also in the work of Southern vaudeville stars like Ma Rainey, Bessie Smith, and Clara Smith, who was billed as "Queen of the Moaners." Still, this does not mean that hollers are simply primitive blues songs. Like ragtime or hoedowns, they left their mark on blues, but plenty of excellent blues performances show little holler influence, and very few have the free-metered, relaxed, murmuring flavor of the pure field songs. From hoedowns to hip-hop, African-American popular styles have been overwhelmingly social, designed for dancing—or in the case of gospel, for uniting a congregation—and marked by their steady, propulsive rhythms.[9]

The Delta seems to have been particularly rich in meditative, free-rhythmed hollers, and this had a strong effect on many Mississippi blues artists. The region had an unusually high concentration of African Americans—in some counties up to 90 percent of the population—and, as I will discuss in the next chapter, other factors combined to make it a rich area for the encouragement of deeply African styles. It is worth noting, though, that the most influential "moaner" among prewar male stars was Lemon Jefferson, from Texas, and that his fellow Texans Bessie Tucker and Victoria Spivey were among the most holler-inflected blues queens.[10]

Indeed, the one prewar blues star who recorded pure, free-form hollers for the commercial market was Alger "Texas" Alexander, a

Dallas-area singer who became a major seller after Jefferson's success sent scouts combing the region for other rural-sounding bluesmen. Unlike most of his male peers, Alexander did not play an instrument—he apparently carried a guitar with him at times, but would deputize someone else to play it—and he must often have performed a cappella, which is probably why he was drawn to the unstructured, arrhythmic hollers. These songs would have been impossible for the average guitarist to accompany, since Alexander improvises them as he goes, stretching measures and taking surprising melodic flights without any form or warning. Luckily, on many of his early sessions he was backed by Lonnie Johnson, a far from average player, and with Johnson's help he cut three pure hollers: "Section Gang Blues," "Levee Camp Moan," and "Penitentiary Moan Blues." These are astonishing recordings, in which Alexander slides extemporaneously from line to line, with no worries about either rhyme or meter, while Johnson listens carefully and tries to find ways to follow and echo him. Alexander recorded sixty-five other songs, with accompanists ranging from the Mississippi Sheiks to the New Orleans trumpeter King Oliver, to a final session in 1950 with an electric band, but they were all relatively straightforward mainstream blues pieces. These three performances are something quite different, as is indicated by their titles, which neatly point up the three most usual sites to hear such material: not juke joints or parties, but railroad gangs, levee camps, and prisons.

To me, blues is often at its most moving when it comes closest to the holler sound, and I fully understand the temptation to think of it as an extension of this older folk form. The Delta singers whom Palmer celebrated in *Deep Blues* have at times an almost unearthly power, and a freedom of tone and rhythm that clearly links them to singers like Tangle Eye. Nonetheless, I must accept the fact that these attributes, much as I love them, did not show any correlation with success in the mainstream blues world. Even among Mississippians, the most popular and influential blues artists were string band and urban studio players like the Chatmons, the McCoys, Memphis Minnie, Big Bill Broonzy, and Walter Davis, all of whom sold a lot more records, even in the Delta, than their nearest "deep" competitor, Charley Patton. The deepest Mississippi singers—Skip James and Son House, for

example—typically had no hits whatsoever. This would change some-
what in the later, electric era, but even then John Lee Hooker was the
only major Mississippi bluesman to record in a pure holler style, and
his meditative moans were almost always released as album filler
tracks, while his hit singles featured more upbeat, danceable
rhythms.[11] (Meanwhile, Robert Pete Williams—considered by some
aficionados to be the deepest blues singer on record—was never even
recorded until the revivalists came along, and had no black audience
outside his local community.)

To a great extent, the problem was one of familiarity. The people
who were buying blues records were not spending their hard-earned
cash to hear the same stuff they heard or sang during their workdays
in the fields. To folklorists, this music was fascinating, but to blues
buyers it was not even music, in the sense that Bessie Smith or Lemon
Jefferson records were music. What is more, plenty of black South-
erners were singing Smith and Jefferson hits while they worked
around the house or in the fields—along with pop and hillbilly songs
heard on records or radio broadcasts—and it is purely due to the folk-
lorists' agenda that such songs rarely show up on field recordings.[12]

I am reminded of a conversation I once had with the curator of an
exhibit of African sculpture at the Harvard University art museum.
She had accompanied a film crew through West Africa, trying to get
footage of traditional carvers making masks and talking about their
work. For a week, they traveled from village to village, seeing wonder-
ful masks, but unable to find any carvers. They were always told that
there was somebody in the next village, but then would just be sent on
again. Finally, they reached a town where everyone agreed that a
carver lived, and were taken to his house. To their disappointment,
they found that he was doing kitschy tourist stuff—sleekly formulaic
drummers and elephants—rather than traditional ceremonial pieces.
"No, no," they told their informants. "We don't want this kind of
carver. We want someone who does the masks for festivals."

"Oh, but those masks aren't made by carvers," they were told. "We
make those ourselves."

In the same way, moaned, free-form, unrhymed verses, flavored
with the flatted thirds and fifths we call blue notes, were part of daily

life in a lot of black households, but no one in those households con-
fused the homemade moans with the blues being sung by professional
entertainers. That conflation was made by outsiders. As Muddy Wa-
ters put it, talking to the English blues expert Paul Oliver, "Every man
would be hollering, but you didn't pay that no mind. Yes, course I'd
holler too. You might call them blues, but they was just made-up
things. Like a feller be workin' or most likely some gal be workin' near
and you want to say somethin' to 'em. So you holler it."[13]

Asked when they first heard blues, Waters and his contemporaries
would regularly refer not to any local singers or musicians, but to
records. Waters's grandmother had a hand-cranked Victrola, and the
list of artists he recalled hearing on it is pretty typical—though in my
experience it is rare for a blues fan of his generation to name no fe-
male singers: Texas Alexander, Barbecue Bob, Blind Lemon Jefferson,
Blind Blake, Roosevelt Sykes, and Little Brother Montgomery. None
of these were Mississippians, though Sykes and Montgomery were
popular piano players around the Mississippi river towns and lumber
camps. Earlier in the same interview, Waters gave a list of favorites
that included some Mississippi players—the Sheiks, Son House and
Charley Patton—but once again the first names he mentioned were
from other areas, in this case the smooth urbanites Lonnie Johnson
and Leroy Carr.[14]

Of course, there must have been Mississippians who were particu-
larly drawn to local sounds, but it is typical of great musicians to have
wide-ranging tastes. B. B. King, born in the heart of the Delta in 1925,
makes a point of insisting that he was relatively unaffected by the re-
gional style:

Scholars . . . like to talk about the Delta bluesmen and how they influ-
enced each other. They break down the blues according to different
parts of Mississippi and say each region gave birth to a style. Well, as a
Delta boy, I'm here to testify that my two biggest idols—guys I flat-out
tried to copy—came a long way from Mississippi. Blind Lemon was
from Dallas and Lonnie [Johnson] from Louisiana. I later learned about
Delta bluesmen like Robert Johnson and Elmore James and Muddy
Waters. I liked them all, but no one molded my musical manner like

Blind Lemon and Lonnie. [King goes on to cite Bessie Smith, Mamie Smith, Ma Rainey, the Reverend J. M. Gates, Duke Ellington, and Jimmie Rodgers. The one Delta musician he considered an important influence was his cousin Booker White, but less as a player and singer than as a model of professionalism.][15]

All in all, African-American blues fans were like most other people in their tendency to think very differently about the pop music they were buying and the songs their parents sang at work or around the house. Especially during the 1920s and 1930s, the peak period of black migration to the urban North, the blues records coming in from New York and Chicago were seen by a lot of Southern blacks as representing the antithesis of old-time field songs. Blues was the music of the present and future, not of the oppressive plantation past. That is why there was no African-American market for the sort of pointedly archaic material that dominated the white country record catalogs. I am told by one of the more assiduous 78 collectors that he often found Mississippi John Hurt records in white homes, and that makes sense, considering Hurt's preference for old-fashioned material. Conversely, he tells me that he virtually never found a fiddle hoedown record in a black home, though he frequently found Jimmie Rodgers discs. Again, fiddling was old-fashioned, while Rodgers's "blue yodels" were a modern sound that ushered in the Gene Autry country-pop style.[16]

I will go into this further in the next chapter, but I want to finish off with a glance at an interesting oddity, the only recording of a pure work song by a Race recording star. As I wrote earlier, while the hollers clearly influenced blues vocal styles and were sometimes mined for lyrical lines, the work-gang songs had little direct impact on blues. However, one such song did surface on the blues market, and in a distinctly surprising setting. Sippie Wallace was a popular blues queen from Houston, one of the Southern vaudeville singers who began recording in the wave that followed Bessie Smith's success. In 1925, she made a record called "Section Hand Blues," which starts with an elegant "old South" orchestration, then goes into a traditional railroad spike-driver's song, beginning, "If my captain asks for me, tell him Abe Lincoln done set us free/Ain't no hammer on this road gonna kill poor

me." Wallace's style gives little indication that she had any experience of railroad gangs, and the whole performance has the feel of a vaudeville set piece, accentuated when she segues into another work song, "This Old Hammer," with her band grunting "uh" between lines, to the accompaniment of a ringing hammer sound.

Though Wallace was a good seller on the Race market, I find it hard to imagine her usual audience going for this number, and am tempted to guess that this one record was aimed at white listeners. Wallace was recording in New York, with the savvy composer and bandleader Perry Bradford, and this was the peak of the "Harlem Renaissance." Four months earlier, Paul Robeson had made his debut as a concert artist, and among his featured numbers was an adaptation of the same traditional hammer song, which he called "Water Boy."[17] Robeson presented the song as an example of black folk culture for the New York intellectual and society crowd, which would continue to be the main audience for work-song recordings, buying albums of "chain gang" chants by Josh White in the 1940s and by Harry Belafonte in the 1950s. It seems likely that Bradford and Wallace had their sights set on this new market. (Admittedly, it is also possible that "Section Hand" was intended for the black vaudeville audience. So little is known about black vaudeville that my speculations on this subject are based as much on instinct as on evidence.)

The role of the white urban audience in the creation of black folk and blues archetypes will be explored at greater length in later chapters, but it is significant that already in the 1920s, white listeners were celebrating songs like "Water Boy" as examples of a pure, noble folk culture, similar to the spirituals and not to be confused with the low-down double-entendres of the professional blues scene. In later years, when artists like Big Bill Broonzy and Sippie Wallace were no longer getting hits on the black pop market, they would in turn be celebrated by white audiences as folk-rooted cultural figures, and the purity of their work would be contrasted with the commercial trashiness of the hits churned out by the pop stars of that later era. In the process, blues would come to be classified as a black folk form, and a new aesthetic developed that defined "true" or "deep" blues by its resemblance to the traditional hollers.

In the 1920s, most white people still thought of blues as racy pop music, but this new aesthetic would gain more power with each passing decade, and has helped shape the modern perception of blues as a black folk style, nurtured not in the publishing houses and studios of New York and Chicago, but in the most isolated regions of the deep South. This is the process by which Mississippi has come to be singled out as the music's unique heartland, and a handful of unquestionably brilliant but relatively obscure Delta artists were crowned kings of the blues pantheon. And one other thing: It has exacerbated the division between white and black blues fans, because if there is one place and time outside of slavery that black Americans have no romanticism or nostalgia about, it is Depression-era Mississippi.

5

THE MISSISSIPPI DELTA:
LIFE AND LISTENING

THE MISSISSIPPI DELTA HAS PRODUCED MORE THAN ITS SHARE of great blues musicians over the years, and there are many people who believe that it is where the blues was born. Maybe so, in some way—blues has meant so many different things to so many different people that it is a bit pointless to argue over origins. If I were feeling contrary, I might suggest that the state's reputation is largely founded on the modern revivalists' passion for later Chicago styles, and that if the West Coast sound of T-Bone Walker, Lowell Fulson, and Charles Brown were valued alongside that of Muddy Waters and Howlin' Wolf, "down home" could as easily mean Texas and Oklahoma. I could add that, in the 1920s and 1930s, none of the blues advertisements took any note of Mississippi roots, while Texas and Georgia birthplaces were cited as selling points. Looking at my list of top prewar blues stars, they were pretty evenly distributed across the South: Georgia accounted for eight names; Tennessee for six; Mississippi for five; Louisiana, Texas and Kentucky for three each; Arkansas and South Carolina for two each; and there are lone artists from North Carolina, Florida, Ohio, Missouri, and Pennsylvania. Only one of the five Mississippians was born in the Delta, and that one (Big Bill Broonzy) spent most of his youth in Arkansas.

All of that being said, the Delta was home to a unique strain of blues music, which has become extremely influential on the modern-day scene, and the Delta musicians were undoubtedly affected by the

special conditions of their home region. The Delta was not as isolated and unusual as its myths might suggest, but if we hope to understand something about Robert Johnson, it is worth taking a closer look at this area and the musical tastes of its inhabitants.

The Delta, with its vast cotton plantations, devastating floods, and grueling poverty, has become the stuff of myth, and not only because of its music. It has been called the most Southern place on earth, and whether that phrase conjures up images of beautiful old mansions, cotton aristocracy, home-style cooking, and Elvis Presley, or the extremes of racism, isolationism, and a social system so archaically unjust as to invite comparisons to medieval feudalism, there is some truth to it.

For black people, Mississippi in the twentieth century was famed for its retrograde brutality. The New Orleans banjo player Danny Barker writes of his family's fear when Little Brother Montgomery asked him to come play some dates in the state: "It was the earnest and general feeling that any Negro who . . . entered the hell-hole called the state of Mississippi for any reason other than to attend the funeral of a very close relative . . . was well on the way to losing his mentality, or had already lost it."[1]

What Mississippi was to the rest of the country, the Delta was to Mississippi. Though it makes up less than a sixth of the state's area, the Delta accounted for over a third of the lynchings reported between 1900 and 1930,[2] and was legendary for towns with signposts warning black people not to be caught within their borders after sundown. By the 1920s, the region was ruled by a sharecropping system that tied black farmers to the land in a form of economic bondage that at times seemed little different from slavery. The plantations were vast, transportation was difficult, and workers had little choice but to buy all their goods at company stores that would sell to them on credit at inflated prices, creating a form of debt servitude. Once in debt, they could be bound to work off the money owed, and the legal system often functioned as an adjunct to the labor system. There are numerous reports of valued workers who could kill someone and never go to prison, because their "bossman" would arrange for them to remain in his fields. Likewise, a man who seemed likely to cause trouble for the

boss could be transferred to a prison farm for a couple of years to "settle him down," then be paroled back to his home plantation, where he would go on doing the same sort of work he had done inside. And that is not to mention all the labor done by convicts, who built much of the levee and railroad system, and were also sometimes leased out to plantations as unpaid farmhands.[3] It is often suggested that it was this vicious oppression, and the misery that went along with it, that fueled the deep emotional power of the area's great blues singers.

Be that as it may, there were other reasons why blues would have been particularly strong in the Delta. One was simply the density of African Americans in the region: In 1910, there was only one Delta county where blacks accounted for less than 80 percent of the population, and two where they accounted for more than 90.[4] However unequal the distribution of power, either politically or economically, African Americans in the Delta lived in a world where there were very few white people, and that was bound to have an effect on cultural life.

Another reason why the Delta was particularly fertile ground for the blues boom was the youth and mobility of its black residents. In this way, it was quite the opposite of the oft-imagined stereotype of a timeless backwater little changed from slavery days, a harsh survival of the antebellum plantation South. Most of the Delta land was cleared and settled only in the decades around the turn of the twentieth century, and in order to attract black farmers and plantation hands, relatively high cash wages were paid. (Delta sharecroppers and renters also did far better at this time than they would in later years.) Life was often difficult, but the Delta promised a future that was unimaginable in the arid hill country to the east, and even in the 1930s black immigrants continued to stream into the area. For many of these immigrants, the Delta served only as a sort of staging ground, preparing them for the more dramatic move north to Chicago, and the overall effect was a population in flux, ready to cast off the old ways and receptive to new musical fashions. If the Delta bluesmen had less of a ragtime or hoedown feel to their music than many of their peers in Georgia and the Carolinas, that was as much a sign of modernity as of any links to the African past.

One can get a unique glimpse of the way black Delta residents regarded their world, and the place music played in it, by looking at the files of a team that visited the region in 1941 and 1942 under the joint sponsorship of Fisk University and the Library of Congress. This group included Alan Lomax, John Work, and the sociologist Lewis Jones, along with one of Jones's graduate students, Samuel Adams, who remained for some months in Clarksdale. Except for Lomax, all of the researchers were African Americans, which may have given them a somewhat different slant from that of the white folklorists who did most of the fieldwork in this period.

The team focused on Coahoma County, where Lomax recorded Muddy Waters, Son House, and Honeyboy Edwards, along with fiddlers, unaccompanied singers, and church services. Meanwhile, Jones conducted interviews about local life and history. While Jones never completed his study, an unpublished draft of his work gives some interesting views of black Delta life.[5] Among the oldest black residents, people from seventy-five to ninety years of age, he found that the two hundred he surveyed had all arrived from other areas as "pioneers." As he wrote:

> There are no memories of slavery in the delta. This section of the delta
> has little history prior to the revolution of 1861. . . . Along the Missis-
> sippi there were a few plantations but these had not been fully devel-
> oped. They had employed slave labor but few Negroes remained after
> emancipation. . . . The memories of slavery preserved in the tales and
> in the lore of the older generation belong to areas other than the delta.
> The earliest accounts of this area are those describing it as a frontier.

Jones's pioneers had mostly come to the region during the last three decades of the nineteenth century. At that time, the Delta was famous for its fearsome floods and the marvelous richness of the soil that would be left behind when the waters receded. (This was the origin of the region's name. It is not in fact a delta, in the sense of an area where a river branches out in a triangular pattern and runs off into the sea, but the fertility of the Delta's soil, created by annual flooding, was reminiscent of the legendary fertility of the Nile Delta, replenished by

similar floods.) It was disease-ridden swampland, but also country where you could drop some seeds in the ground and be rewarded with crops at a speed and of a size that were incredible compared to anything in the played-out cotton lands of Georgia or Alabama, never mind the stony Mississippi hills. As one old woman told Jones: "The cause of my father and my relatives coming here was the talk of people who came down here and returned with big money. They make folks in the hills think greenbacks grow on trees and they had ponds of molasses here, and folks in the hills believed it."

At the turn of the century, less than a third of the Delta was under cultivation, and the early arrivals spent much of their time cutting down forests and building levees, as well as plowing and planting the cotton that would make the area's fortune.[6] Sharecropping was not yet as entrenched as it would become in later years, and some bought their own land, while others rented or worked for cash wages from the white landowners. The farming income was supplemented by hunting and fishing, and Jones's informants seem to have regarded this early period with a good deal of nostalgia. They spoke of summer celebrations, when "the frequent roll of the drums and shrill note of the fife enlivened the picnickers," and of a game called the "ring play," where couples would dance to the singing of a circle of onlookers. The more religious-minded recalled the "rock Daniel," a game played at church events in which "a man and a woman facing each other would place their hands on each other's shoulders, sing and rock."

The Fisk team did its best to record samples of these game songs, but found that many were already forgotten. They also sought out older musicians who still played the repertoire that had been common at square dances, or "breakdowns," which typically featured a fiddler accompanied by a banjo or guitar, and a man who stood on a wooden box and called the figures. Seventy-year-old Alec Robertson recalled his days as a dance caller, remembering tunes familiar throughout the South: "Old Hen Cackle," "Fisher's Hornpipe," and "Billy in the Lowground." Robertson added that he called the same figures for white and black dances.

By the early 1940s, these dances had pretty much disappeared, replaced by several waves of pop music: ragtime, followed by blues, and

then big band swing. Orchestras like the one led by W. C. Handy had already been touring the Delta in the early years of the century, and local groups had done their best to assimilate the latest styles. Son House would recall that his father and uncles had a brass band that was playing regularly for dances when he was a boy. His father also played guitar, he said, but only around the house, since "back in that time they didn't care for guitar much." (House said he was then about ten years old, which places his recollection around 1912.)[7] Such country brass bands would have played ragtime, Handy-style blues, and something like early jazz, and they were both louder and more modern than the square-dance bands. Lucius Smith, a black banjo player from the Mississippi hill country who had started playing for dances around the turn of the century, recalled Handy's blues hits as the death knell of the old ways: "That done ruined the country [music]. . . such as 'Walking in the Parlor' and all them other old pieces, . . . calling figures, promenade, swing your right partner, all that, you know . . . The 'Memphis Blues' and all that, it done brought about a whole lots of trouble."[8]

In the 1930s, jukeboxes arrived in many of the local bars, and the younger generation would come into town to dance to the latest hits of Duke Ellington and Louis Jordan. Nonetheless, the population remained overwhelmingly rural. "Thousands of houses dot the cotton fields that are planted right up to the clusters of houses that call themselves towns," Jones wrote. By 1940 there were nearly 50,000 people in Coahoma County, but the closest thing to a city was Clarksdale, with 12,168 people. There were four other "incorporated places": Friars Point, with 940 people, Jonestown with 706, Lula with 503, and Lyon with 339, but Jones writes that they were "of little more significance than a score of other places which are scarcely more than plantation headquarters." The county's black majority lived out in the fields, coming in to these smaller centers when they had some time off, and traveling to Clarksdale if they had a few spare coins to spend on a movie or some city goods. (Alcohol was a touchier matter. Mississippi was one of three states that chose to continue Prohibition after 1933, and was the longest holdout, remaining "dry" until 1966. A great part of the reason for Friars Point's popularity as a weekend hang-

out was that it was across the river from Helena, Arkansas, where liquor was legal, and hence was an active bootlegging center.)[9]

It was already clear, though, that the rural lifestyle was fading. More people were moving to town each year, though truckloads of workers still came out to the plantations when it was time to chop or pick the cotton crop. Mechanization was replacing much of the back-breaking labor that, hard as it was, had kept small farmers in business. Some of the plowing was still done with mules, but on the bigger farms draught animals had been replaced with tractors, and people were leaving the land, pushed by the disappearance of manual farm work and pulled by the lure of city jobs and the promise of a better life up north.

Jones divided the population he documented by age, and treated the differences between generations as a guide to the changing course of African-American life in the region. He reported that the old pioneers were unimpressed by modern trends. They complained that where once they had planted and brought in their own crop, now the white landowners would send tractor drivers to do most of the work, then charge the farmers the costs. The fishing and hunting grounds had largely disappeared, replaced by endless cotton fields and pricey store-bought goods. "I been all over here in boats," one man said. "I can go and show you places that have cotton and corn on them now where I used to fish." Jones noted that, along with their nostalgia for earlier times, they took pride in what they had accomplished, and considered themselves pioneers in the heroic sense: "They cleared the forests, built levees, traveled on the waters of the Mississippi in skiffs, made bumper crops of cotton, danced, gambled, loved and killed with what seems to have been tremendous zest." They regarded the younger generations as soft and ordinary by comparison.

The next generation, the people between fifty and seventy, had arrived in the settled, prosperous farm years, and represented stability. "All that is established and considered normal in the delta is represented by this generation," Jones wrote. "They frown alike on the violence of the pioneer life they found and . . . the present, [which] seems to them confusing and disorderly. . . . Their world reached its flowering around the First World War and suffered a collapse later

which they never quite understood." These were the pillars of the church, the respectable people who felt that the modern world was dangerous and potentially evil.

The young adults, between thirty and fifty, had been raised by these respectable church folk, but they were comfortable with the changes happening around them. Jones wrote that:

> Growing cotton for them has not departed from the "old way," nor has the church become weakened in its expression of the true faith by the introduction of "a form and fashion." Theirs has been a rapidly changing world. They have no pleasant memories of the isolation and stabilization before motor transportation arrived. They have enjoyed the freedom of movement that the "good road" brought . . . Electric lights in the church and electricity to make their nickels bring music out of "Seeburgs" [juke boxes] and radios are their pride.

The first great wave of Delta blues innovators—Charley Patton, Son House, Tommy Johnson, Willie Brown, Skip James—were all in this last age group, not pioneers or old-timers. Hot on their heels came the generation that would electrify their music and turn it into the toughest roots sound on the urban landscape. These young turks— Howlin' Wolf born in 1910, Robert Johnson in 1911, Muddy Waters and Aleck "Sonny Boy Williamson" Miller in 1913, Willie Dixon in 1915, Big Walter Horton in 1917, Elmore James in 1918, John Lee Hooker in 1920, then Albert King in 1923 and B. B. King in 1925— perfectly fit Jones's final grouping:[10]

> Youths . . . try to get a grip on life in the midst of a disintegrating past and a fascinating present. For them the new has as much place as the old. As they acquire the culture they receive the traditions from the past and the technology and the organization of the present, even the conflicts between the two. . . . They sing the songs currently popular on the radio and juke boxes and learn others as they hear them sung by older people at home and in the fields. Theirs is the task of discovering a pattern of living in conformity with their opportunities and the varied inheritance which their elders have handed on to them.

Jones was clearly excited by this spirit of change and opportunity, but the Fisk team also noted that the local folk culture was disappearing. "On one occasion when an old cotton picker was asked whether or not the people sang as they worked, he laughed as he repeated the question to others," Samuel Adams writes. "In fact he yelled it out across the field. They all seemed to be amused by the question." He also quoted a younger man who explained, "There ain't nothing about a tractor that make a man want to sing. The thing keeps so much noise, and you so far away from the other folks. There ain't a thing to do but sit up there and drive."[11]

Even when people did feel like singing, Adams noted, "Today when a plantation Negro sings he is more likely to sing a popular song than a spiritual or folk song."[12] To him, blues were included in that "popular song" category, reflecting the fact that they were part of a broad national trend rather than a local tradition, though when he compiled song lists he separated them out from other pop styles.

Adams's master's thesis, the final product of the work he did under Jones's advisorship, provides a unique look at what was being listened to by black Delta dwellers at this key period. The Fisk trips were made only three or four years after Robert Johnson's death, and before Muddy Waters and many of his peers had left for Chicago. As Jones stressed, this was a time of rapid and intense change, and what was true in 1942 would in some respects have been quite different from what was true in 1935, but this study still provides the most accurate picture we have of musical tastes in the rural Delta during the blues boom. As part of its formal survey, the research team filled out forms on each person they interviewed, and one of the things they asked was the informant's favorite song. Adams supplies two lists of these titles, gathered in interviews with members of one hundred families living on the King and Anderson Plantation, near Clarksdale, and divided by age into "younger" and "older" tastes.[13] (He did not specify at what age he drew the line between these groups.) Since, as far as I know, these are the only such lists compiled during this period, they are worth looking at in some detail.

Adams supplies only the song titles, with no supporting data on their collection, so it is impossible to know how many overlapped

between informants—that is, which songs were favorites of multiple people—but even this simple list is interesting. Among the older people, church songs slightly outnumber secular songs, and the general grab bag of "popular songs" has twice as many titles in it as the "blues" category. Adams points out that the older people listed far more church songs than the youngsters did, and concludes from this that the power of the church was diminishing. It is equally likely, though, that his informants had simply followed the common human pattern of becoming more religious with age.

Among the favorites named by his older informants, Adams lists twenty-four popular songs, twelve blues, one lullaby ("Hush Little Baby, Don't You Cry") and one work song ("Working on the Levee"), along with twenty-six hymns and eighteen spirituals. He apparently defines hymns as songs from the church hymnal, and spirituals as all other religious songs, from old camp-meeting shouts to modern "gospel" numbers. The popular songs are a mix of patriotic anthems, sentimental parlor songs, and current swing and country hits (for which I provide dates), along with a few unclassifiable titles:[14]

"Daisy May," "Down by the Old Mill Stream," "God Bless America," "Good Morning, Mister Blue Jay," "Good Morning to You," "He's 1-A in the Army" (1941), "Home Sweet Home," "I Don't Want to Set the World on Fire" (1941), "I Want a Girl," "In the Shade of the Old Apple Tree," "In the Mood" (1940), "Jumping Jive" (1939), "Let's Dream this One Out" (1941), "Lift Every Voice and Sing," "My Country 'Tis of Thee," "Old Black Joe," "Star Spangled Banner," "Stardust" (already a standard, but a huge hit for Artie Shaw in 1941), "Swanee River," "Tuxedo Junction" (1941), "Walking by the River" (1941), "Walking the Floor Over You" (1941), "Yes Indeed" (1941), and "You Are My Sunshine" (1940–41).

The blues songs are also mostly of recent vintage, and I have added the recording dates and names of the artists who made them famous, in the cases where I can give these with some accuracy:

"Bumble Bee Blues" (1929), "Chauffeur Blues" (1941), "My Girlish Days" (1941) (all three by Memphis Minnie), "Confessing the Blues"

(1941, Walter Brown with Jay McShann), "Going to Chicago" (1941, Jimmy Rushing with Count Basie), "How Long Blues" (1928, Leroy Carr), "In the Dark" (1940, Lil Green), "St. Louis Blues" (many artists), "Sweet Home Chicago" (originally Robert Johnson, in 1936, but more popularly Tommy McClennan in 1939 and Walter Davis in 1941),[15] "Highway Blues" (a generic title), "Weary Blues," and "Lonesome Blues" (possibly generic titles, or possibly a mistranscription of Roy Acuff's recent record, "Weary Lonesome Blues").

It is interesting that even the older listeners listed so many current hits. Though some of the pop numbers reach back to the nineteenth century, most of the blues and many of the swing and country records had been released within the year. Surprisingly, the list Adams provides for his younger informants contains far fewer recent swing and blues numbers—only one swing cut, "Fur Trapper's Ball," dates from after 1936—forcing one to wonder whether he may have somehow gotten the two lists confused. In any case, they show a similar balance of blues and other pop material.

The "young" list includes thirty-five popular songs, twenty-six blues, two work songs ("Working on the Railroad," but this may be the minstrel favorite rather than a real work song, and "Water Boy," but this may have been named by a progressive Paul Robeson fan), and one fiddle hoedown ("Hell Broke Loose in Georgia"), along with seven hymns and twenty spirituals. The preference for "spirituals" among the youth, if it is not a mistake, probably reflects the growing popularity of gospel groups like the Golden Gate Quartet and Sister Rosetta Tharpe, whose repertoires were largely made up of new numbers and songs from the oral tradition rather than official church hymns. The popular list was as follows:

"Basin Street Blues," "Carolina Moon," "Carry Me Back to Old Virginia," "Coming Through the Rye," "Darkness on the Delta," "Drink to me Only with Thine Eyes," "Fur Trapper's Ball," "Girl of My Dreams," "Going Home," "Honeysuckle Rose," "I Love You Truly," "Is It True What They Say About Dixie?" "The Johnson Girls," "Kiss Me Again," "Lazy Bones," "Livery Stable Blues," "Lost in a Fog," "The Man I Love,"

"Minnie the Moocher," "My Blue Heaven," "My Old Kentucky Home," "My Wild Irish Rose," "Negro National Anthem (Lift Every Voice and Sing)," "Nobody's Sweetheart Now," "The Object of My Affection," "Old Black Joe," "Old Spinning Wheel," "Oh! Susannah," "Rainbow 'Round My Shoulder," "She'll Be Coming 'Round the Mountain," "Stormy Weather," "Sonny Boy," "Sweet Jennie Lee," "Sweet Sue," "When You and I Were Young Maggie," "Yesterdays."

In the blues category, I have once again tried to ascribe songs to the artists with whom they were most identified, but this is not always easy. "Walking Blues" might be the Robert Johnson song, but there were a dozen other artists who made records with that title, including Ma Rainey and the Mississippi Sheiks. I also suspect that a couple of these listings are mistakes, since they do not turn up in any discography, but it is also possible that they were local favorites that happened not to get recorded, or were recorded under other titles:

"Banty Rooster Blues" (Charley Patton or Walter Rhodes), "Beale Street Blues" (a W. C. Handy composition), "Biscuit Baking Woman" (Yank Rachell or Kokomo Arnold), "Black Gal Blues" (probably Joe Pullum), "Black Snake Blues" (Victoria Spivey, Lemon Jefferson, or others), "Careless Love" (Lonnie Johnson or others), "Digging My Potatoes" (Washboard Sam), "Evil Woman Blues" (probably Walter Davis), "Going to Move to Kansas City" (Jim Jackson), "Highway 61 Blues" (probably Roosevelt Sykes), "How Long Blues," "Mean Mistreater Blues" (both from Leroy Carr), "Milk Cow Blues" (Kokomo Arnold), "Railroad Blues," "Railroad Rag" (both too generic to say), "Rattlesnake Blues" (probably Blind Boy Fuller), "Salty Dog Blues" (Papa Charley Jackson, but often covered), "St. Louis Blues" (many artists), "Sitting On Top of the World" (the Mississippi Sheiks), "Sugar Mama Blues" (Tampa Red, Sonny Boy Williamson, or Peetie Wheatstraw), "Talking Blues" (generic), "Tin Can Alley Blues" (Lonnie Johnson), "T.B. Blues" (Victoria Spivey or Jimmie Rodgers), "Walking Blues."

When Adams asked what the favorite dance pieces on the plantation were, his informants provided an even more modern and pop-

oriented list of titles. No traditional pieces were named, though a handful of blues were included along with current hits like "Chattanooga Choo Choo" and "One O'Clock Jump."

Adams also compiled a list of favorite radio stars, and the Fisk-Lomax team made a list of what was available on jukeboxes in Clarksdale's black cafés. Before discussing these, though, it is worth considering the impact that such new technologies had on the music of the Delta, on blues, and on African-American tastes in general.

Radio is rarely discussed in histories of prewar blues, for the logical reason that so little blues—at least of the sort that interests most historians—was heard on the air. There is also the problem that, unlike records, which survive to be studied and organized into discographies, early radio was a live and ephemeral medium, and we can never have more than a rough idea of what people were hearing. This is especially true for the smaller, local stations, but to a great extent it applies even to the most popular, national broadcasts.

Commercial radio broadcasting took off shortly after World War I, and grew at a phenomenal pace over the next decade. By 1923, there were 510 active broadcasting stations, 89 of them in the South. By 1930, there were over twelve million families with radio sets.[16] Only a small proportion of these would have been Southern black families, both because radios were relatively expensive and because so many black Southerners were still living without electricity. Still, radio was a fact of life by the late 1920s, and even people who did not own one would be likely to hear them in public places or the homes of more fortunate friends or neighbors. Radio had several distinct advantages over the phonograph: Once the initial purchase price was paid one could hear a wide variety of programming without having to buy records, one could enjoy a full evening's entertainment without having to get up and change the disc every three minutes, and in general the radio provided much better sound quality, especially when compared to the hand-cranked Victrolas. By the time Adams did his survey, he reported that half the families he interviewed were radio owners.

While blues was not among the more common musical styles on the air, neither was it entirely absent. Eva Taylor, who is best remem-

bered as a blues queen, was identified in a 1934 *Chicago Defender* article as "the radio songster."[17] Bessie Smith made numerous radio appearances, and Delta dwellers could have heard her as early as the summer of 1923, when she was the star of a *Midnight Ramble* broadcast from Memphis's Beale Street Palace Theater.[18] Such *Midnight Rambles* were special concert series produced in otherwise black theaters for an all-white late-night audience, and the Palace series was a regular radio offering.

Many radio singers, whether with jazz bands or vocal ensembles, performed occasional blues numbers, and in some rural areas black string and jug ensembles lined up daily fifteen-minute spots.[19] There were also quite a few blues specialists to be heard on hillbilly programs. The black harmonica player DeFord Bailey played blues along with his trademark train imitations on the *Grand Ole Opry*, and while the other blues singers on that show were all white, John Jackson cannot have been the only person who sometimes had difficulty sorting radio players by race.[20] Sam McGee's hot fingerstyle guitar work was copied by plenty of black musicians, and his "Railroad Blues" was one of hundreds of twelve-bar numbers featured by hillbilly guitarists and singers. What is more, both Jimmie Rodgers and Jimmie Davis used black accompanists on several records, and may well have done the same on radio.

What is even more important is the extent to which radio exposed blues players, and rural listeners in general, to other styles. It was a great leveler, allowing someone in a Delta cabin to listen to anything from hillbilly fiddling to opera. The majority of musical programming, especially on the national networks, consisted of the most mainstream white pop music, and this sound would have been almost as inescapable for most people of that time as Britney Spears or Backstreet Boys is in our day. How much effect this had on black listeners is debatable, but there was a continuum of smooth singing that stretched from artists like Leroy Carr to popular black radio groups like the Mills Brothers and Ink Spots (who covered Carr's "In the Evening") and on to Rudy Vallee and Bing Crosby (both of whom performed W. C. Handy numbers). It has become a cliché of jazz history that Louis Armstrong's favorite band was Guy Lombardo's Royal Canadians, and

in the early 1960s Chris Strachwitz was horrified to find that most of the rural musicians he recorded for his Arhoolie roots label, from blues singers to Tex-Mex bands and Louisiana zydeco outfits, were enthusiastic fans of Lawrence Welk. (Welk had a strong enough following among black listeners to reach the R&B top ten in 1961, with the harpsichord-led "Calcutta." The world is not a simple place.)

This should not surprise anyone reading this book, since it is just as logical for a black Delta sharecropper to like sophisticated white urban music as for a lot of educated white urbanites to have fallen in love with Delta blues. Indeed, it is far more logical, since this music came to Delta dwellers as the sound of hope and promise, of faraway cities with good jobs and a more liberal racial climate.

Plus, a lot of the music was fun and exciting. Black kids were growing up on Gene Autry and Roy Rogers movies just like white kids, a fact that led the Duke Ellington Orchestra's silky voiced Herb Jeffries to star in a series of films with titles like *Harlem Rides the Range* and *The Bronze Buckaroo* ("Stout of heart, quick of eye, sweet of voice"). Autry, in particular, was a superstar who appealed across all boundaries of race, region, and riches. As we have seen, although he always considered blues his favorite music, Muddy Waters listed more Autry hits in his repertoire than songs by any blues artist.[21] However typical this may have been, it is probable that there were very few nonclassical singers of the time—be they specialists in hillbilly, blues, jazz, or Tin Pan Alley—who could not have filled a request for an Autry number. For obvious reasons, no one bothered to record any black Delta musicians performing "Take Me Back to My Boots and Saddle," but it is not just my own conjecture that plenty could have done so if asked. In one of Lomax's Delta notebooks, he mentions meeting a black musician who played on a cowboy music radio show every Saturday afternoon from Greenville and told him, "You have to play all the Western tunes for the colored these days."

Another blues star from the region, Bobby "Blue" Bland, though born in 1930, at the height of the blues boom, recalls that he started out singing hillbilly music off the *Grand Ole Opry* and only turned to blues after moving to Memphis, because "it was the wrong time and the wrong place for a black singer to make it singing white country

blues." In the 1970s, after almost two decades as a blues star, he would say, "I still know more hillbilly tunes than I do blues. Hank Snow, Hank Williams, Eddy Arnold—so much feeling, so much sadness." (He added that, in terms of singers, he liked "the soft touch," and listened to a lot of Perry Como and Tony Bennett.)[22]

As for jazz, a lot of people would not have bothered to distinguish it from blues. Everyone could tell the difference between a big band and a Delta guitarist, but Count Basie and Robert Johnson both played Leroy Carr songs, and both played pieces like "My Blue Heaven." There was nothing contradictory in liking to dance to guitarists at backcountry jukes and to jazz bands when you got near a radio or jukebox, and plenty of blues players were also jazz fans.

I had this fact forced on me one weekend in the mid-1980s, when my local blues club brought in the Texas barrelhouse pianist Whistlin' Alex Moore. Moore was then eighty-seven years old, an exuberant blues and boogie player who regularly improvised verses on the spot, and one of the last living exponents of the classic Dallas juke-joint style. He was playing two sets a night for three nights, and for the first couple of days he stuck to blues. Then, when he came out for the fifth show, he began a sort of rambling instrumental that gradually coalesced into the sentimental pop standard "Cottage for Sale." Finishing it off, and perhaps sensing the perplexity of his listeners, Moore launched into a long monologue about how he had learned that song listening to the Benny Goodman band on the radio, and how he loved them so much that he learned all their songs. For roughly the next hour, he played nothing but versions of Goodman tunes, some recognizable, others so transformed as to be essentially his own compositions.

The point is that African Americans, whether in the Delta or not, have been just as varied in their musical tastes as any other racial group, and this was especially true during the blues era, when more music was available than ever before and styles were changing almost monthly. The list of favorite radio performers Adams compiled in the country around Clarksdale would probably have been typical for black listeners pretty much anywhere in the South, and to a great extent throughout the United States. Most of the acts on it are big bands,

leavened with two hot gospel acts, two country stars, a Broadway show-tune singer, and one lone blues artist: Cab Calloway, Artie Shaw, Benny Goodman, Count Basie, Duke Ellington, Glenn Miller, Tommy Dorsey, Mary Lou Williams, The Golden Gate Gospel Quartet, Sister Rosetta Tharpe, Gene Autry, Roy Acuff and his Smoky Mountain Boys, Lanny Ross (a largely forgotten crooner who in 1936 had been voted America's most popular vocalist), and Memphis Minnie. (Minnie is not known to have done radio work, and her inclusion on this list was probably a mistake. Still, given the gaps in our historical knowledge, one cannot be sure.)

As for the list of jukebox favorites, it includes all the record titles available at five of Clarksdale's black amusement places, and sheds still more light on the tastes of the region's black music fans. (The full list is too long to be given here, but is provided as an appendix.) Once again, this is not a definitive guide to what people wanted to hear— the café owners' personal tastes would have been a factor, as well as which records the jukebox operators chose to promote—but it is way better than anachronistic assumptions by modern-day blues lovers.

Johnny Shines recalled that, back in the 1930s, the jukeboxes (or "vendors") provided a unique source for country blues records he could not hear on the radio—"I could take fifteen cents and go to a vendor and learn any song on there, music and lyrics"—but also for a great deal else. "In those places, the juke joints, there'd be quite a few blues on the vendors, and at that time you also had Duke Ellington, Cab Calloway, Fatha Hines, Teddy Wilson, a variety of guys, piano players and things like that who had those numbers on there. Quite a bit of jazz on those vendors. You had to play those kinds of things if you were a musician playing there."[23]

The Fisk-Lomax list bears out his memories. I have seen no comparable jukebox tabulations from, say, Harlem or Chicago, but assume that there were more blues sides on the Clarksdale boxes than one would have found in most northern, urban locations. However, there was a lot else as well, and even many of the blues songs were by performers who today are more likely to be filed in the jazz category. At Messenger's Café, the one place to list a "top six" titles, the favorites were: (1) Count Basie's "Going to Chicago" (sung by Jimmy Rushing),

(2) Louis Jordan's "Pine Top Boogie Woogie," (3) Johnny Hodges's "That's the Blues Old Man" (a Duke Ellington instrumental), (4) Eddy Duchin's "Maria Elena," (5) Sammy Kaye's "Daddy" (which a note says had been first until recently), and (6) Louis Jordan's "Brotherly Love." The first two are blues songs, and if one tabulates all the artists on all the boxes, one continues to find that a third of them played a fair proportion of blues, but that third includes not only Basie and Jordan but also Lil Green, Earl Hines, Buddy Johnson, Jay McShann, and Sam Price—all of whom are represented by blues titles, but also by quite different music.

There are some straight-ahead blues singers as well: Walter Davis and Memphis Minnie show up pretty regularly, and Davis's "Come Back Baby" was the big hit of the moment, the only record to be included on all five jukeboxes. (The runner-up for this honor was Earl Hines's "Jelly Jelly," a pop-blues sung by Billy Eckstine, which was on four.) Still, there are only two artists whose sides could be considered truly "down home," Tommy McClennan and Blind Boy Fuller, and each is represented by only a single song on a single box. Meanwhile, three-quarters of the artists are mainstream stars like Fats Waller and Artie Shaw. Clearly, there were plenty of people who wanted to hear blues—and it is worth noting that both Davis and Memphis Minnie had gotten their starts in the Delta region—but anyone prone to stereotypes will have to account for all those people who apparently preferred Eddy Duchin and Sammy Kaye.[24]

My intention in providing all these lists is to show the breadth of music that made up the world in which the great Mississippi blues singers lived and worked. Too often, blues lovers picture the Delta as an isolated backwater, a place where blues was the only music played and the typical black sharecropper's notion of a superstar was Charley Patton. The fact is that, greatly as Patton was admired by his local fans, they were also hearing the music of a lot of bigger stars, from Peetie Wheatstraw to Duke Ellington. I am sure that some preferred Patton's music to Ellington's, Louis Armstrong's, or Fats Waller's, but they were perfectly aware that he was a local hero while the others were nationally acclaimed, and that even in the Delta they were expressing a minority taste.

I am also trying to convey how little I or anyone else really knows about what made up the day-to-day soundtrack of black Delta life. Were those Duchin and Kaye records played in the afternoon, when older folks took their grandkids into town for an ice cream, or late at night, when young couples slow-danced close together and dreamed of marrying and moving to Chicago? How many of the great Delta blues players nurtured fantasies of throwing away their ratty guitars and stepping out in front of the Count Basie Band? How many people really did love Gene Autry?

We will never know all, or even most of the answers, but I feel completely secure in saying that rural black Delta dwellers were not only aware of all sorts of non-blues, non-Mississippi music, but were doing their best to keep up with the latest developments. This means that they had a very different set of musical reference points than those of modern blues fans. Many of us still listen to Louis Jordan and Count Basie, but few can claim much familiarity with Gene Autry, and I suspect that not one in a hundred thousand would even recognize the name Lanny Ross, much less have heard any of his music.

None of this is to diminish the importance of blues in Delta life, or to minimize the legacy of the region's guitarists and singers. Clearly, blues was more popular and important to the average person in Clarksdale and the Delta than it would have been in Harlem or Los Angeles. But we need to remember that the taste for blues was far from monolithic, and also that it could include Kansas City band singers as well as acoustic guitarists.

The point is not that the common preconceptions about Robert Johnson's musical world are entirely wrong, but rather that they are part of a much larger story. The Delta that Jones and Adams describe, in which radios and jukeboxes were supplanting work songs and wind-up Victrolas, and in which one-third of black tenant farm families had enough money to own some kind of car and a similar proportion said they regularly read an urban newspaper, is the same Delta that was plagued by intense racism and a plantation system often compared to slavery. And these two worlds not only existed side by side, they were inseparable parts of people's daily lives. The availability of radios and newspapers could at times make rural farm families feel more rather

than less isolated, taunting them with glimpses of a life that to many seemed infinitely unattainable. Others, though, dreamed of moving up and out, even if it was only to Clarksdale or Jackson, and the more ambitious made plans to build new lives in Memphis, St. Louis, or the fabled Chicago. It is surely no coincidence that the only two "favorite songs" in Adams's survey that mention a city in their titles are "Sweet Home Chicago" and "Going to Chicago."

The Fisk–Library of Congress trip was made at a key time, with World War II gearing up and the Delta changing with the shifts of technology, politics, and a mass emigration to the North. One could argue that by 1941 or 1942 the area was already very different from what it had been when Robert Johnson recorded five years earlier, and a world away from anything Charley Patton would have known. And yet, it is not that simple. Modernization was proceeding at a rapid clip, but Muddy Waters was still living in a house without electricity and playing at dances with Patton's old fiddler. Much had changed, much remained the same. After all, the Delta had always been a region in a state of flux, full of comings and goings. Of a hundred families Adams surveyed, only four had spent their whole lives on the same plantation, and the average length of time that any family had been in the community was just over ten years. Robert Johnson was far from alone in having the walking blues and rambling on his mind, or dreaming of his sweet home Chicago.

two

ROBERT JOHNSON

6

A LIFE REMEMBERED

ROBERT JOHNSON HAS BECOME THE ULTIMATE BLUES LEGEND, and it is easy to forget that he was once just a man who sang beautifully and played expert guitar. His life and music are often encountered in a vacuum: To many modern listeners he is all of early blues, and the responsibility of standing in for an entire era of music and culture has made it very hard for him to be seen as a talented, young, ambitious man, with friends and relations, good times, bad times, and moments when he was bored and tired, or cheerful and fun to be around.

I have no intention of attempting a full biography of Robert Johnson. His legend, combined with the many blank spaces in his story, have created a mass of exaggerations, confusion, legal cases, and secretiveness that make any such attempt both frustrating and futile. Instead, I will give a rough outline of his life and personality, told as much as possible in the voices of people who actually knew him. These people have sometimes disagreed or disparaged one another's recollections, but for my purposes they are far more useful guides than any vague paper trail established by later researchers. If a date drawn from a court document is inaccurate, it is simply misleading. The memories of Johnson's contemporaries, while they may be equally inaccurate in a strictly factual sense, at least give a feel for what someone in his world thought and experienced. We cannot get inside Johnson's head, or hear his story in his own words, but by listening to

his contemporaries we can get the flavor, speech, and perceptions of people who were playing and living alongside him.

Johnson's life has been the subject of intense investigation, and sometimes intense dispute, for some sixty years. Once he became a cult idol, every Mississippi blues player of even roughly his generation was bombarded with questions about him, and some almost certainly made up stories or exaggerated their acquaintance with him in order to please their many interviewers. Meanwhile, investigators have hidden material, attacked each other's research, and squabbled over every detail, until by now there are few quotations or documents that someone will not argue are at least in part fabrications or liable to error. The confusion is exacerbated by the fact that Johnson was known by a variety of names over the years, and seems to have avoided any close friendships. If most historians now agree on a general picture of Johnson's life, that may to a great extent be simply a matter of consensus. The few supporting documents conflict with each other on many points, and in the end almost the only things we know precisely and unquestionably are what we can hear on his recordings, plus a handful of dates when he happened to intersect with the Mississippi bureaucracy. I do not emphasize this in order to increase his mysteriousness. There has been far too much emphasis on the mysteries, especially considering that, despite all the confusion, we by now know more about him than about almost any of the bigger blues stars of his day. So much research has been done that I have to assume that our overall picture is fairly accurate. Still, this picture has been pieced together from so many tattered and flimsy scraps that almost any one of them must to some extent be taken on faith, and I could preface pretty much every sentence of this chapter with "it seems" or "according to some sources." I will try to avoid this, for the reader's convenience, but it is worth keeping in mind.

According to the researcher Mack McCormick, filtered through the writer Peter Guralnick, "Robert Johnson was born probably on May 8, 1911, the eleventh child of Julia Major Dodds, whose ten older children were all the offspring of her marriage to Charles Dodds. Robert was illegitimate, which, according to McCormick, was the cause of the name confusion and the cause of many of Johnson's later

problems."[1] (You will note Guralnick's "probably" and "according to." I am not alone here.) Charles Dodds was a relatively prosperous landowner and furniture maker in Hazlehurst, a town south of Jackson and hence some distance outside the Delta region. Around 1909, he was forced to leave for Memphis after a dispute with some white landowners, and Robert was born of a temporary relationship between Julia and a man named Noah Johnson. Shortly after his birth, Julia had to move on as well, and she carried Robert along with her for a couple of years until he was taken in by Charles Dodds (who by now was calling himself Charles Spencer). This would have been about 1914. Dodds-Spencer had a large family, including not only Julia's children but also two from a mistress, and during his stay in this household Robert may have messed around on a guitar belonging to an older brother.

Around 1918 or 1920, Robert rejoined his mother, moving to the area around Robinsonville and Tunica in the Delta. The specific town (really more of a handful of houses out in the fields) is often given as Commerce. Julia was living with a new husband, a man named Dusty Willis, and some people remember Johnson being known as Little Robert Dusty, though records at the Indian Creek School in Tunica give his name as Robert Spencer. He attended this school for several years, and Willie Coffee, who was a few years younger but shared classes in the same one-room schoolhouse, says that among the kids he was already considered an accomplished musician:

> Me and him and lots more of us boys, we played hooky and get up under the church. They had a little stand up there and we'd get up under there . . . and he'd blow his harp and pick his old jew's harp for us and sing under there. We'd play hooky until the teacher would find our variety, and she'd make us come in and give us five lashes.[2]

The first stringed instrument anyone in the Delta recalls Johnson playing was a "diddley bow," a makeshift creation made by stretching wire between nails on the side of a house. A kid would tighten the wire by forcing a brick under the end, then play it by banging it with a stick while sliding a glass bottle along it to change notes. Israel Clark, who

knew Johnson from church and Sunday school, recalls him making a three-string version, then later buying a beat-up old guitar with only four strings and saving pennies until he had a dime and could buy two more. "[He] would noise around everybody till they run us away, and we'd go out on the levee, side of the road somewhere, and that's where we'd shoot marbles and he'd play guitar."[3]

By the time he was nineteen, Johnson had married Virginia Travis, but his sixteen-year-old wife died in childbirth, something far from uncommon among poor black farm families, who had virtually no access to medical care. According to some researchers, this was a major trauma for him and set him to his life of rambling, but as far as I know this is pure speculation.

It was around this time that Johnson met the man who would be his first great musical inspiration.[4] Son House had moved to Robinsonville to play in a duo with Willie Brown, whom he had met farther south on the Dockery Plantation. Both men were associates of Charley Patton, who was one of the most popular entertainers at backcountry parties around Dockery's, and in May 1930 Patton took them up to Grafton, Wisconsin, for a recording session with Paramount Records. Brown had been living in Robinsonville for four years, and shortly after the recording trip, House joined him and they formed a team that became the first-call band at local dances.

Even in the 1960s, House remained a magnificent performer, and I can only imagine how powerful he must have been in his prime. While most popular bluesmen were adept showmen, able to play a wide range of material, and noted for funny, off-color lyrics and fancy guitar tricks—Patton and Tommy Johnson played behind their heads and between their legs, threw and spun their guitars in the air, and Johnson even played with his toes—House played like a man possessed by a fearsome and consuming spirit. Born in 1902, he was in his sixties by the time he was captured on film, and some fans insist that his powers were much diminished, but his best performances remain the strongest—indeed perhaps the only—argument for the blues musician as a sort of secular voodoo master. Though in repose he is soft-spoken and rather courtly, when he begins to play he is trans-

formed. His face contorts, his eyes roll back in his head, sweat pours down, his hands flail wildly at the guitar, and his voice has an awesome, earthshaking power. He seems to be in a trance, channeling energies he can barely control, and it is impossible to take your eyes off him.

House was also a big-time drinker and hell-raiser—though in earlier years he had been a Baptist minister—and he and Brown were Robert Johnson's early idols. In the 1960s, House would frequently tell the story for eager young blues fans:

> Sometimes we'd be up there in Robinsonville, and this old man named Mr. Funk [had a place], called it Funk's Corner Store, and he would ask us to play some on a Saturday night. He had some benches out there in front for us to sit on and play. We would draw a crowd around, and he would give us a little something to do that.
>
> So Robert, he would be standing around, and he would listen too, and he got the idea that he'd like to play. So he started from that and everywhere that he'd get to hear us playing for a Saturday night ball, he would come and be there.
>
> So his parents . . . they found out that he was running 'round to them places where we'd be playing on Saturday nights, and guys would fight all the time, kill up each other, shoot each other. They'd do that regular. So they got afraid and they didn't want him to be out to those kind of places. But he got involved with it so well, and he didn't like to work anyway, because his father and mother they were farmers . . . Robert, he'd wait till they go to sleep at night and he'd play like he going to bed, and when he'd find out they're asleep, he'd get up and crawl out the window, and he'd come on and find me and Willie . . .
>
> He used to play harmonica when he was 'round about fifteen, sixteen years old. He could blow harmonica pretty good. Everybody liked it. But he just got the idea that he wanted to play guitar . . . He used to sit down between me and Willie. See, Willie was my commenter, you know, he'd second all the time, he'd never lead, I'd do the lead. And we'd be sitting about this distance apart, and [Robert] would come and sit right on the floor, with his legs up like that, between us.

So when we'd get to a rest period or something, we'd set the guitars up and go out—it would be hot in the summertime, so we'd go out and get in the cool, cool off some. While we're out, Robert, he'd get the guitar and go to bamming with it, you know? Just keeping noise, and the people didn't like that. They'd come out and they'd tell us, "Why don't you or Willie or one go in there and stop that boy? He's driving everybody nuts."

I'd go in there and get to him, I'd say, "Robert," I'd say, "Don't do that, you'll drive the people home." I'd say, "You can blow the harmonica, they'd like to hear that. Get on that." He wouldn't pay me too much attention, but he'd let the guitar alone. I'd say, "You stop that. Supposing if you'd break a string or something? This time of night, we don't know no place where we can go get a string." I'd say, "Just leave the guitars alone."

But quick as we're out there again, and get to laughing and talking and drinking, here we'd hear the guitar again, making all kind of tunes: "BLOO-WAH, BOOM-WAH"—a dog wouldn't want to hear it!

So we couldn't break him from it, and his father would get at him, dogged him so much that he run away. Went somewhere over in Arkansas somewhere.[5]

House recalled that Johnson was away for only about six months, then came back "with a guitar swinging over his shoulder."[6] According to other sources, things happened a little differently: Johnson remained in Mississippi, but south of the Delta, around Hazlehurst and Crystal Springs (Tommy Johnson's home base), and he was gone for a year or two. During this period, he married a woman named Callie Craft, and began to be a regular performer around the juke joints and lumber camps, often working with a guitarist named Ike Zinnerman. One way or another, when Johnson got back to the northern Delta, House had a surprise coming:

Me and Willie, we was playing out to a little place called Banks, Mississippi. I looked and I saw somebody squeezing in the front door, and I seed it was Robert. I said, "Bill, Bill."

He said, "Huh."

I said, "Look who's coming in the door, got a guitar on his back."

He said, "Yeah, no kidding." He said, "Oh, that's Little Robert."

I said, "Yeah, that's him." I said, "Don't say nothing."

And he wiggled through the crowd, until he got over to where we was. I said, "Boy, now where you going with that thing? T'annoy somebody else to death again?"

He say, "I'll tell you what, too." He say, "This your rest time?"

I say, "Well, we can make it our rest time. What you want to do, annoy the folks?"

He say, "No, just let me—give me a try."

I say, "Well, OK." I winked at Willie. So me and Willie got up, and I gave him my seat. He set down. And that boy got started off playing. He had an extra string he'd put on, a six-string guitar made into a seven-string, he'd put it on hisself. Something I had never saw before, none of us. And when that boy started playing, and when he got through, all our mouths were standing open. All! He was gone![7]

House said that Johnson stayed around for about a week. He would always explain that he tried to advise the young man about the dangers of a musician's life, the booze and wild women, but Johnson just laughed it off. As House told Lomax, "He was awful moufy—a terrible big chatterbox—proud as a peafowl."[8]

It was now roughly 1931, and over the next seven years Johnson would roam far and wide, impressing everyone he met with his musical abilities. "He hung around and left, never would stay long at a time—was his hangout down the road in Bogalusa, Louisiana," House said. "We'd rag around some—the people would say we could beat him, but *we* knowed."[9]

Most of what we know of Johnson comes from these years, from the reports of his sometime traveling companion Johnny Shines and other musicians he ran with for brief periods along the way. Most remember him as a handsome, personable figure, occasionally noting that he had one "bad" eye, but never suggesting that this bothered him. He seems to have impressed everyone with his self-possession

and confidence, his air of knowing what he was about, both on guitar and on the road. "At the time I met him he was fresh out of Memphis," the St. Louis guitarist and piano player Henry Townsend remembered. "He was a dark skinned fellow, kind of round shouldered, very small and very young. I thought he must have been teenage. Of course I didn't know whether he was eighteen or seventeen or fifteen, but he was a teenager at that time. But he didn't like the title of being kid . . . he was a man as far as he was concerned."[10]

Robert Lockwood also recalls how young Johnson looked, and suggests that it was partly because of his having Indian blood: "Never had a beard, never shaved. That's an Indian trait."[11] Shines would confirm the round-shoulderedness, but laid more stress on Johnson's fingers, long and spidery, the envy of every guitarist who has seen his picture: "His sharp, slender fingers fluttered like a trapped bird," Shines recalled, in a startling burst of poetry.[12] He also pointed out that, along with his natural good looks, Johnson was careful of his appearance: "Robert was always neat. Robert could ride highways and things like that all day long, and you'd look down at yourself and you'd be as filthy as a pig and Robert'd be clean—how, I don't know."[13]

As for his character, everyone seems to agree that, while he was pleasant and outgoing in public, in private he was reserved and liked to go his own way. Shines usually described him as a union of opposites: "Robert was a very friendly person, even though he was sulky at times, you know," or "He was very bashful, but very imposing," or "He never talked about himself or bragged nothing, . . . He was quiet most of the time—until he started drinking. Then he was like anybody else—rowdy!"[14]

Lockwood, whose mother was one of Johnson's regular girlfriends and who regards Johnson as his musical mentor, says that Johnson did a lot of drinking, but rarely acted drunk. He enjoyed having Johnson around the place, and says that Johnson not only inspired him to switch from piano to guitar, but showed him playing techniques and even built him a homemade instrument, stripping the thin panel off the front of a Victrola and attaching it to a cheese box, then carving and planing a neck and fitting in some frets.[15] He says that Johnson

stopped by often, and always had money to spend. Like pretty much everyone, though, the things he found most striking in Johnson's character were how unwilling Johnson was to get close to anyone, and that constant urge to travel: "Robert was a strange dude," he says. "I guess you could say he was a loner and a drifter."[16]

"He was a kind of peculiar fellow," Shines agreed. "Robert'd be standing up playing someplace, playing like nobody's business. At that time it was a hustle with him as well as a pleasure. And money'd be coming from all directions. But Robert'd just pick up and walk off and leave you standing there playing. And you wouldn't see Robert no more maybe in two or three weeks."[17]

Shines was one of the few people—maybe the only one—to share any significant portion of this road life. A fine guitarist, and one of the strongest singers in the region, he had originally modeled himself on Howlin' Wolf, a huge bear of a man who was a year older than Johnson. Wolf would go on to be one of the giants of the electric Chicago scene, but at this point he was tearing up the small Delta joints as a young heir to the big-voiced Charley Patton. Shines lacked Wolf's physical presence, but he had a somewhat similar voice and was a more varied and expert guitarist. Still a teenager, he was considered an up-and-comer by his peers, and it was not surprising that he hit it off with Johnson, a thoughtful and adventurous musician only three or four years his senior. Shines recalled that during this period Johnson was playing gigs almost every night around West Helena, Arkansas, and they were introduced by a piano-playing friend who went by the name M&O (after the Mobile & Ohio train line):

> He wanted me to meet Robert, because this friend of mine thought I were good. You know how this thing goes: "There's a good guy playing at such and such a place, I'd like for you to meet him." And the thing about it, what he wants you to do is to go and get your head cut. So M&O finally talked me into going to see him, and Robert played a good guitar, the best I'd heard. Now I had Wolf's style in the beginning, and I was beginning to pick up on quite a few different guys' styles as the time went along, but I thought Robert was about the greatest guitar player I'd ever

heard. The things he was doing was things that I'd never heard nobody else do, and I wanted to learn it, especially a lot of his slide stuff.[18]

Soon, the two young men were on the road together.

Robert was a guy, you could wake him up anytime and he was ready to *go.* Say, for instance, you had come from Memphis and go to Helena, and we'd play there all night probably and lay down to sleep the next morning, and you hear a train. You say, "Robert, I hear a train; let's catch it." He wouldn't exchange no words with you; he's just ready to go. . . . I was just, matter of fact, tagging along. Not that he wanted me along, I don't think, being a soloist, a fellow that really didn't care for nobody very much, I mean so far as running the road with him. . . . That was his personality; that was just his make. You had to be able to deal with him if you wanted to know him, and he was kind of long-armed. What I mean by that, he'd kind of keep you away from him. . . . It made it pretty tough keeping up with him, but Robert had a style that I liked. . . . Robert and I played together a lot—traveled to Chicago, Texas, New York, Canada, Kentucky, Indiana. I tagged along with him cause I knew he was heavy and I wanted to learn.[19]

They played wherever they could find a crowd.

We never had much trouble finding places to play. In New York there were quite a few speakeasies and places like that. In Buffalo there were several places we could play, and over in New Jersey there were two or three places we used to work at . . . speakeasies, taverns, houses. . . .[20]

In those days you didn't have to know nowhere to go. People would just pick you up on the streets—they'd see you with your instrument, say, "Man, you play that?"

"Yeah."

"Play me a piece."

You say, "Well, I do this for my living, man," and by that they know automatically you're not going to be playing for free. Maybe you stand there and play two or three pieces—well, by that time, hell, you got twenty-five or thirty people around you. . . .[21]

It was pretty rough at times; we didn't know where the next food was coming from or where we'd stay that night. Robert and I would travel *any*where to play and make some money. We'd hear about a sawmill going to pay off at a certain time, and we'd be there; we'd pick up maybe seven dollars just playing where the payday was. And then some guy might hire us to play somewhere for four dollars a night and all we could drink. Different guys'd give us a quarter to play this piece or that piece, so we'd end up with twenty-five or thirty dollars.

Everything was fun in those days, though, cause you wasn't taking much of anything too serious. You'd wake up with a couple of black eyes, lip all swollen up and a loose tooth:

"Man, you sure kicked that son of a bitch around last night!"

"Shit, look like to me he kicked *my* ass!"

Sometimes I'd get the worst of something Robert started. . . . He couldn't punch hisself out of a wet paper sack. I've seen many people with the same build that he had that were much more capable of taking care of themselves than he was. He wasn't a scrapper or a fighter, but he tried, and he'd get the hell beat out of *you* if you didn't watch out. 'Cause he'd jump on a gang of guys just as quick as he would one, and if you went to defend him, why, naturally you'd get it![22]

It is not clear just when Shines met Johnson, or how often they got together and split up again over the next few years. Shines's memories varied occasionally as to just how much terrain they covered, but Johnson certainly did his share of traveling, and Shines is not alone in remembering the ease with which he slid into jobs and impressed people with his talents. His childhood friend Willie Coffee, for example, says that whenever he came back through town he was greeted like royalty: "We had a old juke, like we called an old plantation juke. When Robert walked in there, they'd jump up, just like the President done come in. Gettin' ready to dance. Man, he could tear 'em up . . . they'd break the floor in, shouting and jumping."

Around the Delta, most of the work was at those backcountry "jukes," often nothing more than a house with the furniture moved outside to leave space for dancing. Shines recalls that rising local stars like Johnson and himself could demand as much as six dollars a night,

while other musicians were working for a dollar and food, as long as the season was right:[23]

> In the fall it was better than at other times of the year. That was because of the harvest season, cotton picking, corn pulling and so on like that. There was more money around then. In the spring of the year there wasn't much of anything because the people were trying to get themselves straightened out over the winter season. Along about June and July things would begin to pick up to where you could get hold of some money. September, October, November and up through December and sometimes January, that's when you really had to get it. Didn't make no difference what kind of hustle you had to do, you *had* to get it right through then. Those were the big months, that's when the money was floating around. When things would start to fall off, I would go back to Memphis and kind of take it easy till the next season came.[24]

Johnson sometimes stopped off in Memphis as well, but he liked to go a good deal farther, and wherever he went he had no trouble finding a receptive audience. Townsend recalls him turning up in St. Louis—a blues center noted for stars like Lonnie Johnson and Peetie Wheatstraw—and quickly proving his mettle:

> I was playing at Ernest Walker's house party on Jefferson. Robert Johnson had come over to find me, and he was a stranger in the town, so he told me, "Look, I've heard about you." He was just traveling through and he says, "Where you working at tonight?" So I told him and he says, "Can I come over?" and I said, "Yeah," so he came over to Walker's . . .
>
> Well, we sat in the backyard and that fellow, he went over some guitar and I thought, well, this guy's got it. I mean he was amazing. I was a little bit older than him, but I didn't think anybody had any seniority over me on the guitar, really, and he played for Ernest Walker for about three weeks and I came back and he stayed with me another week over there, for a very small scale, of course. He held the job until I came back and the truth is it was Robert's job when I came back. Robert continued until he was ready to leave; then the boss put me

back to work. Robert was very decent about it, I mean we worked to-
gether, but as far as the job was concerned it belonged to Robert . . .
I don't really know where he was going when he left. He said he was
going to Chicago . . ."[25]

Johnson had all the skills necessary for a traveling musician. First
of all, and most important in those days before microphones became
common, he had volume. In Shines's words:

Robert sang pretty loud, and most of the time he sang in a high-pitched
voice, and, naturally, his voice was carrying. We didn't have too much
trouble in having ourselves heard in those places we played in. The peo-
ple that was dancing, they'd just pick up the beat, and if they got out of
earshot, I guess the rhythm just stayed with them and they kept right
on dancing. Because the whole house had the same motion, it wasn't
hard for them to stay in rhythm.[26]

Shines recalled that, along with his musical talents—the powerful
voice and uncanny facility on guitar—Johnson had a personal mag-
netism about him, something that attracted people:

Robert was one of those fellows who was warm in every respect—in
every respect. Even, you know, it's natural for men not to like a musi-
cian too much. But Robert was a fellow very well liked by women and
men, even though a lot of men resented his power or his influence over
women-people. They resented that very much, but, as a human being,
they still liked him because they couldn't help but like him, for Robert
just had that power to draw.[27]

And for showmanship, he had a built-in showmanship radar! He
could just stop anywhere and draw a crowd of people, doing anything.
Now he wasn't a clown or anything like that. Here's an example. We
was staying in West Memphis at a place called John Hunt's and this
place burnt down and burnt our guitars up. I didn't know that he
knew anything about harmonica at all, but he come up with this old
harmonica. We were out on Highway 61 and he started blowing this
harmonica and slapping his hands—patting his hands, blowing and

singing—and in a few minutes the whole highway was almost blocked off with cars, people pitching us nickels, dimes, quarters.[28]

The loud voice and the gift for showmanship were common to all the Delta greats—without them there was no way to distinguish yourself in this world—but Johnson was also very much a man of his time. Shines reported that, like all the musicians of their generation, "he talked really hip . . . like, 'Yeah, man,' you know, or 'Look, Daddy So-and-So.'"[29] While older Delta players like Patton and House were largely tied to a rural, regional repertoire, Johnson had big ears for all the latest sounds, and Shines recalls him performing everything from hillbilly tunes to Hollywood cowboy songs and Bing Crosby numbers.[30]

He did anything that he heard over the radio. . . . When I say anything, I mean *anything*—popular songs, ballads, blues, anything. It didn't make him no difference what it was. If he liked it, he did it. He'd be sitting there listening to the radio—and you wouldn't even know he was paying any attention to it—and later that evening maybe, he'd walk out on the streets and play the same songs that were played over the radio. Four or five songs he'd liked out of the whole session over the radio and he'd play them all evening, and he'd continue to play them. . . . And I know that he was making chords that he never heard before. But still he never practiced, and he never looked for a chord, he just automatically made them . . . and he made them right. . . . He could play in the style of Lonnie Johnson, Blind Blake, Blind Boy Fuller, Blind Willie McTell, all those guys. And the country singer, Jimmie Rodgers, me and Robert used to play a hell of a lot of his tunes, man. Ragtime, pop tunes, waltz numbers, polkas—shoot, a polka hound, man. Robert just picked songs out of the air.[31] [Shines would add that Johnson's favorites included "Yes, Sir, That's My Baby," "My Blue Heaven," and "Tumbling Tumbleweeds."][32]

Along with all the songs learned from recordings and other players, Johnson had a rare ability to create his own material. Often, he would make up songs on the spur of the moment: "He was a great guy for plain inspiration," Townsend says. "He'd get a feeling, and out of

nowhere he could put a song together. . . . I remember asking him about songs he had sung two or three nights before, and he'd tell me, well, he wouldn't, he couldn't do that one again. And I'd ask him why. He'd say, 'Well, that was just a feeling. I was just, just . . . reciting from a feeling.' "[33]

After a while—maybe the turning point came when he began recording, or maybe it was a little earlier—he came to have a few original signature pieces. Along with the popular favorites, he would play "Sweet Home Chicago," his adaptation of a Kokomo Arnold hit that he had renamed to fit the Delta dweller's northern Shangri-La, or "Come On in My Kitchen," his sexy, lonesome reworking of Tampa Red's "Things 'Bout Coming My Way."

According to Shines, Johnson's slide guitar work was particularly distinctive, and could have an almost hypnotic effect on his listeners:

> His guitar seemed to talk—repeat and say words with him like no one else in the world could. I said he had a talking guitar and many a person agreed with me. This sound affected most women in a way that I could never understand. One time in St. Louis we were playing one of the songs that Robert would like to play with someone once in a great while, "Come On in My Kitchen." He was playing very slow and passionately, and when we had quit, I noticed no one was saying anything. Then I realized they were crying—both women and men.[34]

By 1936, Johnson had proved his abilities among his peers, and his power over an audience, but he still had not gotten the respect and reputation that came with a recording career. With all his traveling, it seems a bit strange that he did not head for the studios in Chicago, where most of the top blues hits were being made, but maybe he was afraid he would get lost in the big-city shuffle—or maybe he had given it a try and for some reason it had not worked out. In any case, sometime that year he walked into H. C. Speir's furniture store in Jackson. Speir had expanded from selling phonographs and records to acting as a talent scout, and had been responsible for getting pretty much all the Mississippi blues singers their recording deals—the Mississippi Sheiks, Bo Carter, Charley Patton, Tommy Johnson, Ishmon Bracey,

Skip James, Son House, and many lesser names. By the mid-1930s, the record companies were shying away from rural artists, but Speir was impressed with Johnson and got in touch with Ernie Oertle, the Mid-South agent for the ARC company. Oertle was interested, and arranged a debut session for Johnson in November, in San Antonio, Texas.

Oertle brought Johnson to the Gunter Hotel in San Antonio, where ARC was conducting its sessions, and introduced him to the producers, Art Satherley and Don Law. As was typical for field trips by the big companies, they were in San Antonio to record a range of regional and ethnic music, and that week's acts included two groups of Mexican musicians and a cowboy swing band called the Chuck Wagon Gang. Johnson was the one blues singer on the roster, and according to Law he was "suffering from a bad case of stage fright." Law recalled that he had to turn his back on the other musicians before he could relax. "Eventually he calmed down sufficiently to play, but he never faced his audience."[35]

Many modern commentators dispute Law's assessment of this situation. Some argue that Johnson was "jealous of his own abilities," and turned away to conceal his guitar technique from the Mexicans. Others suggest that Johnson was trying to get an acoustic boost by "corner loading," playing into the corner so that the sound would be amplified by the close walls rather than dissipating in the bigger space of the room. To me, it seems unlikely that Johnson would think he knew recording acoustics better than the ARC engineers, or that he would suspect Mexican ranchera singers of wanting to steal his licks. Law's explanation, by contrast, seems perfectly reasonable: Though confident of his prowess at a juke joint or house party, Johnson was recording for the first time, and everyone agrees that he considered this a make-or-break moment that would define his future. Even a very practiced performer can get nervous in that kind of situation, and what could be more reasonable than to try and shut out the distractions of the recording process by turning away and going into his own world?

If this first session was a somewhat nerve-wracking experience, that would help explain Law's other memories of that week: First, that

the road-savvy Johnson ran afoul of the local law and got busted on a vagrancy charge, and then that, after Law bailed him out, he called the producer again to complain that he was "lonesome."

"Lonesome? What do you mean, you're lonesome?" Law says he responded.

"I'm lonesome and there's a lady here. She wants fifty cents and I lacks a nickel . . ."[36]

Was that really Robert Johnson, or was Law dredging up a favorite blues musician anecdote? Whatever the intervening incidents, Johnson did three sessions that week, on Monday, Thursday and Friday, November 23, 26 and 27. He recorded sixteen songs, generally doing two takes of each.

This was the depths of the Depression, and new blues artists were not selling very well unless they had the Chicago band sound behind them.[37] Still, Johnson's debut produced one moderately good seller, "Terraplane Blues," a high-powered double-entendre number about a fashionable make of car. It did not set the blues world on fire, but impressed a lot of people back home in the Delta. "We heard a couple of his pieces come out on records," Son House remembered. "Believe the first one I heard was 'Terraplane Blues.' Jesus, it was good. We all admired it. Said, 'That boy is really going places.'"[38]

There is no dispute about how important the recordings were to Johnson himself. He proudly brought records to various far-flung family members, and Shines recalls the pleasure he took in talking about the process: "Nearly every time I came upon Robert he'd be telling me about some new recording session. He'd tell me about things I'd never seen, like 'start lights' and 'stop lights' used in recording. About seventy-five to a hundred dollars was all the money he ever got."[39]

In those days, rural artists were rarely paid any royalties for their records. Even if they were offered the option of a royalty deal, it was a gamble that few would take when balanced against a lump sum, paid immediately in cash. Johnson probably got a few hundred dollars for his sixteen sides—a small payment considering what they would become, but a fortune for a wandering guitarist in the midst of the Depression. It was very likely the most money he had ever had at one

time, and may have paid for the slick suit he is wearing in his studio portrait. The recordings also would have increased his drawing power, and hence his earnings at juke joints and house parties.

As for ARC, the company was happy enough with Johnson's sales to invite him back for another session in June. This was by no means standard procedure in that period, and can be taken as a high compliment and demonstration of the producers' belief in his potential. Just seven months after his first sessions, he was in Dallas, in another makeshift recording studio. This time, it was the height of summer and Don Law recalled that at such sessions, "to keep the street noises out, we had to keep the windows closed, so we worked shirtless with electric fans blowing across cakes of ice."[40]

Johnson recorded another thirteen songs, then hit the road again. Shines says that they met up in Texas, then worked their way to Arkansas, where Johnson split off and headed back to Mississippi. Later, they seem to have made another trip north, visiting St. Louis and going up to Illinois, where Shines reports that they got a gig in a small town simply because the locals had never seen a black man: "We stayed there a couple of nights, and the people at that time paid twenty-five cents a head to come in and see what the colored guys looked like. . . . [But] we didn't want to be part of a freak sideshow. The guy thought we wanted more money, but we just wanted to get the hell out of there. After all, a man have pride. And that wasn't in the South either. Well, that just shows you how unthoughtful sometimes people can be."[41]

Some of that year was spent in Helena, Arkansas, where Johnson continued his on-and-off affair with Robert Lockwood's mother, and Lockwood picked up some more guitar tips from him. There are stories that he got a band together, that he was playing with a pianist and a drummer, with his name written across the front of the bass drum, evolving toward what would come to be called a "jump blues" sound.

Unfortunately, as everyone knows, there was trouble ahead. Along with the music and the drinking, Johnson had long had a reputation as a ladies' man. As Shines put it, "Women, to Robert, were like motel or hotel rooms. Even if he used them repeatedly he left them where he

found them. Heaven help him, he was not discriminating. Probably a bit like Christ, he loved them all. He preferred older women in their thirties over the younger ones, because the older ones would pay his way."[42]

Some of the women, probably most of them, went along with this program. After all, they knew they were picking up a rambling musician, and few could have had any illusions about the duration of the relationship. Others, though, were less accommodating. Willie Coffee laughs as he recalls one scrape back in the Delta:

> [There was] a woman that they called Lucille. She chased him one day on the road. He was going out to his mama's, I don't know where he had been, but he come in. And he'd been kind of slinking around with her, you know. Somehow or another, they got into it, and she chased him right 'cross the ditch, from one side 'cross the ditch to the other side and back and forth. He'd jump the ditch, she'd go round to the bridge and come back. Whup! He'd jump back 'cross on that side. Till somebody from Commerce came along in that old T-Model . . . and picked him up and carried him on out to his mama. She swore she was gonna kill him. She had an ice pick at Robert, and trying to stab him.[43]

Even if the women were satisfied with the situation, the men could be another story. As Shines put it, "If women pull at a musician, naturally men's gonna be jealous of it. Because every man wants to be king . . . and if he's not king and somebody else seems to be on the throne, then he wants to get him down. It don't take very much to set people off when you're being worshipped by women. And so naturally we got into a hell of a lot of trouble."[44]

Johnson had annoyed more than his share of husbands and boyfriends, and in the end it caught up with him. David "Honeyboy" Edwards was working around the Delta at that time, and says that he and Johnson had teamed up on a regular gig at a little country joint near Three Forks, a small cluster of houses west of Greenwood. The man who ran the club would pick them up in Greenwood, then drive them back into town after the gig, and Edwards's understanding is that

he got the idea that Johnson was running around with his wife and decided to get rid of him by giving him poisoned whiskey.

> Robert came back to Greenwood and went back the next Saturday night out there. So he gave some of his friends some whiskey to give Robert to drink . . . you see, he give it to him to drink because he had it in for Robert and his wife. But he still kept him to play for him! I think this fellow was named Ralph. So now that's—I don't know was it poisoned or not, but that's the way I got it. I know he got poisoned out there . . .
>
> I come on back to Greenwood, 'cause I played little house parties in the city. And he was playing out there, and the people told me, said, about one o'clock Robert taken sick when he was playing. All the people just came out the city said they wanted him to play, 'cause they was drinking and all them having a good time, and they was begging him to play, and he played sick. And they said he told the public, he said, "Well, I'm sick, y'all see, but I'm playing, but I'm still sick. I'm not able to play." And they said he played on and about two o'clock he got so sick they had to bring him back to town. And he come back to town and he died in Greenwood.[45]

Johnson's death certificate gives us a fairly reliable date of August 16, 1938, but the rest of the story got told and retold a lot of different ways. Aleck "Sonny Boy Williamson" Miller would tell Shines that the poison drove Johnson mad, that he spent his last days crawling around on the floor and barking like a dog, before dying in Miller's arms.[46] House heard that Johnson had been shot or stabbed. The official who made out the death certificate cited the plantation owner's opinion—apparently backed up by no evidence aside from the fact that Johnson was a musician—that the cause of death was syphilis.[47] Willie Coffee says that the family went to Johnson's funeral, and said that he had died of pneumonia.

Frankly, no one at the time seems to have worried very much about the exact circumstances. During his research some twenty years later, Mack McCormick apparently interviewed two witnesses to Johnson's

slaying, but Guralnick quotes him only as saying, "The accounts agreed substantially as to the motive, the circumstances, and in naming the person responsible for the murder. It had been a casual killing that no one took very seriously. In their eyes Robert Johnson was a visiting guitar player who got murdered."[48]

7

THE MUSIC

IN THE END, WHAT REMAINS OF ROBERT JOHNSON IS HIS MUSIC.
Whatever may be vague in his biography, and whatever unrecorded talents may have died with him, we still have two discs' worth of songs, and they are still exciting new generations of listeners.

And yet, even that musical legacy is sometimes hard to view with any clarity. There have been thousands of pages written about Robert Johnson's records over the years, but the vast majority have simply been hyperbolic celebrations of his unique genius. I grew up on this writing, and agree with much of it, so I was unprepared for what happened when I taught my first series of classes on blues history. For the Mississippi class, I started by explaining that, though the state's artists had not been considered particularly important in the commercial blues world of their day, they were justifiably singled out by virtually all later commentators. I then played recordings of the great prewar Mississippians: Charley Patton, with his growling voice and astonishing polyrhythms. Tommy Johnson with his warmer, lighter approach and eerie falsetto. The wild bottleneck styles of Son House and Willie Newbern. Skip James, for me the most intense and transcendent singer in blues. Plus the Mississippi Sheiks, the Mississippi Jook Band, some fife-and-drum music from the hill country, Rube Lacey, Arthur Pettis, Robert Petway . . .

Finally, we came to Robert Johnson, the most famous Mississippian of all. My students had all heard of him, knew he was supposed

to be the pinnacle of the Delta style, but most had never actually listened to his music. Now, as he sang and played, they looked at me blankly. What was so special about this? Compared to some of the earlier players, Johnson seemed rather sedate. Why would he be hailed as a musical revolutionary, towering above his elders and contemporaries?

I did my best to come up with answers, but I was caught off guard, and over the next months this experience forced me to rethink much of what I knew—or thought I knew—about blues. My students' reaction, far from being stupid or ill-informed, was closer to the reaction of most 1930s blues fans than mine was. Even in Mississippi, Johnson's work was hardly greeted as revolutionary. His most celebrated talent, if we are to judge by the reports of his contemporaries, was his versatility, his ability to pick up new guitar parts as if by magic and to command a vast range of styles. It was incredible to them that he could play everything from Son House's raw country slide to the supple, jazzy style of Lonnie Johnson and all the latest pop and western hits. No one would have asked him to be more passionate than Son House and more soulful than Skip James. In fact, at that time there would have been hardly any listeners who were familiar with both House's and James's work, since they came from opposite ends of the Delta and their records sold poorly. It was much more impressive to be able to sound like Leroy Carr, Peetie Wheatstraw, and Kokomo Arnold, national stars familiar to every blues fan. To people in the Delta, Johnson's strength was not that he exemplified the best of the local style, but rather that he had assimilated all the hottest sounds from outside. For his young fellow musicians, he was an example of someone of their own generation who had managed to make records, and whose work pointed the way to forming versatile bands and holding their own with the pop stars up north, rather than being stuck forever playing in rundown country shacks. Meanwhile, for the broader world of blues fans, there was nothing special about one more young guy who sounded like Carr or Arnold, and the unique qualities of the Delta style had never been big selling points.

Which is to say my students were in the rare position of approaching Johnson by way of the records that preceded and surrounded him,

rather than coming to him by traveling backward from the Rolling Stones via Chuck Berry and Muddy Waters—the path taken by virtually all modern listeners. Given this, their reactions made perfect sense. Not that I believe Johnson was in any way an ordinary talent, but what makes him great is by no means as obvious and clear-cut as it has often appeared to the generations of white rock and jazz fans who have heard him in a vacuum, cut off from the larger blues world of his time.

I went back to Johnson's records with a new mission: to understand his work in its natural context. This book is, to a great extent, the result of that experience and the paths it took me down. The first step was to listen to his music, and as much as possible of the music that had surrounded him. I wanted to get a feeling for his background and the popular tastes of his day, to place his work alongside the records he and his peers were listening to, and to try to explore what he was after on his own terms.

Obviously, such an aim can never be completely achieved. I was born twenty years after Johnson's death, and I am not black, not from Mississippi, not a musical genius. I could argue that I have certain insights because I spent many years as a wandering guitarist, hitchhiking into town and looking for someplace to play and someone who would give me a bed for the night, but does that really bring me closer to him, or only give me a deceptive sense of camaraderie? I know of white Mississippians who think that they have insight into Delta blues that no northerner can share, and black college professors who have never been to Mississippi but assume they can get into Johnson's head better than any white person could. Claims of empathy are as potentially slippery and misleading as they are, perhaps, inevitable. Even for a young, brilliant black blues player from Mississippi, it would be an incredible leap of faith (or hubris) to think that one's experiences in the twenty-first century gave any clear insight into what Johnson would have experienced in 1930. Far too much water has passed under far too many bridges in the intervening years. In some ways, a young Mississippi rapper might be in a better position, at least understanding the experience of being a black, poor, forward-looking artist

trying to break into a fast-moving, high-powered national scene despite being based in a regional backwater.

In any case, I have done my best to immerse myself in what is known of Johnson's world. I have listened to thousands of recordings, concentrating (for a change) not on what I happened to enjoy but on what I know to have been popular with blues fans of his day. I have spent a fair amount of time in the Delta, and have worked and talked with blues players of Johnson's generation. And I have tried to be aware of my limitations. I did not grow up surrounded by the children's game songs of rural Mississippi or the jug-band sounds of the Memphis streets. The pop touchstones of my childhood were the Beatles and Monkees, and while thirty years of blues fandom makes it easy for me to tell Lonnie Johnson from Tampa Red, I could not even recognize a Lanny Ross or Rudy Vallee record. Robert Johnson, I assume, would have recognized both, and I have no idea how this affected his musical education or approach—especially since all that remains of his famously varied repertoire is a small pile of three-minute blues recordings, and even those few songs were chosen because they were deemed most likely to sell on the current blues market, not because they were necessarily his favorites or biggest crowd-pleasers.

There are people who will argue that, especially considering all these barriers of time and culture, it makes no sense to try to understand what Robert Johnson was attempting, that all we can do is listen to the music and react to it in the here and now. This is a valid approach, as far as it goes, and yet it also suggests a certain lack of respect for the music. No one writes about Stravinsky as if all one need do to appreciate him is to listen, without knowing anything about Western concert music. It is assumed that the more we can understand of what went into the making of *The Rite of Spring*, the more familiar we are with Beethoven and with the thrill of twentieth-century modernism, the more meaning it will have for us. Given this, I cannot help but think that when blues experts say that they prefer not to discuss Johnson's sources, or consider them irrelevant to his genius, that is often because they do not approve of his tastes—that they would be

happy to trace him to Son House, but do not like to think of him copying what they regard as dull assembly-line hits by the popular studio stars. And yet, this was precisely what made Johnson great: the ability to bridge that gap, and be both completely a product of the Delta and completely in tune with the world outside.

The more I have listened to Robert Johnson, the more I have come to admire what he accomplished. He was indeed a unique genius, and created some of the most moving and complex music of the twentieth century. Fortunately for those of us interested in understanding his work, he was also the first major blues musician whose roots and sources are almost all apparent and accessible to us. What is more, he was one of the few who made recordings of high enough technical quality that we can actually hear how he sounded up close, and the only one for whom we have so many "alternate takes," allowing us to compare his varying approaches to a song. All of this makes his work particularly rewarding of deeper study, of listening and relistening, with his models available for comparison. That is what I have tried to do in the next three chapters. I do not claim to have made earthshaking discoveries, or to have found the ultimate answers to every question. I would hope, though, that these chapters will provide some food for thought and serve as a spur to other listeners to take the same journey and reach their own conclusions.

8

FIRST SESSIONS, PART ONE:
GOING FOR SOME HITS

ON MONDAY, NOVEMBER 23, 1936, WHEN ROBERT JOHNSON entered a studio for the first time, he was an ambitious and experienced professional hoping to cut a hit record. While he was a master of several styles, and deeply steeped in the Delta juke music he had known since childhood, he was well aware of the current blues market, and naturally started with his most commercial material.

"**Kind Hearted Woman Blues**," the first song at the first session, was Johnson's addition to a cycle of spin-offs that had followed Leroy Carr's hit "Mean Mistreater Mama."[1] Carr's song had originally been recorded in 1934 and spawned a series of sequels ranging from Carr's own "Mean Mistreater Mama No. 2" to covers by Tampa Red, Josh White, and Bumble Bee Slim. Slim had also recorded a follow-up called "Cruel Hearted Woman Blues," and Johnson apparently thought it would be a good trick to write an "answer song," defending the woman—at least up to a point. This approach, in which he both celebrated and lamented the relationship, was in perfect keeping with Carr's original, which began "You're a mean mistreating mama and you don't mean me no good/And I don't blame you, baby, I'd be the same way if I could." Johnson's fourth verse seems modeled on one of Carr's, and the high guitar part he plays under the second verse is very similar to what Scrapper Blackwell played on the earlier record.[2]

That said, Johnson's song is the most musically complex in the cycle, and immediately gives some insight into what set him apart from

the competition. First of all, it was relatively rare for rurally based singers to carefully compose a whole blues lyric. At country jukes, the dancers made so much noise that it would have been hard to make out more than a phrase here or there, and the musician's job was simply to produce a strong, steady rhythm. On street corners, passersby could hear more clearly, but only occasionally stuck around for more than a few minutes. Delta veterans like Son House or Charley Patton were quite capable of writing complete songs, but normally did not bother. At a dance they could play a single blues guitar arrangement for twenty minutes or more, singing a couple of verses, playing a solo, then singing another verse as inspiration hit. A song would thus be made up largely of "floating" verses, rhymed couplets that could be inserted more or less at random. Some of these might be original to the performer, some learned from other singers. When it came time to make a recording, the producers generally required blues singers to perform original material, but this did not necessarily mean that one needed to write a full song. Even a major star like Lemon Jefferson would often fulfill the requirement by composing one or two verses, then reach into his grab bag of floating couplets to fill the rest of the record.

By contrast, even the most mediocre of the studio regulars working out of St. Louis and Chicago tended to compose cohesive pieces around a single theme. This was a matter of necessity: They were churning out records by the dozens, often with virtually identical accompaniments, so they needed to come up with themes that would set one song apart from the next. The best lyricists would create little vignettes that flowed smoothly from verse to verse, describing a woman, a relationship, or something as vague as—to cite two of Carr's masterpieces—the feeling of loneliness at sunrise or midnight.

Johnson had studied these northern, urban styles, and his compositions are generally professional, composed works, carefully designed to fit the three-minute limit of a 78 side. "Kind Hearted Woman" does not have a perfectly cohesive lyric: One moment he is praising his kind hearted woman, the next he is complaining that she drives him to drink with her cheating ways, the next he is saying that she studies evil all the time and might as well kill him, and he ends by warning that

he will leave her because he is not satisfied. The verses show a nice turn for poetry, though, and if the theme is a bit confused, it at least stays on one subject throughout. On the whole, it is an expert but hardly earthshaking variation on Carr's pattern.

What makes "Kind Hearted Woman" unique is that, rather than just playing an accompaniment for his vocal, Johnson has worked out a full-fledged, abundantly varied musical arrangement. The guitar part for the first verse is clearly based on the sort of piano lines that Carr played—not flashy, but providing some nice, moody chords between the vocals. This was already something of a departure for a Delta player, since most rural guitarists tended to stick to approaches that derived naturally from guitar and banjo playing. (When Johnson played a Son House piece, for example, his work had no hint of piano phrasing.) The second verse uses Blackwell's high guitar riff, and Johnson changes his vocal melody to match it. Then, for the third verse, he produces a kind of musical bridge, a four-line verse that starts out like a similar verse in "Mean Mistreater Mama," with touches from another contemporary star, Kokomo Arnold, then leaps into a startling falsetto passage.

Johnson had apparently planned to play an instrumental break after this verse, then sum up with two final verses. Unfortunately, he was still new to the recording process and had not timed the arrangement right. The three-minute mark was approaching, and he had to cut the song short before getting to the last verse. For the second take, he solved this problem by dropping the instrumental interlude and picking up the tempo, which gave him time to finish as planned.

It is interesting to compare this performance to the ones that followed. Sitting in front of a microphone for the first time, Johnson is clearly nervous, muffing some guitar licks and sounding a bit tentative at times. The carefully thought-out structure of "Kind Hearted Woman" conceals much of this nervousness, but also keeps him from relaxing. Blues artists were typically asked to have at least four original songs prepared, and Johnson was clearly starting with the most arranged and up-to-date pieces in his repertoire. This was the most varied arrangement he ever recorded, and it may be due to that as much as to nervousness that he sounds so careful, and even rather stiff

in places. This is particularly noticeable when he sings the falsetto "oooh" in the second verse: He has obviously decided exactly where and how he wants it, and places it there with an antiseptic exactitude on both takes. By the second take he is a bit more relaxed, and adds a sly twist to the word "love" in that verse's final line, but—perhaps because he has lowered his guitar half a tone—he does not have the same intensity on the falsetto lines.[3]

All in all, it is an admirable recording, but there are still some bugs to be worked out, and even some of its strengths reveal more professionalism than brilliance. There is a care and solidity about the whole thing, a very conscious attempt to produce a finished product that fits the current trends. This was no mean feat, since those current trends were based on piano and guitar duets, and employed some very experienced songwriters. The song has all the hallmarks of urban, professional work, not the sort of music that would have gotten a backcountry juke joint rocking, and if Johnson's playing sometimes seems a little unsure, his voice has the strong, regular sound of the Carr school. He does not have Carr's relaxed cool, but does amazingly well for a guy getting his first chance in front of a microphone.

Though Carr was an obvious influence, Johnson's choice of material at this session shows an even more direct debt to Kokomo Arnold. James Arnold was one of the most spectacular guitarists of the blues era, a slide master who played jagged, lightning-fast passages in startling counter-rhythms to his powerful vocals. Originally from Georgia, he had spent time in upstate New York, Mississippi, and Memphis before settling in Chicago, where he made his living as a bootlegger and played guitar on the side. He became a major star in 1934, when he cut "Milk Cow Blues," which was imitated by everyone from Memphis Minnie and Josh White to Bob Wills's Texas Playboys and eventually Elvis Presley, and recorded seventy-five more numbers in the next four years.

The four-line bridge verse in "Kind Hearted Woman" was based on a pattern Arnold had established in "Milk Cow," and Johnson's next two songs were both pastiches of Arnold's work. This may simply have been a matter of taste, or may reflect a personal connection. While the dates are not completely clear, Arnold seems to have spent a fair

amount of time playing in Memphis and Jackson in the mid-1930s, and Johnson could well have hung around and learned songs directly from him. Though Arnold had released over twenty records by the time Johnson entered the studio, the lines Johnson used all came from his first three releases, and it may be that these songs were Arnold's own favorites, and Johnson had picked them up at live performances. (It may also be that these just happened to be the records on hand at the moment when Johnson was going through a Kokomo Arnold phase.)

One striking thing about these first Arnold adaptations is that Johnson chose not to use a bottleneck or slide. This is probably because—like most modern players—he was intimidated by the velocity and precision of Arnold's work. Johnson was a master of the more countrified Delta slide style, and arguably a more intense player than Arnold, but he never approached the frenzied speed that is still Arnold's most dazzling characteristic. There is an anarchic energy in Arnold's playing that makes it inimitable, and though "I Believe I'll Dust My Broom" and "Sweet Home Chicago" would come to be Johnson's most covered songs, neither has the wild excitement or instrumental virtuosity of the records on which they are based. Paradoxically, this probably had a lot to do with their enduring influence.

"**I Believe I'll Dust My Broom**" uses a melody that originated with Leroy Carr's "I Believe I'll Make a Change," but had already undergone some transformations in Arnold's hands. If Johnson learned it off records, he blended two Arnold pieces: Arnold had used the title verse in his "Sagefield Woman Blues," and two others in a novelty called "Sissy Man Blues." (Johnson leaves out the latter song's defining verse: "I woke up this morning with my pork-grinding business in my hand,/Lord, if you can't send me a woman, please send me a sissy man.") On the other hand, if he learned the song from Arnold directly, there is no reason to think that any merging was needed. Unlike Carr, Arnold was not a careful songwriter, and both songs were simply collections of more or less random, "floating" verses, which he undoubtedly assembled differently on different occasions, or strung together into one long song that we only hear slices of on his three-minute recordings. Johnson could easily have picked a handful of favorite

Arnold lines and strung them together to suit his own tastes, incidentally making a more cohesive lyric than either of the Arnold pieces— while not strictly linear, Johnson's song concentrates on the theme of traveling, and being away from the girl he loves. This is not to say that all of his changes were necessarily felicitous. Arnold had sung, "I'm gonna ring up China, see can I find my good gal over there/Since the good book tells me that I got a good gal in the world somewhere." Johnson, in the most geographically flamboyant verse of his career, changed the second line to "If I can't find her on Philippine's Island, she must be in Ethiopia somewhere." This had a topical touch, since Italy had recently invaded Ethiopia, but lacks the lonesome logic of Arnold's version. In another verse, where Arnold sang "I believe, I believe I'll go back home/I'll acknowledge to my good gal, mama, lord, I know I have done you wrong," Johnson changed the second line to "You can mistreat me here, babe, but you can't when I get home," which may be more interesting, but rhymes "home" with "home."

What made "I Believe I'll Dust My Broom" exciting for Johnson's fellow musicians was not the lyric but his stripped-down, driving guitar accompaniment. Though the revolutionary nature of what he played may be lost on modern listeners, it is still easy to be caught up in the way the fast high-note triplets alternate with a pulsing boogie beat. His choice to sometimes sing over the triplets, using the bass figure as an instrumental break, and sometimes to reverse this pattern increases the tension and energy of the performance—as does the fact that he expands and contracts the time, changing chords as inspiration hits, rather than keeping a regular count of twelve bars. In 1930s Mississippi, though, what was most significant about this record was its now rather prosaic-sounding boogie bass line. Lightnin' Hopkins, Jimmy Reed, and thousands of other guitarists have made this sort of solid guitar boogie their stock in trade, but it was brand-new when Johnson did it, and must have sounded astonishingly modern and exciting.

Other guitarists, including Lemon Jefferson and the Delta legend Hacksaw Harney, had recorded boogie-woogie bass figures before this, but their versions did not have the steadily propulsive one-two beat that Johnson used.[4] This sort of basic shuffle had appeared on only

one previous record, cut a year and a half earlier by a Mississippi guitarist named Johnnie Temple. Temple had made his start as a musician around Jackson and Vicksburg, then moved to Chicago, where he worked as second mandolinist in a string trio led by Charlie McCoy, playing Italian favorites in restaurants patronized by Chicago's Mafiosi. Along with the Italian gigs, Temple made a series of blues records, and the first of these was "Lead Pencil Blues," a double-entendre number about sexual impotence, which premiered the now-classic guitar shuffle pattern.

According to some blues scholars, Temple had actually learned this bass pattern from Johnson, whom he played with occasionally in Jackson and knew as "R.L.," though others report that Temple did not remember meeting Johnson and took pride in having pioneered the style.[5] If primacy is important, there is at least a bit of circumstantial evidence in Temple's favor: He had been employed for a while as chauffeur to Little Brother Montgomery, one of the greatest barrelhouse pianists working the lumber camps and river towns along the lower Mississippi, and since this guitar pattern is adapted from a basic piano left-hand figure, Temple was certainly in the right place to pick it up. On the other hand, so was every other guitarist who ever hung out in a barrelhouse, Johnson included. (And it is worth underlining the fact that pianists like Montgomery were, at least in some areas of Mississippi, so much more popular than guitarists like Temple and Johnson that they could hire the latter as chauffeurs.) If Temple and Johnson did meet, it appears that they traded tunes, as Temple was an associate of the extremely obscure Skip James and probably introduced Johnson to James's work.

Even if he was not its originator, Johnson was the first guitarist to make the boogie shuffle a standard accompaniment pattern and use it for multiple songs, and he inspired other players to pick up the style. This innovation was not particularly important at the time, but when electric amplification allowed guitars to supplant pianos as the rhythmic timekeepers of blues combos, it became a basic part of the musical language and one of the building blocks of rock 'n' roll. Meanwhile, it gave Johnson's song a propulsive dance beat, and he comes off sounding considerably more relaxed than on "Kind Hearted Woman."

The straight-ahead rhythm was in stark contrast to the idiosyncratic complexities of Arnold and the older Mississippians, and "I Believe I'll Dust My Broom" would bubble in the memories of Johnson's young peers for the next dozen years, before resurfacing on a 1949 record by Big Boy Crudup and two years later in the spectacular Elmore James version, which turned it into a blues standard.

To the early white blues fans, who valued Johnson as an idiosyncratic folk artist, the straight-ahead, modern quality of this piece was not so appealing. They preferred to think of him as a mysterious Delta roots musician, and wanted to hear him moaning deep laments and playing old-fashioned slide numbers, not kicking off boogie shuffles that sounded only one step removed from the R&B hits of Jimmy Reed and Junior Parker. Thus the irony that his two most influential records in the black blues world, "Dust My Broom" and "Sweet Home Chicago," were both left off the 1961 album that made him a posthumous legend.

This was not just scholarly or folkie obtuseness. If one considers Johnson's records as works of art rather than historical markers, he certainly gave more interesting performances than these. "**Sweet Home Chicago**," in particular, is about as musically ordinary as his work gets. This is not to deny its strong points: There is the relaxed way Johnson breaks off the guitar boogie for a sweet melodic turnaround at the end of each verse, laying back and giving us a chance to breathe before pumping up the energy again. More important, he is finally sounding completely at home and comfortable, and there is something infectious in the way he balances the whining moan that starts the song with the humorous, conversational tone in which he throws off lines like "I'm heavy-loaded baby, I'm booked, I gotta go!"

Still, even at the time, this song was held until Johnson's sixth release, and anyone who wonders why need only refer back to Arnold's "Old Original Kokomo Blues." As the flip side of "Milk Cow Blues," this record would have been familiar to many blues buyers at the time, and Arnold's frenetically inventive performance has an energy and excitement that Johnson does not even approach. Its unpredictable slide work slices and stabs around the comic arithmetic of the lyric, and Johnson's version sounds stolid and flat by comparison. However,

Johnson made one essential change that would prove decisive, transforming an entertaining, upbeat song into an anthem: Kokomo may have been a logical destination for the Indianapolis-based Scrapper Blackwell, who originated the number, but Chicago was the promised land, and would become the world famous "Home of the Blues." Arnold's "Old Original Kokomo Blues" sold a lot more copies than Johnson's "Sweet Home Chicago," but in the eyes of history he bet the wrong pony. Later singers would often ignore everything else about the Johnson record—even dropping the whole concept of math-oriented stanzas—but the association with Chicago would make this Johnson's most-covered song. Tommy McClennan weighed in first in 1939, followed by Walter Davis in 1941, and so on up through the chart-making 1959 hit by Junior Parker and beyond.[6]

Johnson continued the traveling theme on his next number, "**Rambling on My Mind**," but this song would be remembered less for its lyric than for the slide triplets that Elmore James adopted for his hit version of "Dust My Broom." "Rambling on My Mind" was the first slide piece Johnson recorded, and there is clearly something about the technique that inspired him not only as a player but as a vocalist. For the first time in this session, he gets a touch of the Delta tear, the Son House rawness into his voice, sounding more passionate than on the three previous songs.

In terms of structure, "Rambling" provides some interesting insight into how Johnson thought about his compositions, because its two takes are so different. He seems to have defined this song by its first verse, "I got ramblin', I got ramblin' on my mind/Hate to leave my baby but you treats me so unkind," and its central bridge verse. As with "Kind Hearted Woman," this bridge is carefully worked out, framing a programmatic train imitation played on the bass strings, which Johnson introduces by saying, "I hear her coming now. . . ." This sort of announced musical mimicry was common on the nineteenth-century stage, in both classical and minstrel performance, and continued to be featured by medicine-show players and vaudeville entertainers, but it was rare in blues.[7] It is a self-conscious display of instrumental technique, the sort of thing that intellectual purists—whether in classical, blues, or jazz—tend to dismiss as cheap theatrics rather than serious

music, though for blues fans of the period a greater drawback would have been that such interludes break up the dance rhythms. In Johnson's work, these programmatic breaks show the extent to which he saw his records as arranged performances, rather than simply assemblages of blues verses. Clearly, he was already thinking of himself as a featured entertainer, able to hold an attentive audience, and not just as a juke-joint dance musician.

Surprisingly, considering the care that went into the bridge verse, Johnson seems to have considered the rest of "Rambling on My Mind" to be little more than filler. Though from the record company's point of view his two takes of the song were essentially identical—they turn up interchangeably on the released 78s—Johnson's lyric changes completely from one to the next. The first take is lyrically repetitive, with three verses that are differentiated by only a couple of words, and a fourth that continues to use the same tag line. By contrast, take two has no repeated verses, and its lyrical variety is reinforced by a more upbeat tempo. This should make it by far the more interesting performance, but that is not quite how things turn out. There is a seductive nastiness in the way Johnson stresses the phrase "mean things all on my mind" on take one that makes it stick in my mind in a way that nothing from the second take quite matches, and the slower tempo also allows him to get more out of the programmatic train imitation. Altogether, if one ignores the lyrics, this take is more musically varied, while the second feels less thought-through and more passionate.

Johnson had tuned his guitar into an "open E" tuning for "Rambling on My Mind," but this seems to have been a relatively rare key for him, so he immediately tuned back to standard for the next song.[8] As a result, he starts "**When You Got a Good Friend**" with the same riff he had already used to open "Kind Hearted Woman," "I Believe I'll Dust My Broom," and "Sweet Home Chicago," and which he would go on using on other tunes, moving his hand position up and down the guitar neck to fit whatever key he happened to be in. When one hears several of these songs in a row, this can seem repetitive, but it may have been a quite intentional professional choice. I am aware of no other guitarist who did anything like this, but Peetie Wheatstraw had a similar mannerism, beginning song after song with the same brief pi-

ano riff. As a result, fans could instantly recognize his records, and this would have had obvious advantages when it came to selling new material.

"When You Got a Good Friend" was Johnson's most personal and distinctive lyric so far, but if he took pride in this fact it can only have led to disappointment, since it was also one of the three songs from this session that the record company chose not to release. This may have been due to the very things that attract many present-day listeners: The understated sensitivity of the song, while appealing to those who consider Johnson a blues poet, was not likely to produce any quick sales on the 1930s commercial market.

It is equally possible that the record was held back because of Johnson's performance, which is relatively lackluster and marked by the same conservatism that affected "Kind Hearted Woman." On this sort of song, Johnson was one of the most carefully calculated singers in blues, and the two takes show him singing the first three verses virtually identically, complete with the same "mmmm" replacing the lyric in the same spot. Then he seems to have become distracted, forgot the fourth verse, covered his confusion with an impromptu "mmmm," and picked up with verse five, but having lost the impact of its striking opening line: "It's your opinion, friend-girl, I may be right or wrong." On the second take, he partially cleared this up, but still failed to remember the fourth verse properly, and ended up repeating three variations on the same line—something he never did anywhere else, and which it seems fair to assume was a mistake.

These errors may have doomed the song, and it cannot have been helped by its relatively pedestrian musical arrangement: The guitar part is just "Sweet Home Chicago" over again, and the lyric lacks that song's verse-chorus pattern and the catchy geographical hook. It is a pity that Johnson did not work it up more thoroughly, because the lyric is beautiful. It is also one of the rare blues lyrics that follows the African tradition of expressing social admonishments rather than romance, something that still surprises Europeans and Americans when they see translations of African pop hits. There is a flavor of secular preaching, of the singer providing social guidance, which this song captures perfectly both in its title verse—"When you got a good friend

that will stay right by your side/Give her all of your spare time, try to love and treat her right"—and in the churchy maxim, "Watch your close friend, then your enemies can't do you no harm."[9] There is also an unusual care and delicacy in the choice, for example, to sing "spare time" rather than just "time" in that first verse, or "girlfriend" rather than just "girl" in "She's a brownskin woman, just as sweet as a girlfriend can be."

The failure to release "When You Got a Good Friend" may have been disappointing, but it is nothing compared to the choice the record producers made on Johnson's next selection. From the point of view of modern-day fans, the original take of "**Come On in My Kitchen**" is his first unquestionable masterpiece, a hypnotic lament that makes it easy to believe Johnny Shines's recollection that this song reduced an audience to tears. The beginning is unique: three voice-like notes of high, vibrating slide guitar that resolve into a bell-like chord; the same passage played in descending notes; a momentary pause for a bass figure; then the same line repeated, this time with Johnson moaning in unison; then another line of this lonesome, word-less duet; and finally the invitation, sounding like a plea: "You better come on in my kitchen, babe, it's going to be raining outdoors." Then—as if more were needed—a tumbling bass progression that, just when it seems finished, resolves in a startling, shimmering high note.

There is only one other player in early blues who recorded anything this moodily soulful, the sort of music that sounds as if the singer is somewhere off alone, absorbing all the world's sorrows and transforming them into a perfectly formed, deeply personal gem of poetic wisdom. That was Skip James, and it is no surprise that the first full verse Johnson sings is taken from James's masterpiece, "Devil Got My Woman": "The woman I love, stole her from my best friend/But he got lucky, stole her back again." The two songs have nothing else in common, as far as words and melody go, but that one couplet alerts us to a kinship that gave Johnson the most moving, spiritual—I want to say unearthly, except that it is also desperately human—strain in his music.

This is the sort of performance that makes me want to drop all of my normal views about blues as essentially popular music, intended

primarily as entertainment, and rave along with the most extreme fa-
natics. Except that it is in no way typical of blues. James was a unique
and unappreciated though transcendent artist, and Johnson's choice to
emulate him is a rare departure from his general trajectory toward the
hit sounds of Carr and Arnold. For a moment he defies genre and fash-
ion, and the result is timeless, universal music that can stand along-
side Miles Davis's *Kind of Blue* or Pablo Casals's 1930s recording of
the Bach cello suites.

Oddly, the lyric Johnson sings is not particularly distinctive. It is a
collection of unrelated stanzas of varying quality, though all share a
sense of loss. What makes them great is what he achieves with them.
On the first two verses, his voice is rather heavy and consistent, but
it is shadowed by feathery slide notes that give the performance a
ghostly quality. On the third verse, this quality comes to the fore as he
stops singing entirely, and instead whispers, so quietly that you would
have to be right next to him to catch the words: "Oh, can't you hear
that wind howl?" The guitar whines like a mournful wind, not so much
howling as moaning.

There is nothing else quite like this in recorded blues, nor in most
cases could there have been. Johnson had the good luck to have ended
up with one of the few record companies that bothered to record blues
artists with high enough fidelity to capture anything this subtle. If
Charley Patton or Lemon Jefferson had tried it while recording for
Paramount, it would have just sounded like an indistinct rumble. Like-
wise, it is not something Johnson could have done in live performance,
except when playing in a very quiet room for a small, completely at-
tentive audience—by no means a normal situation for a blues musi-
cian, or indeed for anyone outside the classical field.

This whispery, programmatic interlude seems to suggest to him
that he has been singing too loudly, and his next verse has a new inti-
macy, phrasing with more attention to the words. In the last line,
"Looking for her good friend . . . ," his voice drops to a murmur for the
ending, ". . . none can be found." There is one more verse, and then a
carefully played coda brings the song to a close.

It is an amazing achievement, and there are reasons why Johnson
would have believed it fit the tastes of the current blues world. James's

"Devil Got My Woman" had a structure all its own, abandoning any semblance of a standard progression for a loose, hypnotically repetitive form that puts the full burden of its magic and power on James's unique abilities as a singer. Listening to the two records back-to-back, it is clear that Johnson did not yet have anything like the kind of vocal control he would have needed to cover James's work. Instead of trying, and producing a poor substitute—as Johnnie Temple had done the previous year with "The Evil Devil Blues"—he found a brilliant solution, and one that could theoretically have produced a substantial hit.

Tampa Red was the most influential and celebrated slide player in the Race market and, along with his rollicking hokum numbers, he also recorded beautiful, slow blues that showed off his impeccable tone and voicelike phrasing. The first of these to make a major impression seems to have been "Things 'Bout Coming My Way," a song that was probably inspired by the success of the Mississippi Sheiks' "Sitting On Top of the World."[10] Red's song was covered by several other artists, and he went on to cut a "Things 'Bout Coming My Way No. 2," as well as a haunting instrumental version of the tune. The melody of "Come On in My Kitchen" was based on this song, and Johnson's playing suggests a clear debt to Red's work.

This was the antithesis of the Delta slide style, which depended on a hard, slashing attack that could cut through crowd noise. Red's approach was a slide equivalent to Leroy Carr's crooning, a modernism dependent on the intimacy of the recording process and the different performance demands of urban venues. To bridge the gap between this popular style and James's obscure masterpiece was a stretch that required someone with Johnson's genius as an adapter and synthesizer.[11] Since Tampa Red was a major star, and his theme had been covered just the previous year by Kokomo Arnold, Johnson could well have felt this was potential hit material—an already successful tune, augmented by an injection of eerie Jamesian soul and that theatrical touch of the howling wind.

If so, the producers did not share his view. Apparently, they could not imagine the blues audience accepting such a quiet, delicate performance, so they rejected the take and instead had Johnson do a hot, upbeat version of the song. He did his best to comply, picking up the

tempo and using some riffs he had prepared for his next number, but clearly his heart was not in it. This second "Come On in My Kitchen" is not a complete failure on its own terms, but it is relatively disorganized and has none of the magic of take one. And I do not think I am simply displaying my own prejudices when I assume the producers pushed Johnson into changing his approach. He had obviously put so much care into the original arrangement, and so much of it was lost in the retake, that he must have been under orders rather than following his own commercial instincts. Indeed, it is quite possible that the passionate energy of his delivery on take two—its main saving grace—comes from irritation at having his masterpiece dismissed so cavalierly.

Whatever the interaction in the studio, the end result was that take two was chosen for release, and take one surfaced only in 1961. Since then, it has been so generally accepted as the canonical version that when I read the discographical entry saying that it was left unissued, I at first assumed that this was a typographical error. There could be no better example of the differing aesthetics of 1930s blues producers and modern-day fans—or of the way Johnson's work highlights these differences.

There are also points of agreement, though, and Johnson's next selection would please everybody. "**Terraplane Blues**" was his one hit, albeit a modest one by the standards of 1937's busy blues market. It would be chosen as his first release, and considerably increased his prestige with Mississippi music fans.

Once again, the song is an adept combination of Delta styles and hot contemporary trends. The Delta can be heard in Johnson's intricate rhythmic juxtapositions, while the basic structure is taken from "Milk Cow Blues," and the lyric is a typical example of the sort of songs being churned out by the Chicago hit factories. Big Bill Broonzy famously explained the formula for writing such lyrics:

> You can take a chair, a box, an ax, anything, a knife . . . and start writing a blues from it. Because you can think of the different things you would do with a knife. Take a knife and you could maybe skin a fish, or cut a chicken's throat, trim your toenails or your fingernails. Then you

could kill somebody with it too. By the time you think of all the things
you could do with a knife, then you got the blues. It don't take but five
verses to make a blues. Think of five things you can do with something
and that's it.[12]

What Broonzy did not mention is that, at least in the 1930s, it was
extremely helpful if all the things you did with the chosen object could
be understood as double-entendre descriptions of sexual acts. Such
"party blues" were ubiquitous, sung by almost everyone in the field,
but the most prolific master of the form was Bo Carter. Along with be-
ing a sometime member of the Mississippi Sheiks, Carter was proba-
bly the most popular Mississippian recording on his own in this
decade, and his song titles are a comic catalog of phallic objects—
"Banana in your Fruit Basket," "Pin in Your Cushion," "Ram Rod
Daddy," "Cigarette Blues," "Please Warm My Wiener"—and other
imaginative metaphors: "She's Your Cook, but She Burns My Bread
Sometimes," "Squeeze Your Orange," and "Pussy Cat Blues."

Johnson seems to have had relatively little interest in this sort of
"naughty" comedy, but his next two songs show that he could handle
the style if necessary, and the success of "Terraplane"—in which the
mechanical components of an automobile substitute for various body
parts—showed the wisdom of making the attempt. That said, the lyri-
cal games can only get partial credit for the song's popularity, since
they are so utterly subsumed in Johnson's performance. His singing
draws on two of his favorite models, Kokomo Arnold and Peetie
Wheatstraw: Arnold's falsetto "plee-ease" shows up in a couple of
verses, while Wheatstraw's "ooo-well" yodel is quoted in verse two.
These were famous mannerisms, and Johnson must have been aware
that he was paying homage, but another borrowing may have been un-
concious, and shows how deeply he had assimilated the styles of his
heroes: In two verses, he sings the phrase "oo-ooh, since I've been
gone" with exactly the same inflections that Wheatstraw had used to
sing the same phrase in his "Police Station Blues."

Johnson carefully varies his approach from verse to verse, adding a
new phrasing pattern here, a neatly placed rhythmic break there, and
using an Arnold-style bridge verse in the middle. Since there is only

one take it is impossible to say how fixed this pattern was, but all the verses fit the car theme, and the interplay between voice and guitar is so tight that he must have worked much of it out in advance. The most distinctive touch is the way he keeps his slide in reserve, employing it only for emphasis at key moments. Any other player would have played slide riffs to punctuate the verses, but instead he plays fast, high figures with his bare fingers, and it is easy to forget he even has a slide until he breaks off the rhythm and hits one vibrating, heart-stopping note—on a bass string, at that—before singing the final phrase. When he plays a quick set of slide triplets—the same passage he used throughout "Ramblin' on My Mind"—near the end of the bridge verse, it comes as a startling surprise rather than an expected affectation.

All in all, "Terraplane" was the obvious choice for a single out of that first day's recording, and it would have been a fine dramatic finish if Johnson had stopped there. Instead, he finished the session with "**Phonograph Blues**," another double-entendre composition with lines like "We played it on the sofa, we played it 'side the wall / My needles have got rusty and it will not play at all," balanced by a few romantically lonely phrases that would have been better suited to something like "Kind Hearted Woman." It was well played and sung, but had nothing to set it apart from other Johnson efforts, and ARC did not bother to issue it.

Once again, though, the song is interesting for what it reveals about Johnson's compositional style. Melodically, "Phonograph" is very similar to "Terraplane," including the central bridge verse, and he could easily have sung it over the same guitar part. Instead, he sang the first take over the accompaniment he had used for "Kind Hearted Woman," and the second take over the accompaniment he had used for "I Believe I'll Dust My Broom." The reason for switching arrangements in midstream seems to have been that, as with "Kind Hearted Woman," his original take threatened to run over the three-minute limit. His solution was to recut the song with a faster arrangement that would let him get all the verses in, even though this meant sacrificing the varied melody of the bridge verse and just singing it like all the others— apparently he had not worked out an appropriate variation to fit the "Dust My Broom" arrangement.

The ease with which Johnson made this transition suggests that his accompaniments on some of the other songs may well have been less fixed than we imagine. We have only the records, and since each song was recorded with a particular arrangement it is natural for us to think of them as a unit, but Johnson obviously had some stock arrangements that he used over and over. In a similar way, Josh White had novel and interesting arrangements for most of his own songs, but when the ARC producers handed him a recent hit to cover he would just sing it over a stock twelve-bar pattern. Johnson had several of these stock patterns, and it is probable that while we think of "Rambling on My Mind" as having one accompaniment and "When You Got a Good Friend" another—to choose two songs with virtually identical vocal melodies—Johnson would have used either song's accompaniment interchangeably for the other. Or, to consider a more interesting example: When Elmore James played the "Ramblin' on My Mind" arrangement to accompany the "Dust My Broom" lyric, he may just have been imitating what he had heard Johnson do on a different day.

The one other thing worth noting about "Phonograph Blues" is that, on both takes, Johnson's vocals and guitar work sound surer than they had on "Kind Hearted Woman" or "Dust My Broom." Finishing his first session, he had relaxed into the process. Any microphone fright was gone, and by now he could be confident that the producers were happy and that he really was going to see his name on a record label and hear his voice wailing from the jukeboxes back home.

9

FIRST SESSIONS, PART TWO: REACHING BACK

AFTER TWO DAYS OFF, JOHNSON RETURNED TO THE HOTEL ROOM studio on Thursday, November 26, but recorded only one song. Perhaps this is because the group before him, the Chuck Wagon Gang, took up more time than expected, or because the Mexican duo that recorded right after him needed to get in and finish their recordings.[1] In any case, he made up for it by cutting another seven songs on Friday, and these two sessions would be quite different from Monday's, or from the further recordings he made seven months later. Apparently, Monday's session had used up most of the material he had prepared for his recording debut, and he was now cast back on his more general repertoire. Thus, while on Monday he had stuck to the current commercial trends, Thursday and Friday found him playing a more varied range of material, and reaching back to the countrified styles he had heard growing up in Memphis and the Delta.

The song he recorded on Thursday, "**32-20 Blues**," was the closest thing he had yet done to a straight cover of a previous record. While one can trace the roots of the songs he had played on Monday, he had made significant changes to all of them and they can rightly be considered original compositions. "32-20," though, is simply a guitar version of Skip James's piano-accompanied "22-20 Blues," and even the difference in caliber does not count as an alteration, since James actually sang "32-20" in his early verses. Just as James had revealed his debt to Roosevelt Sykes's "44 Blues" by slipping back to the .44 caliber

in his last verse, Johnson makes a similar slipup: James sang that, if his baby did not come when he sent for her, "all the doctors in Wisconsin" would not be able to help her, and though Johnson changes the doctors' location to Hot Springs, he messes up in the eighth verse and sings "Wisconsin."[2] Obviously, he was still hearing the James version in his head and had not completely assimilated his changes to it.

Johnson's appreciation for James's work was unusual, to say the least. James was the ultimate prophet without honor in his country, a unique genius whose work bore little resemblance to that of the players around him, and whose records made few concessions to any taste but his own. His singing was the eeriest, most haunting sound in early blues, his guitar accompaniments used a rare minor-key tuning and followed few standard blues patterns, and his piano playing verged on anarchy, while brilliantly fitting whatever he chose to sing. He seems to have confined his public performances almost entirely to local joints around Bentonia, a small town just south of the Delta, and his records hardly sold at all. They are among the rarest prewar 78s, and Gayle Dean Wardlow, a Mississippian who spent years going door to door in search of such records, writes that of six he finally managed to dig up, none were found in Mississippi.[3]

While Johnson played a few other pieces adapted from Mississippi artists who had made recordings, most notably Son House, in general these seem to have been songs he learned in his youth and picked up at live performances. Aside from James's work, almost all the records he emulated were by top hit makers. Because of this, I would read a good deal into his attraction to James. There are two ways to interpret this attraction, and they are by no means mutually exclusive. One is that Johnson heard a unique soulfulness, and a self-conscious artistry on James's records, and was attempting to emulate these characteristics. The other is that he heard something in them that he was already feeling and trying to attain in his own work, and gravitated to James as a soul mate. Either way, his connection to James is basic to any understanding of Johnson's deeper material, and to the way his songs still capture the imagination of later generations of listeners.

Most present-day critics, asked to name Johnson's greatest works, would put James-derived songs, "Hell Hound on My Trail" and "Come

On in My Kitchen," near the very top of the list, in both cases because of the haunting, hypnotic character of the performances and the completeness with which Johnson has conceived them as works of art, designed to reach deep inside the listener. Though it is a stereotype of blues fandom to say that such profound artistry is typical of the genre, the number of recordings that succeed in having anything like this strong an effect is vanishingly small. Most of even the most despairing blues recordings are soulful in the way that country music is soulful—they speak to people in their own language and accent, reminding them of their troubles and assuring them that others are going through the same things. Very few have a musical depth and complexity that transcend the norms of the style, standing alone as finished artworks, the blues equivalent of Ornette Coleman's "Peace" or Picasso's *Guernica*. Frankly, as we saw with "Come On in My Kitchen," such works were unlikely to get onto records even if the musicians took the time and effort to create them, and still less likely to sell on the commercial blues market.

"32-20 Blues" was not one of James's deepest efforts, and the original recording is most notable for its spiky, staccato piano lines, which Johnson was in no position to duplicate. He did, however, try to capture the flavor of the barrelhouse piano style, using the surprisingly effective trick of simply drumming a steady rhythm on the damped bass strings of his guitar. James got the same effect on some verses, apparently by beating his feet on the floor, but generally avoided playing an even rhythm. This shifting, jagged approach worked on piano but would have been chancy on the quieter guitar, and Johnson's solution is brilliant, allowing him the freedom to capture some of James's spare phrasing, since he is only picking on the treble strings while at the same time keeping the tempo chugging along at a brisk pace.[4]

It is Johnson's singing, though, that makes the record. He has taken little from James here, aside from the yowled "aww" that begins his sixth verse, and which he uses for quite different effect. Instead, he produces his most imaginative vocal so far, coming up with a different way to present each verse: He sings one low, one high, and in another simply talks the words. The combination of the regular, propulsive rhythm and the conversational, humorous inflections of his delivery

have a clarity and excitement that would have been instantly appealing coming off a jukebox, and it is no surprise that the record company chose this song as his second single.

Back in the studio on Friday, Johnson started off with a performance so unlike his earlier recordings that it might almost be by a different person. Here, for once, we get a taste of his gift for picking up non-blues styles. "**They're Red Hot**" is an odd fusion: On the one hand, the song itself is the sort of upbeat, comic hokum that was about to be repopularized by the Carolina ragtime-blues guitarist Blind Boy Fuller. On the other, the first measure of Johnson's guitar introduction signals a hipper influence, the swing jive sound pioneered by the Mills Brothers and Spirits of Rhythm, which by the mid-1930s was being imitated by hundreds of groups throughout the country.

Most of these groups were never recorded, and certainly no record company was heading to Mississippi in search of a down-home Ink Spots, so it is hard to say just how much of this kind of stuff was being played on Johnson's home turf. However, the same kind of fusion suggested by "They're Red Hot" had been made in a more complete—and far more commercially successful—way just a few months before Johnson's session, by the Harlem Hamfats, the Chicago band fronted by Joe and Charlie McCoy. (This is the same Charlie McCoy who played Italian music with Johnnie Temple. The Chicago-Mississippi connection was always strong, with plenty of visiting in both directions.) The McCoys had been hotshots on the Jackson scene for years before moving north, and it is probably an accident of the recording market that Joe McCoy is the only guitarist from the area who has left evidence that he played in the style Johnson uses on this piece.

The Hamfats mixed Mississippi strings with New Orleans–style horns, and their debut recording, "Oh! Red," was a major, widely covered hit. How much influence they had on players back in Mississippi, or what black clubgoers in Jackson were listening to in the mid-1930s, cannot be known with any certainty. Still, it seems fair to assume that local musicians were aware of radio stars like the Mills Brothers, that "Oh! Red" made a splash in the area, and that a lot of people who ten years earlier would have been playing like the Mississippi Sheiks were

now adopting jazzier rhythms. Naturally, these changes did not happen overnight—street and barroom players like Johnson were fielding requests for everything from country dance tunes to early blues favorites and pop ballads, depending on the tastes of the customers—but for some young hipsters, the intro to "They're Red Hot" would have been more exciting than any of Johnson's other guitar riffs.

The song itself is a bit more open to question. As far as I know, no jive vocal group had recorded a piece with the ragtime progression Johnson used for "They're Red Hot," though it is a natural mix and could easily have been covered by a Hamfats-style outfit. Instead, the vast majority of songs in this pattern were recorded by eastern guitarists like Fuller, who played in an intricate fingerpicking style adapted from ragtime piano. That particular brand of virtuoso guitar work had never hit Mississippi, and the one great recording of this chord progression to come out of Johnson's area was the Mississippi Jook Band's "Hittin' the Bottle Stomp," a romping band number played on piano, guitar, and tambourine. The Jook Band's members were based in Jackson and Hattiesburg, and they made their recording four months before Johnson's, so it is no stretch to imagine that he knew them or groups like them, and at least occasionally worked with similar instrumentation. The sort of rhythmic strumming he does here would make more sense in a band context than it does as a solo style, though for one tune it is effective enough.

Johnson sounds thoroughly comfortable with this uptown approach. His vocal demonstrates a gift for jive comedy that is hardly suggested in his other material, and the guitar intro shows that he had a good handle on the new swing style (though he adds an extra beat that would have tripped up any bandmates). Since no record company was bothering to cut this sort of music in Mississippi, it is hard to say how original his approach was, but the verses he sang are an entertaining grab bag. They mix old-time country lines, like one about a girl so tall she sleeps in the kitchen with her feet in the hall, with trendy hokum: "The monkey and the baboon playing in the grass / The monkey stuck his finger in that old—good Gulf gas!" There is also violent braggadocio—"I'm gonna upset your backbone, put your kidneys to

sleep/I'll do the breakaway on your liver and dare your heart to beat"—
in the Southern tradition that runs from Mark Twain to Muddy Wa-
ters to rap.

The energy and humor of Johnson's performance, and the ease with
which he twists his tongue around the quick stop-time sections, indi-
cates that this was a regular part of his performing repertoire, and he
could undoubtedly have come up with a lot more songs in this style if
the producers had wanted them. While Johnny Shines has said that
Johnson rarely worked with other musicians, the guitar work here is
that of a band rhythm man, not a blues picker, and implies that he was
somewhat rethinking his approach. Much as this may horrify the hard-
core blues crowd, it is possible that if Johnson had lived long enough,
he would have put together a commercial radio quartet, found a tenor
guitarist to play lead, and devoted the 1940s to playing rhythm chords
and singing swing jive.

Such speculations are amusing—and make as much sense as the
common notion that he would have ended up an electrified Delta
roots musician à la early Muddy Waters or Elmore James—but admit-
tedly it is a bit extreme to base them on a single number, and with his
next selection Johnson returned to familiar territory. All too familiar, in
fact, since "**Dead Shrimp Blues**" simply recycled the guitar chart he
had already used for "Kind Hearted Woman" and "Phonograph Blues."

The most interesting thing about "Dead Shrimp" is the obscurity of
its lyric. Once again, Johnson was taking a common item and weaving
it into an erotic image, but it is hard to see how exactly the dead
shrimps he invokes relate to the woman who has left him for another
man. The one line that makes thorough Freudian sense is, "Hole
where I used to fish, you got me posted out," and that does not solve
the larger problem at all. The usual blues scholar gloss is to explain
that "shrimp" was slang for prostitute, but this does not in any way fit
the way the word appears in Johnson's lyric. (If shrimp are prostitutes,
what does he mean by telling his lost girlfriend, "You take my shrimp,
baby, you know you turned me down"?) My own interpretation is that
shrimp were used as bait, and symbolize what he had that his girl-
friend wanted, but now she has had her fill and gone her way, so his

bait is dead. Whatever the meaning, it is not one of his greatest pieces, and the fact that it was released while several better songs remained on the shelf is pretty baffling. My best guess is that, since it was the flip side of "I Believe I'll Dust My Broom," no one expected it to be played much anyway, but the producers hoped that its odd title might attract a few curious buyers.

Any suggestion that "Dead Shrimp" was weakened by Johnson's use of a stock arrangement is neatly countered on his next selection. The first take of "**Cross Road Blues**" also recalled a previous chart—in this case the one from "Terraplane Blues"—but the result was anything but boring. First of all, on "Cross Road" Johnson makes much greater use of the slide, and while this means that the arrangement lacks some of the tension of "Terraplane," it is also a good deal more flashy, as well as being the first piece to showcase his command of the rootsy, Son House–derived Delta style. Secondly, the song's lyrics are of an entirely different order, subtly evocative rather than straining for cleverness. Finally, though the first take is strong, by the second he has slowed the piece down, losing most of the resemblance to "Terraplane," and achieves something of a masterpiece—though, once again, it was the fast take that was chosen for release on 78.

Johnny Shines once said that he was surprised by how powerful Johnson sounded on record, because he had never thought of him as having such a full, strong voice.[5] Shines, like Charley Patton, Son House, or Howlin' Wolf, had a huge voice, and he took pride in the fact that he could be heard over all the crowd noise in the joints, just as the Kansas City "blues shouters" would take pride in their ability to sing over a full band of horn players. Johnson sounded strained and a bit thin when he tried for that kind of volume, but the demands of recording were utterly different. Here, there was no need for a voice that was louder than a guitar—in fact, that would only create problems in the balance. What was needed was a voice that matched the instrument, and on "Cross Road" the match is just about perfect.

Johnson was singing hard, and one can hear him pushing, but that just makes him sound more impassioned. Meanwhile, the slide acts as an equal partner rather than an accompaniment, answering back with

the same sort of strained intensity. Both reinforce the gritty imagery of the song lyric, conveying the desperate loneliness that is the flip side of a traveler's freedom: It is nightfall, and Johnson is stuck out at a crossroads in the middle of nowhere, with no one to help him, and nowhere to go in any case—the cars are passing him by, and he has no sweet woman waiting "to love and feel [his] care." He falls on his knees and prays to the Lord above, but there is no reason to hope that his prayers will be answered, and he ends the song as lost as he began it: "I'm standing at the crossroad, babe, and I believe I'm sinking down."

This is both a deeply personal testament and theater of the highest order, and it is odd to note that the perfect ending was accidental. Johnson had planned to sing at least one more verse, presumably the same one with which he finished take one, and he can be heard preparing to go into it before the engineer must have signaled that he was out of time. Poetically, it was a fortunate accident.

"Cross Road Blues" was an ideal choice to take the mood back to the Delta, and that is where Johnson remained for the four songs that would complete his first recording trip. The fact that these songs were tacked on at the end shows that they were not the ones on which he had pinned his hopes for commercial success. Their style was already considered old-fashioned, and no one could have imagined how fresh and exciting this approach would sound to urban audiences when Muddy Waters revived it a dozen years later, souped up with a blast of electric power.

In large part due to the influence of Waters and his generation of Chicago-based Mississippi expatriates, this is the sound most people mean today when they say "Delta blues," but there is nothing to suggest that more than a good-sized handful of the region's musicians ever played it. Indeed, many writers have traced the whole style back to one large farm, Dockery's, and to one man, Charley Patton. Of course, the story is more complex than that. Patton's influence was important, but to treat him as the sole root of the hard Delta sound ignores the contributions of other musicians, and especially of Son House, who was mentor to both Waters and Johnson.

Trying to pinpoint the source of the Delta sound is a supremely iffy

business, but a few generalizations seem safe. The earlier black rural guitarists, whose work would be reshaped by the first blues players, appear to have played in more or less the same style throughout the South, and regional differences actually became more rather than less marked in the early decades of the twentieth century. The older style, which is echoed in the work of Mississippi John Hurt, Furry Lewis, Elizabeth Cotten, and white players like Sam McGee, was based in part on banjo styles, blended with the basic guitar techniques taught in early instruction manuals. Such manuals usually started the beginner off with a simple "open tuning" piece, "Spanish Fandango," then went on to show how one could pick the melody of a popular song—"The Blue Bells of Scotland" was typical—on the treble strings, while keeping a simple one-two accompaniment pattern in the bass. In the eastern states, this evolved into the complex ragtime styles of Blind Blake, Blind Willie McTell, and the Reverend Gary Davis. In other areas, it never reached those heights, but still remained a basic underpinning of rural playing techniques.

Sometime in the early twentieth century, a group of Delta guitarists took a dramatic turn toward a tougher-sounding, more rhythm-oriented approach. I do not want to join the legions of writers who have gone out on shaky limbs in search of the roots of the Delta style (the metaphor is consciously tortured), but by the early days of recording there were players in the region whose command of complex polyrhythms was unique for rural musicians—or indeed for any American musicians outside New Orleans. The proximity to New Orleans, and hence to the Caribbean, was likely a contributing factor. The fact that the area had a substantial black majority was certainly another. The fact that the Delta was largely settled only around the turn of the twentieth century, and was thus full of energetic young "pioneers," made it fertile soil for music that might have been considered barbaric in older, more established communities. There is also the "fife and drum" music of the east Mississippi hill country, which takes its name and basic instruments from military bands, but sounds as purely African as anything in the United States. While this music is quite different from anything we call Delta blues, a lot of the Delta pioneers came out of these hills, so it is certainly relevant.

One way or another, the Delta produced the most rhythmically expert musicians in the blues genre, and Charley Patton was the defining master of this strain. Unfortunately, the brilliance and variety of his recordings has led some historians to list artists like Tommy Johnson and Son House as pure Patton disciples, as if that explained all that was great in their music. In House's case, this is demonstrably ridiculous. He certainly admired Patton, and played some Patton pieces, but the slide style for which he is most famous, and which was what both Robert Johnson and Muddy Waters were most struck by in his playing, bears virtually no stamp of Patton's influence. When this slide work was combined with Patton's rhythmic innovations, then matched with the amazing depth and power of House's voice, the result was awe-inspiring. And that is just to judge from a handful of miserably worn 78s, a rather low-key recording for the Library of Congress, and some records and films made after House's "rediscovery" in the 1960s. Muddy Waters would call him "the best we had," and testified that "to my ideas he never did sound so good on record as he did when you heard him."[6]

Johnson had idolized House in his youth, and House's bottleneck technique was almost certainly the first virtuoso guitar style he mastered. He had this sound in his bones, and played it with the ease and assurance of many years' practice—and yet, he must have been conscious that it had brought House no fortune or fame outside the small area around Robinsonville. House had recorded only once, and though four records were released, they had no success whatsoever. (Today, they are so rare that only one copy of "Preachin' the Blues" is known to exist, and one of the other records has never been found.) In the commercial music market of 1936, this was archaic, countrified material, and from a professional point of view, it is a bit surprising that Johnson recorded any of it. This was the end of the session, though, and since he clearly enjoyed this sort of music, the producers may have figured that such songs were good enough for B-sides, and that they might even sell a few extra records to some old folks.

Johnson had proved his debt to House in the slide work of "Cross Road Blues," and for his next selection he chose a song he had learned directly from his mentor, "**Walkin' Blues**." House had recorded a

song with this title six years earlier—though it was not released until the 1980s—and another of his records, "My Black Mama," featured the guitar arrangement and one of the verses Johnson used. While it is commonly said that Johnson's record combines these two earlier songs, there is no reason to think that he had heard House's records, and House sang these lyrics over different arrangements on different days, mixing and matching according to his mood and memory.[7] At juke-joint gigs, a song might last for fifteen or twenty minutes, and which of House's grab bag of verses happened to be captured on a three-minute record was largely a matter of chance. The record titles simply reflect which verses House sang first on each occasion.

Johnson's "Walkin' Blues" is likewise made up of unconnected, floating verses, and is probably a similarly happenstance occurrence— if he had done a second take, there is no reason to think he would have sung more than a couple of the same verses. Some of his lyrics were learned from House, but others may well have been his own creations or assembled from other sources. The last verse, for example, had been recorded eight years earlier by Lemon Jefferson, and its reference to "Elgin movements"—from ads for the Elgin watch company— had been common among black entertainers for at least a quarter century.[8]

Johnson's debt to House is clear in his vocal approach, which is rougher and stronger than on his more commercial sides. Nonetheless, his record's strengths are quite different, and it would be wrong to class it as simply an expert imitation. When he copied the inflections of urban stars, Johnson sometimes sounds forced or derivative, but he had been playing House's music for years and it fits him like well-worn work clothes. He did not have House's awesome power as a singer, and had he been limited by Paramount's low-fi recording techniques, as House was, his record might come off a rather pale second. Given the advantage of good fidelity, his guitar sounds fuller and warmer than House's, and his vocals show more dynamic variation. He mixes a conversational flavor with the Delta growl, and adds some well-placed falsetto. All in all, it is an excellent tribute by a student who had learned his lessons well, then applied some personal touches to make the song his own.

Johnson would reach back still further for his next number: "**Last Fair Deal Gone Down**" is an anomaly in his repertoire, by far the most "country" piece he recorded. Its basic form, a first line repeated three times followed by a final rhyming line, predated the standard blues pattern and, though it likely originated with black players, by the early days of rural recording it was already more common with white than black musicians, except in gospel songs. (Though this may just reflect the fact that it was considered a hillbilly rather than a blues style, and thus tended to be recorded by artists stereotyped in that category.) Johnson's variant is related to the hillbilly song popularized by Fiddlin' John Carson as "Don't Let Your Deal Go Down," and also to a work song recorded in Mississippi's Parchman prison farm, and titled "It Makes a Long Time Man Feel Bad." Whether it started out as a dance tune or a work song is impossible to say, and the distinction is probably meaningless: Songs constantly moved back and forth, sung along with a fiddle breakdown at a country dance, then more slowly and in a different rhythm to match the pace of the next morning's plowing or chopping.

As if to emphasize this overlap and interchange, and the way it affected virtually all rural music, Johnson's guitar part on "Last Fair Deal" is very similar to the one Charley Patton had played on "You Gonna Need Somebody When You Die," a gospel preaching record he made back in 1929. This was one of Patton's less imaginative arrangements, and may just represent the standard way of playing this sort of tune among older Delta musicians, but both have a similarly solid bass, broken by the same repetitive high slide notes, though Patton's playing on the whole is more melodic.

It is a little hard to see what Johnson is after here. Is the fast pace of his arrangement inspired by fiddle hoedowns, or by the chugging engines of the Gulf and Island Railroad? Is he consciously trying to find new things to do with an old tune, or is this a stock arrangement that medicine-show guitarists were performing before he was born? In any case, he is obviously having fun. There is none of the tortured passion he brought to other slide tunes, but instead a set of showy inflections, both in his singing and—toward the end of the song—on guitar.

If I wanted to indulge in pure speculation, I would guess that he sang this on the streets to amuse white listeners, providing them with an upbeat exaggeration of the levee work songs. He sings lines like "My captain's so mean on me" with a good deal more humor than anger, and though the verses look pained on paper, the whole effect is broadly theatrical rather than deep or personal.

In the hands of a less able performer, it would also be pretty dull. This sort of song was usually played in the light country-dance style of Mississippi John Hurt or Frank Stokes. By contrast, Johnson's arrangement is a steady, damped bass chug, punctuated by a repetitive slide on the two top strings, which he breaks only halfway through the song, abandoning the slide for some punchily plucked riffs and then using harmonics to imitate the sound of a bell. It is the sort of arrangement that makes his imitators tend to sound flat and monotonous, a skeleton of instrumental work that only comes alive because it supports the muscle and sinew of his voice.

Johnson finished these first sessions with two of his wildest and most exciting performances. The first, "**Preachin' Blues (Up Jumped the Devil)**," was another Son House piece, and in its original form had been House's farewell to an earlier career as a Baptist minister. Judging by the fervor of his blues performances, House must have been a fiery and compelling preacher, but one day he heard a bottleneck guitarist on the street and could not resist the temptation to make that sound for himself. On his record "Preaching the Blues," he described the result: "Up in my room, I bowed down to pray/Say, the blues come along and it blowed my praying away." The change of lifestyle brought dire consequences: Within two years of becoming a musician, House had shot and killed a man and was in Parchman penitentiary. He was released a year later, just in time to make the recording trip with Patton and Willie Brown, and he turned his story into a passionate, seriocomic masterpiece, mixing gospel imagery with bitter satire, and ending with a blasphemous invitation: "I'm going to preach these blues, and choose my seat, and sit down./When the spirit comes, sisters, I want you to jump straight up and down."

Johnson was clearly struck by this song, but he did not share

House's church background, so he completely refocused the lyrical theme. Indeed, it is surprising that he bothered to retain the title, since the only mention he makes of preaching is an encouraging aside to his guitar: "Yes! Preach 'em *now*." He opens with House's powerful image of the blues coming to him, "walking like a man," and asking for his hand, but instead of becoming the music's preacher, he becomes its victim: In his lyrics, the blues tears him up inside, and is compared to a shaking chill, heart disease, and a slow death from consumption (tuberculosis). These comparisons were not original—the shaking chill verse was one of House's standbys, and the one comparing blues to heart disease and consumption was from Clara Smith's 1924 hit, "The Blues Ain't Nothin' Else But!"[9]—but those who seek references to Johnson's own life in his songs can read the whole story of his wife's death in childbirth and his subsequent lonely rambles in the lines "The blues felled mama's child, tore me all upside down / Travel on, poor Bob, just can't turn you 'round."

The problem with this interpretation, good as it looks on paper, is that Johnson does not seem particularly caught up in the trials he describes. Where House's song sounded like a tormented personal testament, Johnson's sounds like an enthusiastic display of guitar technique. His singing is fine, but the main thing I hear in it is excitement at the pace he is keeping, and his enthusiasm is more than justified. There is a smooth ease to his playing that recalls not the hard, Delta approach he had adapted from House, but the lilting feel of "Come On in My Kitchen"—only this time jacked up to lightning speed. There have been few guitarists who could play this fast without sacrificing tone, but every note rings clear and gleams like mercury. Then, just as we are getting carried along by the sheer pace of it all, he brings us up short, as he did in "Terraplane," going to the bass strings and a halting counter-rhythm that makes us stumble and pause, setting up the last line of each verse.

Given the pace and energy of this performance, and the obvious enjoyment Johnson takes in it, the lyric of suffering and disease undergoes a complete metamorphosis. Here he is not going for the anguished passion of "Cross Road." Instead of being beset by the blues,

when he sings that it is "an aching old heart disease" he sounds as if he is exulting in its power. The listeners may be trapped, but he is in control, and his dialogue is not with demons but with the sparkling guitar riffs: The slide flies up to a new, higher lick, and he smiles: "Do it now." The old lick comes back, slick as grease. "You gon' do it?" Sure it will. "Tell me all about it."

Johnson may have been a moody loner, but he loved to travel, and he fills this performance with the exhilaration of a fast car on a new-paved road, or the wind whipping over the roof of a highballing freight train. "I'm acceleratin', oh, oh, drive, oh, oh, drive my blues—I can 'celerate an' I'm gon' drive my blues away." And then he breaks the rhythm one more time and ends on a humorous downbeat: "Going to the 'stillery, stay out there all day."[10]

There is one last minor but intriguing mystery about this song: the parenthetic second title. Since the lyrics do not mention the Devil at any point, what does "Up Jumped the Devil" have to do with it? Was it Johnson or the record company who tacked this on? If it was Johnson, it may be that he was coming up with his own name for the Son House tune, that when asked what the song was called, he automatically said "Preachin' Blues," then realized that he might as well change it and added something like ". . . or, I don't know . . . 'Up Jumped the Devil.'" Whoever chose it, the title was far from original. "Up Jumped the Devil" was the name of a popular fiddle tune, and also of a jazz number that had been recorded by a couple of white New Orleans bands in the 1920s. "Preachin' Blues" remained on the shelf for three years, being issued only in 1939 as Johnson's final, posthumous 78 release (on the flip side of "Love in Vain"), and it may be that the producers were trying to piggyback on the popularity of a hot jazz record, or just to spice up an overly churchy song title.

If the religious implications troubled them, they would have had similar problems with Johnson's final selection—and indeed, "**If I Had Possession Over Judgment Day**" remained unreleased until 1961. More likely, though, it was the song's old-fashioned style rather than its lyric that kept it off the 78 market. Another upbeat, driving performance, it was Johnson's version of an older tune that had been

recorded in 1929 by a medicine-show entertainer named Hambone Willie Newbern as "Roll and Tumble Blues." Johnson had apparently heard Newbern's record, since his guitar work is based closely on Newbern's and there is a high proportion of overlapping lyrics. On both counts, though, Johnson has improved on the original. Newbern was an old-time entertainer who specialized in comic ragtime numbers, and "Roll and Tumble" was his one foray into this sort of deeper, wilder playing. Johnson takes Newbern's basic arrangement, repeats it virtually note for note, then begins to go to work on it. This was clearly the style in which he felt most at home, and as on "Preachin' Blues," he plays with dazzling precision and control, adding little pauses, rhythmic subtleties, and slide riffs that Newbern could not have negotiated.

The opening verse is one of Johnson's most memorable lyrics. Son House, in "Preachin' the Blues," had sung "I wish I had me a heaven of my own/Then I'd give all my women a long, long happy home." It was a sexy verse, the fallen preacher imagining a paradise in which he was surrounded by loving girlfriends and able to take care of all of them. Johnson took this fantasy and turned it on its head: A woman might get into heaven if she did him right, but if she did him wrong he could send her elsewhere without recourse to appeal. "If I had possession over judgment day/The little woman I'm loving wouldn't have no right to pray."

It is a fearsome verse, but also a pretty funny one, and I imagine the hometown boys would have laughed and repeated the threat to their drinking partners. As he keeps singing, though, piling up verse after verse of painful breakups, Johnson drops the wry twist of that first couplet and begins to sound deadly serious. He loses the angry bravado as well, becoming lonely, upset, and by the end, painfully vulnerable: "Run here, baby, sit down on my knee/I want to tell you all about the way they treated me." Or maybe I should say attractively vulnerable: Johnson was reputedly in the habit of seeking out older women who would treat him right and take good care of him, and few songs could be more perfectly shaped to achieve this aim. He is angry, hurt, abandoned and mistreated by the bad women; he folds his arms and walks off, murmuring that their day will come, and comforts him-

self with his powerful, virtuosic guitar riffs, then ends with that final, childlike appeal. Meanwhile, the men are still laughing, shouting, "Baby, watch out or it's Judgment Day tonight!" Everybody can take the song as they please, and Johnson will get his drinks bought, some money in his pocket, and a warm bed for the night.

10

SECOND SESSIONS: THE PROFESSIONAL

JOHNSON'S FIRST RECORD, "TERRAPLANE BLUES" BACKED WITH "Kind Hearted Woman Blues," was released early in March of 1937 and quickly turned up on some Mississippi jukeboxes. Honeyboy Edwards recalls seeing Johnson playing on the street in Greenwood just as the record was hitting:

> He was right outside of Emma Collins's—she kept a good-timing house and used to sell whiskey, too. He was standing on a block and had a crowd of people back in the alley ganging around him. But they didn't know who he was! I didn't know at first either, and when I first walked up I thought he was sounding a little like Kokomo Arnold. . . . One woman, she was full of that old corn whiskey, she said, "Mister, you play me 'Terraplane Blues!'" She didn't know she was talking to the man who made it! She said, "If you play me 'Terraplane Blues' I'll give you a dime!" He said, "Miss, that's my number." "Well, you play it then." He started playing and they knew who he was then.[1]

ARC was clearly pleased with the sales, since they released two more records in April and another in May, then brought Johnson back to Texas for a second round of recordings in June.[2] His session on Saturday, June 19, was sandwiched between two by western swing bands, and he cut only three numbers, but on Sunday he was the last artist of the day, and he recorded ten songs.

This time, he was fully prepared. Where the first sessions had found him speeding up and rearranging songs because they were too long to fit on a 78, this time his pieces were perfectly timed for recording, and the alternate takes were virtually identical. The songs were all carefully composed, and he had at least as many as were needed, so this time he recorded no old Delta favorites or songs compiled on the spot out of other people's verses. It has sometimes been said that Johnson carried a little notebook with him and wrote lyrics in it, though other people recalled him as virtually illiterate. If he did not write down his songs, he had an extraordinary facility for making up and remembering cohesive compositions. In any case, in the seven months since his studio debut, he had devoted a lot of attention to composing, and had also become a noticeably more polished and professional recording artist.

Judging by his new lyrics, he had also become a good deal more somber and introspective. The second sessions included very little upbeat material, no "Sweet Home Chicago" and certainly nothing like "They're Red Hot." There were some seductive invitations, and some songs patterned on current hit formulas, but he often followed the model of "Cross Road Blues," limning the dark wanderings of a traveler in an unfriendly world.

Looked at one way, "**Stones in My Passway**" was a schizophrenic attempt to follow this path and at the same time make "Terraplane II, the Wreck." Johnson revisits the guitar arrangement of his hit, but this time instead of taking off on an auto-erotic romp, he finds stones blocking his path, enemies who have betrayed him, and a general misery that subsumes even his few pleasures: "I have a bird to whistle and I have a bird to sing/I got a woman that I'm lovin', boy, but she don't mean a thing."

There are at least two ways to hear this song. If one listens to it with "Terraplane" echoing in one's ears, it can seem less than satisfactory. The propulsive rhythm, with the bass-string slide breaking it up for final phrases, has us zooming off down the highway, while Johnson is singing, "I got stones in my passway and my road seems dark as night." The combination makes no sense, and it is tempting to assume that he simply needed another "Terraplane," and grabbed a handy lyric

that should have been used elsewhere. By the bridge verse, where he is once again recycling Arnold's falsetto "plee-ease," the imitation has gone too far, and it becomes ridiculous when he finishes off with a verse that simply repeats a pair of "Terraplane" phrases—"please don't block the road" rhyming with "I'm booked and I've got to go."

Looked at another way, Johnson has taken what at his first session was a comic double-entendre number and turned it into something subtler and more complex. The bass slide provides a stinging pause for lines that drive each verse home with raw directness. "I have pains in my heart"—the slide hits like a stroke—"they have taken my appetite." He is singing better than ever, and has also developed as a writer. There is a cohesiveness to his better lyrics, apparent since "Kind Hearted Woman," and in songs like "Stones in My Passway" there is also what later writers have celebrated as a self-conscious artistry, a style that has provoked comparisons to European poets rather than blues singers. Such comparisons are meant to elevate his stature in the literary world, but it should be emphasized that even his finest passages have their analogues in the work of his peers. While the rich language of the Bible permeated African-American culture, and it should be no surprise that the great blues writers occasionally sound like cousins of the Elizabethans, it is equally important to see blues as a poetic form with its own strengths. It is also vital to remember that, although a blues lyric on paper may look like formal poetry, the comparison is not necessarily a compliment. This was a performed art, for a largely illiterate audience, and the words on paper could be completely transformed by a twist of the singer's delivery in ways that no reader would expect.

Johnson's uniqueness has been stressed so often that it is fascinating to see how thoroughly his work fits into the patterns of his contemporaries. There were no classicists laying down formal strictures for blues lyric forms, as there were for the Elizabethan sonneteers, but a good ear and a sense of oratorical tradition can create patterns almost as fixed as those of the academy. For example, it is educational to see how formally Johnson adapted Arnold's bridge verse from "Milk Cow Blues": Arnold played two such bridges in the song, both four-line stanzas in which the first couplet was a three- or four-part list and

the second resolved the idea while employing his trademark falsetto leaps:

> Now you can read out your hymn book, preach out your bible,
> Fall down on your knees, and pray the good Lord'll help you,
> 'Cause you gonna *nee-eed*, you gonna *nee-ee-eed* my help someday.
> Mama, if you can't quit your sinning, *plee-ease* quit your lowdown ways.

In "Terraplane," Johnson fit his car metaphor neatly into this framework:

> You know, the coils ain't even buzzing, little generator won't get the
> spark,
> Motor's in a bad condition, you gotta have these batteries charged.
> But I'm cryin' *plee-ease, pleeee-ease* don't do me wrong.
> Who's been driving my Terraplane now, for *you-ou* since I been gone?

For "Stones in My Passway," Johnson employed the pattern yet again, though this time he replaced the list of physical items with a list of events encapsulating the history of a relationship gone sour, followed by a plea that it get back on track:

> You tryin' to take my life, and all my loving too,
> You laid a passway for me, now what are you trying to do?
> I'm cryin' *plee-ease, pleeee-ease* let us be friends.
> And when you hear me howlin' in my passway, rider, *plee-ease* open the
> door and let me in.

Whether in sonnets or blues patterns, the best writers harness predetermined forms to serve their meaning rather than finding such rules constricting, and in this case the bridge verse functions as a bridge between misery and hope. The song's first three verses, with their loneliness and frustration, have set the mood, but now Johnson recalls that at one time he had a good relationship, and reaches out for a lifeline—if his girlfriend will just take him in again, everything could be all right. He shakes off his despondency, and the final verse fits the

quicker pace of the guitar. He is on the road again, and hope springs eternal: "I got three lanes to truck on, boys, please don't block my road!"[3]

There is still something schizophrenic about the performance, but in this interpretation that is part of its brilliance. "Stones in My Passway" perfectly evokes the paradoxes of a rambling life. There are the moments of utter despair and loneliness, but they are balanced by the thrill of freedom and movement. Listening again to the opening verses, I am struck by the beauty of Johnson's singing, a sureness and ease that suggests that he is reflecting on his trials but confident that he can get beyond them. I am reminded of a quotation I once read from Bob Dylan, in which he argued that the difference between the old blues singers and the young interpreters of the 1960s was that the young performers sang as if they were trying to get into the blues, while the older artists had been singing to get out of them.

Johnson's next piece was an altogether slighter effort. "**I'm a Steady Rollin' Man**" is in a mainstream Peetie Wheatstraw style, complete with the falsetto "ooh well" and a guitar part that nicely captures elements of the piano-guitar duet sound. The lyric is a bit out of character, painting Johnson as a steady, hard worker whose baby keeps rambling off with "cream puffs" and "monkey men." It is well put together, each verse flowing logically into the next, and Johnson sings with a nice, relaxed swing, but it does not have anything like the power of his more personal work.

Still, "Steady Rollin' Man" shows that Johnson was developing his musicianship—though not necessarily in ways that would please his later fans. More and more, he was shaking off the complex polyrhythms of the Delta and replacing them with styles that might be more harmonically advanced, but had less quirky rhythmic interplay. "Steady Rollin' Man" was in the key of A-natural, like "Kind Hearted Woman," and though on the whole it was a far less interesting arrangement, he had added a new walking bass figure, and his playing was sounding closer to that of the East Coast and Piedmont pickers.[4]

Johnson's next selection was even more firmly in the Eastern camp. "**From Four Until Late**" was fingerpicked in a basic C position, the favored style of ragtimey guitarists like Blind Blake, and indicated his

growing interest in smoother playing techniques.[5] His singing was in the same line, a mellow croon much lighter than any of his earlier vocals. Blind Blake has sometimes been criticized as a relatively weak singer who compensated for this deficiency with spectacular guitar work, but he had a pleasant, relaxed delivery on mid-tempo blues songs that Johnson seems to be emulating. This vocal style came naturally to Blake, but for Johnson it was something of an affectation and occasionally sounds forced and fake. On the whole, though, his performance shows surprising warmth. His voice sounds prettier than ever before, and while that may turn off the deep Delta fans, his delivery is nicely suited to the urbane and rather formal lyrics, with their sly punning and flowery phrases like "When I leave this town I'm gon' bid you fair farewell."

With that, Johnson had finished for the day, but he was back the following afternoon, and opened with one of his most celebrated performances. Whatever its strengths, nothing in "From Four Until Late" hinted at the tortured poetry Johnson would unleash in "**Hell Hound on My Trail**"—though the two songs would be paired as the session's first release. As if to counter the idea that he was smoothing out his delivery, Johnson made a complete about-face into his darkest, most anguished performance on record. Once again, he was inspired by Skip James's "Devil Got My Woman," but the effect was quite different from the sweetly aching, meditative feel of "Come On in My Kitchen." Johnson followed James's minor-keyed, almost modal arrangement, and strained to approximate his eerie and idiosyncratic singing style, while reshaping the lyric into a saga of haunted flight. It is his poetic masterpiece, a nightmare of hellhounds and magic powders, illuminated by lightning bolts of sharp, natural imagery: "I've got to keep moving, blues falling down like hail," "I can tell the wind is rising, the leaves trembling on the tree." Placed alongside the memories of his friends and traveling partners, it seems painfully autobiographical. He may end two verses with the thought that all he needs is his sweet woman, his little sweet rider to keep him company, but the delivery gives no sense that he could find peace so easily. It is the cry of an ancient mariner, cursed by his fates and doomed to range eternally through the world without hope of port or savior.

The strain in Johnson's voice adds to the song's power. He has patterned his arrangement on James's guitar part, but tunes his guitar a full tone higher, despite the fact that he was normally a lower singer than James. The result is a profoundly unnatural vocal, as removed from Johnson's normal voice as the smooth inflections of "Four Until Late." It sounds painfully tight and forced, with no warmth and only the briefest hint of relaxation in the spoken aside that follows the vain wish, "if today was Christmas Eve and tomorrow was Christmas Day"[6]: "Oh wouldn't we have a time, baby?" Johnson murmurs, sounding like his old self, but he soon is straining again, giving the lie to this momentary optimism.

It is a great performance, but there is also something disturbing about it, beyond the anguish of the lyric and the power of the delivery. There is so much effort being expended that it takes on a contrived and theatrical quality. Effective as it may be, it is less human and genuine than "Come On in My Kitchen," where Johnson spoke to us directly rather than assuming such a deliberately tortured persona. In his extended essay on Johnson's life and work, Peter Guralnick writes that at the second sessions Johnson produced "his most inspired and his most derivative recordings."[7] To me, "Hell Hound on My Trail" shows both sides of this equation. It is a gripping snapshot of a great artist at a moment when he was extending his already formidable powers, commanding new tools, sharpening his gaze, moving beyond the familiar influences of his youth. Such moments are striking, fascinating, dramatic, but they are also incomplete.

Gertrude Stein famously quoted Picasso as saying, "When you make a thing, it is so complicated making it that it is bound to be ugly, but those that do it after you they don't have to worry about making it and they can make it pretty." In the same way, Johnson at this point was breaking out of his old patterns, stretching himself, and had not yet found a mature style that fit him comfortably. The excitement and passion he was investing in his work are palpable, but only rarely in his second session does he play anything that feels as natural as "Preachin' Blues" or "Cross Road Blues," which were anchored in the techniques he had learned from Son House and had been living with for years.

If "Hell Hound" was a daring stretch, Johnson was soon back on fa-

miliar commercial territory. "**Little Queen of Spades**" was a feminist reworking of Peetie Wheatstraw's "King of Spades," using the same melody and "hoo, fair brown" interjections. Where Wheatstraw had opened with "I am the king of spades, and the women takes on over me," Johnson began "She is a little queen of spades, and the men will not let her be." For the guitar part, he used a variation on his basic "Kind Hearted Woman" arrangement, but this time did not bother to vary it from verse to verse or add a bridge section.

Indeed, the most surprising difference between Johnson's first and second recording trips is that he was no longer striving to provide musical variety within each song. Rather than creating bridge verses and alternate accompaniments, on this session he tended just to settle on one basic pattern and leave it at that. Only two of the thirteen songs from 1937 had bridge verses, and in both cases it was because Johnson had cast them in Kokomo Arnold's "Milk Cow" pattern. By contrast, he had used bridges or verses with clearly differentiated guitar or vocal parts for roughly half the songs he recorded in 1936, and the proportion is even higher if we count only the earlier, prepared pieces and put aside the old Delta numbers with which he filled out his session time.

It is hard to see why Johnson would have abandoned his commitment to musical variation, which had set him apart from the more pedestrian composers crowding the blues field. The change brought no benefits, and pointed the way toward monotony, though Johnson almost always found other ways to keep the listener interested. It is true that basic, unvaried arrangements were the order of the day, and none of Johnson's fans or producers were likely to note the absence of four-line bridges and alternate guitar parts. The Chicago stars were outselling anyone else in blues, and their musical arrangements could be virtually the same not only throughout a song, but throughout dozens of records. What mattered was the soul, humor, or uniqueness of the singing, or a catchy turn of phrase. As Johnson surveyed the market, he may have concluded that the more involved compositional approach he had adapted from Leroy Carr was becoming a thing of the past. He also may have been working more with other musicians—or at least hoping to—and decided that straightforward, unchanging

accompaniments would be easier to teach to unrehearsed pickup players.

Johnson certainly had his sights set on a more uptown, urban blues style. He had introduced a sweet, crooning approach on "From Four Until Late," and his next two songs proved that, whatever else he had been doing in the last few months, he had spent some time wood-shedding with a Lonnie Johnson record. According to Johnny Shines, Lonnie was Robert's greatest hero:

> He admired his music so much that he would tell people that he was one of the Johnson boys from Texas. He'd give people the impression that he was from Texas and he was related to Lonnie Johnson. I think he admired Lonnie Johnson just that much. . . . I could never under-stand why he'd do that, 'cause I thought he was a wonderful musician in his own right. I guess everybody idolizes somebody.[8]

He was by no means unique in this admiration. Lonnie Johnson was the first male superstar of the blues era, and among musicians he was widely considered to be the finest guitar player in blues or jazz. For a young, hip musician, he was an obvious role model, both for his success and for the breadth of his innovative virtuosity. He traded licks with Louis Armstrong, was the first major bluesman to record on elec-tric guitar, and was still topping the R&B charts in the late 1940s. He was also the first important studio guitarist, recording as a sideman with over thirty other performers and bands.

Lonnie Johnson's fastest, most complex guitar solos would have been far beyond Robert's technical abilities, but he was a supremely tasteful player as well, and especially on his earlier records created some lovely, understated blues accompaniments. He was also an un-usually versatile lyricist, writing not only double-entendre comic num-bers and paeans to lost love, but songs about floods and cyclones, bedbugs and racketeers. In 1927, he had done a whole series of songs about ghosts, starting with "Lonesome Ghost Blues" and following up with "Blue Ghost Blues" and "Low Land Moan."

Whether attracted by the title or just because that particular record happened to be handy in some home where he was staying, Robert

settled in with "Blue Ghost" and its flip side, a ballad about a ship-wreck titled "Life Saver Blues." He learned the guitar part to "Life Saver" virtually note for note, missing a couple of the faster passages but managing all the jazzy diminished chords and making a respectable attempt at Lonnie's superb vibrato, and used this arrangement for his next two songs, "**Malted Milk**" and "**Drunken Hearted Man**."[9] Both spoke of the charms and dangers of alcohol—though "Malted Milk" tacked on an incongruously spooky line from "Blue Ghost"—and both were sung in a decent approximation of Lonnie's cultured pop-blues tones. Robert's voice is darker and deeper than Lonnie's, but the style suits him quite well. He sounds less affected than on "From Four Until Late," and on the whole these performances are comfortable and fully realized, though markedly different from his other work.

That said, they are also rather unexceptional. If we knew Robert Johnson only from these cuts, we would consider him an acceptable Lonnie Johnson clone—no mean feat as far as that goes, but not worthy of any particular attention. At this point in his development, he was still broadening his reach, trying out various musical identities, and he probably could have done quite convincing imitations of Jimmie Rodgers, Gene Autry, or Louis Armstrong as well, had that suited the blues market.

"Malted Milk" had some novelty value, if only for its title—it clearly refers to some sort of alcoholic beverage, though none of the myriad Johnson scholars has yet identified the ingredients[10]—and this may be why it was selected for release, while the two takes of "Drunken Hearted Man" were vetoed. As with "Little Queen of Spades," these takes were virtually identical, showing that Johnson had put some effort into preparing the song for recording, but since it was so much like "Malted Milk," the record company can hardly be blamed for treating the two songs as a single piece and setting one aside.

Next up was "**Me and the Devil Blues**." This was yet another piece in the Wheatstraw style, backed with a "Kind Hearted Woman" guitar part, and Johnson sounds very much at home. His vocal is beautifully modulated, starting the first and third verses in a comfortable mid-range, adding tension by straining for high notes as he begins the

second and fourth verses, and in each case dropping to a whispery bass as he delivers the final line. He had also worked out little spoken asides for the last two verses, interrupting the smooth progress of the song for a touch of conversational intimacy.

These asides are worth thinking about a little, because they fly in the face of one of the classic blues stereotypes. Older street and juke-joint players like Son House, who were used to singing twenty-minute songs, would often go into the studio and simply record a random slice of their typical performance. At his earlier session, Johnson had done the same thing at times, singing whatever verses happened to jump into his mind on a particular take, and chopping and changing his phrasing and accompaniment as inspiration hit. This sort of spontaneity has often been hailed as a hallmark of great blues; indeed, there is a degree of excitement that comes from improvisation in any music, be it flamenco, Indian *ragas*, or jazz. When we go to hear B. B. King, we expect him to do more than simply recycle the same solos he played on his old records, and are thrilled when he is still able to surprise us, after fifty years, with some unexpected twist or bend. One can argue that this spontaneity is what keeps the music fresh and alive, while classical performances—and, more recently, note-perfect recreations of Jelly Roll Morton and Duke Ellington recordings—have become stodgy museum pieces. I myself have criticized young blues revivalists for interjecting the same "Oh Lord" or "Help me now" at the same place and in the same tone every time they play a song, arguing that the original artists made such cries on the spur of the moment, rather than carefully working them out in advance to create a pre-planned effect.

Johnson's second session, and "Me and the Devil" in particular, force one to rethink this issue. In the third verse, he quits singing to remark, "No, baby, you know you ain't doing me right," and this makes the record feel more casual and live, as if he were sitting with us and addressing us directly. To hear him make exactly the same remark in almost exactly the same way on the second take is more than a little disconcerting. Clearly, while he was quite capable of performing in the loose, spontaneous country style, he put no particular value on improvisation, and if he thought about it at all, he seems to have viewed

it as rather unprofessional, at least on recordings. His models were some of the most careful and prepared artists in the field, and no blues singers have ever polished their work more thoroughly than he did "Me and the Devil." Virtually every musical phrase, every falsetto "ooo," every offhand comment has been planned in advance.

This is not meant as a criticism. I am a great fan of Leroy Carr and Lonnie Johnson, and am writing this book in large part because I feel that their more polished, professional approach has been disrespected by generations of blues writers in search of wild Delta primitivism. I only want to stress the degree to which, to the best of his abilities, Johnson was attempting to place himself on the Carr side of this aesthetic divide. Far from being the spontaneous heart-cry of a demon-driven folk artist, "Me and the Devil" is a superbly constructed piece of pop music in the style of the best urban studio performers of the time. It has the easy intimacy of the studio, rather than the loud attack of the streets and jukes, and its effect is carefully calculated.

The lyric, as well, has more than a touch of hip humor and sophistication. This is an aspect of Johnson's work, and of blues in general, that has far too often been overlooked or undervalued. White writers, performers, and audiences, living in a world where blackness is routinely equated with toughness, violence, primitivism, and innate rather than conscious artistry, have a tendency to interpret songs rather differently than the black songwriters, musicians, and audiences that supported blues as a modern, relevant pop style. Dave Van Ronk, one of the pioneer white revivalists, told me of a performance he once gave at a blues festival in New England: He arrived late, and did not know who else was on the bill, but gave his usual show, ending with a shouting steamroller version of "Hoochie Coochie Man," full of aggressive macho bluster. Exiting to wild applause, he found to his embarrassment that Muddy Waters, the song's originator, had been sitting in the wings watching him. Waters, always the gentleman, hastened to put him at ease. "That was very good, son," he said, putting his hand on Dave's shoulder. Then he added, "But you know, that's supposed to be a *funny* song."

The idea that violence, mayhem, death, and misery are fertile soil for humor is common among poor people throughout the world, and

frequently inexplicable to those who are cushioned from the harsher and earthier aspects of life by money and formal education. Thus, as I have previously noted, it is common for white scholars to remark on the dark passions and superstitious terrors expressed in lines that in a juke joint would have produced laughter.[11] In the case of "Me and the Devil," Johnson was working within a well-established tradition of blues Devil songs. Just three months earlier, the Chicago-based slide guitar wizard Casey Bill Weldon had recorded a remake of Clara Smith's 1924 hit, "Done Sold My Soul to the Devil," a display of the same sort of tongue-in-cheek braggadocio Waters used in "Hoochie Coochie Man" or Peetie Wheatstraw was employing when he called himself "The Devil's Son-in-Law": "I'm stubborn and I'm hateful, I'd die before I'd run," Weldon sang. "I drink carbolic acid, I totes a gatlin gun/I done sold my soul, sold it to the Devil, and he won't let me alone."[12] Lonnie Johnson had been a master of this kind of macho-satanic joking, singing, "The undertaker's been here and gone, I give him your height and size/You'll be making whoopee with the Devil in Hell tomorrow night" and "I told you next time you go out, please carry your black dress along/'Cause a coffin will be your present and Hell will be your home."

Johnson's song is full of this spirit, starting with the friendly way he greets his visitor, "Hello, Satan, I believe it's time to go," and ending with the clever, Wheatstraw-inspired, "You may bury my body down by the highway side/So my old evil spirit can catch a Greyhound bus and ride."[13] The Greyhound bus was still a new arrival in the 1930s, and beyond the means of most black Delta dwellers. It conveyed an idea of fast, modern transportation, and would have seemed a particularly comical conveyance for an evil ghost. As for the line in which Johnson says, "I'm going to beat my woman until I get satisfied," it is ugly, but no one familiar with rap will be surprised if I suggest that it evoked more guffaws than horror from its intended audience.

This is not to say that "Me and the Devil" was intended purely as an extended joke or comedy routine, but simply that there is a good deal of dark humor mixed in with the fine singing, the brilliantly understated guitar work, and all the other factors that go to make this one of Johnson's most fully conceived performances. The range of tone he

can pack into a few lines is astonishing: The final verse starts with his voice sounding tight and forced—"You may bury my body," then a pause for the guitar, then "down by the highway side," sounding as if he is squeezing the words out of an unwilling voice box. Then he steps aside, and remarks that he does not care where his body is buried, talking in a normal, conversational tone, completely relaxed and dispassionate. Then he is singing the opening line again, but now in a comfortable mid-range, sounding like a more muscular Leroy Carr. In the middle of the line, he places that "ooo," which to my ear always sounds a little too careful, but finishes with a crooner's ease and a lovely slide down to a low register on the word "si-ide." Then he hits hard on the last line, singing the word "spirit" with field-holler power—even to ending it with a slight grunt—before trailing off to a quiet low note and playing the guitar tag. None of this was accidental, or the result of a momentary burst of feeling: the description I have given applies equally well to either take.

Johnson picked up the tempo for his next tune, "**Stop Breakin' Down Blues**," an upbeat boogie with a strong chorus line, which would later be reworked into a blues standard by John Lee "Sonny Boy" Williamson. While the guitar part has some of the same elements as "I'm a Steady Rollin' Man," this time Johnson is playing in open tuning, and the song is structurally unusual, set in a quite different pattern from anything else in his repertoire.[14] Its selling point is the way his exuberant vocal drives home the story line, a series of verses about no-good women set off by the chorus phrase "Stop breaking down"— which means roughly "straighten up," or "stop messing around"[15]—and a final macho boast: "The stuff I got'll bust your brains out, it'll make you lose your mind."

The two takes sound very similar, though on the second Johnson fluffs the opening verse and finishes with what sounds like an old folk couplet chosen at random. (If evidence is needed to show how little this troubled the record company, once again the two takes were released interchangeably, some 78s having one and some the other.) The one truly odd thing about the song is its final four notes, which Johnson plays with a slide. As any guitar player knows, it does not make a lot of sense to have a slide on one finger unless you are using it, since

it means that you cannot use that finger for anything else, and if you are not careful you are likely to clunk the slide against the guitar neck. In his "Terraplane" arrangement, Johnson had used the slide for only one note per verse, plus a brief, ear-catching introduction—an unusual choice but very effective. To use the slide only for a final, four-note coda was something else. It sounds good, certainly, but few people were likely to notice, and none to care very much. It is like a little inside joke, something Johnson tosses in for his own amusement or as a wink to some friend or fan—maybe someone who had suggested he play this song as a slide number. In any case, it is not accidental, since he plays the quirky slide fillip to end both takes.

If Johnson had known that his recordings would eventually be released in a long-playing format, grouped in chronological order, the slide coda would have made more sense. In a session that had assiduously followed the current national trends, it set the stage for a proper slide workout and a return to his Delta roots. "**Traveling Riverside Blues**" revived the "Rollin' and Tumblin'" arrangement he had used for "If I Had Possession over Judgment Day," with a new lyric that name-checked three Mississippi riverbank hot spots—Friars Point, Vicksburg, and Rosedale—and was one of his most thoroughly satisfying performances.

Once again, the song had been carefully rehearsed. The two takes are structurally identical up to the last verse, where on take two Johnson underlines the salacious line, "You can squeeze my lemon till the juice run down my leg," by repeating it in his speaking voice and prompting, "You know what I'm talkin' 'bout . . ." Despite lines about "barrelhousing" all night long, he has slowed and calmed down the arrangement. There is little of the wildness of "If I Had Possession," which had been played in the old country style and ignored the concept of counting regular measures. The riffs are the same, but now he is playing a consistent twelve bars per verse, except when he consciously chooses to insert a brief solo.

It is particularly fascinating to compare the two takes of this song, because they highlight Johnson's awareness of and attention to the subtleties that separate a good performance from a great one.[16] If one heard them several days apart, it would be easy to mistake one for the

other until that spoken section in the last verse, but heard back-to-back they are utterly different. The first take is well sung and well played, a perfectly respectable performance that is easily the equal of "Stop Breakin' Down," and better than quite a few other Johnson recordings. But consider his differing approaches to the song's first line: On take one, Johnson just sings it straight. "If your man gets personal, want y' to have your fun." The guitar keeps a regular railroad rhythm, only briefly doubling up for a little jump between the two phrases, then he repeats the line almost exactly the same way, just adding a hint of slide at the end. On take two, Johnson is singing slightly slower and with more emotion, and the guitar swoops up to a powerful slide chord after the first phrase, holds it with a touch of tremolo under the second phrase, then slides back down into the instrumental riff. When he repeats the line, he sings "persona-*al*," giving the note a wry twist, as if nudging the girl in the ribs. Then, on the third line, "Best come on back to Friars Point, mama, and barrelhouse all night long," he holds "night" with a hint of invitation that flows into a long "looong" that leaves no doubt what he is thinking about.

It is Johnson's sexiest performance since "Come On in My Kitchen," with the slide lazily echoing some vocal lines, slicing quick and delicate behind others. The lyric is sly and romantic, describing his favorite girl: "I ain't gon' state no color, but her front teeth is crowned with gold/She got a mortgage on my body, now, and a lien on my soul." She is from Friars Point, but he will take her down to Rosedale and promises that they can still barrelhouse there, "'cause it's on the riverside." At that time, Mississippi was still a dry state and liquor came across the river from Arkansas. In the river towns, a guy could lay up with his girl, drink and party all night long. "You can squeeze my lemon . . ." If you were in love with the good-looking guitar player with the long, expert fingers, it could be a tempting invitation. As for Johnson, he was ready for whatever might come: "I'm going back to Friars Point, if I be rocking to my end," he sings, and slides up to a final, shimmering chord.[17]

Good as it was, "Traveling Riverside Blues" was yet another song the producers chose to veto, and would not be released until the 1960s. In this case, it is hard to imagine their rationale. If I had wanted to pick

one song from Johnson's second sessions as a likely follow-up to "Terraplane," this would have been it. The lyric and singing style more than balanced the old-fashioned approach that may have doomed "If I Had Possession," and the exuberant party feel was exactly what the blues market was going for. Some writers have suggested that the verse about lemon squeezing was too racy, but there were plenty of similarly racy verses that were released without any problem in this period—including Bo Carter's "Let Me Roll Your Lemon," with its repeated tag line: "Let me squeeze and roll your lemon, babe, until your good juice come," Tampa Red's "Juicy Lemon Blues," Blind Boy Fuller's "Let Me Squeeze Your Lemon," and Bumble Bee Slim's "Lemon Squeezing Blues"—so this makes little sense.[18] Obviously, the producers did not automatically rule it out, because they recorded two takes and the second was sexier than the first. It may be that there was no reason at all, that the song was planned as a later release, then simply overlooked. None of Johnson's records sold particularly well, and if one or two decent songs happened to fall by the wayside that would hardly have been a major concern of anyone at ARC or Vocalion.

If a song had to be overlooked, though, Johnson's next effort would have been a more logical choice. "**Honeymoon Blues**" was set to yet another variation of the "Me and the Devil"/"Kind Hearted Woman" arrangement, and though Johnson adds a new descending passage on guitar—yet again reminiscent of a Carr piano riff—the song broke no new musical ground. Still, Johnson sings with easy assurance, and the words are pleasantly romantic, the one completely optimistic lyric he recorded. It is a relief, after all the heartache and loneliness, to hear him deliver a love song, even if his idea of the perfect woman was "a sweet little girl that will do anything that I say." He does sing "my life seem so misery" in the third verse, but since he follows with the observation that "I guess it must be love, now, Lord, that's taking effect on me," I take this to be the sort of sweet misery celebrated at least as far back as the Elizabethans. There were few blues celebrating marriage rather than barrelhousing or its equivalent, and it is interesting that it should have been Johnson, famed as a rambling womanizer, who chose to sing, "Someday I will return with a marriage license in

my hand." He sounds completely sincere, and "Honeymoon Blues" deserves to be taken into account by anyone trying to understand Johnson by way of his lyrics, providing a little balance to his image as a haunted loner.

Admittedly, the celebration of matrimony was only momentary. With his next song, Johnson remained a loving romantic, but abandoned all traces of optimism. "**Love in Vain**" is one of his most beautiful and internally cohesive compositions, a sad little picture of a man bidding his loved one farewell. The images are simple and carefully observed: the suitcase he carries for her, the way he looks her in the eye as the train arrives, and finally the way the train looks as it pulls away, two lights shining at the tail of the caboose. It is only then that he shifts from storytelling to metaphor, comparing the blue light to his blues, the red to his mind. (This verse was not original, having appeared eleven years earlier in Lemon Jefferson's "Dry Southern Blues," but it fits perfectly in Johnson's new context.) Altogether, there are just three verses, each with the mournful tag line: "All my love's in vain." To finish off, Johnson moans a fourth verse, wordless except for the name of his sweetheart, Willie Mae, his sadness too powerful for speech.[19]

As usual, this song was based on a previous model, taking both its form and the distinctive wordless verse from Carr's last major hit, "When the Sun Goes Down." Carr's song was so popular that it was covered not only by half a dozen blues artists, but also by pop groups like the Ink Spots, and in 1949 it would resurface and hit the R&B top ten—retitled "In the Evening"—in versions by both Charles Brown and Jimmy Witherspoon.

Carr's success obviously served as an inspiration to Johnson, but this should not be taken as a lack of originality. Using an existing framework for one's compositions is part of both folk and formal traditions—whether one is writing ballads, sonnets, blues, minuets or concertos—and "Love in Vain" is no less a masterpiece because Johnson shaped it to match a recent hit. For a virtually unknown Delta guitarist to aspire to the level of sophistication of Leroy Carr, a defining urban blues star and one of the music's finest and most enduring

poets, was not a sign of weakness, but a daring leap of the imagination. To succeed in producing work that can stand alongside Carr's own masterpiece was an astonishing triumph.

On at least one front, Johnson actually bested Carr: The wordless verse as he sings it is far stronger than the original, drawing on the Mississippi field-holler tradition and sounding not merely like a musical interlude—which is all Carr makes of it—but like the cry of a lonesome, breaking heart. If there were only one take of the song, one might think that this effect was spontaneous, an outpouring of emotion inspired by what is arguably Johnson's finest lyric. In fact, there are two takes, and they are so nearly identical that I can barely distinguish one from the other. The emotional power of Johnson's vocal is equally strong on both versions, driving home the point that he was a supreme professional, intensely aware of what he was doing and how to achieve his effects. Even the one tiny difference in the lyrics is revealing: On take one, he sings, "I was lonesome, I felt so lonesome," while on take two he sings, "I felt lonesome, I was lonesome." In both cases, he made sure to vary the phrase slightly, giving the sense that he is mulling over the emotion rather than simply repeating himself.

By now it must have been pretty late in the evening, and Johnson had completed nine songs plus alternate takes. He had time for only one more piece, and it is probably fitting that he finished with a last tribute to Kokomo Arnold. He had been mining Arnold's "Milk Cow Blues" ever since "Kind Hearted Woman," but only now did he produce an explicit follow-up, "**Milkcow's Calf Blues**." Though intended as a sequel, even trading off lines from Arnold's song to end the bridge verse, Johnson's piece was a more cohesive and developed composition.[20] Where Arnold had used the title metaphor in only one of his six verses, picturing himself as a farmer and his straying girlfriend as a missing cow, Johnson extended it throughout the song and cast himself as the cow's hungry calf.

If one accepts the stories of Johnson's habitual attraction to older women, this lyric was oddly appropriate, and one cannot help smiling as he sings, "Your calf is hungry, I believe he needs a suck." There is a note of pleading in his words and in the hesitant mildness with which he sings some phrases that is a far cry from the macho sexiness of

"Terraplane"—it may just be that he was getting tired, but it suits the mood. If his last three songs had been cut at a later date, rather than tacked on at the end of a marathon effort that had included "Me and the Devil" and "Traveling Riverside," one might suggest that they showed a new romanticism and sensitivity. As it is, they wrap up one of the most varied one-man sessions in prewar blues, a survey of the 1930s scene as reinterpreted by a unique and extraordinary artist.

11

THE LEGACY

ROBERT JOHNSON CREATED A BODY OF WORK THAT IS FASCINAT-
ing and inspiring, but also at times both frustrating and ambiguous.
Unlike Lemon Jefferson or Charley Patton, who were already fully
formed artists when they began to record, he entered the studio while
still in a stage of artistic growth and flux. He had been playing for only
a few years, during which he had progressed from rootsy Delta juke
music through the work of uptown players like Carr and Lonnie John-
son, meanwhile assimilating the wide range of pop and hillbilly mate-
rial that we know of only by hearsay. His final session found him still
trying on various styles, from the smooth balladry of Johnson and
Blind Blake to the eerie soulfulness of Skip James, and reports from
his acquaintances suggest that he was also experimenting with a small
band and moving toward a jazzy or "jump" combo sound.

Johnson's death, just fourteen months after this session, thus leaves
us without any clear idea of which directions he might have pursued,
or how he would have sounded even a few years further on. To judge
by the choices his peers went on to make, he could have done any-
thing from forming a jazz group to quitting music entirely, and if we
grant that he had a breadth of talent unmatched by any of those peers,
that opens up still broader vistas. And that is not even taking into ac-
count what might have happened if the jazz impresario John Ham-
mond had succeeded in his attempt to find Johnson and present him
at 1938's groundbreaking "From Spirituals to Swing" concert at New

York's Carnegie Hall, introducing him to the progressive, intellectual world of Café Society.

To get a sense of how little we really know about all this, imagine for a moment that Ray Charles had died in 1954, rather than continuing to develop and expand his work into the present century. By the early 1950s, Charles had recorded far more sides and achieved much greater popular success than Johnson, but he was still a relatively minor figure, despite having proved himself a brilliant synthesizer of the current blues-pop styles. He could play anything from the smooth cocktail jazz of Nat "King" Cole to gritty down-home sounds, to gospel-infused shouts. Still, he had not yet fused all of this into the unique personal style that would transform the black music world. Had he died then, there is no saying how the soul revolution would have developed, and there would have been no way to even imagine his later evolution, the genre-smashing ventures into country, modern jazz, and the pop mainstream. In the same way, we know a certain amount about Johnson's talents, the influences he had assimilated, and the way he chose to apply all of that over two recording sessions, but we can never know which stylistic tics he would have retained and which he would have abandoned in the next few years, or even whether he would have continued to have much interest in blues.

One could argue that any discussion of Johnson's theoretical potential is beside the point, but in many ways it seems to have been as important to his contemporaries as anything he actually put down on record. For the Delta musicians of his generation, it was inspiring to hear someone of their own age and background on a jukebox, proving that a young local player could stand alongside the national stars. Some played his songs or copped his guitar licks, but when they talked about him in later years it was rarely these specifics that seem to have captured their imaginations. Rather, it was his ability to reach beyond their own ambitions, to point the way toward more distant musical possibilities than playing Son House riffs in a backcountry juke joint.

Johnson was very much a "musician's musician," never reaching a broad record-buying public, and it was this small circle of Mississippi peers who kept his work alive in the black blues world. The boogie bass pattern he used on a few songs became a favorite style among

younger Delta players, and three of his songs—"Sweet Home Chicago," "I Believe I'll Dust My Broom," and "Stop Breaking Down"—eventually became standards, though in the latter two cases only after a decade had passed, and in substantially different forms.[1]

To speak of Johnson as a star, or compare his influence in the black blues world to the effects of artists like Louis Armstrong, Charlie Parker, Jimmie Rodgers, Hank Williams, Bob Dylan, or Jimi Hendrix, who revolutionized and redefined the music of their times, is absurdly misleading. Had one made any such sweeping statements to a black blues fan during the twenty years following Johnson's death, the response in the vast majority of cases would have been a puzzled "Robert who?" By the time he recorded, blues was moving in another direction, and soon the acoustic guitarists would be supplanted by jive combos, band singers and rhythm trios, modeled on the success of Louis Jordan, T-Bone Walker, Dinah Washington, and Johnny Moore's Three Blazers. There were a few "down-home" players who managed to make an impact in the 1940s, and a couple of them did cover one or another Johnson song. Still, until the 1960s Johnson's name was all but forgotten, except by his immediate neighbors, his playing partners, and a handful of white folk and jazz fans.

It was these white fans who would crown him king of the Delta, and whose opinion has come to be the gospel of blues history, and it is worth noting that until quite late in the establishment of this gospel they were acutely conscious of expressing an elite, extremely minority taste. To white aficionados in 1960, it was taken for granted that no blues artist without strong Delta connections would know of Johnson's records, and they were not surprised if his name rang few bells even in Mississippi. Johnson's obscurity and mystery were part of his appeal, setting him apart from the kind of blues that was still regularly featured on radio playlists throughout the United States.

Even today, when Johnson CDs have sold in the millions, Johnson posters are on the walls of multinational chains, conferences are held about his music, and his face has graced a postage stamp, if you go to a blues festival in the Mississippi Delta and take a poll of black listeners, you will find that many (in my experience, most) will not even recognize his name. Those who do will tend to know of him only as a

vague historical figure, without any sense of his music. Johnson is a hero to the white blues scene—defined as "white" not according to the race of the performers, but that of the overwhelming mass of audience members—but remains unknown to the remnants of the black blues audience, an audience now largely limited to older people in the South who would consider the top names in the field to be people like Denise LaSalle, Bobby Bland, and Clarence Carter.[2]

This is not to deny Johnson's importance, either as an artist or as a historical figure, but only to put it in context. In later chapters, I will pick up the story of his discovery by the white world, and his elevation as the central figure of the modern blues pantheon. First, though, I want to return to the history of blues as black popular music, and sketch out its path in the decades following his death.

three

THE BLUES ROLL ON

12

JUMP SHOUTERS, SMOOTH TRIOS, AND DOWN-HOME SOUL

IT CANNOT BE SAID TOO OFTEN THAT MUSICAL CATEGORIES ARE artificial constructs, useful for many purposes but meaningless and limiting for others. Simply because blues has been separated into all sorts of subcategories—Delta blues, Classic blues, Piedmont blues, Chicago blues, Jump blues, Rhythm & Blues—does not mean that these categories meant much to the players or consumers of the music, or even existed at the time the music was being made. Every category is defined with a set agenda in mind. Sometimes a historian wants to make a point. Sometimes a marketing executive wants to make it easy for consumers to find a particular kind of product. Sometimes a performer wants to distinguish himself or herself from previous artists, or those with whom he or she disagrees about something. There is nothing wrong with any of this, but there are always confusing examples that illustrate the limits of the taxonomy.

In jazz, there came a moment when a group of fans tried to declare the whole category closed. The New Orleans music originally called jazz was jazz, they said, and "swing" was something else. Less hard-line members of the clan might even admit a Duke Ellington or Benny Goodman to the jazz pantheon, but still barred boppers like Charlie Parker and Dizzy Gillespie. The New Orleans purists were dubbed "moldy figs" and eventually lost the battle, and with their loss it was generally agreed that the word "jazz"—like the word "classical"— would apply to a huge range of musics, some of them so dissimilar that

if one did not know the historical links one could hear no connection between them.

Blues could have gone the same way. We could easily think of Louis Jordan, Chuck Berry, Aretha Franklin, James Brown, George Clinton, Dr. Dre, and Missy Elliott as blues artists, since there is an easily traceable continuity linking them to each other and to all the blues artists who preceded them. Such taxonomy would not change the music, and would be neither more nor less meaningful than the taxonomy that separates them into R&B, rock 'n' roll, soul, funk, and hip-hop. This is not to say that the names are meaningless, or that they do not describe real musical changes, but only that the reasons such changes led to a complete recategorization here and not in jazz were cultural and commercial rather than musical.

As usual, my solution to this problem is to define blues in the years following the Second World War as the range of music that an average black pop listener would have been apt to refer to as blues, but I am well aware that this has its problems—starting with the questions of what is average and how I would measure "apt." Still, it is clear that if somebody had called Joe Turner's "Shake, Rattle and Roll"—or even Elvis Presley's "Heartbreak Hotel"—a blues record in a Harlem bar in 1955, no one would have bothered to dispute the terminology (though they themselves might have called it R&B), while not many people in the same bar ten years later would have been likely to use that word for "Papa's Got a Brand New Bag"—even though James Brown's declaration of soul modernity was, musically, a straight twelve-bar blues. By the mid-1960s, at least in the northern cities, the black pop audience had come to use "blues" as a synonym for old-fashioned or countrified, and it would never again be used to describe a style regularly appearing on the R&B (or "Soul" or "Black") record charts.

Through the 1940s and 1950s, though, blues often seemed to be stronger than ever. Times changed, but the blues changed with them. When Robert Johnson died, the sort of recordings he had made were already disappearing from the black pop scene. The single singer accompanied only by his acoustic guitar or piano was being replaced by larger ensembles, and only a few isolated figures would have further hits in the older style. However, while historians often describe this as

the end of an era, it is not at all clear that the normal run of music lis-
teners noticed much of a change. There may have been fewer blues
records being pressed in the early 1940s than in the mid-1930s, but
the music continued to have a very significant presence. In 1943, the
first full year for which *Billboard* magazine compiled its "Harlem Hit
Parade" chart (renamed "Race Records" in 1945, and "Rhythm and
Blues Records" in 1949), January found Wee Bea Booze's version of
Ma Rainey's "See See Rider" in the number-one spot, and it stayed in
the top ten for twenty-two weeks.

In a way, what had happened was a return to the era of the blues
queens, with blues as a vocal style within the jazz world. "See See
Rider" was supplanted in the number-one spot by "What's the Use of
Getting Sober," a blues-inflected tune by Louis Jordan, an all-around
entertainer who had made his name with a smash version of Casey Bill
Weldon's "I'm Gonna Leave You on the Outskirts of Town." That song
was in turn replaced by a twelve-bar blues called "That Ain't Right," by
the King Cole Trio—the first major hit for the man who would become
famed as the greatest of black pop crooners. Jordan and Cole could be
considered the Tampa Red and Leroy Carr of the 1940s (though Cole
soon moved beyond the blues field, as Carr probably aspired to do),
and they were widely imitated, along with the Kansas City styles of Joe
Turner and Jimmy Rushing, the Texas sound of T-Bone Walker, and
the overwhelming influence of the new "Queen of the Blues," Dinah
Washington.

The *Chicago Defender* took note of this trend in 1944, writing that:

> Time was when only California and the solid south gave two hoots for
> the blues—and then only the Negro populace of those sectors did the
> raving. The rest of the world was swing conscious. Today that is far from
> true. Such bands as Louis Jordan, Sam Price, Count Basie (the latter
> plays both swing and blues), Buddy Johnson and Jay McShann are fa-
> vorites in every section. They prove it by drawing more patrons into the-
> atres and dance halls and selling more records than any other band or
> bands. Even Erskine Hawkins had to resort to a "blues" number, "Baby
> Don't You Cry" to rate number one on the juke boxes for 1943.

Of course the "Boogie Woogie" moved in to split the ticket, but that

part of the appeal is limited almost to the piano. And besides such in-
dividual artists as T-Bone Walker, Big Joe Turner, Wynonie Harris and
others kept pace to provide the blues with a majority. . . . Yes, it looks
like we are headed the way Ida Cox, Ma Rainey, Bessie Smith, Mamie
Smith and others started us years ago."[1]

Part of what was happening was a shift toward harder, more driving
dance rhythms, as exemplified by Kansas City bands like Count
Basie's. These had a more blues-based sound than eastern outfits like
Duke Ellington's orchestra, not to mention Glenn Miller's or Guy
Lombardo's. Basie even cut a series of piano-and-rhythm records that
were pure adaptations of 1930s blues hits—"How Long Blues," "The
Dirty Dozens," and "When the Sun Goes Down" were typical—and
his first vocalist, Jimmy Rushing, was equally schooled in the Carr
style, with an overlay of the louder, Kansas City "shouting" approach
of Big Joe Turner. As with many performers who are most famous for
their blues work, Rushing resented being typed as a blues singer. He
sang Tin Pan Alley standards and tender ballads as well, and was frus-
trated when Basie hired Helen Humes to do the pop material and he
was pushed pretty much full-time into a blues role. (Ironically, Humes
herself had first recorded as a teenaged blues queen, accompanied by
Lonnie Johnson.)

In the first years of the 1940s, band singers were taking over the
blues field. The defining new hits were Billy Eckstine's "Jelly, Jelly"
with Earl Hines's orchestra, Walter Brown's "Confessin' the Blues"
with Jay McShann, and the Rushing-Basie "Going to Chicago Blues."
The singing styles still owed a lot to Carr and Lonnie Johnson, but ra-
dio and jukeboxes were making it possible for folks all over the coun-
try to hear full-sized horn bands, played at whatever volume they
pleased, and that was the sound of the moment. The big bands were
already on their way out, though, threatened by the twin forces of eco-
nomics and technology, and their demise was hastened by the extreme
contraction of the record business during World War II. The War Pro-
duction Board issued an order restricting domestic use of shellac,
which was the main component of phonograph records, and in August
1942, the American Federation of Musicians imposed a recording ban

to force the payment of royalties for records played on radio and in public places.[2] This meant that virtually no records were made between 1942 and 1944, and by the time recording resumed, the full orchestras found a lot of their work taken by smaller groups. With electronic amplification, five players could be as loud as fifty, and club owners saw no reason to foot the expense of any more musicians than necessary.

Smooth trio balladeers and hot "jump" combos were on the rise, and both made blues a staple of their repertoires. By 1945, six of the eight songs to hit number one on the *Billboard* "Race" chart were blues. Two were with big bands, Eddie "Cleanhead" Vinson singing "Somebody's Gotta Go" with Cootie Williams and his orchestra, and Wynonie Harris singing "Who Threw the Whiskey in the Well" with Lucky Millinder, but the rest were by small groups. Two were actually versions of the same trendsetting song: "I Wonder" took off in a version by Private Cecil Gant, whose smooth style established a cocktail blues sound that made it one of the decade's defining records, and it had stiff competition from a cover by the old-time barrelhouse master Roosevelt Sykes, which held the number-one slot for seven weeks. Gant was from Nashville, as Leroy Carr had been, and "I Wonder" blended a vocal style formed under Carr's influence with the sophisticated piano approach of Nat Cole. It was a potent fusion, at once familiarly soulful and suavely urbane, and was instantly picked up by two Texas pianists, Charles Brown and Ivory Joe Hunter. Both started out with the Three Blazers, a Cole-style trio led by guitarist Johnny Moore, and both were such smooth, cultured singers that they became musical matinee idols—and later would be banished from the mainstream of blues history. Hunter did not rate even a mention in 1979's massive *Blues Who's Who*, and Brown only edged his way into the consciousness of the white blues world in the 1980s, when Bonnie Raitt took him on tour.

Gant, Brown, and Hunter all made their names on the West Coast scene. World War II had brought a flood of African Americans to California, forced out of the Southwest by the same dust storms that were ruining white farmers, and drawn by job openings in the war industries. After Pearl Harbor, there was a rush to build ships for the Pacific

Fleet. Los Angeles became a major center of war workers and, to serve them in their off hours, of black clubs and entertainers. These artists came mainly from Texas and the Southwest: the Texans included T-Bone Walker, Lowell Fulson, Cleanhead Vinson, Amos Milburn, Lloyd Glenn, Pee Wee Crayton, and Floyd Dixon, while Oklahoma provided Roy Milton and the Liggins brothers, Jimmie and Joe. Many of these names will ring few bells with modern blues fans, but Joe Liggins, for example, skewed the 1945 chart in favor of small-combo blues by keeping a twelve-bar hit called "The Honeydripper" in the number-one position for eighteen solid weeks.

These artists were contemporaries of Robert Johnson and the Mississippians who would shortly pioneer the electric "down-home" sound associated with Chicago, but they tended to be more musically sophisticated, as at home in jazz or pop as in blues settings. Charles Brown had been a high school science teacher before moving west, and got his start in the L.A. music world after winning a talent contest in which he played Earl Hines's piano showcase, "Boogie Woogie on St. Louis Blues," then encored with the "Warsaw Concerto."[3] Such artists played blues because it was in demand, and updated the style to suit the mood of the time—just as Carr and Tampa Red had done fifteen years earlier. As with Carr and Red, this did not negate their deep blues roots. Texas had always been a major blues center, and T-Bone Walker had spent part of his childhood leading Lemon Jefferson, while Lowell Fulson had traveled around the state as accompanist to Texas Alexander.

The fact, once again, is that blues and jazz were part of the same musical world. Some rural bluesmen were unable to negotiate swing chord changes, and some swing bands were incapable of getting any blues feel, but a great many musicians straddled both genres, often without even thinking about it. In the 1940s, the Three Blazers were in the same bag as the King Cole Trio, the Kansas City shouters were hitting as part of the big band craze, and the Race charts were dominated by such unclassifiable figures as Louis Jordan and Dinah Washington.

Along with the West Coast sound, a lot of blues was coming out of the middle of the country. Kansas City spawned a series of "blues

shouters," influenced by the majestic Big Joe Turner. Turner's raw, exuberantly powerful style was taken up by singers like Jimmy Witherspoon and Wynonie Harris, and is generally hailed as a root source of rock 'n' roll. Both Witherspoon and Harris started out as big band vocalists but were equally at home with smaller combos, and they can be taken to represent dozens of other, less successful singers. Indeed, as with the 1920s or 1930s, the names I am mentioning throughout this chapter are only tips of a vast iceberg, not necessarily more talented—or even more influential, at least on a regional level—than dozens of other performers who did not get the same breaks in a notoriously capricious music business. I am not trying to mention even all the major hit-makers, but only to give a sense of the trends that drove blues in this period.

Three artists, though, must be covered in somewhat greater detail. Louis Jordan is the first, both because of his overwhelming popularity and because he is so often thought of as a jive comedian rather than as a blues singer. Jordan had been born in 1908, in rural Arkansas, and his father played in the orchestra for the Rabbit Foot Minstrels, the touring tent show in which Ma Rainey had introduced blues to the world. Jordan started playing with the troupe in his early teens, and also traveled with Rainey's own touring show.[4] An adept saxophonist, he worked in various bands before joining Chick Webb's orchestra in 1936. Two years later he formed his trendsetting combo, the Tympany Five (tympani was misspelled, and the group always had more than five members, but it hit so big that no one quibbled), and by the mid-1940s he had achieved a dominance of the R&B charts that remains unequaled to this day. In 1946 he had five of the seven number-one records, with his "Choo Choo Ch-Boogie" holding the top spot for eighteen weeks.[5] The following year, he had four of the seven chart toppers, accounting for forty weeks in all. And that does not include the dozen top-ten records he had in those two years that failed to reach the number-one spot, in most cases only because other Jordan songs had gotten there first.

Jordan's appeal was almost as strong with white as with black listeners, and fourteen of his hits crossed over to the *Billboard* pop charts, while in 1944 he even put two songs in the number-one

position on the magazine's country chart.[6] All of this has led historians to classify him as something other than a blues singer, as if his pop and novelty numbers somehow negated his status as one of the top blues artists of the 1940s. Certainly, he recorded non-blues pieces as well, but B. B. King is only one of many bluesmen who are indebted to him for much of their style and material. "All of my things are based on the blues, twelve-bar blues,"[7] Jordan said, and while that is a slight exaggeration, most of his hits were indeed in the basic twelve-bar pattern. Even jumping jive numbers like "Caldonia," "Choo Choo Ch-Boogie," and "Ain't Nobody Here But Us Chickens" were sung over twelve-bar boogies, and if some aspects of their rhythm and feel were unusual for the blues mainstream, the same can be said of Tampa Red's work with the Hokum Boys, or the ragtime rhythms of Blind Blake and Blind Boy Fuller. Indeed, it makes perfect sense to consider Jordan's records an extension of the hokum blues style. He was an entertainer first and foremost, but blues was always his mainstay and his influence was felt as much by later blues singers as by such disparate disciples as Chuck Berry and James Brown. His most sincere memorial may be a quote from Berry, who credited his own humorous wordplay and engaging stage persona to Jordan's example (and his guitar style to the Tympany Five's Carl Hogan): "I identify myself with Louis Jordan more than any other artist," Berry said. "If I had only one artist to listen to through eternity, it would be Nat Cole [but] if I had to work through eternity, it would be Louis Jordan."[8]

A more obvious model for Berry's music, if not his writing, was T-Bone Walker, who was the defining blues guitarist of the 1940s, as well as being the top live entertainer among the West Coast crooners. Though his first record, from 1929, was a pure Leroy Carr imitation, by the time he hit in the 1940s Walker had become a stronger and more modern singer. The Carr inflections were still there, but now colored with a wealth of jazz phrasing. History remembers him as a trailblazing guitarist, since he and Charlie Christian—who in their youth had worked together as a dance team—essentially invented electric lead playing, blending Lonnie Johnson's innovations with the sustained, hornlike phrasing that had been impossible on the acoustic instrument. His first hit, though, was as a guitarless vocalist with Les

Hite's orchestra, and it was his singing and dynamic live shows that made him a superstar. He was famed for his hot dance moves, doing the splits while he played guitar behind his head, and delivering songs with a suave romance and humor that took blues out of the juke joints and put it in the classiest urban nightclubs.

Walker's blend of biting electric guitar, exciting stage moves, and big band backing was an inspiration to a generation of blues artists, though only a handful would ever have the financial security to build a similar sound—for the last forty years, B. B. King and Ray Charles have been the only bluesmen to regularly carry a Walker-sized band on the road. Like King, who has often named Django Reinhardt as his favorite player, Walker was a far more complex and sophisticated musician than he is usually given credit for, and at live shows he interspersed his blues numbers with pop ballads like "Stardust."[9] He never equaled Jordan's genre-spanning success, but his showmanship and musical innovations transformed blues, and his image as a thrillingly attractive guitar-hero frontman presaged generations of blues and rock idols.

The third trendsetter of 1940s blues was Dinah Washington, who almost single-handedly reinvented the role of the blues queen. If I had to propose three names as the most underrated influences in American singing, they would be Carr, Sam Cooke, and Washington—all recognized as important figures, but rarely given full due for the overwhelming effect they had on later generations of vocalists. In Washington's case, this is particularly odd, since she was so widely celebrated over so many years, and carried the mantle of the century's defining blues superstars.

From its earliest days, blues had been considered primarily women's music, and it is an almost immutable rule that when men were the genre's biggest stars that meant that it had become a secondary market rather than a mainstream black pop style. In the 1930s, for example, women had ceased to lead the blues field because they were too busy setting the vocal standard for swing and big bands, and to many music listeners blues had disappeared with them. Throughout the pages of the main black newspapers—the *Chicago Defender* and New York's *Amsterdam News*—for that decade, the word "blues" is

almost never used in reference to a male singer. (The sole exception is W. C. Handy, still touring as the music's pioneering progenitor.) As far as the mainstream black entertainment business was concerned, the decade's most visible blues star was still Ida Cox, who continued to carry a full troupe including dancers and comedians, and to fill theaters throughout the South, as well as in Chicago and other northern cities that had substantial black populations.[10] Alberta Hunter and Ethel Waters were by then considered pop singers rather than blues queens, but remained major figures. Billie Holiday was occasionally mentioned as a blues stylist on the strength of her breakthrough hit, "Billie's Blues," but soon became better known for her unique transformations of Tin Pan Alley material. In 1940, when Lil Green hit with "Romance in the Dark," then followed up with "Why Don't You Do Right," this was widely hailed as a return of the blues, as if the music had essentially disappeared when the Depression ended the era of the great blues queens. Green's guitarist was Big Bill Broonzy, and her second hit was penned by Kansas Joe McCoy, but neither of these names had ever been considered on a par with Cox, Hunter, or any of the various Smiths, and neither was even mentioned in her newspaper reviews. Wee Bea Booze's success with "See See Rider" was only one manifestation of the revival Green was spearheading. Holiday, who had briefly returned to blues in 1939 with "Fine and Mellow," covered "Romance in the Dark," while Peggy Lee had her first major hit with "Why Don't You Do Right."

It was during this flurry of big-band canary blues that Lionel Hampton hired Ruth Jones, a teenager who sang in the thin-voiced, jazz-inflected Green-Holiday style. Jones had been a member of the Sallie Martin Singers, one of Chicago's top gospel groups, and she brought a gospel inflection to her blues work that would eventually lead to the new style known as "soul" music. With Hampton, she changed her name to Dinah Washington, and her first, four-song recording session produced two top-ten Race hits, "Salty Papa Blues" and "Evil Gal Blues." That was in 1944, and for the next twenty years she was America's most popular and influential female blues singer.

If Washington rarely receives her due in the history books, it is in part because jazz and pop historians tend to feel that she devoted too

much of her life to blues and R&B, while many blues historians dismiss her as essentially a pop singer. Of course, this was no problem at all for the record-buying public, which could not have cared less about such classifications, and the only regrets along these lines to come from her legion of imitators were at their own failures to duplicate her genre-spanning success. It is true that Washington started out worshipping Billie Holiday, and ended up sweeping the pop charts with "What a Difference a Day Makes," but she was also regularly billed as the "Queen of the Blues," and most of the top female blues singers to come, including Esther Phillips, Ruth Brown, and Etta James, started out by slavishly modeling themselves on her example.

Washington would achieve her greatest overall pop success toward the end of her career, but her most influential period was the late 1940s and early 1950s. Her dominance of the R&B charts started in 1948, with the torchy ballad "Am I Asking Too Much," but by 1949 she was in solid blues mold with "Baby Get Lost." This was a hard-hitting twelve-bar declaration of war, shaded with traces of gospel melisma that foreshadowed Ray Charles's breakthrough blend of church and barroom. Her next hit, "Long John Blues," was a hiply phrased update of the kind of racy hokum that had dominated the 1930s blues market, a song about a dentist who "said he wouldn't hurt me but he'd fill my hole inside." Over the next five years, she would put twenty songs in the *Billboard* top ten, including big band pop ballads and even covers of country hits. (She reached number three on the R&B chart with Hank Williams's "Cold, Cold Heart" in 1951, and the same position three years later with a fiery, gospelized reimagining of Hank Snow's "I Don't Hurt Anymore," pioneering another fusion for which Charles has received the historical credit.) She always returned to blues, though, reaching number four in 1952 with the old standard "Trouble In Mind," and amusing the kids with stripped-down twelve-bar Rhythm and Blues romps like "TV Is the Thing (This Year)."

The term "Rhythm and Blues" became standard in 1949, after being adopted by *Billboard* as the new chart euphemism for music aimed principally at African-American consumers. Such landmarks understandably get seized upon as evidence of sweeping musical changes, and this was indisputably a period of transformation and upheaval in

African-American life and culture. World War II had sparked a new racial pride, segregation was beginning to crumble at the edges, and it is easy to detect a growth of power and optimism in black pop music. That said, it is at least as easy to detect a lot of continuity. Many of the records on *Billboard*'s chart came from singers already well known for their blues work, and would be classified by most modern listeners as blues. As various historians have defined their terms, many have drawn a dividing line between blues and R&B, but no two would be likely to agree on exactly which songs end up on which side. B. B. King has regularly pointed out that the terms varied from city to city and year to year, and that he always considered himself firmly part of the R&B era. Meanwhile, the newly named chart still included names like Tampa Red, who made the top ten in both 1949 and 1951—not to mention Lonnie Johnson, whose lilting ballad "Tomorrow Night" had taken the number-one spot for seven weeks in 1948. The lines became no clearer in the next decade: In heavy blues towns like Memphis or Chicago, innovative hits like Muddy Waters's "Hoochie Coochie Man," Little Walter's "Juke," or any number of King's records might have been considered modern R&B, while in New York or Los Angeles they might sound countrified enough to be classified as blues. More to the point, nobody in any of these places would have cared much one way or the other.

One artist who perfectly exemplifies the absurdity of insisting on such categories is Big Joe Turner. Born in 1911, Turner started out leading blind street singers and listening to records of everyone from Ethel Waters to Leroy Carr, but the full-voiced Bessie Smith left the strongest mark on him, and he became the prototypic Kansas City shouter. By about 1930, he had teamed up with Pete Johnson, a pianist whose solid left-hand bass rhythms would form one of the cornerstones of the boogie-woogie craze, and was doubling as singer and bartender in the city's thriving after-hours clubs. A big, funny man, famed for his overpowering volume and endless supply of verses, Turner influenced a generation of Midwestern male singers before making his first record. Everyone toured through Kansas City, which thanks to a particularly corrupt political machine was then the region's center for booze, prostitution, gambling, and—by direct extension—

jazz, and Turner got all the work he wanted without bothering to leave town.

It was only in 1938 that he and Pete Johnson finally recorded, after John Hammond brought them to New York for the first "From Spirituals to Swing" concert. This was a key event in introducing blues, gospel, and jazz artists to a white intellectual audience, but only in Turner's case did it lead to the top of the R&B charts, and only by a rather circuitous route. The concert sparked a nationwide boogie-woogie craze, and made Turner the idol of white jazz fans who found Billie Holiday too thin for their blood and Josh White and Big Bill Broonzy too folky. He had a couple of R&B hits in the mid-1940s, but struck gold only after meeting Ahmet Ertegun, an erudite young jazz fan who was co-owner of the new Atlantic record label. It was 1951, and Turner had recently taken over Jimmy Rushing's chair in the Count Basie Orchestra, but felt hobbled by the big band's tightly tailored arrangements. Ertegun offered him a solo deal, and teamed him with small combos that were better suited to his tastes. Their first hit was a blues ballad, in line with Lonnie Johnson's "Tomorrow Night," but Turner was not a ballad singer and he only hit his stride two years later, with "Honey Hush," an original blues shouted over boogie piano. The basic pattern was unchanged from Turner's days in the K.C. barrooms, but Atlantic added a shuffling drumbeat, electric guitar, and honking sax, and the ebullience of Turner's vocal—the last two verses find him singing just the words "Hi yo, hi yo, Silver" over and over in various voices—put the record at number one for eight weeks. Eight months later, he topped the charts again with a soundalike sequel called "Shake, Rattle and Roll," another slice of classic Turner, featuring verses like "You wear those dresses, the sun comes shining through/I can't believe my eyes all that mess belongs to you." When it was covered—with cleaned-up lyrics—by a white country singer named Bill Haley who had formed a good-time combo in emulation of the Tympany Five, the forty-three-year-old Turner was suddenly a teen idol and leader of the rock 'n' roll revolution.

Like virtually all the blues singers so far mentioned in this chapter, and most blues stars of the1920s and 1930s, Turner was quite capable of singing other material. At the same session that produced

"Shake, Rattle and Roll" he also cut versions of Irving Berlin's "How Deep Is the Ocean" and the Frank Sinatra hit "Time After Time," which he would continue to perform until the end of his career.[11] In blues as in other styles, the more versatile and sophisticated artists, who could adapt to changing fashions, tended to be the most consistent and reliable hit-makers. This was particularly obvious in the work of the smooth balladeers, since blues crooning and pop crooning involved essentially the same vocal techniques, but the big band shouting style, descended from pre-microphone powerhouses like Ma Rainey and Bessie Smith, also proved remarkably adaptable. Men like Turner and women like Big Mama Thornton, Big Maybelle, and La-Vern Baker proved that the old, loud style was as well suited to the hard-rocking R&B horn bands of the 1950s as it had been to the jazz horn bands of the 1920s.

There was another kind of blues performer, though, who was less adaptable and more idiosyncratic. Just as Lemon Jefferson and Charley Patton had found audiences for their unique styles even in the era of piano combos and vaudeville queens, the late 1940s and early 1950s saw a new wave of "down-home" bluesmen rising up alongside the jazzier, poppier R&B artists. The most surprising of these were singer/guitarists like Lightnin' Hopkins and his cousin Smokey Hogg, who played their own accompaniments, at times on acoustic guitars. These players could to some extent be considered survivals of an earlier era—Hopkins had accompanied Texas Alexander, and Hogg had billed himself as "Little Peetie Wheatstraw"—but their sound was distinctive, and they managed to put a string of singles in the R&B top ten.

Hopkins and Hogg were from Texas, but the biggest star in this style was a Mississippian, John Lee Hooker. Hooker burst on the scene in 1949 with "Boogie Chillen," and put three more records in the top ten before ending his run with another number one, 1951's "I'm in the Mood."[12] From a musical perspective, Hooker's approach was astoundingly archaic, and if one wanted to get involved in arcane musicological battles it would be easy to argue that most of his work was not even blues in any normal sense of the word. Many of his songs were far closer to field hollers than to any previous blues hits, consist-

ing of unrhymed lines interspersed with moody moans, with no regard for normal bar lengths. His style was so personal and improvisatory that sidemen routinely got confused trying to follow him, and most of his greatest recordings were done alone, with only his voice, electric guitar, and sometimes his tapping feet. (As for his penchant for ignoring rhymes, it could reach perverse extremes: The first verse of "I'm in the Mood" begins "Every time I see you, baby, walking down the street/Know I get a thrill now, baby, from my head down to my toes.")

Not all the down-home bluesmen were as deep as Hooker and Hopkins, and one who would prove to be singularly influential came from the opposite end of the spectrum. Arthur "Big Boy" Crudup, who hit in 1945 with "Rock Me Mama" and continued his run through 1951, was a Mississippi singer with a light voice and musically regular guitar style, worlds away from Hooker's ominous moan and eerie electric improvisations. Backed only by bass and drums, he kept an infectiously danceable beat that at times seemed to owe as much to western swing or hillbilly as to older blues, and delivered his lyrics with cheerful exuberance. The result was savvy and youthful, but with a countrified flavor—a combination that would hit a decade later for another Mississippian, Jimmy Reed—and it is easy to see why it was taken as a model by some young white rural musicians.

"The colored folks . . . played it like that in the shanties and juke joints, and nobody paid it no mind till I goosed it up," Elvis Presley would say in 1956, two years after launching his career with a high-energy cover of Crudup's "That's All Right." "I got it from them. Down in Tupelo, Mississippi, I used to hear old Arthur Crudup bang his box the way I do now, and I said if I ever got to the place I could feel all old Arthur felt, I'd be a music man like nobody ever saw."[13] Presley recorded a number of Crudup's songs, and to some extent can be filed as a similarly light, countrified, down-home blues singer—though his debt to Dean Martin was equally obvious and in the long run probably accounted for more of his popularity. He stuck to the stripped-down trio or quartet format, eschewing horns, and plenty of people in his first heyday reflexively thought of him as a blues singer.

There was obviously a vast difference between Presley—countrified as he was—and down-home artists like Hopkins, Hooker and the

crowd of Mississippi expatriates who came roaring out of Chicago's South Side on the heels of Muddy Waters. Nonetheless, it is worth remembering that Presley was also on the R&B charts, was originally hailed as a wild, primitive, and startlingly black-sounding singer, and might have fit more easily alongside them than alongside Dinah Washington or Louis Jordan.

To a great extent, what makes us file some artists as rock 'n' rollers, others as R&B singers, and still others as hard bluesmen has more to do with who accepted them, and how famous they became, than with how they sounded. Bo Diddley, for one, is routinely filed as a rock 'n' roller, though in musical terms he had as much in common with Hooker or Waters as he did with Presley and Chuck Berry. The only logical reason for this is that white teenagers bought his work in a way that they did not buy Hooker's—that his popularity was broad enough to lift him out of the blues category.

This highlights an important fact: Part of what defines the artists who have been remembered as "pure" bluesmen is that they were always a relatively minority taste. Hooker and the Chicagoans, great and popular as they were, never had the widespread appeal of Charles Brown, Big Joe Turner, or a jazzier player like B. B. King, whose obvious links to uptown stars like T-Bone Walker and Louis Jordan made him more acceptable to the cosmopolitan clubgoers of Harlem and Watts. The down-home singers could never even dream of reaching the heights attained by someone like Dinah Washington. Even at the moment of their greatest popular success, much of the more educated and urbanized black population thought of them in terms that are exemplified by an article that ran in the *Chicago Defender* in 1951:

> For over a year the trend in the sepia music circle has been toward the blues. Blues artists such as Baby Face Leroy, Smokey Hogg, The Howling Wolf, Muddy Waters and Joe Turner are enjoying unprecedented popularity.[14]
>
> One other artist, John Lee Hooker is by most standards the undisputed "king of the blues." . . . His records invariably create a picture—a picture of a big strapping buck sitting on a log playing his guitar. At Hooker's feet lies a coon dog, his nose resting on his outstretched paws.

Surrounding Hooker are four other young bucks who have brought their instruments and jugs. The combo plays for fun, joyful in the knowledge that the day's work is over and the best part of the day, night is yet to come. . . .

John Lee Hooker personifies a way of life that is familiar to many of our older citizens who have migrated from the south. For the most part these people love the blues, especially when they hear familiar instruments like the guitar and harmonica.

Blues are a part of our American heritage—a heritage that we should be proud, not ashamed of.[15]

Note that this is in Chicago, the apex of the down-home craze. Nationally, Hooker would have been considered more of an anomaly than a trendsetter, and no equally rural-sounding artist would come close to matching his success. Waters, for example, never placed a song higher than number three on the R&B charts—and that was "I'm Your Hoochie Coochie Man," the first record on which he used a full, piano-driven band and sang a hip, funny lyric by the pop-oriented Willie Dixon rather than one of his own Delta-derived, Son House–style slide guitar numbers. Indeed, it is educational to compare a list of the Chicago-based Mississippians who are considered legends—Waters, Howlin' Wolf, Aleck "Sonny Boy Williamson" Miller, Elmore James—with those who actually got number-one hits during this period: Eddie Boyd and Bo Diddley joined Tennesseeans Memphis Slim and Willie Mabon and the Louisianan Little Walter as the Chicago blues scene's R&B chart toppers.

Diddley was the only one of this bunch who might be considered a primitive, rural-sounding player, and he is a musical eccentric of his own unique stamp. The other four were versatile performers with few rural touches, three of them pianists. Boyd was actually Waters's cousin, and Waters briefly worked in his band, but could not manage the jazzy Johnny Moore licks Boyd favored.[16] Little Walter, by contrast, worked for Waters and is often classed alongside him because of their almost telepathic gifts as collaborators, but he was nearly twenty years younger, and his harmonica playing resembled nothing from the older, acoustic era. He thought like a saxophonist, completely transforming

his instrument's musical range, and left the band in 1952 after hitting with "Juke," a revolutionary instrumental that was Chess Records' biggest chart success to date, spending eight weeks at number one.[17] Mabon was the only other Chess artist to equal this feat—with a slinkily nasty blues novelty called "I Don't Know"—until Chuck Berry came along three years later with "Maybelline."

This is not to say that the deeper, more down-home players did not have a significant impact. Their strongest audience was in the South or among urbanites with strong Southern connections, but they also gained converts in the wider market, and measured over the long haul, some were more successful than the bigger hit makers. Leonard Chess, who founded the Chess label, has been quoted as saying, "Fuck the hits, give me thirty thousand on every record."[18] Whereas a single like Eddie Boyd's "Five Long Years" could spend five weeks at number one because of its mainstream, Carr-style appeal, it did not inspire the hard-core devotion that kept fans following their idols for record after record, making individualists like Waters or Wolf into long-term consistent sellers. And, of course, none of this is to deny the greater adventurousness, emotional power, and artistic depth of the best down-home singers. Once again, I am not trying to diminish the stature of geniuses like Waters and Wolf, but only to stress the fact that there were always smoother, more mainstream blues singers who were reaching larger audiences. In 1952, it was impossible to imagine that half a century later the earthiest of the Chess bluesmen would be more famous than T-Bone Walker, Charles Brown, or Dinah Washington. Not only could they not compare in sales, but they were considered essentially a backward, archaic taste, appealing mostly to country folk and Southern immigrants. With the arrival of rock 'n' roll, the down-home players were wiped off the charts, and everyone in the music business took it for granted that in another few years they would be completely forgotten.

In a way, the brief craze for down-home styles in the late 1940s and early 1950s can be compared to that period in the 1920s when Blind Lemon Jefferson, Blind Blake, Charley Patton, and the other rural guitarists came to the fore. Once again, the music business was aston-

ished to find that a lot of black record buyers (and a few white ones) would go for idiosyncratic, countrified individualists. And, once again, a cooler, more urbane style came along and flooded the country players out. In this way of looking at things, Chuck Berry was the 1950s' Leroy Carr, a role he actually fits rather well. Waters, in particular, had an influence beyond his sales, but by the 1960s pretty much all of the down-home players would have been hard-pressed to make a living in music if the white audience had not discovered them.

This is not to say that blues, in a more general sense, saw any downturn with the coming of the rock 'n' roll revolution. Basic twelve-bar songs, sung in styles that reached back at least to the 1930s, remained a very strong part of the black entertainment world. Even if we look only at the records that made it to number one on the R&B charts in the mid- to late 1950s—a very limited selection, sometimes reflecting luck as much as sales, since one month's number three could outsell another's number one—they still include plenty of blues:

1954: The year's biggest R&B hit was Guitar Slim's "The Things That I Used to Do," topping the charts for fourteen weeks; Joe Turner had "Shake, Rattle and Roll"; Hank Ballard and the Midnighters had "Work with me Annie" and "Annie Had a Baby"; and B. B. King had "You Upset Me Baby."

1955: Little Walter had "My Babe," and Fats Domino reworked Big Bill Broonzy's "All By Myself."

1956: Little Richard had "Long Tall Sally" and "Rip It Up" (the twelve-bar form with a new beat); Ray Charles had "Drown in My Own Tears" (a variation on the Charles Brown sound); Elvis Presley had "Hound Dog" (an R&B number one for six weeks, and Pop number one for eleven); and Bill Doggett had the year's top hit with the instrumental "Honky Tonk." (Meanwhile, Joe Turner went to number two with the old Mississippi favorite "Corrine Corrina.")

1957: Chuck Willis sang a new version of Ma Rainey's trademark hit, now respelled "C.C. Rider"; Jerry Lee Lewis had "Whole Lot of Shakin' Going On," an update of "Pinetop's Boogie

Woogie"; Bobby "Blue" Bland had "Farther Up the Road"; and there were also blues-inflected chart toppers from Fats Domino and Ivory Joe Hunter.

1958: Two versions of "Raunchy," an instrumental that slightly varied the twelve-bar form, made it to number one, though the year's other top hits were lighter, teen-oriented fare.

1959: Two old-fashioned songs made number one in both R&B and pop: Lloyd Price's New Orleans version of the pre-blues ballad "Stagger Lee," and Wilbert Harrison's "Kansas City."

1960: Buster Brown had the harmonica-powered, country-sounding "Fannie Mae."

There are people who will argue that some of the songs on this list are not blues, but in a way that is my point. We are so used to accepting modern categories that we forget how little they meant at the time. It is easy to say that Muddy Waters was a bluesman, Ruth Brown was R&B, the Coasters were rock 'n' roll, and Ray Charles was the inventor of soul music. The fact is that "Hoochie Coochie Man," Waters's biggest hit, crossed all those lines: The old folks would have called it blues—some particularly clueless white people might even have said "jazz"—a young black record buyer would have called it Rhythm and Blues, and a white kid would have been more likely to say rock 'n' roll. Whatever the name, it was obviously a hip, funny song, and all three of the above artists shortly had their own comedy hits using the same arrangement: Charles was on the charts a month after Waters with "It Should Have Been Me," Brown had "I Can't Hear a Word You Say," and the Coasters (then called the Robins) did "Riot in Cell Block Number Nine."

Which is to say when Waters and Hooker were at the peak of their success in the black pop world, the people buying their records thought of them as exciting and up-to-date. There was a "down-home" audience that was particularly drawn to rootsy, Southern-sounding artists, but I suspect that very few of the original supporters of the electric style we now call Chicago blues considered it old-fashioned. On the contrary, when Marshall Chess (co-owner of Chess Records) was asked what made Waters so successful, his answer was one that

could be applied to pop stars from Frank Sinatra to Ricky Martin: "It was sex. If you had ever seen Muddy then, the effect he had on the women! Because blues has always been a women's market. On Saturday night they'd line up ten deep."[19]

Listening in the twenty-first century, it is easy to hear Waters and his peers as essentially electrified Delta bluesmen, one step away from Son House and Robert Johnson, and to emphasize their roots rather than their urban stardom. As the *Chicago Defender* piece I have quoted demonstrates, there were intellectuals in the black community as well as the white who would have made that case even at the time. But that ignores the other side, the showmanship and hipness that attracted the screaming crowds of fans and late-night radio listeners across the country. Like Johnson himself—or Sinatra, Presley, James Brown, the Beatles—they were rooted in older sounds, but were creating something very much of their time. Waters appeared not only in smoky ghetto clubs, but also on rock package shows alongside acts like the Clovers, Bill Haley, Fats Domino, Charles Brown, and even Sarah Vaughan. These were not always perfect matches—James Cotton would recall the Waters band being booed when they opened for Vaughan at Washington's Howard Theater—but at the rowdier rock 'n' roll shows, Waters did just fine.[20] This was a time when Wolfman Jack was broadcasting from the Mexican border, and one of his typical segments would segue from Bob B. Soxx and the Blue Jeans singing "Zip-A-Dee Doo-Dah" to Jerry Lee Lewis's "Great Balls of Fire," then into a rap that would go something like: "Here's Elmore James and his *funky*-funky slide guitar. Makes me want to get naked every time I hear it, baby . . . and I wantcha to reach over to that radio, darlin', right now, and grab my knobs!"[21]

It is hard for us to understand this today, not only because the world has changed but because we can never see these artists as they appeared in their prime. By the time Muddy Waters was caught on film, he was already working for a white revivalist audience, and we tend to see him sitting in a chair, his guitar in his lap, stolidly singing his down-home blues. We do not see him striding the stage of a Chicago club, sweating from every pore and driving the women crazy.

For me, the revelation in this respect came when I finally saw some

film of Howlin' Wolf. Wolf was the rawest of the down-home stars, and his voice blasts out of my speakers today with a growl that reaches back to Charley Patton and beyond into some terrifying, prehistoric past. The quotations from his peers and fans suggest the same primeval power: Johnny Shines said, "I was afraid of Wolf. Just like you would be of some kind of beast or something."[22] Sam Phillips, who recorded Wolf for his Sun Records, still considers him the greatest raw talent he ever met, and famously described his sound in otherworldly terms, as "where the soul of man never dies." And yet, this is the same Wolf who, comparing himself to the other blues singers who moved north to Chicago, said, "I had a four thousand dollar car and $3,900 in my pocket. I'm the onliest one drove out of the South like a gentleman."[23]

The only extended Wolf footage I have seen was filmed in 1966, at the Newport Folk Festival, in a reconstruction of a rural Mississippi juke joint. (As with Big Bill Broonzy's being presented to white audiences as an Arkansas sharecropper, it is worth pausing a moment to consider how appropriate this setting was for a man who had already been a star of the Chicago club scene for over a dozen years.) Wolf sits in a chair and plays four songs, sounding as gruff and untamed as on his records. But, in contrast to the ferocity of his sound, he is funny. Broadly, ridiculously funny. He pops his eyes and lasciviously licks his harmonicas and his guitar neck. To introduce "Meet Me in the Bottom," he mimes the comic fear of an adulterer caught in the act and forced to hastily jump out a window: "This is the blues here—this here's when you're in devilment and ain't got no business *in* there! And then when you get scared and break and go to running, then you're gonna send, call back to some of your friends and say, 'Joe, bring me my running shoes, please, because I'm barefooted . . .'"

He wags his finger like a scolding parent, mugging and breaking into a broad smile as he introduces "Dust My Broom." Blues experts have explained ad infinitum that this title phrase was a slang expression for leaving town, but Wolf explores the possibilities of another comic scenario: "You know, when you've got a lazy woman, then you hate to come in and tell her, say, 'Why don't you sweep up the house?' And she'll jump up and say, 'Sweep it up yourself!'" The guitar plays

an introductory riff, and he is singing, "I'm gonna get up in the morning, I believe I'll dust my broom. . . ."

In this performance, Wolf did not proceed to roll around the floor with a broom between his legs, but old fans recall others in which he did. He could be one of the most outrageous performers in blues, crawling across the stage like his namesake, or climbing theater curtains à la King Kong. The man was an entertainer. Like Charley Patton or Leadbelly or Robert Johnson. Like Louis Armstrong, Cab Calloway or James Brown. Like Elvis Presley or Mick Jagger or Eminem. He was also a great musician, a deeper and more vital artist than most on that list. There is no contradiction there. One can be a great artist and at the same time a pop star, a comedian, and a sex symbol. Indeed, on the blues scene as on most other popular music scenes, that was often a necessity. The pop audience, black or white, is one of the most demanding on earth. At times it will accept artists whom the intellectuals and critics consider mediocre, but it will not stand for being bored—something the intellectuals and critics are often all too willing to do. And when Howlin' Wolf, Muddy Waters, T-Bone Walker, Dinah Washington, Bessie Smith, or Charley Patton were in their prime they made music that sounds great on record, but they also paid attention to current trends, polished bits of eye-catching stage business, dressed their best, and put on a show that had plenty of humor and sex appeal mixed in with the deep soul and expert musicianship.

Which brings us back to Marshall Chess's comment on Muddy Waters: "Blues has always been a women's market." That was also true in the Delta in 1930, according to everything I have heard or read. It was usually women who had a little disposable income and were at home when the record salesmen dropped by. It was female record buyers who made Bessie Smith into a star for telling their stories, and Leroy Carr into a star for seducing them with his sweet poetry. Not women alone, obviously. Men bought too. But Chess's point would be echoed by pretty much everybody in the blues business, as long as they were selling to a largely black public. "I think my audience is more women than men," Little Milton told me in 1994. "And I tell you what, see, that really makes me feel good—because basically for every woman that comes, you can figure that she's going to have at least

three men to follow that one woman. You're laughing, but from experience and observation, it's true. So then I know if I get two or three hundred women, then I'm going to like double that with men. So I just love the ladies."

There is another fact that went along with that. Blues was singers' music. It spawned great guitarists, great pianists, and a complete reinvention of the harmonica, but blues was not about fancy instrumental work. Like country and western—and blues singers have made that comparison over and over—it was about telling stories that reflected people's day-to-day experiences, sharing their troubles and celebrating their pleasures.

Hence the fact that the most popular blues singer of the 1960s, at least as measured by the R&B charts, was Bobby "Blue" Bland—today the only blues star of that generation who still regularly fills clubs in black communities. When Joel Whitburn compiled his list of the Top 500 R&B Artists of all time—an admittedly somewhat bogus list, based on applying an arcane mathematical formula to the *Billboard* charts from 1942 to 1995—B. B. King came in at number 11 and Bland at number 13. The only other artists in the top 100 who are generally considered blues singers are Etta James, Amos Milburn, and Joe Turner, all down in the 90s. (As for the down-home singers, Muddy Waters is at 205 and John Lee Hooker at 334.) As with my list of top recording figures of the prewar era, this list is flawed but indicative, and once again what it indicates is that the more sophisticated and urban-sounding performers generally had the biggest sales and most enduring careers in the African-American market.

Not that Bland was exactly a smooth balladeer. Born just outside Memphis in 1930, he entered the music business as King's chauffeur and valet. Having watched King become the biggest hard-blues hit maker of the early 1950s, he set off on his own and stormed his way to number one with 1957's "Farther Up the Road." Bland and King were a sort of middle ground between the down-home players and the café bluesmen. They were influenced by the Carr crooning tradition, in that they could sing soft and pretty when they cared to, but what was most striking in their work was the infusion of hard gospel inflections. This meant that, along with capturing the urbane, post–T-Bone

Walker crowd, they had a grit and rootsiness that appealed to the same older and Southern audiences that bought Muddy Waters.

Bland was the last major black hit-maker to be classed as a blues singer, and it is symptomatic of the differing tastes of black and white blues fans that, despite being the biggest-selling bluesman at what is generally considered to have been the height of the blues revival, he has never had much of a white following. Between 1960 and 1974, he put twenty-three songs in the R&B top ten and, along with King, defined the soul-blues trend that would include Little Milton, Albert King, Little Johnny Taylor, and Junior Parker. All of these artists were singers first and foremost, which has always been what counted with black blues buyers. It was only the musicians and the white fans who cared much that B. B. King played guitar and Bland did not. Both were magnificent communicators, with a screaming, emotional delivery that provoked an ecstatic response, drawing obvious comparisons to gospel preaching. Both were also hip, contemporary stars. They paid tribute to the down-home sound but, despite their geographical roots in Mississippi and Memphis, would never be confused with old Delta bluesmen. Today, though rarely receiving his due in books and on revival albums, Bland is still going strong, and still draws his biggest crowds in black neighborhoods.

A couple of down-home players did get chart action in the 1960s, and one could argue that they provide the only example of obvious nostalgia in the history of the African-American pop scene. Jimmy Reed was a startlingly old-fashioned player, his guitar rocking along in the solid boogie shuffle that Robert Johnson had pioneered, while his harmonica whined and his relaxed, sly drawl sounded as if he was just singing to a few friends on his back porch. He might wear sharp zebra-patterned jackets, but where Waters, Wolf, or Hooker had an awesome, frightening power that made them sound tougher than the hardest rockers, Reed sounded like a laid-back country boy. His chart success was a startling anomaly, but he hung on into the mid-1960s, when he was joined by another harmonica-guitar drawler, Slim Harpo, a Louisiana swamp bluesman who went to number one in 1966 with the seductively lazy "Baby Scratch my Back." It is worth mentioning, though, that although Reed sold as an R&B artist, he recalled his

audiences outside of Chicago as always including more white faces than black. "It'd be either some Indians, some Polacks, or some white folks, or somethin' like that. Just now and then there'd be some colored people . . ."[24]

And that pretty much finishes the story of blues as black pop music. The soul revolution had deep Southern roots, and it was no surprise to find Aretha Franklin or Otis Redding singing a twelve-bar blues on occasion, but it was hard to hear many echoes of the blues era in disco (though, bizarrely, there were several disco-ragtime hits). As I said at the beginning of this chapter, it is all a matter of definition, and one could easily make the argument that James Brown was simply a new kind of blues singer and follow this logic through to Snoop Dogg. Having decided to let the musicians themselves do the defining as much as possible, however, I am struck by how insistent Brown, for one, has been on killing that argument. Born in Georgia, Brown grew up hearing his father sing Blind Boy Fuller numbers, and even had a few guitar lessons from Tampa Red. He modeled himself on figures like Louis Jordan and Little Willie John, both of whom recorded fine blues tracks. And yet, he maintains that while he loved everything from gospel music to Count Basie to Frank Sinatra, he always hated blues. "I don't remember whether I sang them, but I know I never liked them . . . I still don't like the blues. Never have."[25]

Considering that the two hits with which Brown announced himself as the king of funky soul modernity in 1965, "Papa's Got a Brand New Bag" and "I Got You (I Feel Good)," were both cast in the twelve-bar blues form, this seems more than a little odd. By that time, though, Brown was defining a new musical movement founded on black pride, and the word "blues" had come to symbolize the poor, rural, Southern, segregated past. Some black intellectuals might claim artists like Robert Johnson as a valuable part of their cultural heritage, but to a lot of people scraping by in the ghettos of urban America, one of the few consolations in life was that at least they were well away from any cotton fields. As Arthur Crudup would put it, the attitude was: "What's the use in my worrying about going to hear such-and-such-a-one play the blues and I done already had the blues all my life?"[26] By the late 1960s, a lot of black music listeners equated blues

with slave-time music, and in 1969 *Billboard* retitled its "Rhythm & Blues" chart "Hot Soul Singles." By then, all but a handful of blues stars were either working for white audiences or had given up the business. B. B. King, Bobby Bland, and Little Milton still had a few hits coming, but King would soon be working almost entirely for white concertgoers, while Bland and Milton would more and more find their touring confined to the Southern "chitlin' circuit," with occasional forays into the ghetto clubs of Midwestern cities like Chicago, St. Louis, and Detroit. Over the next two decades, this circuit would continue to shrink, though through the 1990s it remained strong enough to provide a decent living for later arrivals like Z. Z. Hill, Denise LaSalle, and Latimore.

Meanwhile, the mainstream of black listeners turned to disco, funk, and rap, and more recently to a new generation of sexy ballad singers and neo-soul sensations. In 1982, the *Billboard* chart for African-American pop music changed its name from "Soul" to "Black," and in 1990 it once again became "R&B," but by then the letters had stopped standing for words, and today the magazine actually has a separate "Blues" chart. Some of the artists on that chart—which ranges from white Stevie Ray Vaughan clones to old-time soul masters like Tyrone Davis—remain far better known to black than white fans, but these singers tend to consider it a musical ghetto and yearn to cross over to R&B. Pretty much any professional performer who is happy to be labeled as a blues artist has long ago become reconciled to playing mostly for white people—except when touring Japan.

Obviously, I am generalizing here. The soul era's standard-bearers of black pride are now in their fifties or sixties, and in the twenty-first century it is not clear that any young black music listeners in urban America have anything against the idea of blues. That whole era is ancient history, and hip-hoppers name-check Robert Johnson along with Marcus Garvey. If anything, though, that simply proves the point. They are not name-checking Leroy Carr or T-Bone Walker, Louis Jordan or Bobby Bland, or any of the black community's biggest blues stars. The white, cult, museum mentality has triumphed, and the whole idea of blues as black popular music rather than a historic folk heritage has disappeared.

13

THE BLUES CULT: PRIMITIVE FOLK ART
AND THE ROOTS OF ROCK

WHEN SCREAMIN' JAY HAWKINS, ONE OF THE WILDEST RHYTHM and Blues performers of the 1950s, made a comeback album in 1991, he appeared on the cover in full jungle regalia, with a snake around his neck and a bone through his nose, holding in his arms the limp body of a pale blonde in a wedding dress. The album's title was *Black Music for White People*.

While individual tastes obviously vary, black and white fans have tended to feel quite differently about blues. To revisit Robert Johnson's example, black fans in the 1930s heard a good singer and writer in the contemporary blues mainstream, with a solid beat, interesting lyrics, but little to distinguish him from a lot of similar and far-better-known stars. The few white fans who heard him at that time seem to have considered him a brilliant rural primitive. In the 1960s, mainstream black blues buyers who stumbled across an LP reissue of his work would have heard a guy who sounded like the old-fashioned countrified music their parents or grandparents might have liked. Meanwhile, young white fans were embracing the same recordings as the dark, mysterious, and fascinating roots of rock 'n' roll.

Jorge Luis Borges once said that every author creates his own precursors. In this sense, the Robert Johnson that most listeners have heard in the last forty years is a creation of the Rolling Stones. Indeed, for most modern listeners, the history, aesthetic, and sound of blues as a whole was formed by the Stones and a handful of their white, mostly

English contemporaries. That is why Leroy Carr and Lonnie Johnson have disappeared from the pantheon, along with almost every other major star of the 1920s and 1930s.[1] They were geniuses, perhaps, but also smooth, intelligent professionals. And as we now know, that is not blues. Blues is the image presented by Keith Richards and Mick Jagger: sex and drugs, and raw, dirty, violent, wild, passionate, angry, grungy, greasy, frightening outlaw music.

Check any popular image of an old-time blues singer. He is male and black, of course. He plays guitar. He is a loner and a rambler, without money or a pleasant home. He is a figure from another world, not like the people next door, or anyone in your family, or anyone you know well. And his music is haunting, searing, and cuts you to the bone.

That is how the blues struck a small clique of English kids in the late 1950s and early 1960s, and it is through their eyes that the rest of the world has come to see it. Which is not to say that they were the first white people to fall for this music, or even the first to seize on it as their personal door into a wilder, more exciting world. The lure of blackness, of primitivism and African rhythms, of the elusive freedom of otherness, has attracted Europeans for centuries. Jagger's love for Muddy Waters is in a line that reaches back to Caesar's love for Cleopatra and Desdemona's for Othello, as well as to Elvis Presley's for Arthur Crudup. ("I said if I ever got to the place I could feel what old Arthur felt, I'd be a music man like nobody ever saw"—he was not just after the notes or style, but the feel.) And it is not for anyone to sneer at such ambitions. Whatever our color, our language, or our continent, we all have images we associate with our favorite music, and the pretensions of blues lovers are no worse or weirder than the pretensions of those who love Beethoven, salsa, or Britney Spears.

But let us stick to the case at hand, and quickly run through its history: White Americans have been attracted to the music of black Americans since colonial times. In the mid-eighteenth century, a French immigrant to rural New York State was writing that, "If we have not the gorgeous balls, the harmonious concerts, the shrill horn of Europe, yet we dilate our hearts as well with the simple Negro fiddle,"[2] and reports of society dances in cultural centers like Charleston,

South Carolina, tell of white dancers enjoying "Negro jigs" along with European minuets.

There are occasional mentions of black performers and styles crossing over to white audiences in the late 1700s, but the real flood came toward the middle of the next century. From about 1840 until the early 1900s, the whole country was caught up in the minstrel craze, with thousands of white entertainers blacking their faces with burnt cork and singing what purported to be "plantation melodies." Many of these songs were simply reworkings of English music-hall entertainment, but others were directly based on African-American sources. Within a few years, the white "Ethiopians" were facing competition from entertainers who required no makeup to look black—though minstrel custom would dictate that all comedians use burnt cork, whatever their natural hue. A newspaper article from 1858 reports: "A company of real 'cullud pussons' are giving concerts in New Hampshire . . . we do not see why the genuine article should not succeed. Perhaps this is but the starting point for a new era in Ethiopian entertainments."[3] As the century rolled on, it became common for African-American minstrel troupes to try to one-up their more numerous Euro-American competitors by stressing their genuineness, often boasting that they were presenting a true picture of black plantation life—even including segments such as "a real cotton picking scene, showing the darkies picking cotton, while singing their melodies."[4] Such claims to accuracy were pretty dubious, but the consistency with which they were made proves that there was an audience that valued the idea of observing "real" black Southerners displaying their "natural" gifts.

While the mass white audience flocked to see professional entertainers presenting a bizarrely reimagined picture of Negro life, there were also some enlightened spirits who tried to draw attention to genuine black folk traditions. Writers, especially if they favored abolitionist views, sought to counter the minstrel and literary stereotype of happy, childlike plantation "darkies." A reporter to the *Continental Monthly* in 1863 noted that, when one heard true Southern Negroes singing, "a tinge of sadness pervades all their melodies, which bear as little resemblance to the popular Ethiopian melodies of the day as twilight to noonday."[5]

Usually, such writers concentrated on religious music. Good Christian folk would praise the Negroes' sincerity of religious observance, and contrast this to the negative stereotype of the lying, lazy savage—though the sincerity was frequently described as "childlike," and few suggested that it was the product of any elevated intelligence. By the 1870s, a group of African-American college students had begun making fund-raising tours as the Fisk Jubilee Singers, and their success spawned a number of "Negro spiritual" ensembles, which generally performed in churches and concert halls. The spirituals were hailed as a rich, valuable cultural heritage, as opposed to the demeaning and grotesque minstrel ditties. Though the student ensemble style was hardly closer than the minstrel approach to the normal singing of rural black Southerners, it did draw attention to the religious songs that had become popular in the oral tradition, and helped to encourage their collection and preservation. Hailed as a valuable cultural expression, these spirituals account for almost all the transcribed examples of African-American rural music before the dawn of recording, which has created the widespread impression that the slaves sang far more religious than secular songs. (The seminal collection of African-American folk songs, *Slave Songs of the United States*, published in 1867, consists overwhelmingly of religious material. Oddly enough, seven of the thirteen secular songs that are included come from Louisiana, and are sung in French.)

It should not surprise us that so little secular music was transcribed, even if—as I tend to believe—it was as common as the spirituals. At the beginning of the twentieth century, the whole field of folklore was still in its infancy. The idea that music created by untrained singers and players might be important, valuable art was fairly avant-garde, and very few educated people made the still greater leap to valuing it precisely because the performers were untrained. Such an idea, though, fit the spirit of America's self-image as the world's cradle of democracy, and also the Romantic movement, which celebrated the wonders of nature and "natural man." It was only a matter of time before folk songs would be hailed as the truest, deepest expression of the American people.[6]

The breakthrough for American folklore publication came in 1910,

when John A. Lomax published his *Cowboy Songs and Other Frontier Ballads*, with a prefatory note by Theodore Roosevelt that pointed out cowboy culture's similarity to the conditions that produced the medieval English ballads. Ballads had become the one folk form that was hallowed in the academy, considered a sort of ancient rural poetry, and the other great American folk music book of the period was 1917's *English Folksongs from the Southern Appalachians*, by the English folklorist Cecil Sharp.

As long as folk song was valued as a carryover of the epic ballad tradition, black singers were not going to get a fair shake. There are a handful of narrative ballads in African-American culture, most famously "John Henry" and the badman ballad "Stagolee," but on the whole the form was not particularly popular.[7] As a result, when early writers would praise the "poetry" of black singers, their examples tended to be only a line or two long, on the order of W. C. Handy's recollection of the phrase he heard at the Tutwiler railroad station. Black music was praised less often for its lyrics than for the style of performance, which could be described as weird, exuberant, plaintive, melancholy, joyous—an array of adjectives that tended to emphasize natural, unspoiled qualities rather than anything that smacked of formal composition or conscious artistry. Perhaps unsurprisingly, these were precisely the same adjectives used by those who loved the minstrel tunes, which ranged from exuberant, joyous songs like "Oh! Susannah" (by Stephen Foster, a white composer from Pittsburgh) to plaintive, melancholy songs like "Carry Me Back to Old Virginny" (by James Bland, a black composer from Flushing, Long Island).

This attitude began to shift with the Harlem Renaissance of the 1920s, which marked a sea change in white America's appreciation of black culture. In particular, it marked a new consideration of black popular music as art. Langston Hughes wrote a number of poems in blues form, and while some people looked askance at such efforts— the academic celebration of "popular culture" was still to come—his work exemplified a hitherto unimagined respect for the literary gifts of the blues singers.

It is worth emphasizing here the extent to which the Harlem Renaissance was driven by white tastes. Of course, the most celebrated

artists were black, and many of the guiding spirits as well, but the people who financed, published, and consumed the fruits of the artistic flowering—whether theatergoers, readers, or buyers of art—came overwhelmingly from the white intellectual and social elites, and their sensibilities were always a prime consideration. As Hughes pointed out, most black Harlemites of the time had not even heard of the Renaissance, "and if they had, it hadn't raised their wages any."[8] For the black artists caught up in this movement, it was a wonderful time, full of promise, but they were also confronted on a daily basis with the stereotypes and romanticism of their patrons. Figures like Carl Van Vechten, the white socialite who was a famous supporter and sometime participant as both an author and a photographer, frequently mixed ardent enthusiasm with more than a hint of condescension. For instance, while Van Vechten compared his first Bessie Smith concert to the experience of "going to a Salzburg Festival to hear Lilli Lehmann sing Donna Anna in *Don Giovanni*," it is hard to imagine him describing Lehmann's art as he described Smith's:

> Her face was beautiful with the rich ripe beauty of southern darkness, a deep bronze, matching the bronze of her bare arms. Walking slowly to the footlights, to the accompaniment of the wailing, muted brasses, the monotonous African pounding of the drum, the dromedary glide of the pianist's fingers over the responsive keys, she began her strange, rhythmic rites in a voice full of shouting and moaning and praying and suffering, a wild, rough, Ethiopian voice, harsh and volcanic, but seductive and sensuous too, released between rouged lips and the whitest of teeth, the singer swaying slightly to the beat, as is the Negro custom:
>
> "Yo' brag to women I was yo' fool, so den I got dose sobbin' hahted Blues."[9]

I do not want to simply dismiss such descriptions as racist or patronizing. The point is that, however complimentary, they are celebrating otherness as much as art. Van Vechten truly admired Smith, took gorgeous pictures of her, and did all he could for her career. He did not insist that African Americans only do "black" art, but also supported the work of many who preferred to work in traditionally

European forms. Nonetheless, his romanticization of black culture was integral to his appreciation of it. There is the famous story of his party where Bessie Smith was invited to sing some songs, then responded to a request for a parting kiss from Mrs. Van Vechten by knocking the small white woman to the floor, and snarling, "I ain't never heard of such shit!" Van Vechten's response was to follow Smith out to the elevator and murmur, "It's all right Miss Smith, you were magnificent tonight."[10] I think it is not overstating the case to suggest that he regarded her behavior as part of the thrilling, savage character that he admired, and that he would have reacted quite differently if a white stockbroker had behaved in a similar manner.

Unlike many later white blues fans, Van Vechten socialized with black people, and did not insist that all of them be blues singers.[11] He supported and encouraged a wide range of poets and musicians, and did not assume that all great African-American art was made by illiterate geniuses from the depths of the rural South. When he compared Smith to Lilli Lehmann, the implication was that her work should be considered a kind of formal concert music rather than folklore. This was an idea that would be short-lived among white blues lovers. While jazz would go on to achieve the stature of "black classical music," blues would come to be seen as something entirely different, a folk form that should be appreciated on a par with the world's other great rural folk forms. It would be presented in concert halls, at times, but not with the gaudy, theatrical trappings of operatic show-women like Smith and Rainey. Instead, the appropriate costume for blues singers would be overalls, work clothes, or anything that suggested that they were simple country people, demonstrating their native culture.

While the Harlem Renaissance laid the groundwork, the key moment in the transformation of black vernacular music into an important white taste came on December 23, 1938, with the "From Spirituals to Swing" concert at Carnegie Hall. Here, for the first time, white New York society heard a broad range of African-American music presented as art rather than simply entertainment.[12] John Hammond, who organized the program, was a wealthy connoisseur who is justly famous for his work on behalf of such artists as Teddy Wilson, Billie Holiday, Count Basie, and many others. It was through his in-

fluence at Columbia Records that Bessie Smith was able to make her last recordings, after her glory days were past, and he would go on to sponsor the varied talents of Charlie Christian, Aretha Franklin, Bob Dylan, and Bruce Springsteen. He conceived of "Spirituals to Swing" as a capsule history of African-American music, and began the evening by playing some field recordings of traditional African chants. Then came the Count Basie Band, the boogie-woogie pianists Meade Lux Lewis, Albert Ammons, and Pete Johnson with Joe Turner, gospel from Sister Rosetta Tharpe and Mitchell's Christian Singers, New Orleans jazz from a group fronted by Sidney Bechet, stride piano by James P. Johnson, a harmonica instrumental from Sonny Terry, and blues from Big Bill Broonzy.

How Hammond thought about blues and its place in this mix is implied in the way he always wrote of Broonzy's appearance. He recalled that "Big Bill Broonzy was prevailed upon to leave his Arkansas farm and mule and make his very first trek to the big city to appear before a predominantly white audience," and described him as a "primitive blues singer" who "shuffled" onstage to sing a song about one of his dreams.[13] Reviewers, presumably on Hammond's briefing, noted that Broonzy had bought a pair of new shoes for his trek north, and this entertaining tidbit was routinely recycled by jazz critics over the following decades.

Now, Broonzy had been born in Mississippi and raised in Arkansas, but he learned to play guitar only after moving to Chicago in the early 1920s. By 1938, he had released over two hundred sides under his own name and appeared as an accompanist on many hundreds more. He wore fashionable suits, and kept up with contemporary musical trends: three months before Hammond brought him to New York, he was leading a group that included trumpet and alto sax for a session that included songs like "Flat Foot Susie with Her Flat Yes Yes." Which is to say it had been a hell of a long time since he could reasonably be described as an Arkansas farmer. Nonetheless, that was what Hammond wanted and what appealed to the Carnegie Hall public, and it would remain Broonzy's image whenever he appeared for white audiences, right up to his death in 1958. Though he was shortly back in Chicago working on a series of hit records for Lil Green, he returned

to the folk scene when the market for old-time blues collapsed, and consciously shaped himself into the living embodiment of his white fans' fantasies. Some blues historians attempted to set the record straight, but when I bought my first Broonzy record in the mid-1960s, the liner notes were still perpetuating the popular myth:

> An important element in understanding Big Bill Broonzy lies in the fact that he spent the first forty years of his life on a farm in Arkansas. Playing guitar was at that time a relaxing outlet for him after a full day's work in the field. The relationship of his life as a farmer to the virile, profoundly simple style of his music is undeniable. The dearth of any extensive, popular data concerning his background, and the comparative mystery surrounding his life seems to suggest a personality sealed in an abstract existence. The very opposite is true of the man, but while a number of his contemporaries sought and achieved popular recognition, Big Bill resisted the possibly hazardous temptation of becoming an "entertainer".[14]

As it happens, Broonzy had not been Hammond's original choice for the blues singer slot in "Spirituals to Swing." He had been brought in at the last minute, as a replacement for a genuinely rural and mysterious artist: Robert Johnson. Hammond had produced jazz sessions for Columbia Records, and it was apparently through his special access to the company's product that Johnson came to his attention.[15] It is not clear exactly what it was about Johnson's work that so appealed to Hammond, but there are a couple of clues. He would write that he originally considered Blind Boy Fuller for the blues singer slot in the concert, but rejected him because his voice was too nasal. Johnson's voice was fuller and more emotional, closer to that of Broonzy and the other mainstream stars, and thus easier on white urban ears. Its relative smoothness, however, was balanced by the high, eerie moan of his slide guitar, a sound that to white listeners would become synonymous with Delta blues.[16] Hammond apparently sent an emissary to invite Johnson to New York, and when he heard that Johnson had recently been murdered, he hired Broonzy as a replacement. Unwilling to give up completely on his original choice, he played two Johnson records

for the Carnegie Hall audience: "Walkin' Blues" and "Preachin' Blues." Since, aside from the African field recordings, the rest of the concert was devoted to live music, this demonstrates the extent to which Hammond considered Johnson a uniquely great artist, for whom there was no substitute.

At the time, this was an extremely unusual position—indeed, I am tempted to suggest that Hammond was the only man on earth who held it. Not even Johnson's friends and playing partners would have described him as America's greatest blues singer; they were proud enough to consider him the greatest young player in the Delta. Furthermore, had they been inclined to make a broader case for his supremacy, they would never have based it on two Son House covers that were among the most archaic numbers in his repertoire. Hammond, though, was specifically looking for a "primitive" blues sound, and there is no reason to think that he had ever heard the older Mississippi players—certainly, House's records would have been very unlikely to have come to his attention. Johnson exemplified the deep, old-time style he was looking for, and the tracks he played at "Spirituals to Swing" defined what several decades later would become known as the Delta blues style.

In those days, the Delta was not yet regarded as a major blues center. North Mississippi had produced a few important stars, like Memphis Minnie and Walter Davis, but they were trendy, modern Chicago- and St. Louis–based players whom few fans would have associated with any particular rural region. The one group that would have sprung to most blues buyers' minds as having a down-home, Mississippi sound would have been the Mississippi Sheiks, both because of their name and because their fiddle lead was the epitome of the old-time country style. However, the average blues buyer never gave much thought to where singers were from. Local fans might support their favorite sons and daughters, and certain records sold better in some places than others, but the whole idea of classifying blues by region would not appear for another twenty years. Hammond was no exception, routinely mentioning Johnson alongside Blind Boy Fuller, who was from the Carolinas. In terms of the 1930s market, this pairing made sense, since Fuller and Johnson were among the relatively few

exceptions to the current blues mainstream, working solo, in rural-sounding styles. (Both also recorded for the Columbia family of record labels. It is not clear to me that Hammond had heard any rural blues singers who did not.)

Hammond would remain a key figure in Johnson's posthumous career. A man of varied and passionate tastes, he had a gift for persuading other people to share his enthusiasms, and his place in history is less as a producer than as the most effective of fans, the man who would force Benny Goodman to listen to Charlie Christian, or insist that friends come down to a bar to hear Billie Holiday. In those days, he does not seem to have had as many friends who were into the folkier, more rural black styles, and although in 1938 he had convinced Columbia to put out an album of Bessie Smith reissues, it would be more than twenty years before Johnson received similar attention. Still, he caught the ear of Alan Lomax, and Lomax became an important fellow prophet.

Lomax was already well on his way to being America's foremost folk music collector, promoter, and popularizer—at a time when "folk music" still meant music created and performed by nonprofessional, usually rural people without formal training.[17] With his father, John, he had done extensive field recordings in the South, and had been intimately involved in Leadbelly's career. If it had been up to him, Leadbelly undoubtedly would have been the bluesman at "Spirituals to Swing," and it surprises me that Hammond never seems to have considered this.

Lomax paid closer attention to commercial blues records than other folklorists of his generation, but generally regarded them as an adulterated form of the pure folk style. He was devoted to the idea of folk music as a voice of the voiceless, the heartfelt expression of ordinary working people who could not write books or enjoy access to the academy or high society. He appreciated someone like Leroy Carr—or more specifically, Josh White, whom he presented in numerous radio shows—as a bridge to the broad pop audience, but was not as excited by their work as by that of more countrified players like Leadbelly. Furthermore, he laid little stress on originality. He could recognize a fine songwriter when one came his way, but he tended to speak of even

such uniquely gifted creators as Big Bill Broonzy and Woody Guthrie as representatives of their cultures and carriers of older traditions.[18] Still, he had been struck by the work of Blind Lemon Jefferson, and when Hammond introduced him to Johnson's records he filed Johnson as a Jefferson disciple and "one of the two or three great originals of the blues."[19] One of the reasons he chose to go to Mississippi in 1941, rather than to one of the other regions he and the Fisk team had considered, was to explore Johnson's musical circle, and this was how he came to meet Son House and Muddy Waters. (In assessing Johnson's local reputation, it is worth noting that the first white, northern blues fan that House, Waters, Honeyboy Edwards, and other Delta players met was already an ardent Johnson admirer. One has to wonder what effect this had on their own estimations of their onetime peer.)[20]

While their influence would eventually reach around the globe, Lomax and Hammond were to a great extent operating within the small bubble of New York liberal intellectual society, and in this world virtually everyone accepted their opinions as definitive when it came to "country" blues. However, it is important to remember that pop songs with "Blues" in their titles had been familiar fare for whites as well as blacks for several decades, and Hammond and Lomax were fighting to change a broad-based, preexisting concept of the music. After a quarter century of jazz, vaudeville, and Broadway treatments, most educated people considered blues to be cheap, flashy, good-time entertainment, possibly fun but certainly not important. This view was shared by a substantial portion of the scholars who had made a serious study of black folklore. When the first thorough survey of African-American rural folk music, *The Negro and His Songs*, was published in 1925, the authors divided secular performances into three categories: Most valuable were the folk songs created by rural blacks themselves; then came "modified or adapted" songs, which had white or Tin Pan Alley sources but had been significantly changed by the singers; of least interest, despite their widespread popularity, were the purely commercial pieces, which were subdivided into three further categories: "'Nigger songs' [the authors' term for minstrel pieces], popular 'hits,' and 'blues.'"[21]

While Hammond and Lomax each viewed blues through his own

aesthetic lens—Hammond saw it as the roots of Basie and Goodman, while Lomax considered it a black equivalent of the Appalachian ballads—both felt that it was a vital, important folk form, central to the broader field of African-American music. Thus, both sought to present it in what they considered to be its purest form, sung by "real" blues singers, fresh out of the country.[22]

The idea that some blues singers were "realer" than others would become a commonplace (and the source of infinite arguments) among white enthusiasts, but in the late 1930s it was quite new. Of course, plenty of black record buyers appreciated blues as "real"—one of the music's greatest strengths had always been that it expressed what listeners were experiencing in their daily lives—but they did not consider Bessie Smith's songs less real because she was wearing an expensive gown and backed by painted sets and a jazz band, or Leroy Carr and Lonnie Johnson less real because of their cool, urbane vocals. It was a purely white aesthetic that considered the blind street guitarists to be "realer" than the Smiths and Carrs, or Robert to be the "realest" of Johnsons—or that needed to imagine Big Bill Broonzy back on an Arkansas farm in order to consider him a true bluesman.

Leadbelly's New York career was Exhibit A for the white blues aesthetic. When the Lomaxes came upon him, he was a prisoner in Angola State Penitentiary and had never recorded for a commercial label. He could sing blues, but also the whole panorama of black traditional music, from children's rhymes to field hollers and work songs, and once he was out of jail, he learned and performed other pieces the Lomaxes had collected, such as "Rock Island Line," along with his previous repertoire. The Lomaxes brought him to New York in 1935, and his early appearances got a splash of publicity that tended to focus as much on his colorful past as on his music. A *March of Time* newsreel recreated his prison meeting with John Lomax, and a *Life* magazine profile was titled "Bad Nigger Makes Good Minstrel."[23]

In the folk world, where he has remained an icon, Leadbelly is simultaneously treated as a major blues figure—though the black blues audience never even knew he existed—and as a pure folk artist who eschewed the commercial mainstream. (The folk world has always thrived on the myth of folk art for art's sake: Leadbelly's white coun-

terpart, Woody Guthrie, is remembered as an Okie hobo rambler who somehow wandered onto the folk scene, rather than a popular hillbilly entertainer who starred on one of Southern California's most popular country radio shows before moving to New York.) In fact, Leadbelly was neither exceptionally devoted to blues nor unaware of the popular music around him, whether black or white. He consistently linked himself to Blind Lemon Jefferson, the biggest star in his home region, and once he discovered that he could attract a white audience, he began dreaming of movies and hit recordings. The Lomaxes chose to focus on his more traditional repertoire, but when left to his own devices he was a big Gene Autry fan, enjoyed singing pop and country tunes like "Dancing with Tears in my Eyes," "Springtime in the Rockies," and Jimmie Rodgers yodels, and imagined himself performing with Cab Calloway's band.[24] While white folk fans of the time recall him as the most "authentic" and countrified figure on the New York scene, the black entertainers who worked with him inevitably recall him as a polished, serious professional. Brownie McGhee told of Leadbelly instructing him to wear a tie and buy a decent case for his guitar, and the Haitian dancer Josephine Premice described him as "a dandy," noting his fine suits and gold-topped cane.[25]

McGhee had a particularly interesting slant on this issue. When he made his "folk" debut in Washington, D.C., as accompanist to Sonny Terry, he recalled that they were immediately surrounded by fans urging them to come to New York: "They said they didn't have any blues singers up there; that Josh White was the only one, and he'd gone white." At the time, White had recently finished a run partnering Leadbelly at the Village Vanguard—the one time Leadbelly got a regular nightclub gig—and had taken up with the white Broadway singer Libby Holman, recorded an album with her, and started a residency at one of New York's fanciest cabarets, La Vie Parisienne. Though born in Greenville, South Carolina, and a successful Race artist in the early 1930s, White had moved to Harlem as soon as he got the chance, and had adapted his blues guitar technique to everything from leftist political songs to English ballads and pop hits. He paid lip service to the black folk tradition, and continued to sing old blues and spirituals, but had quickly realized that there was more money to be made from savvy

professionalism than rural purity. (Lomax understood this as well, though he was not happy about it, and he used White on some of his radio shows as a way of preparing audiences for Leadbelly.) As a result, he became America's defining black folksinger, a model for Harry Belafonte, and by far the best-known blues artist on the white market even at the height of the 1960s folk-blues revival.[26] Equally, he became the hard-core folk and blues worlds' bête noire, condemned as a symbol of all that was fake, slicked up, and adulterated. When McGhee and Terry moved to Greenwich Village and became regulars on the folk circuit, they were treated as more genuine representatives of the African-American tradition. However, McGhee himself had a rather different view of White's artistic choices: "A little while after we got up there, I met Josh, and when I saw how much money he was making, I said, 'Hey, show me how to go white, too.'"[27]

McGhee did not have White's cabaret charisma, but neither was he satisfied with a career in the white folk museum. While he and Terry worked for the rest of their lives as traditional country bluesmen, and white fans would see them doing their basic acoustic show at colleges, folk clubs, and formal concerts—or appearing as colorful rural characters in the Broadway production of *Cat on a Hot Tin Roof*—he also managed a parallel career on the black R&B scene. He reached the number-two chart position in 1948 with "My Fault," and recorded the pioneering rock 'n' roll hit "Drinkin' Wine Spo-Dee-O-Dee" with his brother Stick McGhee. Whether by design or simply because the two worlds were so separate, these careers never overlapped. Many of the fans crowding the duo's folk gigs were there precisely to see "real" blues, the pure antithesis of the loud, commercial R&B on the radio, and would have been shocked at the idea that their heroes were equally comfortable playing contemporary electric pop.

Understanding this division between "folk" and "pop" is vital to understanding the emergence of the modern blues aesthetic. Van Vechten, Hammond, and Lomax, as well as later figures like Samuel Charters, were striving to establish the music they loved as a great art, deserving of serious, intellectual attention. In a way, their mission was like the attempt by acolytes of modern art to bring European academic sensibilities to bear on African sculpture, or of earlier folklorists to win

respect for medieval ballads. A great part of the battle was to separate important "folk art" from disposable everyday entertainment. All of these men were fond of music that was commercially popular, but they also believed that the best blues, jazz, or folk had enduring qualities that the vast majority of current hits did not. It was an article of faith for them that while Bing Crosby or Frank Sinatra might be passing fancies, a handful of unrecognized black artists were creating music for the ages, and they were trying to make the world aware of this, preferably while the artists were alive to enjoy the attention. This was no easy task in a world where such "artists" were poor, despised, and relegated to loud clubs and sweaty, crowded dance halls, working for audiences of drunken hell-raisers. Hence Carnegie Hall, sit-down concerts, lectures, and articles written in the most humorless, scholarly prose. Modern fans like myself, when we fantasize about going back to the 1930s and seeing the Count Basie band in its prime, dream of being transported to Harlem's Savoy Ballroom, surrounded by a hot, swinging crowd of dancers. At the time, though, the chance of a college professor or other solid white citizen showing up at the Savoy was comparable to that of their present-day counterparts turning up at a rap show in South Central L.A.—it happened, but was considered extremely daring. When the cream of New York intellectual society filled Carnegie Hall for the "Spirituals to Swing" concerts, sitting respectfully and recognizing the music of Basie, Broonzy, and the other performers as an acceptable form of modern art, that was a huge breakthrough. It was part of the broader movement that would eventually enshrine "popular culture" as an important academic discipline, so that today it is taken for granted that people can get doctoral degrees by writing about the poetic tropes of rap lyrics or the sociosexual implications of Madonna. It was also inextricably connected to the social movement for desegregation and Civil Rights, and the Hammonds and Lomaxes saw themselves as part of both an artistic revolution and a crusade for social justice.

Sometimes, the need to make popular culture sufficiently serious could be taken to extremes. When Lomax presented Josh White and the Golden Gate Quartet in a concert at the Library of Congress, a setting where classical music had been the norm, he arranged for each

song to be introduced with spoken commentary by himself or an African-American college professor (Sterling Brown and Alain Locke shared the honors).[28] Even so, such efforts were chancy, and there was always a conservative columnist ready to sneer about "minstrel shows" coming to Carnegie Hall. Hence the constant insistence that valuable black cultural expressions not be confused with shallow entertainment. If white tastemakers were properly to appreciate the Ellingtons and Basies of the world—and the Leadbellys and Big Bill Broonzys— a clear divide had to be made between these important artists and the Louis Jordans, chart-topping musical comedians who were still singing minstrel-flavored lyrics like "Ain't Nobody Here But Us Chickens" and "Saturday Night Fish Fry." This was not an easy matter, since even the purest and most artistic musicians often aspired to Jordan-style commercial success, but especially as they got older and their styles ceased to appeal to black pop buyers, many saw the advantage of playing along with a white connoisseur aesthetic.

There were essentially four groups of connoisseurs who nurtured the white blues cult: the jazz fans, the folk fans, the record collectors, and the beats. These groups overlapped a good deal, but each had its own fiercely defended standards of purity, and the hard core of each group was made up of people who at times seemed more interested in enforcing these standards than in the music itself. Each group also considered itself to be made up of people whose tastes were proudly outside the mainstream. They celebrated the romantic honor of going one's own way rather than slavishly following the current pop trends. Then as now, the work of poor black musicians had a natural outsider mystique. For white fans, an appreciation of black vernacular culture showed daring and individuality, as well as a virtuous respect for and solidarity with the downtrodden. Since, almost by definition, those musicians who were obviously, garishly successful were not outsiders, it is no accident that these groups routinely rejected the work of major, important artists simply because they were too widely appreciated—though the same artists might have been hailed as geniuses before they broke into the mass market, and might be hailed as geniuses again once their popularity faded.

The first white audiences to embrace blues as more than enter-

tainment were the folk and "trad jazz" crowds. The record collectors would not have their day until the late 1950s, when reissue programs and rediscoveries of older bluesmen gave them a moment of tastemaking cachet. As for the beats, blues was only rarely their music of choice. However, at the dawn of the blues revival they were the most visible white "rebels without a cause," and their literary and aesthetic stances were adopted wholesale by the hipper trad fans and folkies.

This is not the place to give a history of the trad jazz boom or the folk revival, but the former, in particular, probably needs some introduction for modern readers. It is now largely forgotten that, in the 1940s, a bitter battle developed between the traditionalist "moldy figs" who declared that jazz began and ended with the New Orleans music of the teens and twenties, and the supporters of swing and contemporary styles. Celebrating roots and good-time music over modernism and self-conscious artiness, the trad fans naturally embraced figures like Leadbelly and Broonzy as slightly older cousins of King Oliver and Jelly Roll Morton. Rudi Blesh, in his jazz history *Shining Trumpets*, devoted two full chapters to blues, dividing the music into "archaic" (including everyone from Lemon Jefferson through Leroy Carr and Robert Johnson), "classic" (the blues queens), and "postclassic" (including later Roosevelt Sykes and Lonnie Johnson, whom he rather liked, but also Billie Holiday, whom he dismissed as "not a real blues singer but merely a smart entertainer").[29]

In keeping with other white experts, Blesh showed a blithe disregard for whether blues artists had any particular standing with the black audience. The six "archaic" records he singled out for discussion included one by Jefferson, but also works by such obscure figures as Montana Taylor, Romeo Nelson—and Robert Johnson. In Johnson's case, Blesh focused on "Hell Hound on My Trail," and it is worth presenting his description at length, both because it was the first piece to be written on Johnson's work and because of the degree to which it set the tone for decades of romantically purple blues criticism:

> The voice sings and then—on fateful, descending notes—echoes its
> own phrases or imitates the wind, mournfully and far away, in *huh-uh-*
> *uh-umm*, subsiding like a moan on the same ominous, downward

cadence. The high, sighing guitar notes vanish suddenly into silence as if swept away by cold, autumn wind. Plangent, iron chords intermittently walk, like heavy footsteps, on the same descending minor series. The images—the wanderer's voice and its echoes, the mocking wind running through the guitar strings, and the implacable, slow, pursuing footsteps—are full of evil, surcharged with the terror of one alone among the moving, unseen shapes of the night. Wildly and terribly, the notes paint a dark wasteland, starless, ululant with bitter wind, swept by the chill rain. Over a hilltop trudges a lonely, ragged, bedeviled figure, bent to the wind, with his *easy rider* held by one arm as it swings from its cord around his neck.[30]

In France and England, in particular, blues was considered a basic adjunct to the trad scene. It was jazz fans who crowded clubs for Josh White's and Big Bill Broonzy's early tours, and by the mid-1950s it was not unusual to find British jazz bands including some jug-band, or "skiffle," numbers as part of their sets. In 1954, Chris Barber, a trumpet player who was the reigning star of the English trad scene, released an album called *New Orleans Joys* that included versions of Leadbelly's "Rock Island Line" and "John Henry" performed in jug-band style by the band's banjo player, Lonnie Donegan (who had changed his first name from Tony in honor of Lonnie Johnson). Issued as a single in 1956, "Rock Island Line" made the pop top ten in England and then, to everyone's astonishment, repeated this feat in the United States. In the States, Donegan's record fit into the post-Weavers folk scene, which was dominated by Harry Belafonte and the series of clean-cut, sports-shirted young ensembles that reached its apogee with the Kingston Trio. In Britain, where the folk revival was as likely to consist of a cappella renditions of British ballads, many people filed Donegan alongside trad, blues, and the upbeat, countrified, guitar-driven R&B of Chuck Berry.[31]

Of course, many trad fans despised the "childish" rock 'n' roll tunes, but the British scene was small enough that some overlap was inevitable. Barber and his cohorts were sponsoring tours not only by Big Bill Broonzy, Lonnie Johnson, and McGhee and Terry, but also by Muddy Waters and his full electric band. Alexis Korner, who replaced

Donegan in Barber's group, was soon leading an electric outfit called Blues Incorporated, which had fellow jazzman Charlie Watts on drums and featured occasional vocals by a teenager named Mick Jagger. Korner was also providing sleeping quarters for another teenager, Brian Jones, who had started out playing saxophone in suburban trad bands, but now had turned to electric slide guitar and renamed himself Elmo Lewis in honor of Elmore James.[32] With the addition of a bass player named Bill Wyman, and Keith Richards, who had cast off an early infatuation with Roy Rogers in favor of the hillbilly rock licks of Berry and Scotty Moore, the Rolling Stones were born and soon supplanted Korner as leaders of a British blues boom. But I am getting ahead of the story.

Over in the States, Leadbelly, Broonzy, and McGhee and Terry were more likely to be considered folk than jazz, and less likely to be filed alongside any group that used electric instruments or even piano. This became even more true in the 1950s, when the entertainment world was riven by the anti-Communist Red Scare, and one no longer found Dizzy Gillespie and Pete Seeger appearing at the same left-wing summer camps. The climate of Red-baiting destroyed the old folk scene, forcing Alan Lomax into self-imposed exile in Europe and artists like Seeger out of nightclubs, radio, and television. Nonetheless, Seeger and the Weavers had put Leadbelly's "Goodnight Irene" on the pop charts, and their success inspired a wave of clean-cut guitar pickers. Folk music was presented as a wholesome antidote to rock 'n' roll, with Harry Belafonte as the reigning star, joined by groups like the Tarriers, the Limelighters, and the awesomely popular Kingston Trio. Blues was only a minor part of this trend, though Belafonte would occasionally pay homage to Leadbelly's chain-gang work-song tradition, and college folkies gave a warm welcome to acoustic players like Josh White and McGhee and Terry. Some of the same audience was buying Elvis, but would be less likely to admit the fact to teachers and parents. Throughout the revival, folk was associated with a collegiate image, as contrasted with the delinquent idiocy and jungle beat of rock 'n' roll.[33]

In Bohemian enclaves like Greenwich Village and the jazz coffeehouses of Harvard Square, things were somewhat different. There,

another sort of folksinger began sharing stages with the jazz modernists and beat poets. Dave Van Ronk, a founding leader of this crew, would later refer to them as the "neo-ethnics," and they were out to rescue "real" folk music from the pasteurized and homogenized style of the Weavers clones. Van Ronk himself came from a trad jazz background, and had discovered rural blues while searching for records of old New Orleans music. He became king of the Village blues singers, and along with Eric Von Schmidt, a painter who was his opposite number in Cambridge, set out to capture the sound and feel of the older black guitar and vocal styles, adopting all the roughness and immediacy of the blind street performers who had recorded in the 1920s.

The neo-ethnic movement was nourished by a spate of LP reissues that for the first time made it possible to find hillbilly and country blues recordings in white, middle-class, urban stores. The bible was Harry Smith's *Anthology of American Folk Music*, a pioneering six-LP set that included three Blind Lemon Jefferson cuts along with songs from Charley Patton, Mississippi John Hurt, and Sleepy John Estes (plus plenty of hillbilly, Cajun, and religious music). Smith was specifically interested in the oldest and most rural-sounding styles, and set a pattern for future folk-blues reissue projects by intentionally avoiding any artist who seemed consciously modern or commercial. Thus he eschewed Leroy Carr and the piano bluesmen in favor of Jefferson, and the "blue yodels" of Jimmie Rodgers in favor of the more archaic-sounding Carter Family.

Far from balancing this taste, the other record collectors tended to be even more conservative. Much as they loved the music, they were also driven by the same mania for rarity that drives collectors of old stamps or coins, and many turned up their noses at Jefferson or the Carters, since those records were common. To such men, the perfect blues artist was someone like Son House or Skip James, an unrecognized genius whose 78s had sold so badly that at most one or two copies survived. Since the collectors were the only people with access to the original records or any broad knowledge of the field, they functioned to a great extent as gatekeepers of the past and had a profound influence on what the broader audience heard. By emphasizing obscurity as a virtue unto itself, they essentially turned the hierarchy of

blues stardom upside-down: The more records an artist had sold in 1928, the less he or she was valued in 1958.

This fit nicely with the beat aesthetic, and indeed with the whole mythology of modern art. While Shakespeare had been a favorite playwright of the Elizabethan court, and Rembrandt had been portraitist to wealthy Amsterdam, the more recent idols were celebrated for their rejections: Van Gogh had barely sold a painting in his lifetime, *The Rite of Spring* had caused a riot, Jack Kerouac's *On the Road* had been turned down by a long string of publishers. Where jazz had once been regarded as a popular style, a new generation of fans applauded Miles Davis for turning his back on the audience and insisting that his music speak for itself, while deriding Louis Armstrong as a grinning Uncle Tom. On the folk-blues scene, Van Ronk and his peers regarded anything that smacked of showmanship as a betrayal of the true tradition, a lapse into the crowd-pleasing fakery of the Weavers and Josh White. As he would later recall with some amusement, "If you weren't staring into the sound-hole of your instrument, we thought you should at least have the decency and self-respect to stare at your shoes."

As in John Hammond's Carnegie Hall, art was opposed to entertainment. And, as in the 1930s, this meant that the blues Van Ronk and his friends were reviving had to be clearly differentiated from the blues that Elvis Presley was turning into the first global pop craze. A major figure in this redefinition was Samuel Charters, a writer and occasional trumpet player who was Van Ronk's close friend and sometime bandmate. Charters had produced a couple of sessions for Folkways Records—including one reuniting some of the older Memphis players, which in honor of Lonnie Donegan's success was titled *Skiffle Bands*—and in 1959 he came out with a book and record, both titled *The Country Blues*. The book was a broad survey of prewar blues, with a nod to more recent players like Muddy Waters, and though further scholarship turned up some factual inaccuracies, it gives a remarkably clear-sighted picture of the scene. However, Charters's title maintained the central myth of the Hammond and Lomax approaches: that older blues was fundamentally rural music. (He also joined them in singling out Robert Johnson. A three-page chapter argued Johnson's unique artistic importance—though emphasizing his

obscurity within the black blues market—and the accompanying album included the first reissue of a Johnson song, once again "Preachin' Blues.") Charters was not a hard-core purist, and his album included cuts by urban stars like Leroy Carr and Lonnie Johnson, but this subtlety was lost on all but the cognoscenti, and his work established the term "country blues" to describe all prewar Race recordings that did not feature women or jazz bands. (The cognoscenti were profoundly irritated, and a group of them rushed out a release called *Really! The Country Blues*, which included no urban stars.)[34]

In keeping with the folk revivalist aesthetic, Carr was the only pianist included on Charters's collection, and the next few years would cement a new prejudice in favor of guitars—and to a lesser extent harmonicas—as the defining blues instruments. As the revival picked up steam, and young white fans scoured the South in search of the surviving exponents of the prewar boom, the hallowed "rediscoveries" would be Mississippi John Hurt, Skip James, Booker White, Son House, and Sleepy John Estes, along with previously unrecorded figures like Mance Lipscomb and Robert Pete Williams.[35] By historical standards, Roosevelt Sykes and Little Brother Montgomery should have been equally celebrated, since they had helped invent the deep Mississippi style and had been significant influences on James, in particular—and in the 1960s they were playing and singing better than a lot of the guitarists—but their choice of instrument banned them from the coffeehouse circuit and most folk festivals, and they remained a minority taste, more celebrated by the trad-jazz wing of blues fandom.

In Europe, things were generally a bit looser. With less American music to go around, audiences were forced to be more broad-minded, and pianists like Memphis Slim, Champion Jack Dupree, and Eddie Boyd shortly relocated to the continent. Lonnie Johnson, who refused to be turned into a walking museum of his youth, also found the Europeans more welcoming than folks back home. Stateside fans were horrified that he wanted to play electric guitar and mix his blues numbers with Tin Pan Alley torch songs like "How Deep Is the Ocean" and current hits like "I Left My Heart in San Francisco."[36] In the United States, down-home artists like John Lee Hooker and Lightnin' Hop-

kins, who on their home turf had built enduring careers as aggressive electric players, were urged to play acoustic instruments and perform their most archaic-sounding repertoire.[37]

Thus, it was in Europe that the folk-blues scene crossed the line into blues-rock. In 1962, the first of a series of German-sponsored Folk Blues Festival tours featured Sonny Terry and Brownie McGhee along with ex-Basie vocalist Helen Humes, Memphis Slim, John Lee Hooker, T-Bone Walker, and Willie Dixon leading a tough Chicago rhythm section. To a lot of people, this music sounded very close to rock 'n' roll, even though the presenters worked hard to maintain the distinction between art and pop. Producer Horst Lippmann would later explain that he had to coach the artists on how to be less flashy, saying he had particular difficulty with T-Bone Walker, whose dynamic stage antics had made him the prototypic lead guitar hero:

> I told the blues people, "You are now here in a different area. You're not back in America anymore, where you have to use gimmicks to entertain the people." . . . For some it was very difficult to understand this. For instance, T-Bone Walker . . . used to play the guitar behind his neck and all these kinds of tricks that became popular with Jimi Hendrix. Naturally, he wanted to show all his facilities. It took me a long time, but the European audience takes it in a way more or less like a classical concert. They like to sit in the concert hall, don't want to see gimmicks. . . . This I explained to [the artists], and this they followed.[38]

A lot of younger Europeans did not choose to fit Lippmann's stereotype. By this time, Bo Diddley and Little Richard were touring England, and their hopped-up versions of Chicago blues and boogie-woogie piano were inspiring purist groups like the Rolling Stones —who at first had sat onstage, carefully recycling licks off their favorite American records—to loosen up a bit. "Watching [them] was the way we were drawn into the whole pop thing," Keith Richards would later explain. "We didn't feel we were selling out, because we were learning a lot by going into this side of the scene."[39] The barriers were coming down, and despite its serious concert atmosphere, even that first Folk Blues Festival tour spawned a hit single, a romping John

Lee Hooker boogie called "Shake It Baby," which shot up the French pop charts. Over the next two years, the festival would bring Muddy Waters, Howlin' Wolf, and Sonny Boy Williamson (along with Lightnin' Hopkins, Lonnie Johnson, Big Joe Williams, Sleepy John Estes, Victoria Spivey—playing a ukulele—and Chess Records' new soul star, Sugar Pie DeSanto), and during the 1963 tour Williamson met up with the Yardbirds, a bunch of young English blues players that included a guitarist named Eric Clapton.

Clapton and the Stones were the first pop stars ever to insist that they were playing blues. Even Muddy Waters and John Lee Hooker, deep-dyed as they were in the Delta tradition, were happy to be considered R&B singers, and if their records had crossed over to pop they would not have argued genre definitions.[40] They had no interest in being purists, they just sounded like they sounded. When "Hoochie Coochie Man" hit, Waters put aside his guitar and belted out this more rocking, funnier music, and he would not bother to record any more Delta slide licks until the white kids started demanding them. With the English players, it was different. They heard something in blues that spoke to their deepest needs and desires, and they made themselves into apostles of that sound. They would mix it with rock, especially rock recorded on Chess records, but they knew that Chuck Berry and Bo Diddley—bright and entertaining as they might be—were still the real thing, coming from the same place as Muddy and Wolf. And that was the sound they loved: no horns, no string sections, no girls going "oo-wah"—just slashing guitar and wailing harmonica.

Then the English kids flew across the Atlantic, bringing the gospel home. And they did something unprecedented: Unlike the hundreds of white blues singers before them, all the peers of Jimmie Rodgers, of Elvis Presley, of—forgive me, but history is history—Georgia Gibbs, they took it upon themselves to educate their audience. "Our aim was to turn other people on to Muddy Waters," Keith Richards would later say. "We were carrying flags, idealistic teenage sort of shit: 'There's no way we think anybody is really going to seriously listen to us. As long as we can get a few people interested in listening to the shit we think they ought to listen to. . . .' That was our aim, to turn people on to the

blues. If we could turn them on to Muddy and Jimmy Reed and Howlin' Wolf and John Lee Hooker, then our job was done."[41]

The English musicians were shocked to find that the adoring throngs who met their planes were unaware of the giants who strode Chicago's South Side. "Muddy Waters? Where's that?" one reporter asked an incredulous Paul McCartney, who responded, "Don't you know who your own famous people are here?"[42] The Stones, using their newfound power to further their evangelical aims, brought Howlin' Wolf along for their 1965 appearance on the teenage pop show *Shindig!* and sat admiringly at his feet as he sang "How Many More Years."[43]

That year and the next were the high-water mark for the blues revival. Clapton was declared God by a horde of white kids on both sides of the Atlantic—most of whom had never heard of his idol, Freddie King—hitting first as the guitarist for John Mayall's Bluesbreakers and then with Cream. Meanwhile, inspired by the success of the English bands, American record labels began paying attention to the young white blues disciples on their home turf. Paul Butterfield, a harmonica player who had actually grown up in Chicago and spent his teens apprenticing himself in the city's toughest clubs, made an album that made pretty much all the Brits sound like the foreigners they were. John Hammond Jr., son of the "Spirituals to Swing" producer and the most assiduous of Robert Johnson acolytes, went electric and started jamming with Duane Allman. As Muddy Waters recalled, "Before the Rolling Stones, people over here didn't know nothing and didn't *want* to know nothing about me."[44] Now, there was a whole new audience clamoring to hear his music, and Chess Records captured the spirit of the moment by repackaging his and Wolf's early singles on twin albums titled *The Real Folk Blues*. (This was, of course, immensely irritating to those who considered the electric Chicago sound the antithesis of "folk," but such purists were fast becoming an insignificant minority.)

Meanwhile, backed by some of Butterfield's sidemen and some of Hammond's, Bob Dylan created a whole new kind of fusion, and revivalism took a sideways turn into modern art. With Dylan, it was no longer about going back to Chicago and Mississippi, it was about

creating the new sound of the 1960s, and Jimi Hendrix built on that vibe, and after a little while no one was calling it blues anymore. The Brits were hanging in the same rooms, hearing the same records, and doing the same drugs as Dylan and Hendrix (indeed, Hendrix had paid his dues with Little Richard and the Isley Brothers but developed his new style in London), and soon everyone was singing lyrics inspired by symbolist poetry or—since few except Dylan bothered to thumb through Verlaine—a potent combination of hubris and LSD.[45]

The Stones, Clapton, and a few others tried to keep the revivalist fires burning. As they rolled across America, hailed and damned as the prophets of youth revolution, the Stones would follow "Sympathy for the Devil" with understated, reverent acoustic versions of old songs by Robert Wilkins, Fred McDowell, and Robert Johnson. By now, though, these were staged set pieces: When the band had played Chuck Berry's "Come On" or Howlin' Wolf's "Little Red Rooster," Jagger had sung with the same blend of self-conscious Americanisms, enthusiasm, and sarcastic humor that he used when singing "Satisfaction." When he and Richards sat down with acoustic instruments to present "Prodigal Son" or "Love in Vain," they were giving a demonstration of a music they loved, showing their audience how the blues used to sound in the old days, before returning to the roar and clash of the present.

As the old records became more widely available, and the young revivalists increased in technical proficiency, such demonstrations would become the standard fare. Down in the plains that surrounded the Olympus of the rock gods, acoustic players took the stages of folk clubs to perform virtuosic, note-for-note recreations of a vast repertoire of prewar blues songs, culled from the grooves of an ever-growing flood of LP reissues. A few—Spider John Koerner leaps to mind—came up with their own variations on the classic formulas, and a couple—Taj Mahal, Larry Johnson—were even black, but the dominant strain was made up of white middle-class kids who were proudly, meticulously imitative of the old masters.

As for those older bluesmen who had been lucky enough to survive the intervening decades, for some of them the 1960s really was a revival. They might be baffled by the audiences of young white kids

acclaiming them as voices from a vanished world, but the money could be very good, and it was a pleasure to have one's work treated with such seriousness and enthusiasm. Some were less pleased than others, of course, especially if they were not among the handful who became major drawing cards, and at times even the lucky few might succumb to the loneliness of being appreciated only by strangers. In one of his more meditative moments, Muddy Waters would remark: "I thinks to myself how these white kids was sitting down and thinking and playing the blues that my black kids was bypassing. That was a hell of a thing, man, to think about."[46] On the whole, though, the revival provided the older artists with a lot of paydays they could never have hoped for as black pop has-beens, and the rewards more than balanced the oddity of it all.

One thing that must have been particularly surprising to the survivors of the first blues boom was the concentration on Robert Johnson, an artist most of them had never even heard of. In 1961, spurred by the attention being given to blues reissues, Columbia Records released a full LP of Johnson recordings as part of its Thesaurus of Classic Jazz. In keeping with John Hammond's critical judgment of the 1930s—and because hyperbole has never hurt record sales—it was titled *King of the Delta Blues Singers*, and most of the new blues fans accepted this as a simple statement of fact.

Eric Clapton was one of many whose lives were changed by that record:

> It came as something of a shock to me that there could be anything that powerful. . . . At first it was almost too painful, but then after about six months I started listening, and then I didn't listen to anything else. Up until the time I was 25, if you didn't know who Robert Johnson was I wouldn't talk to you. . . . It was as if I had been prepared to receive Robert Johnson, almost like a religious experience that started out with hearing Chuck Berry, then at each stage went further and deeper until I was ready for him. . . . I have never found anything more deeply soulful than Robert Johnson. His music remains the most powerful cry that I think you can find in the human voice.[47]

Like the effect of seeing Elvis Presley jumping out of the living room television in 1956, the discovery of Robert Johnson fulfilled needs that people did not even know they had. To a lot of white kids who had traveled from Elvis to Chuck Berry to Muddy Waters—or from the Weavers to Josh White to Leadbelly—Johnson defined everything that had drawn them to blues, to rock, to folk or just to want to break out of the boring, ordinary world of suburban England or Eisenhower America. His music was older, deeper, and more mysterious than anything they had heard before. The lyrics were powerful and exciting, the voice moaned, soared, and whispered, and the guitar work showed an astonishing subtlety combined with a virtuosic command of rhythm and tone. Most of all, there was the feel, a primal, visceral heart-cry that fit like a missing puzzle piece into all the James Dean/Marlon Brando dreams of pained, sensitive, brilliant, masculine rebellion. It was more than just the sound: Johnson was a dark, unknown spirit, without any history aside from his songs. There were no photographs of him, and the album cover showed only a painting of a faceless black man hunched over a guitar, contemplating his shadow. That was how we all thought of Johnson, and we could never have imagined the photo that would surface in 1990 of a handsome young man in a neat pinstripe suit, smiling confidently into the camera.[48]

The following year, Columbia released an LP of Leroy Carr's recordings, but no one much cared. Carr and his music did not feel like the roots of rock 'n' roll, no matter how many black R&B singers were still doing his tunes. He did not sound angry or haunted, or even play guitar. He had not the slightest connection to Mississippi, and no one who listened to him for long would picture a broken, lonely rambler. A fine writer and singer, he was pleasant enough in his way, but there was nothing dangerous or otherworldly about him.

I am not trying to sneer at the taste that hailed Johnson as a genius dead before his time while dooming Carr to obscurity, or that worshipped Muddy Waters as the greatest living bluesman while ignoring Bobby Bland. That is my world, and as a guitar player and a white male and a youthful acolyte of both folk romanticism and the rock rebel image, I remain deeply affected by the enthusiasms and prejudices of this aesthetic. I like to think that I can step outside it and regard it

with some degree of perspective, but I still thrill to many of the same sounds that first attracted me to blues, and for many of the same reasons.

Indeed, one could argue that I am simply fitting into my generational profile when I choose to end the story here, to say that blues and its iconography were set by about 1970, and have changed very little in the ensuing thirty-odd years. I saw Stevie Ray Vaughan, and admired his chops, and I am grateful to him for turning on a huge, new audience and keeping the blues clubs open for another while, but the image of the guitar god was set before Vaughan appeared on the scene. It was an invention of the 1960s, courtesy of Clapton and Michael Bloomfield, Jeff Beck, Steve Miller, and—most brilliantly if not most profitably—Hendrix. In the end, that image may well be the main addition the white audience has made to the blues genre.

That, and the idea that the greatest blues comes from someplace far outside our modern neighborhoods and ordinary lives.

And, of course, nostalgia—or, as some of us prefer to call it, history.

14

FARTHER ON UP THE ROAD: WHEREFORE AND WHITHER THE BLUES

In the end, it is all about the audience. Musicians are hailed as geniuses and innovators, but there are always far more listeners than players, and it is they who create the world in which some performers will prosper and others will labor in obscurity. What defines a style, a genre, or a movement is the audience that supports and consumes it. If people want to dance, a band with a great rhythm section will beat out one with astonishing soloists. If teenagers want to be in rooms without anyone but other teenagers, they will seek out bands that their parents hate. Everyone listens to music as part of a larger experience, whether it is the experience of getting drunk in a honky-tonk or of putting on a tux and going to the opera, or simply of relaxing at home after a hard day's work.

The audience affects not only styles and approaches to music, but also quality. If an audience is large enough, it will support enough musicians that some of them will be wonderfully talented, and if it is demanding enough, it will push them to realize and even exceed those talents. If it is smaller, the talent pool will be less, and if it makes few demands, then mediocrity will be the norm, even when players are capable of doing better.

When the audience for blues shifted from being mostly black to being mostly white, that could not help but have a profound effect on the music. As long as blues was being created for African-American listeners, although it changed with the changing fashions, its core virtues

were entertainment, swing, and familiarity. The consumers had no patience with being bored, wanted to dance, and expected any singer to act and sound more or less like one of themselves—flashier and in fancier clothes, perhaps, but still regular folks, singing about normal life, and sharing the same aims and frustrations. The white blues audience, from the moment one appeared for black singers rather than vaudevillians and hillbilly yodelers, expected these singers to be quite unlike themselves, and to provide both a profound emotional experience and a view into another way of life. White listeners were often willing to be bored if they felt that the experience was sufficiently educational or uplifting, and they wanted a blues concert to express the singer's world and experience, without insisting or expecting that it express their own.

Obviously, I am not talking about individuals here. Plenty of black people have loved music that gave them a view into a different world, and plenty of white people have demanded music that mirrored their own lives. Maybe it would be more accurate to split the audience along class lines, and say that the shift was from a working-class audience that wanted to hear working-class music to a middle-class audience that wanted to hear working-class music. There was also a gender shift that went along with the shift in race and class: Everyone in the field agrees that as long as blues was primarily played for black audiences, the main consumers were women. The white blues audience, by contrast, is overwhelmingly male.

Different audiences, by definition, have different musical standards, and it is not necessary to say that one standard is better than another in order to see that different standards will produce different music. To leave blues for a moment, I once read a quotation from Arthur Rubinstein about Vladimir Horowitz's first tour of Europe as a young piano prodigy, saying that Horowitz was the first person to perform the Chopin *etudes* perfectly, without any mistakes or deviations from the score. This quotation has always fascinated me, because no pianist could graduate from any classical conservatory in the world today unless he or she could play Chopin as written. Technical exactitude has become the baseline, and whatever else one brings to the music, one is at least expected to be able to play it accurately. Clearly,

though, this was not true in Chopin's time, and even in the early years of the twentieth century the greatest pianists were expected to be great in ways that did not demand this sort of precision. So what were the standards then? Emotion, theatricality, individuality? And are the technically immaculate pianists of our day "better" or "worse" than those of the nineteenth century?

That last question is meaningless, unless one brings one's own taste to bear on it, and it is equally meaningless to argue about whether blues is dying, dead, or in better shape than ever. To one person, the 1980s were a new golden age, to another the rise of Stevie Ray Vaughan proved that true blues feeling was gone forever. Similar debates have been taking place for as long as there have been fans and critics who liked to argue about such things. In 1959, Alan Lomax could condemn the contemporary urban electric styles as "the blues in decadence . . . a picture of a violent and decadent society."[1] A decade later, critics were saying much the same thing about the Rolling Stones.

Black audience tastes shifted from year to year, long before the white audience became a factor. Indeed, African-American pop fans—like all pop fans—have often been crueler than any revivalist, discarding last year's idol as if he or she had never sung an exciting note. Still, there was a continuity in the audience itself: The mainstream of black blues fans was always relatively young, always relatively poor, and always felt a strong link to the South. And it always turned to blues as its own home sound, a musical extension of the most natural, day-to-day speech. (It also kept the musicians up-to-date: In the later 1950s, when Muddy Waters played in a black club, his band would warm up the audience with pop tunes like "Misty" and the latest Lloyd Price hits; in the 1960s, Junior Wells and Buddy Guy played straight blues for white fans but had to throw in James Brown and Wilson Pickett numbers for their home audience in Chicago.)

It is no criticism of the white audience to say that it applied a different standard to blues. Dreams of another world, love affairs with the exotic, aspirations to something outside one's own experience—all of these have been prime motivations for much of the greatest art, as well as centuries of exploration and technological innovation. There is

nothing wrong with a middle-class, college-educated white kid falling in love with the Delta blues, any more than there is something wrong with a poor, black Mississippi sharecropper developing a taste for Mozart. It would be odd, though, if that sharecropper made the same demands on the music as were made by listeners in the Viennese court of the late eighteenth century. The court expected Mozart to write pieces that its members could play in amateur recitals, suited to their instrumental tastes and capacities, and operas suited to the current fashion and the local company. Modern listeners, sharecroppers or not, expect something rather different.

In the same way, the modern blues audience hears Robert Johnson's music very differently from the way his peers heard it in 1935, and makes very different demands on those musicians who consider themselves his heirs. In a sense, the white audience turned blues into a sort of acting. At first, it demanded "real" blues singers, black men and women who had already established themselves as performers in their own communities. Since one of the measures of "realness" was that the music create the atmosphere of another world, that it carry the listener from Carnegie Hall or a Cambridge coffeehouse to a dilapidated porch in rural Mississippi or a barroom on the South Side of Chicago, this audience automatically gravitated toward the blues artists who made those connections most obviously. An audience of poor black Texans knew that T-Bone Walker was still one of them even though he was wearing a zoot suit and diamonds, dancing onstage and playing guitar behind his head. A white revivalist audience worried that someone that sharp and snappy was some kind of faker, adulterating the music's pure country roots.[2]

As the revival picked up steam and white musicians entered the blues field, these standards forced them to attempt a sort of impersonation. Especially if a singer was not from the South, an effort was necessary to sound "real," since a London or New York accent was clearly not appropriate to true blues singing. (Mahalia Jackson sang that God had "the whole 'woild' in his hands," but if a Jewish guy from Brooklyn sang in that accent it would sound ridiculous.) All the older blues artists, from Mamie Smith and Leroy Carr to Lemon Jefferson and Muddy Waters, had sung with an accent and timbre that were

simply extensions of their normal speech. Like white country singers, or indeed singers of any style of vernacular music (what else would "vernacular" mean?), this was basic to what they were doing. The black pop audience had always assumed that when they heard a blues singer, that was what he or she sounded like offstage as well. The white audience liked to make the same assumption, when dealing with an older, black performer, but—except for a few caviling purists—was willing to embrace a good acting job by a white artist. In-deed, the white audience tended to give even greater rewards to white artists who sounded convincingly black than it gave to black artists. Such artists acted as a bridge, seeming more accessible both artisti-cally and personally, and also had a more societally acceptable form of sex appeal.

As with the classical world's note-perfect conservatory students, the recreators of blues had some virtues that the older, more natural musicians did not.[3] Since they were learning the music as outsiders, rather than working in their personal musical language, a single per-former could present a dramatically varied range of styles. In folk clubs, it became common to hear a guitarist play arrangements by artists as unlike one another as John Hurt, the Reverend Gary Davis, and Robert Johnson in the course of a single set. This variety of themes and approaches could make for a far more interesting show than an hour of virtually indistinguishable songs by a "genuine" blues-man who was used to playing all-night dances for crowds that cared only about the rhythm. The new electric guitar heroes were similarly virtuosic, able to fire off solos in the styles of such disparate players as B. B. King, Albert King, and Freddie King—something that none of the Kings would have bothered to attempt.

With the passage of time, such recreative skills have become more and more necessary, as there are fewer and fewer unique, personal stylists working in the blues idiom. This decline in individuality is as indisputable as it was inevitable. It is startling to think that all of the evolution from the first Bessie Smith record to the first Rolling Stones record took only forty years. When Skip James and John Hurt ap-peared at the Newport Folk Festival, they were greeted as emissaries from an ancient, vanished world, but it was only three decades since

they had first entered a recording studio—that is, they were about as ancient as disco is to us today. No one can argue that blues has continued to show similar progress since the 1960s. (That is, unless one wants to declare rap a modern form of blues—which would be fine with me, but seems not to be the general opinion.) As a result, virtually all present-day blues artists, whether black or white, are largely recreators, acting the part of characters who came of age when blues was still black popular music. Some fans will continue to find black performers more convincing than white ones, but that is a question of verisimilitude.[4] A young black man from New York or Colorado—or even from Mississippi—who is trying to sound like someone from his grandfather's time may well produce a better simulacrum than a young white man trying to do the same thing, and the quest for a personal heritage may provide links that the quest to master a foreign language does not. Nonetheless, it remains a fundamentally different effort from playing the music of one's own time and place. Which is to say no young musician who is playing anything that sounds like Robert Johnson is making an artistic decision that even vaguely resembles Johnson's.

Again, it comes back to the audience. Any musician, regardless of race, who chooses to play blues in the twenty-first century has to serve the tastes of the current blues audience. That audience extends around the world, and supports performers of everything from acoustic rural styles to post-Vaughan electric guitar-slinging, but it has certain criteria. For one thing—and here we go with the Horowitz bit again—it expects instrumental virtuosity. The Stones, the Animals, and their English peers made up the last significant wave of blues performers to feature singers over expert instrumentalists.

There was a good reason for white musicians to concentrate on instrumental rather than vocal styles. As Muddy Waters put it, "They got all these white kids now. Some of them can play *good* blues. They play so much, run a ring around you playin' guitar, but they cannot vocal like the black man."[5] One could argue that they should not have bothered trying, since the greatest white blues singers—Jimmie Rodgers, say, or Hank Williams—had always sung in their own natural voices, but that was not the kind of singing the new blues audience cared to

hear. So white singers adopted black mannerisms, and as it turned out, their audience showed little concern for any vocal deficiencies. With Clapton, searing, screaming guitar solos became the defining blues sound, and the fact that his singing was weak and perfunctory mattered only to those who did not much care for his style in the first place. (Among later blues stars, Bonnie Raitt is pretty much the only one who has continued to stress her vocals over her guitar work, and she has spawned relatively few disciples—Susan Tedeschi and her peers are a tiny minority compared to all the male guitarslingers.)

This emphasis on instrumental technique was by no means limited to the electric blues-rock world. The acoustic blues scene was also dominated by guitar fans, who routinely acted as if speed and technical proficiency were the key attributes of the genre. By the 1970s, one could find an expert writing that Kokomo Arnold and Robert Johnson had "nothing in common as musicians"[6]—despite Johnson's careful study of Arnold's vocal approach and song structures—since all that counted was their guitar work. Likewise, it became commonplace for anyone performing a Johnson song to add solos in "Johnson's style," usually meaning a flashy slide break, despite the fact that Johnson recorded only one short solo, it did not feature slide, and as a guitarist he was always more notable for his subtlety and control than for any flashy licks.

Overall, the shift away from vocals marked blues's evolution toward a more clinical and less subtle or conversational approach. Especially in the post-Clapton electric scene, blues stars have tended to be described in much the same terms as heavy-metal guitarists: as technical wizards who can play blindingly fast and have mastered a dazzling range of styles. Their audience has also come to resemble the metal crowd, overwhelmingly white and male, and prone to play air guitar along with the extended high-volume solos.

The dominant blues attitude is a grungy, hard-bitten machismo. Blues artists, male or female, are expected to be hard-drinking, hard-loving tough guys. This flowed naturally from the white fascination with black singers as primitive, primal figures. The black blues audience looked to singers to tell truthful, day-to-day stories—essentially the same standard applied by white country fans—and appreciated

cool words of wisdom or sly comic observations more than shouts of rage or despair. The white audience did not come to blues in search of understated intelligence. It came for emotional release, for a raw, direct passion that it found lacking in white styles. It came in search of Leadbelly fresh off the chain gang, John Lee Hooker's "Boom boom, I'll shoot you right down," Janis Joplin's uninhibited wail, Stevie Ray's Texas outlaw stance.

On the acoustic scene, this could be a bit more subtle, but the rule still holds. Dave Van Ronk, a thoughtful, scholarly man, was well aware that his success as a blues singer was built at least as much on his huge, bearish appearance, ferocious vocal power, and reputation for being able to drink untold quantities of whiskey as it was on his subtle guitar arrangements and intricate, jazz-flavored phrasing. It troubled him that a superbly talented musician like Paul Geremia would be forever handicapped by not being loud or scary enough.

Blues has always been marketed with a strong dollop of *nostalgie de la boue*. Even back in Bessie Smith's day, records were advertised with pictures of broken-down wooden shacks and ragged characters, accompanied by descriptions written in dialect and reeking of poverty, drunkenness, and violence. (Though the music was being marketed almost exclusively to an African-American audience, it is not clear that black people were consulted about the composition of these ads.) Plenty of blues lovers were irritated by such stereotypes, and in 1941 Richard Wright was already protesting that "The blues, contrary to popular conception, are not always concerned with love, razors, dice, and death."[7] Sixty years later, it is still common to find white blues fans equating poverty and grunge with true blues feeling. Writer after writer has made the trek to Mississippi or Chicago, looking for a juke joint or bar where the customers are poor, drunk, and rowdy, and where there is the stimulating fear that at any moment someone might pull a knife. I have done it myself, and for an urban white kid such trips have the thrill of a journey to Afghanistan or Tierra del Fuego. The band may be mediocre or worse, but for a moment one can feel transported back to the glory days of Muddy Waters, or Robert Johnson himself.

Exciting as it is, this is pure outsider romanticism. The most

popular and influential blues players were rarely stuck playing the lousiest joints. Waters and Johnson were known for their clean, sharp suits, and they played for the hippest crowds their neighborhoods provided. And they were among the poorer, more down-home performers. Dinah Washington and T-Bone Walker did not play any dark holes-in-the-wall if they could help it, and their audience was as swanky as it could manage. Even today, go to a Bobby Blue Bland show in a solidly black neighborhood, and it will be full of people wearing nice clothes. In fact, one of the reasons there are so few black people at most blues shows is that the average blues club is grungy and uncomfortable, with sweaty fans packed together as if they were at a rock concert. Put the same acts onstage at an upscale jazz club, and the proportion of African-American listeners instantly skyrockets. In part, this is because the remaining black blues audience is older, made up of people who grew up on Bland and the Kings, but it is also because black fans have never been charmed by poverty, or needed a sordid atmosphere in order to feel that they were having a real blues experience. While white fans drink straight whiskey to get in a blues mood, Muddy Waters drank only champagne, and insisted that it be the real French stuff.

Once again, I am not trying to damn anyone's tastes. I have spent great nights in grungy bars, dancing and sweating and soaking up the funky atmosphere. One of my favorite gigs of all time was playing guitar in the third-string zydeco band on a Saturday night in Mamou, Louisiana, where I was the only white guy in the place. It was like a trip to another world, and I was fascinated, and drunk, and proud that folks complimented my playing—even though I was just with the relief band, and we were no great shakes. In later years, I seized every opportunity to get out to backcountry juke joints, even if the band was a bunch of unknown locals, and I expect to be in a lot more such rooms before I die. But, while those experiences are engraved in my mind as exotic adventures, I tend to remember few details about the music. Ask me about the most memorable blues shows I have seen, the ones where I remember specific songs and exactly how the performers looked, moved, and sounded, and I recall Jimmy Witherspoon with a first-rate pickup band of jazz players, Etta James or Eddie Kirk-

FARTHER ON UP THE ROAD

land at Boston's nicest blues club, or B. B. King blowing all the down-home cats offstage at the Providence Civic Center. The settings may or may not have been ideal in terms of atmosphere, but they were the ones that could pay for the best singers, and the ones where those singers preferred to work. Anyone who would rather hear a mediocre band in a juke joint than a great one in a clean, comfortable nightclub is looking for something other than music—which, once again, is a perfectly reasonable choice, but will have an effect on what gets played.

Incidentally, that Providence Civic Center show was a revelation for me. It featured, in order of appearance, Roomful of Blues, Koko Taylor, Junior Wells and Buddy Guy, Willie Dixon, Freddie King, B. B. King, and Muddy Waters, who ended his set jamming with Dixon, Wells, and Guy. Even now, as I write those names, that finale sounds like a dream. I had gone there to see Waters, Dixon, and Wells and Guy, all of whom I considered legends. In comparison, I thought of B. B. as too slick and smooth—that horn section in nice uniforms and all—and in those days I had not yet heard of Freddie. I was a pure, down-home, folk-blues fan. But Freddie knocked me out, sweating and shouting and playing slide with the microphone stand. And then B. B. came on, and taught me that everything I knew about blues was wrong. Because he just stood there calmly and played the most amazing music I had ever heard. He was awesome, in the literal sense that he seemed immense, majestic, and it was impossible to look away from him. And it was all so relaxed and natural, as if he were talking directly to each person in that huge stadium. It was everything I had always loved about blues and more, the perfect blend of deep emotion and flawless musicianship. The Muddy Waters jam session was great too, and I still feel very lucky to have seen Waters in that company, but it did not have that kind of magic.[8]

Maybe it was a matter of the room and the audience; maybe Waters needed a more intimate setting. Or maybe he was just having a slightly off night, while B. B. was on fire. In any case, it was one of the greatest blues performances I have seen, despite the fact that the Providence Civic Center was as unconducive to blues "feeling" as any structure on earth. Unlike what I have heard in a hundred bars and

jukes, where I was drinking and feeling good, the band was rocking, and the smoke and stale beer and sweat blended into a perfect honky-tonk bouquet, this was music that could transcend its setting and deserved to be ranked as one of the world's greatest styles. And that is no small distinction, because I do believe that blues, at its best, can rank up there with the finest work of the Ellington band, with Pablo Casals playing Bach, with Billie Holiday and Ali Akbar Khan and the early Ornette Coleman Quartet—make your own list, and whoever is on it, I swear that there have been blues artists of that stature. But they came up in another world.

Again, it is all about the audience. Because all of those artists—like almost any artists, anywhere, anytime—did their greatest work when they were performing regularly for audiences that understood them and demanded their greatest work. An audience that yells its approval whenever the guitar hits a screaming, sustained high note, but misses the subtleties of a vocal phrase and does not chuckle at the inside jokes, will get what it cheers for. Most players will drop the subtleties—which involve far more work and care—and just give the people what they want, collect the check, and go home. The performers who insist on keeping their artistic standards high may hold out and resist the temptation to provide cheap thrills, but they will not think much of the audience, and the more years they spend playing for it, the less enthusiastic they will be. And it hardly matters how brilliant or talented any of these musicians are. If the audience is happy with mediocrity, great musicians will produce mediocrity. Or quit, or drink themselves to death.

If I had to name the greatest blues recordings of all time, virtually all of them would be from before 1970, and there are few serious blues fans who would not say the same. There has been plenty of good work done since then, but awesome, transcendent classics on the order of Skip James singing "Devil Got My Woman" or Leroy Carr's "Midnight Hour Blues," or Bessie Smith's and Lemon Jefferson's finest records, or the first hits Muddy Waters had on Chess? No way, no how. And this is not because of any decline in musical expertise. The current blues stars can play faster, cleaner, and with more versatility than ever—if music were the Olympics, we would be seeing records broken

every couple of years. But the world where an artist like Jimmy Rogers (the Muddy Waters band guitarist, not the white yodeler) could record a masterpiece like "That's All Right" is gone. And I pick that record because Rogers was not an exceptionally great blues singer. He was a fine second-tier artist, a marvelous sideman, but in 1950 he was able to make superb, astonishing music because he was pushed to the absolute top of his potential and beyond, by a scene that knew blues backward and forward, loved it, and could tell the difference between a musician giving his all and a showman with a fine line of shuck and jive. (And I am not saying that the audience did not like showmanship and jive, just that it knew the difference.)

Perhaps more importantly—since I seem to be lapsing into my own strain of romanticism—it was a scene on which blues was hot, young, and attracted the best and brightest musicians in America. To revisit the old iceberg metaphor, all the blues artists we have ever heard represent only a tiny fraction of all the people who were playing in local bars, at parties, at dances, and on street corners. There was a pool of thousands of performers, maybe tens of thousands, and the ones we are aware of represent only the top fraction, the ones who were distinctive enough or had enough hustle to be recorded. An idea of the unrecorded talent pool can be gleaned from the fact that Leadbelly, Mance Lipscomb, Robert Pete Williams, Johnny Shines, Honeyboy Edwards, and dozens of other musicians who recorded later but were already active in the 1920s or 1930s were missed by the commercial companies. As Muddy Waters remembered it, "Several boys around there could use the slide and I'd say they were just as good as Robert Johnson, the only thing about it is they never had a chance to get a record out."[9] When we listen to Johnson, we are hearing the cream of a large crop, and that particular crop was not playing that way even a decade after his death. By the 1940s, those young men were joining jump combos, as Robert Lockwood did. By the 1950s, they might have been singing doo-wop. Today, they would be rapping and mixing.

It takes a special sort of person to want to play unpopular, archaic music. Thank God there are a few out there, since a lot of old, unhip styles remain brilliant, complex, and moving, and all the records on earth cannot substitute for hearing them played live. In a world where

creativity and innovation are constantly cited as the prime artistic virtues, it is important that some people still take on the tough task of mastering classic forms, of becoming traditional craftsmen. It can also be an inspiring artistic journey. I once met a sculptor who, after years of doing modern, nonrepresentational work, needed some money and accepted a commission to copy a Michelangelo. "It was the strangest thing," he told me. "There I was, cutting into the stone, and a Michelangelo was coming out. The feeling was like nothing I had ever experienced, completely different from making my own pieces. But none of my friends understand, they think I am just prostituting myself." It can be an equally amazing feeling for a young guitarist to move her fingers on the fretboard and hear the sound of Robert Johnson, Memphis Minnie, or Albert King emerge from her hands. I imagine Johnson must have experienced a similar feeling when he mastered a new Lonnie Johnson lick, or heard his falsetto whoop coming back off a record as cool and strong as Peetie Wheatstraw's original.

Except that Johnson and his peers were learning the latest, best-selling styles of their day, the ones that promised money and sex, bright lights and big cities. They were, like Michelangelo, leading an artistic revolution, not revisiting some favorite old sounds. Some of the early blues masters may have been antisocial loners, but the music that made them famous was not antisocial loner's music. It was mainstream, big-selling pop, with all the pleasures and compromises that entails. And the urge to be a pop star is worlds away from the urge to play cult music, fine as that cult music may be.

To say that there is a museum-like or classical quality to the greatest blues as we hear it today is to put it in a category with Rembrandt, with Egyptian sculpture, with van Gogh and Beethoven and Duke Ellington. It is not an insult, but it is a description, and a reminder that things have changed since the days when it was a new sound, taking off and racing toward a wide-open future. It is the museum-goers who have made Robert Johnson a legend, who consider him the emblematic figure of the classic blues era. He fits the bill perfectly, and not only because he recorded superb music. He tried out all the different blues approaches of his day, wrote his own variations on them, and got

them on record, providing a better survey of 1930s trends than we can hear in the work of any other single player. He came from the Mississippi Delta, which has become hallowed in blues lore for its combination of racist underdevelopment, astonishing musical talents, and unique status in the development of the later Chicago/Detroit sound that, in turn, inspired the hard core of rock 'n' roll. He exemplifies the lifestyle that white listeners have always associated with the music: a homeless wanderer, alone in the world, haunted by demons, destroyed by violence. His early death and his introspective lyrics cast him as the early blues world's Keats or Mozart, James Dean, Jim Morrison or Jimi Hendrix.

Which is to say that when Robert Johnson became a mythic, godlike figure, it was as part of the European religion of art, not any African-American spiritual tradition. He is not famed in black folklore for selling his soul. He is famed in white folklore as an archetype of the sensitive artist cut down in his prime. White blues fans elevated him to the pantheon, and it is the pantheon of the nineteenth-century Romantic movement.

Romanticism was an important, valuable movement, like the early blues boom, with standards that are just as worthy of respect. It nurtured a salutary distrust of the mainstream and successful. It argued that a thunderstorm was more awesome than St. Paul's Cathedral, and that an obscure artist dying alone and unheard could be greater than Bach or da Vinci. Those of us who have nourished our souls on Skip James or Robert Johnson owe an infinite debt to the romantics who reissued their records and acclaimed them and their Delta peers as the ultimate expression of twentieth-century American music.

It is worth being reminded occasionally, however, that our blues world bears little resemblance to the world in which our idols lived and played. There are still some fine musicians mining the classic styles. Alvin Youngblood Hart is playing music that is deep, quirky, and ranges with apparent ease from Johnson to Jimmie Rodgers to Leadbelly to Captain Beefheart. Paul Geremia remains for me the most consistently satisfying musician and writer in the field, constantly pushing himself to absorb more from the greatest older styles and to

find new ways of adapting them to his own experience. And they are not alone. There will be plenty more good shows to be seen, and talented new players entering the field.

But it is a small field, and will never again produce a Ma Rainey, a Leroy Carr, a T-Bone Walker, a Dinah Washington, a Muddy Waters, a B. B. King. Or, needless to say, a Robert Johnson. A lot of years have passed, and our world is a different place, and that makes for different music. When a young black man with Robert Johnson's ambition comes along today, he will be rapping about today's women, cars, and drugs, not playing an acoustic guitar and singing of riders, Terraplanes, and malted milk. Not because there is anything wrong with that style, but because all it can promise its devotees is a lifetime of playing in small rooms of middle-aged white people, for embarrassingly little money.

The world changes, and music changes with it, and some things are lost and others are gained, and the past may repeat itself, but always in new ways. I obviously love blues, and if I had a time machine I would go back to Robinsonville, Mississippi, in 1930. But I do not have a time machine, and I cannot fool myself that any modern blues club will provide me with one. The current blues scene has its own charms and weaknesses, but if I want to recapture a hint of Johnson's spirit, I may do as well in the Congo or Brazil or Paris as in the Delta, and I cannot expect the music to sound like anything from the old days, or to be called blues. François Villon, the medieval French bluesman, said it best over five hundred years ago: Do not ask where the beauties of ancient times have gone, for I can only reply: "Where are last year's snows?"

Except that we are in better shape than that. We still have the records, and they sound as good as ever.

AFTERTHOUGHT:
SO WHAT ABOUT THE DEVIL?

*I done sold my soul, sold it to the Devil, and my heart done turned
to stone,*
*I've got a lot of gold, got it from the Devil, but he won't let me
alone.*
He trails me like a bloodhound, he's slicker than a snake,
He follows right behind me, every crook and turn I make.
*I done sold my soul, sold it to the Devil, and my heart done turned
to stone.*

—"DONE SOLD MY SOUL TO THE DEVIL,"

SUNG BY CLARA SMITH, 1924

IN RICHARD WRIGHT'S AUTOBIOGRAPHY, HE TELLS OF A PER-
formance that transformed his life, back when he was a small boy in
Mississippi: It "made the world around me be, throb, live . . . reality
changed, the look of things altered, and the world became peopled
with magical presences."

Then his grandmother caught him listening. "You stop that," she
cried. "I want none of that Devil stuff in my house!"

The performance in question was a prim young schoolteacher
telling him the story of "Bluebeard and his Seven Wives."[1]

It is a universal fact that the terrors of the occult are fascinating,
and it is common for them to be condemned by respectable people.

So it is not surprising that white blues fans have eagerly accepted the connection of blues with mysterious, demonic forces, nor that they have found black churchgoers whose views confirm this connection. The fans ignore the fact that the church folk frequently put fiddlers and tellers of fairy tales in the same category as Robert Johnson, and that in a lot of deep Southern communities blues was no more connected with the Devil than any other dance music was. When Harry Middleton Hyatt collected stories of musicians going to the crossroads to gain supernatural skills, as part of a vast study of Southern folk beliefs in the late 1930s, he reported as many banjo players and violinists as guitarists. (Also one accordion player, and that is not to mention all the stories of people seeking mastery over cards or dice.)

Which is to say I can be as fascinated by occult musings as the next guy, but it is long past time for music journalists to get over the cliché of always linking Robert Johnson and the Devil. For at least a few years, I propose a moratorium on sentences like "Persistent themes in his blues were religious despair and pursuit by demons," or "Johnson seemed emotionally disturbed by the image of the devil, the 'Hellhound'. . ." Such sentences tell us less about the realities of Johnson's music than about the romantic leanings of his later, urban white listeners. There is no suggestion from any of his friends or acquaintances that the hellish or demon-harried aspects of his work were of particular importance to him, or that they were even noticed by the people who crowded around him on the streets of Friars Point. The songs his contemporaries have recalled as most striking or popular have never been those cited by later fans as showing his fealty to demonic forces. And this is not just because the folks back home were all good-time jukers—witness Johnny Shines's eloquent reminiscence of an audience reduced to tears by Johnson's performance of "Come On in My Kitchen."

Nothing is more dangerous than psychologizing a pop artist by studying his themes, since these often have as much to do with contemporary fashion as they do with personal taste. It would be easy to write a thesis on Johnson's weird sexual fetish for inanimate objects—hot tamales, phonographs, fishing holes, car engines, dressers, lemons, butter churns—ignoring how common such verses were in 1930s

blues. That stuff was funny, and it sold, and that may be all there is to it. Likewise, it is worth noting that in the first song that supposedly demonstrates Johnson's satanic connections, "Preachin' Blues (Up Jumped the Devil)," Johnson makes no mention of any devil. As I mentioned in the relevant chapter, it is very likely that Johnson did not even know about the parenthetic addition—that it was simply tacked on by someone in the Okeh offices in an attempt to attract the Peetie Wheatstraw fans.[2]

There is some argument as to whether Peetie Wheatstraw, the Devil's Son-In-Law, the High Sheriff from Hell, was already a legendary African-American folk character before a singer named William Bunch appropriated the pseudonym, or whether Bunch's popularity was so great that his character grew into a folk hero.[3] Either way, the character was at least as exciting as the music, as witness the record and movie *Peetie Wheatstraw: The Devil's Son-In-Law*, produced by the comedian-rhymester Rudy Ray Moore in the 1970s, which contained not the slightest reference to blues singing, but instead told of a superfly ghetto character who agrees to marry the Devil's daughter. Back in the 1930s, the image helped make Bunch a star, and as Peetie Wheatstraw he became one of the prime influences on Johnson's singing and songwriting styles. Given Johnson's obvious admiration for him—and no blues fan of the time would have failed to recognize where that falsetto *"ooo-well"* came from—I have sometimes toyed with the idea that it could actually have been a savvy producer who cooked up the whole Devil theme. In my fantasy, Johnson arrives for his second recording date, ready to follow up his "Terraplane" success with more double-entendre party numbers, and the producer says, "Hey, the dirty songs are getting kind of played out, but I notice you're a big Wheatstraw fan. How about some Devil stuff? You know, something a little more unusual." Fast worker that he is, Johnson riffles through his mental catalog of favorite songs, reworks a couple of them, and comes in the next day with "Hell Hound On My Trail" and "Me and the Devil." Unfortunately, these songs do not sell, and are quickly forgotten even by him, but it was worth a try. . . .

It is just a fantasy, but it makes as much sense as a lot of the other Johnson fantasies out there. Not that I am discounting the lure of the

supernatural, or the fact that the Delta was and is rife with what some call superstition and others consider a survival of ancient African religions. I am just baffled by all the writers who assert that blues singers were the famous adepts or priests of hoodoo. This has become common currency in certain circles, and the idea was reinforced by an odd book called *Bluesman* by a writer named Julio Finn. Finn is brother to the blues musician Billy Boy Arnold, and he clearly knows a lot about blues. He has also made a quite thorough survey of African religious survivals in the Caribbean and Brazil. However, the only evidence he provides to link these two fields is his personal intuition, and it does not add up. For one thing, the African-American musicians who have always been deepest into hoodoo have been not Delta blues singers, but New Orleans jazz and R&B players. The Caribbean sources of hoodoo/voodoo/vodun—African magical powers, by whatever name— were known throughout the South, and when a Mississippian imagined a quest for such things he headed "down in Louisiana to get me a mojo hand," to quote the Muddy Waters hit. And he did not buy that mojo hand from a juke-joint guitarist.[4]

Strange as it may seem to present-day fans, musicians were not that important. Even on their most famous stomping grounds, they were not the reason for the juke joints, nor were they the kings of the juke joints. They were the entertainment—specifically, that portion of the entertainment that has come down to us on records, unlike the bootleggers, gamblers, and prostitutes who also had their fair share of fans and legends. It would be interesting to see what would happen if, instead of going up to the oldest folks on Dockery's plantation and asking, "Who were the famous blues singers around here?" the folklorists asked, "Who were the famous people around the juke joints?" If we judge by who was immortalized in song, there are ballads of gamblers and gunfighters like Stack O'Lee and Billy the Lion, and legendary workers like John Henry and Casey Jones. Charley Patton immortalized a couple of local sheriffs, a steamboat, and a tough plantation boss. Barroom "toasts" celebrate the amatory prowess of famous pimps and whores. Who sang or recited legends of famous musicians, before the northern white kids got into the game?[5]

The New Orleans jazz pianist Jelly Roll Morton regularly boasted

that music was just a sideline for him, that he made his real money as a gambler and a pimp. It was the gamblers and pimps, the bootleggers, tough guys, and gangsters who ruled the barrooms and juke joints, often hiring and firing musicians at their whim. Especially in Louisiana and the deep South, a lot of these guys were pretty heavily into hoodoo, and it was easy for their less fortunate admirers to assume that they had signed pacts with satanic powers. That is what all those charms, the mojo hands and John the Conqueror roots, were usually about. They brought their owners inhuman control over love affairs and the rolling of dice. Sure, Robert Johnson looked solvent and sharp in that fine suit, and that was no small thing for a guitar player in the Delta, but did he ever own a second suit? Even his greatest admirers could not imagine him acting out the following scene from Morton's autobiography:

> I would land in some little town, get a room, slick up, and walk down the street in my conservative stripe. The gals would all notice a new sport was in town, but I wouldn't so much as nod at anybody. Two hours later, I'd stroll back to my place, change into a nice tweed and stroll down the same way. The gals would begin to say, "My, my, who's this new flash-sport drop in town? He's mighty cute."
>
> About four in the afternoon, I'd come by the same way in an altogether different outfit and some babe would say,
>
> "Lawd, mister, how many suits you got anyway?"
>
> I'd tell her, "Several, darling, several."
>
> "Well, do you change like that every day?"
>
> "Listen, baby, I can change like this every day for a month and never get my regular wardrobe half used up. I'm the suit man from suit land."
>
> The next thing I know, I'd be eating supper in that gal's house and have a swell spot for meeting the sports, making my come-on with the piano and taking their money in the pool hall.[6]

In the 1970s, Little Brother Montgomery was still recalling the figure Morton cut: "He always had a thousand-dollar bill in his pockets somewhere: and then he had diamonds on his fingers and all in his shirt and in his teeth and a .38 special in his bosom."[7] There were

quite a few characters like that around, but most have been forgotten because they did not possess Morton's musical genius along with their more remunerative skills. Now, if you were sitting in a juke joint, and had to guess which person in the room had made a bargain with the dark powers, would you pick the rich gambler who won all bets and was supported by a string of women, or the guy in the back playing expert guitar?

I am not sure when people first began suggesting that blues singers were the high priests of some secret hoodoo cult, or were regarded in their communities as the anti-preachers of Southern spirituality. I suspect that this legend may have its roots in the New York of the 1930s and 1940s, when the folklorists, artists, and writers who were becoming interested in blues were also exploring the African religious societies of Haiti and Cuba. Far from the Delta, experiencing its culture only on records, they thought it logical to suggest that blues was a mainland analog to the ceremonial songs of the islands, and Robert Johnson's records fit this bill better than Leadbelly's, Josh White's, or Big Bill Broonzy's. Back in Mississippi, though, music was just one part of what made up black life and culture. As for magical beliefs, there were certainly some that could be traced back to Africa, but also many that traced to Europe and points farther east. One of the older Delta residents Alan Lomax interviewed in 1941 spoke of the "Egyptians" who used to come through with lodestones, saying that they could cure sickness, repel bullets, and lift a wagon just by passing their hands over it. Such Gypsies, real or fake, traveled the South working charms and predicting the future, and there were also plenty of "Indian" wonder-workers, of both the Native American and Asian varieties. There was a lot of belief in "ancient wisdom," and both blacks and whites found it easy to accept the idea that the Far East, the American forests, or the African jungles were populated by mystical forces that could be harnessed by those who possessed the required knowledge.

Quite a few blues songs mention mojo, hoodoo, goofer dust, and other charms, but that was by no means unique to blues: There were ads for all these products in the pages of the *Chicago Defender*. Likewise, stories about people selling their souls to the Devil were common in South and North, and told by blacks and whites alike. As with

so much in American culture, African and European beliefs blended and overlapped. European stories of great musicians—Tartini and Paganini are famous examples—selling their souls in return for musical gifts were matched by African stories of similar gifts being given by the spirits of forests, rivers, or pathways. It is possible, as some blues scholars argue, that the old European legend of going to the crossroads to meet the Devil was overlaid with African memories of a "spirit of crossing paths" that Cuban Santeria belief calls Eleguá. The beliefs belittled as "superstition" and "folktales" frequently have roots in older, more formal religious beliefs, changed and distanced from their origins. Parables from Africa survived in the United States—albeit far more rarely than in areas of the Caribbean and South America where slave owners did not work so hard to destroy African culture—as did some African musical techniques. It is logical to assume that African religions survived to some extent in the beliefs of African Americans, especially in majority-black regions like the Delta, forming a rich mixture with Christian teachings and the commercial magic and soothsaying of Gypsies, Arabs, and Indians. Nonetheless, such beliefs were by no means either universal or consistent, even in relatively small and isolated areas. Among black Delta dwellers, as among most people in most places, one person's Devil was another person's superstitious silliness. Some folks believed, some mocked, and many swung back and forth depending on the situation.

One man who certainly believed was Tommy Johnson's brother LeDell, who provided the story that has formed virtually the entire basis for the Mississippi blues devil legend:

> Now, if Tom was living, he'd tell you. He said the reason he knowed so much, said he sold hisself to the devil. I asked him how. He said, "If you want to learn how to play anything you want to play and learn to make songs yourself, you take your guitar and you go to where the road crosses that way, where a crossroad is. Get there, be sure to get there just a little 'fore midnight that night so you'll know you'll be there. You have your guitar and be playing a piece there by yourself . . . A big black man will walk up there and take your guitar, and he'll tune it. And then he'll play a piece and hand it back to you. That's the way I learned to

play anything I want." And he could. He used to play anything, don't care what it was. Church song. You could sing any kind of tangled up song you want to, and I'll bet you he would play it[8] [We think of Tommy Johnson as a bluesman, but notice that LeDell emphasizes his versatility, not even mentioning blues.]

I would stress that the Johnson in this story was *Tommy*, one of Mississippi's most popular and influential blues performers. Tommy Johnson was a local star with a smooth, mellow voice and distinctive falsetto cry that was imitated by many Delta singers. There is nothing particularly haunted about this voice, and the only demons that crop up in his lyrics are the prosaic ones of cheating women and the vile alcoholic preparation he made famous in his "Canned Heat Blues." As a result, those who have written about him have talked about his music, and paid only passing attention to the devil story, which has been transferred to Robert Johnson ex post facto, to match the character white listeners had already created in their imaginations. As an example of how far this has gone, the *New York Times* review of the movie *O Brother, Where Art Thou?*, which featured a blues-playing character named Tommy Johnson who had sold his soul to the Devil, described this character as "a reference . . . to the real-life bluesman Robert Johnson."[9]

Not only was it Tommy, not Robert, who provided the one thorough account of a Mississippi guitarist selling his soul, but his testimony came to us only by way of his brother LeDell, who seems to have been singularly enamored of such stories. LeDell was a reformed blues singer who had become a minister, and he traced his conversion to supernatural roots, saying that his guitar had become bewitched, and this scared him off secular music. The folklorist David Evans, who recorded LeDell's story about Tommy in the late 1960s, notes that he heard nothing similar from the blues star's other siblings or acquaintances.[10]

LeDell Johnson was only one of a number of Mississippi blues musicians who became preachers, among them Ishmon Bracey, Rube Lacey, and Robert Wilkins. Then there were Skip James and Son

House, both of whom did stints in the ministry before turning to music. This is often cited as evidence of a parallel between blues singers and preachers, as if the two professions were flip sides of the black Delta belief system. The two trades could certainly overlap, since someone who is expert at reaching and keeping an audience can channel that skill in various ways, but how many patent medicine salesmen, comedians, and other sorts of entertainers took the same route? Indeed, how many pimps, thieves, and gamblers? I do not know the answer, but a glance at St. Augustine's *Confessions* suggests that such transformations are anything but new.

It is easy to see how outsiders would have concluded that bluesmen and preachers were two sides of the same coin. I have already written of Son House's trancelike performances, and it requires no great leap to imagine his listeners acclaiming him as a sort of *loa*, a receptacle of voodoo spirits. The problem is that, much as I am struck by his appearance of mystical possession—the shivering, the eyes rolling back, and that amazing voice bursting forth—no one has ever suggested that folks in the Delta regarded House as anything more than a great dance musician, fond of strong drink and pretty women. His performances seem to have been considered far less memorable than the "clowning" of Charley Patton or Tommy Johnson, with their jokes and acrobatic guitar tricks.

In fact, the only reports I have read of old-time blues singers "possessing" their audiences come not from the Delta jukes, but from the vaudeville theaters. There is Thomas Dorsey's recollection of Ma Rainey, and similar descriptions of Bessie Smith hypnotizing people with her live performances, in one case "walking" an audience member across the stage like a zombie. This sort of mystical control is far more practicable in a theater setting, where the crowd's attention is focused on the singer, than in a juke joint full of rowdy customers dancing, drinking, talking, gambling, and generally casting off the troubles of the working week. In later years, there would be more such stories, but always attached to the higher-level performers, and in particular the pioneers of the gospel-soul fusion, who had a battery of church tricks up their sleeves. If one wanted to build legends about

singers acting as priests of the dark forces, Sam Cooke, James Brown, Ray Charles, and Aretha Franklin have effected more voodoolike possessions than all the down-home bluesmen put together.

But enough generalities. Let me finish off with a look at the specific evidence connecting Robert Johnson and the Devil. This is ground that has already been covered by others, such as Gayle Dean Wardlow, a white Mississippian who has done as much research into prewar Delta blues as anyone in the field, including finding Johnson's death certificate and much of the other information that is endlessly recycled by writers like myself. In *Chasin' That Devil Music*, Wardlow goes through some of the lyrics that have been used to prove Johnson's special connection to the Devil.[11] He points out that such lyrics were good business, that the "hellhound on my trail" line had been recorded by Funny Paper Smith six years earlier, and that both Johnnie Temple and Kansas Joe McCoy had already done Devil songs based on Skip James's piece before Johnson recorded his adaptation.[12] Wardlow does not parse "Me and the Devil," but others have pointed out what an unbiased reader, unaware of the Johnson legend, might see quite easily: That as far as the lyrics go, this is meant to be a funny song. The most obviously comic lines are "You may bury my body down by the highway side/So my old evil spirit can get a Greyhound bus and ride," but the dark humor common to blues is there throughout. Disturbing as it may be, even lines like "Me and the Devil was walking side by side/I'm going to beat my woman until I get satisfied" would have been more likely to provoke chuckles than horror in a juke-joint crowd. Indeed, similar lines are regularly greeted with guffaws and cheers today, at shows by everyone from Chris Rock to Eminem.

The Devil-seekers have also attempted to drag in other songs, farther-fetched and with less evidence. "If I Had Possession Over Judgment Day," for example, is quite obviously a jokey threat, a cousin of the medicine-show song "I'm Gonna Buy a Graveyard of My Own." As for "Cross Road Blues," the satanic connection has to be made by first citing the Tommy Johnson story, tracing it through the ancient beliefs in a dark spirit who appears at the meeting of pathways, then jury-rigging it to fit a song that never suggests any such theme. Johnson sings that he was down at the crossroad trying to flag a ride—any

hitchhiker can tell you that this is the place where cars slow down and are more likely to stop for passengers—but everybody passed him by. Seeking spiritual assistance, he did not call on the Devil, but instead "asked the Lord above, 'Have mercy, now save poor Bob, if you please.'"[13]

I cannot answer those people who say that all of this is irrelevant, that they perceive the demon-haunted aspect of Johnson's character in the tone of his voice and the slashing power of his slide work. *De gustibus non est disputandum*, and it would be pointless for me to try to deny anyone the right to get anything out of a work of art that they want. Speaking for myself, when I listen to Johnson I hear a great poet and musician, someone who could communicate zest for life and searing misery with equal ease and power. It would seem to me that this ability is the hallmark of any truly great artist, from Homer to James Joyce to Billie Holiday, Charlie Parker, Cesaria Evora, Hank Williams . . . I do not see why, except because some disenchanted urbanites want to create a mystical Delta fantasy, we need to single out Robert Johnson for satanic honors. If the Devil was real to him, the same was true of John Milton and Paganini, of Jelly Roll Morton and any other believer in the powers of light and darkness. If one believes the world is caught in a Manichean battle between God and the Devil, good and evil, saved and damned, it follows logically that the psalm singers go to heaven and the fiddlers go to hell. But assuming that Delta dwellers of the 1930s were humorlessly Manichean about such matters is condescending bullshit.

Yes, Son House once answered a question about Johnson's speedy mastery of the guitar by suggesting that he had sold his soul to the Devil, but House did not emphasize the point with any seriousness, nor did he repeat it whenever he told the story. And listen to Johnson's school friend Willie Coffee. In the documentary *Hellhounds on My Trail: The Afterlife of Robert Johnson*, the blues expert Steven LaVere asks him if Johnson ever talked about selling his soul to the Devil. Coffee says that yes, he did, then promptly adds, "I never did think he's serious, because he'd always, when he'd come in here with us, he'd come in with a lot of jive, cracking jokes like that. I never did believe in it."

In another documentary, *In Search of Robert Johnson*, the modern-day blues singer John Hammond is interviewing an old girlfriend of Johnson's, a funny, toothless character called "Queen" Elizabeth. She is quite adamant that Johnson sold his soul to the Devil, but to Hammond's apparent amusement insists that the same is true of all blues singers. "Yeah! You're singing the blues, ain't you?" She looks at Hammond quizzically. "Do you sing?"

"I sing, but I didn't sell my soul," he says.

"Don't you sing?" she asks, with the air of a district attorney catching a witness in a prevarication.

"Yeah, I sing."

"Well!" she says, with an air of finality. "Ain't you done sold your soul?"

The scene shifts to Hammond sitting opposite Johnny Shines. Shines reaches out a hand, and quietly asks, "Let me see your soul. Hand it over. Can you?"

Hammond demurs.

"Then what can you do about selling it? How can you sell something you've got no possession over? You've got possession over life; you can become a dead soul. But now you're a living soul."

Then the scene shifts again, to Mack McCormick, perhaps the foremost modern Johnson expert, as he reassures us that Johnson was indeed devoted to the Devil legend.

Every culture has its legends—one could argue that this is what makes for a culture. The legend of Robert Johnson selling his soul at the crossroads is one of ours. The "us" being present-day, urban, literate, mostly white music fans. It is a legend carried on by the Rolling Stones, by heavy-metal bands, by blues guitarslingers, by journalists, by filmmakers. It is a potent and intriguing legend, and says a great deal about our yearnings and dreams. Just as the legend of the brilliant young musician who traveled to big cities, made records, wore fancy clothes, and never had to pick any cotton ever again says a great deal about the yearnings and dreams of black people in the Mississippi Delta of the 1930s. We are all romantics in our fashion.

appendix

Records on jukeboxes in African-American amusement places in Clarksdale, Mississippi, c. 1941, as noted by the Fisk University–Library of Congress team, including Samuel Adams, Lewis Jones, Alan Lomax, and John Work.

MESSENGER'S CAFÉ
(numbers indicate most-played selections)

"I Know How to Do It"—Sam Price
"Goin' to Chicago Blues"—Count Basie (1)
"Vine Street Boogie"—Jay McShann
"That's the Blues Old Man"—Johnny Hodges (3)
"The Boogie Woogie Piggy"—Glenn Miller
"Until the Real Thing Comes Along"—Ink Spots
"When I Been Drinking"—Big Bill
"Solitude"—Billie Holiday
"Daddy"—Sammy Kaye (5) (was first, now waning in popularity)
"Julia"—Earl Hines
"I Like My Sugar Sweet"—Fletcher Henderson
"I See a Million People"—Cab Calloway
"Brotherly Love"—Louis Jordan (6)
"Twenty Four Robbers"—Fats Waller
"I'll Get Mine Bye and Bye"—Louis Armstrong
"Love Me"—Lil Green
"Jelly Jelly Blues"—Earl Hines
"Come Back Baby"—Walter Davis
"Yes Indeed"—Tommy Dorsey
"Maria Elena"—Eddie Duchin (4)
"Tonight You Belong to Me"—Erskine Hawkins

"Basie Boogie"—Count Basie
"Pine Top's Boogie Woogie"—Louis Jordan (2)
"Romance in the Dark"—Lil Green

CHICKEN SHACK

"There's Something Within Me"—Sister Rosetta Tharpe
"Beer Drinking Woman"—Memphis Slim
"Buckin' the Dice"—Fats Waller
"Blue Flame"—Woody Herman
"Blues"—Artie Shaw
"Come Back Baby"—Walter Davis
"Throw this Dog a Bone"—Ollie Shepard
"Love Me"—Lil Green
"Goin' to Chicago Blues"—Count Basie
"Call Me a Taxi"—Bob Crosby
"Daddy"—Sammy Kaye
"Saxa-Woogie"—Louis Jordan
"Pan-Pan"—Louis Jordan
"Down, Down, Down"—Count Basie
"Jelly Jelly"—Earl Hines
"My Mellow Man"—Lil Green
"I'm Falling for You"—Earl Hines
"Keep Cool Fool"—Ella Fitzgerald
"Yes Indeed"—Bing Crosby
"Stand By Me"—Sister Rosetta Tharpe

DIPSIE DOODLE

"Romance in the Dark"—Lil Green
"All that Meat and No Potatoes"—Fats Waller
"Undecided Blues"—Count Basie
"Key to the Highway"—Jazz Gillum
"Beer Drinking Woman"—Memphis Slim
"Stand By Me"—Sister Rosetta Tharpe
"Because of You"—Erskine Butterfield
"Yes I Got your Woman"—Washboard Sam
"Wee Baby Blues"—Art Tatum
"Whiskey Head Man"—Tommy McClennan
"Boogie Woogie's Mother-in-law"—Buddy Johnson
"Shortnin' Bread"—Fats Waller
"My Mellow Man"—Lil Green
"Come Back Baby"—Walter Davis
"Love Me"—Lil Green
"Pine Top's Boogie Woogie"—Louis Jordan
"My Blue Heaven"—Artie Shaw

"Rocking Chair Blues"—Big Bill
"Please Mr. Johnson"—Buddy Johnson
"Jelly Jelly"—Earl Hines

LUCKY'S

"Throw this Dog a Bone"—Ollie Shepard
"Goin' to Chicago Blues"—Count Basie
"Jelly Jelly"—Earl Hines
"Boogie Woogie's Mother-in-law"—Buddy Johnson
"My Blue Heaven"—Artie Shaw
"Do You Call that a Buddy?"—Louis Jordan
"Good Feeling Blues"—Blind Boy Fuller
"Look Out for Yourself"—Peetie Wheatstraw
"What You Know Joe"—Jimmy Lunceford
"Buckin' the Dice"—Fats Waller
"Red Wagon"—Lou Holden
"Please Mr. Johnson"—Buddy Johnson
"Love Me"—Lil Green
"All that Meat and No Potatoes"—Fats Waller
"2:19 Blues"—Louis Armstrong
"Stand By Me"—Sister Rosetta Tharpe
"Beer Drinkin Woman"—Memphis Slim
"Saxa-Woogie"—Louis Jordan
"Come Back Baby"—Walter Davis
"Summit Ridge Drive"—Artie Shaw

NEW AFRICA

"Summit Ridge Drive"—Artie Shaw
"All that Meat and No Potatoes"—Fats Waller
"Cross Your Heart"—Artie Shaw
"Undecided Blues"—Count Basie
"New Please Mr. Johnson"—Buddy Johnson
"Pan-Pan"—Louis Jordan
"I Been Dealing with the Devil"—Sonny Boy Williamson
"Fine and Mellow"—Andy Kirk
"Dig these Blues"—The Four Clefs
"Mama Knows What Papa Wants When Papa's Feeling Blue"—Georgia White
"Knock Me Out"—Honey Dripper
"Blue Flame"—Woody Herman
"That's the Blues Old Man"—Johnny Hodges
"My Mellow Man"—Lil Green
"Keep Cool Fool"—Erskine Hawkins
"Blues Part 2"—Artie Shaw
"Come Back Baby"—Walter Davis

"Twenty Four Robbers"—Jimmie Lunceford
"Fan It"—Woody Herman
"Red Wagon"—Count Basie
"Do You Call that a Buddy"—Larry Clinton
"Just Jivin' Around"—Sam Price
"Chocolate"—Jimmie Lunceford
"T-Bone Blues"—Louis Jordan

notes

INTRODUCTION

1. B. B. King with David Ritz, *Blues All Around Me* (New York: Avon Books, 1996), p. 23.
2. Robert Neff and Anthony Connor, *Blues* (Boston: David R. Godine, 1975), p. 1.
3. This is one of two markers, and it is not clear that either really marks the churchyard where Johnson was buried, or if it does, that his body is still there.
4. Samuel B. Charters, *The Country Blues* (London: Michael Joseph Ltd., 1960), p. 142.

I
What Is Blues?

1. William Christopher Handy, "The Significance of the Blues," *Talking Machine Journal*, August 1919, p. 50, quoted in Stephen Calt and Gayle Dean Wardlow, *King of the Delta Blues: The Life and Music of Charley Patton* (Newton, N.J.: Rock Chapel Press, 1988), p. 18.
2. Jim O'Neal and Amy Van Singel, *The Voice of the Blues* (New York: Routledge, 2002), p. 352.
3. The use of the word "blues" to signify an emotional state has been common since at least the early nineteenth century. It appears in a few African-American songs and minstrel skits that predate the blues era, but these show no particular connection to the genre we call blues.
4. Richard Nevins, personal communication with the author, 2002.
5. William Christopher Handy, *Father of the Blues* (New York: Macmillan, 1941), p. 74. Some experts insist that the "slide" guitar style comes from African roots and was barely influenced by the popular tours of Hawaiian troupes around the turn of the century. It is worth noting that both Handy and

the Delta guitarist Son House referred to this style as Hawaiian. The idea that rural musicians were archaic conservatives rather than willing explorers of whatever new styles came their way is both patronizing and inaccurate.

6. Little Milton Campbell, interview with the author, 1996.

7. Son House, interview with John Fahey, Barry Hansen, and Mark LeVine, Venice, Calif., May 7, 1965, on file at the JEMF Archives, Chapel Hill, N.C.

8. David "Honeyboy" Edwards, interview with the author, 1997. There are similar quotations from other Mississippians, including Sam Chatmon, Skip James, and Richard "Hacksaw" Harney, in Calt and Wardlow, *King of the Delta Blues*, p. 63.

9. Both Josh White, in South Carolina, and Henry Townsend, in the Mississippi Delta, recalled their parents referring to their blues records as "reels." Townsend gives a unique etymology for the usage, showing how far it had come from being a term for European folk dances: "Although they call it the blues today, the original name given to this kind of music was 'reals.' And it was real because it made the truth available to the people in the songs" (William Barlow, *Looking Up At Down* [Philadelphia: Temple University Press, 1989], p. 326).

10. John W. Work, *American Negro Songs and Spirituals* (New York: Crown Publishers, 1940), pp. 32–33.

11. Ferdinand "Jelly Roll" Morton, *New Orleans Memories* (Commodore Records CR 8, 1947), phonograph recording. While Morton was not always a reliable raconteur, his main weakness was a tendency to claim credit for himself, and there is no reason to doubt him here.

12. At other times, Handy reported hearing blues or blues-like songs as early as 1890, including a version of the eight-bar "East St. Louis Blues" (David Evans, *Big Road Blues: Tradition and Creativity in the Folk Blues* [New York: Da Capo Press, 1982], p. 33). Once again, this lyric refers to a major Mississippi River port, rather than the rural outback. The process of urban and composed pieces showing up years later as folk songs would continue into the blues recording era. Both black players like Peg Leg Howell and Charley Patton and white ones like Prince Albert Hunt and Dock Boggs recorded songs they had learned off records by the blues queens, and their rural instrumentation and approach could lead one to assume that these pieces were older than the recorded models, were there not plenty of evidence to the contrary.

2

Race Records: Blues Queens, Crooners, Street Singers, and Hokum

1. Lewis Mumford, *The Myth of the Machine* (New York: Harcourt, Brace & World, 1966), p. 23.

2. Lynn Abbott and Doug Seroff, "'They Cert'ly Sound Good to Me': Sheet Music, Southern Vaudeville, and the Commercial Ascendancy of the Blues," *American Music*, vol. 14, no. 4, 1996, p. 405.

3. Lynn Abbott and Doug Seroff, *Out of Sight: The Rise of African American Popular Music, 1889–1895* (Jackson: University Press of Mississippi, 2003), p. 296.

4. Abbott and Seroff, " 'They Cert'ly Sound Good to Me,' " p. 413.

5. Handy, *Father of the Blues*, p. 99.

6. Handy confirmed that this change in nomenclature was made for commercial reasons: "Long ago, I wrote 'Yellow Dog Rag.' It sold mildly well, and after a while I forgot about it. When the popular taste for blues asserted itself I took out that old number and changed its name to 'Yellow Dog Blues.' Other than the name, I altered nothing. Within an incredibly short time I had earned seventy-five hundred dollars in royalties from 'Yellow Dog Blues'—which, as 'Yellow Dog Rag,' had not sold well at all" (W. C. Handy, "The Heart of the Blues," *The Etude*, March 1940, p. 193).

7. The black comedian Bert Williams had been a major record seller in the teens, but his work was considered standard pop fare, marketed to the same broad public that was buying Fanny Brice or Al Jolson, rather than being targeted at African-American consumers. It should be added that, while Mamie Smith and her followers were soon segregated into separate "Race" catalogues, this did not prevent their work from being marketed to white buyers in regions where the record companies sensed a receptive consumer base.

8. I expect that broader scholarship will turn up other claimants for some of the "firsts" listed in this section, but will not alter the overall pattern. Who happened to publish the first sheet music or make the first record in a certain style is interesting, but the important thing to understand is that there was plenty of blues bubbling up in the minstrel and vaudeville world around this period.

9. Evans, *Big Road Blues*, p. 62.

10. Harris, a native of Kentucky, explained her attraction to blues material in a 1922 Columbia Records catalog: "In order to please you must do your best, and you usually do best what comes naturally. So I just naturally started singing Southern dialect songs and the modern blues songs, which closely resemble the darky folk songs" (Tim Gracyk, *Popular American Recording Pioneers: 1895–1925* [New York: Haworth Press, 2000], p. 173). While I describe all of these pre-1920 blues singers as "white," Bayes (née Goldberg) was Jewish—like Al Jolson, Sophie Tucker, and many other performers who specialized in "Negro" or blackface material—and that was not quite the same as being white. However, it was easy for Jewish entertainers to "pass" as white in vaudeville, and along with singing blues numbers, Bayes got her start doing Irish characters and made a huge hit as a hillbilly "rube," singing "How You Gonna Keep 'Em Down on the Farm?"

11. It is common to describe such ethnic impersonations as examples of the mainstream culture mocking minority or immigrant groups, but it is not that simple. Lynn Abbott has supplied me with several citations for African-American vaudevillians who specialized in this sort of material, drawn from Indianapolis's widely read African-American newspaper, the *Freeman*: On

July 14, 1900, an ad for Louis Vasnier boasted of his "Natural face expressions in five different dialects, no make up—Negro, Dutch, Dago, Irish and French. I sing in all. The only colored comedian who can do it." On May 6, 1911, a review of a performance by H. Quallie Clark (later an associate of W. C. Handy's) noted that "His Hebrew song, 'Rebecca,' won him big acknowledgement. At times it was hard to believe he was a colored man, so perfect was his accent and so realistically faithful were his portrayals of a real Jew." On October 7, 1911, a review of the vaudeville team of Pinkey & Walker said, "'Chinee Walker' has already won his laurels as a 'Chink' impersonator . . . His 'Dago' is equally as strong and he uses both in his act."

12. This song was one of several variants of a theme popular with minstrel and vaudeville performers in the Dallas area. The "Dallas Blues" published by the white composer Hart Wand in 1912 had a similar melody, though in its original form there were no lyrics included. Lyrics similar to those Cahill sang were registered for copyright in 1912 by a white minstrel, Le Roy "Lasses" White, of the Happy Hour Theater in Dallas, as "Negro Blues," and published in Dallas the following year as "Nigger Blues." This was recorded in 1916 by George O'Connor, a white lawyer from Washington, D.C., whose hobby was Negro dialect humor (Abbott and Seroff, " 'They Cert'ly Sound Good to Me,'" pp. 408–412). The song's distinctive "stuttering" pattern would turn up in many later blues songs, notably "Bad Luck Blues," recorded in 1926 by the Dallas street singer Blind Lemon Jefferson. Jefferson's version may have drawn on an earlier "folk" source, but Peg Leg Howell, in Atlanta, recorded a similarly stuttering "Banjo Blues" in 1928 that is clearly derived from the minstrel stage, and it is possible that Jefferson was likewise adapting a minstrel theme.

13. Handy, *Father of the Blues*, p. 195.

14. Ibid., p. 200.

15. Harris's original title for the song was "I Ain't Got Nobody Much," but the "Much" was dropped on most later recordings.

16. Strictly speaking, Smith was not the first African-American singer to record a blues. In 1917, Ciro's Club Coon Orchestra cut a version of "St. Louis Blues," which included a vocal. However, this group was a hotel band in London, England, and its records had no impact in the United States.

17. The *Chicago Defender* was pleased to note that Mamie Smith's live show was not simply a blues performance: "One would imagine from the records that she was of a rough coarse shouter [sic]. To the contrary, she was a splendid reproduction of May Irwin, who made this class of amusement what it is today . . ." ("Mamie Smith a Hit," *Chicago Defender*, March 5, 1921, p. 5). The high point of her show was "Crazy Blues," but the paper's vaudeville critic reported that "She has a personality and a smile that is infectious . . . And her gowns! . . . There is one made of some blue spangled material which has the ordinary rainbow skinned 40 ways from the deuce and she wears a flock of diamonds that has her lit up like a Polish church on Sunday night." Her troupe included "Minstrel Morris, the Race's premier juggler," a dance team, a man

doing animal imitations, and an ethnic comedy team offering "one of those Chink things that are so popular" (Tony Langston, "'Mamie Smith Co.' Fills the Avenue," *Chicago Defender*, March 5, 1921, p. 5). Today, all that is remembered of this golden age of black entertainment is the jazz bands and blues singers, whose work makes up the vast majority of what survives on recordings. There were a couple of black-owned record companies striving to redress the imbalance, and one can find examples of African-American singers doing everything from sentimental ballads, minstrel comedy, and yodeling to traditional spirituals and operatic arias, but not nearly enough to give a full picture of the field. In any case, it is only the blues recordings that have attracted the attention of modern-day fans, and much of this material remains unavailable except to collectors.

18. "Mamie Smith is Still the South's Favorite Singer," *Chicago Defender*, September 15, 1934, sec. 1, p. 8.

19. Bessie Smith's biographer says that Rainey never appeared in New York (Chris Albertson, *Bessie* [New York: Stein and Day, 1972], p. 65), but Pigmeat Markham recalled her performing at Harlem's Lincoln Theater. Markham noted, however, that she was nervous because New York was not her usual turf (Pigmeat Markham with Bill Levinson, *Here Comes the Judge!* [New York: Popular Library, 1969], no page numbers).

20. Black Swan owner Harry Pace is quoted in Jitu K. Weusi, "The Rise and Fall of Black Swan Records," *Red Hot Jazz*, Spring 1996 (March 24, 2003), www.redhotjazz.com/blackswan.html. Sam Wooding is quoted in Michael W. Harris, *The Rise of Gospel Blues* (New York: Oxford University Press, 1992), p. 81.

21. Paramount Records emphasized Rainey's pioneer status, announcing her first record with the screaming headline "Discovered at Last—'Ma' Rainey, Mother of the Blues!" and calling her "the wonderful gold-neck woman who starred for five years in three theaters in Pensacola, Atlanta, and Jacksonville!" (*Chicago Defender*, February 2, 1924, sec. 2, p. 10).

22. Harris, *The Rise of Gospel Blues*, p. 93.

23. Ibid., pp. 89–90.

24. Okeh Race records ad, *Chicago Defender*, January 8, 1924, sec. 1, p. 6. This ad shows a headshot of Martin alongside a drawing of a little black girl listening to an old black man with a guitar, in front of a ramshackle wooden shack. It is interesting that Okeh should have chosen to emphasize the guitar and the rural setting. A possible explanation is that they had been having some success with white "hillbilly" records, and were testing the waters to see if there was a similar market for rural styles in the black community.

25. A sample from the *Chicago Defender*'s entertainment pages finds Trixie Smith headlining a show that included acrobats, a couple whose act consisted of "iron jawed balancing [and] a muscular display by the lady part of the team," various dancers and singers, and "an Ofay mentalist" (Tony Langston, "Trixie Smith Pleases Grand Patrons," December 23, 1922, sec. 1, p. 6). Sara Martin toured Texas with a troupe that included the comic couple Butterbeans

and Susie and a contortionist ("Sara Shines," January 25, 1924, sec. 1, p. 6). Bessie Smith made her Chicago debut supported by a blackface comedy duo, a "prima donna," a trio of child dancers, and a juggler ("Bessie Smith & Co. at the Avenue," May 10, 1924, sec. 1, p. 6).

26. There were a handful of male singers who recorded blues during the first years of the 1920s, in much the same style as the blues queens. George Williams shows up in several record advertisements, and there was also the blues-singing, yodeling female impersonator Charles Anderson. Compared to the female singers, though, their impact was minimal. The Norfolk Jazz Quartet, a popular black male vocal group, also recorded some songs with "blues" in their titles. None of these sound much like blues, but one, 1921's "Monday Morning Blues," was adapted by the Atlanta guitarist Blind Willie McTell for a section of his "Georgia Rag."

27. There was also a guitarist named Johnny "Daddy Stovepipe" Watson who recorded in this period. My lists, here and elsewhere, are far from exhaustive. I have concentrated on the few artists who opened significant new markets and changed the course of the blues boom, so many fine musicians are omitted or mentioned only in passing. My intention is not to provide a comprehensive survey of early blues artists, but simply to trace the dominant commercial styles.

28. This ambivalent status is evident in contemporary descriptions of Jackson's records. A newspaper blurb about his third release, "Cat's Got the Measles," called him "the greatest novelty entertainer on the records" (*Chicago Defender*, March 28, 1925, sec. 1, p. 8), and an advertisement for the Paramount Race catalog filed Jackson's records not in the "Vocal Blues" category used for the blues queens, but in a separate "Novelty Blues" section (*Chicago Defender*, May 2, 1925, sec. 1, p. 7).

29. Paramount Records, which was probably the most influential label in promoting rural blues styles, had its head offices in Chicago, and Okeh also did frequent sessions there.

30. *Chicago Defender*, August 23, 1924, sec. 1, p. 6. Though Ed Andrews and Daddy Stovepipe had already made solo blues recordings, they had so little impact that Paramount advertised Jackson as the "Only man living who sings, self-accompanied, for Blues records." Jackson played a six-string banjo, tuned like a guitar, and for the first year and a half of his success the Paramount ads referred to this as a "Blues Guitar," dropping this terminology only when they began to release records by blues guitarists.

31. This is a startling fact, especially since it was common for bluesmen like Lemon Jefferson and Blind Blake to be pictured with guitars in record advertisements, and Johnson's record company, Okeh, routinely referred to artists like Sylvester Weaver as "singer and guitar player." Johnson was never shown with a guitar (though an ad in the *Chicago Defender*, December 17, 1927, sec. 1, p. 6, showed him playing violin), and if his record ads mentioned instrumentation at all, they referred to him as a singer "with guitar accomp.," never making it clear that he was himself the player. The only

time he was listed as a guitarist was in an ad for a Texas Alexander record, which parenthetically noted "Lonnie Johnson plays the guitar" (*Chicago Defender*, December 9, 1928, sec. 1, p. 12), but in ads for the other Alexander records on which he appeared there was only the standard notation "with guitar accomp." It is odd that Okeh neglected this aspect of Johnson's talent, but this indicates the extent to which blues was considered a singers' medium.

32. The term "down home" is now generally associated with the rurally rooted electric styles of John Lee Hooker and Muddy Waters, but it was regularly used by Paramount in its ads for Blind Lemon Jefferson's early recordings.

33. Robert M. W. Dixon and John Godrich, *Recording the Blues*, republished as part of Paul Oliver et al., *Yonder Come the Blues* (Cambridge: Cambridge University Press, 2001), p. 271.

34. This letter is sometimes ascribed to a clerk named Sam Price, who would go on to become a popular blues and jazz pianist (Ibid., p. 262). However, Price wrote that he suggested Jefferson to a local record store owner, and this man then contacted Paramount on his own (Sammy Price, *What Do They Want?* [Urbana: University of Illinois Press, 1990], p. 27).

35. "Little Log Cabin in the Lane" had been recorded as early as the 1890s, and Carroll Clark, a black singer from Kentucky who performed light classical and Tin Pan Alley material, made three recordings of the song between 1907 and 1918, accompanied by the white banjo player Vess Ossman. The song had first hit on sheet music in 1871, and was the most popular composition of William Shakespeare Hays, the best-known minstrel composer after Stephen Foster and James Bland. Clearly, it was not the novelty of the material that made Carson's record so successful. (Information on Hays is from Bill C. Malone, *Singing Cowboys and Musical Mountaineers* [Athens: University of Georgia Press, 1993], pp. 60–64; information on Carroll Clark is from Norm Cohen, *Minstrels & Tunesmiths* [El Cerrito, Calif., JEMF 109, 1981], phonograph album notes, p. 30).

36. The story of Peer's trip to Atlanta is drawn from Dixon and Godrich, in Oliver et al., *Yonder Come the Blues*, p. 265, and Paul Kingsbury, ed., *The Encyclopedia of Country Music* (New York: Oxford University Press, 1998), p. 81. On the same trip, Peer also recorded the black singers Lucille Bogan and Fannie Goosby, and there seems to be some question whether he went to Atlanta specifically for Carson, or recorded Carson as a side project while in search of new Southern blues queens.

37. Jefferson's birth date is normally given as July 1897, but the U.S. census conducted in January 1920 recorded his age as twenty-five, and recent scholarship suggests a still earlier date of 1893.

38. McTell's final session, recorded in 1956, would range from the minstrel standard "Married Man's a Fool" to the Tin Pan Alley pop of "Call Me Back Pal O' Mine," the Carter Family's "Wabash Cannonball," and hokum blues like "Salty Dog" and "Beedle Um Bum." Bruce "Utah" Phillips, who met him around this time, tells me that when asked how he had sounded before

he began recording, McTell responded that he had sung just like Elvis Presley.

39. The first blues Christmas record was Bessie Smith's "At the Christmas Ball," in 1925. In 1927, Victoria Spivey did "Christmas Morning Blues," while the Reverends A. W. Nix and J. M. Gates produced "Death May Be Your Christmas Present," and "Will the Coffin Be Your Santa Claus?"

40. *Chicago Defender*, August 27, 1927, sec. 1, p. 7.

41. *Chicago Defender*, December 12, 1931, sec. 1, p. 2.

42. "one of the most important . . . has produced," Robert Palmer, *Deep Blues* (New York: Viking Press, 1981), p. 57; "the first blues superstar," Elmore Leonard, *Tishomingo Blues* (New York: William Morrow, 2002), p. 33. Leonard is a crime novelist, not a blues expert, but his assessment of Patton reflects a common perception among fans who have not spent much time researching the field. Interestingly, he puts this phrase in the mouth of a black character.

43. Patton's black fans often remembered him more as a guitar trickster than as a master musician. Muddy Waters's recollection is typical: "What got to me about Patton was that he was such a good clown man with the guitar. Pattin' it and beatin' on it and puttin' it behind his neck and turnin' it over" (Robert Gordon, *Can't Be Satisfied: The Life and Times of Muddy Waters* [Boston: Little, Brown, 2002], p. 24).

44. Patton did not, in fact, have any success outside the rural Southern market. Judging by copies of his records found in later years, John Fahey reported that "The records which have been canvassed from black homes have all turned up in rural areas. This is in marked distinction to Blind Lemon Jefferson's records, which are found in cities as well." Fahey also noted that only Patton's early records sold well: Six of his first eight releases did fine, the exceptions being the gospel "Prayer of Death" and the pre-blues minstrel pairing "A Spoonful Blues" b/w "Shake It and Break It But Don't Let It Fall Mama," but none of the later records were successes. This statement was based on how many records survived into the 1950s and 1960s, which is not a foolproof method, but seems reliable at both extremes: A record that could still be found in hundreds of homes across the country was certainly a hit, while one that survived only in a single copy must have sold poorly (John Fahey, *Charley Patton* [London: November Books, 1970], p. 111).

45. Arnold Shaw, *Honkers and Shouters: The Golden Years of Rhythm & Blues* (New York: Macmillan, 1978), pp. 268–269.

46. Anthony Heilbut, *The Gospel Sound: Good News and Bad Times* (New York: Limelight Editions, 1997), p. 81.

47. These days, it is common to find Carr and Blackwell billed as a duo, but three-quarters of their records—including all the early hits—bore only Carr's name, and he is the one remembered by decades of fans. Blackwell was a fine player, but blues was singers' music.

48. "How Long" was not a Carr original. A version had been recorded by Ida Cox with Papa Charlie Jackson as early as 1925, and the melody was closely re-

lated to "East St. Louis," which W. C. Handy recalled hearing in 1890. Still, it was Carr's record that made the song into a standard and his style that was generally imitated on later records.

49. "Hokum" was a common vaudeville term for rowdy comedy or clever stage business. It is not clear that anyone used it as a name for the kind of music played by Red and his peers until the 1960s.

50. In 1927, there were reported sales of 987,000 phonographs and 104,000,000 discs. In 1932, the respective figures were 40,000 and 6,000,000 (Mark Katz, "Making America More Musical through the Phonograph, 1900–1930," *American Music*, Winter 1998).

51. These numbers represent issued recordings, as listed in Robert M. W. Dixon et al., *Blues and Gospel Records 1902–1943* (Oxford: Clarendon Press, 1997). I have included records issued under pseudonyms, but not those on which the singer made an entirely unbilled appearance. I have included duplicate songs as two entries if they were issued separately, but as one if they simply appeared interchangeably on the same 78 release. I have not filtered out gospel or pop releases, because it was not always either appropriate or possible to do so. Finally, I have confined myself to artists listed in Dixon et al., leaving out people like Clarence Williams who are generally considered jazz rather than blues performers, although I am dubious about such divisions and do this with some misgivings.

3
What the Records Missed

1. Quoted by Mack McCormick in Charles Keil, *Urban Blues* (Chicago: University of Chicago Press, 1966), p. 58. McCormick added that Lipscomb thought of all his pieces in terms of dance accompaniments: "Ella Speed" was a breakdown, "Alabama Bound" a cakewalk, "Bout a Spoonful" a slow drag. Most modern fans would call all of these blues, but Lipscomb thought of blues as "a particular slow-tempoed dance that became fashionable around World War I."

2. Some amusement places did have player pianos and other sorts of mechanical music boxes, but these were not mobile, nor were they generally considered to be adequate substitutes for live music. It was not until the arrival of jukeboxes that musicians faced serious competition from inanimate objects. The place of barbershops in African-American song is explored in Lynn Abbott, "'Play That Barber Shop Chord': A Case for the African-American Origin of Barbershop Harmony," *American Music*, Fall 1992.

3. "Over the Waves," a light classical waltz by the Mexican composer Juventino Rosas (1868–1894), was mentioned as a standard early repertoire piece by Son Simms, the Delta fiddler who recorded with both Charley Patton and Muddy Waters (Alan Lomax field notes).

4. Tony Russell, *Blacks, Whites and Blues*, republished as part of Oliver et al., *Yonder Come the Blues*, pp. 152–53.

5. Pete Welding, "Ramblin' Johnny Shines," *Living Blues*, no. 22, July–August 1975, p. 29.

6. The other common open tuning, "open D," is often referred to as "Vestapol" (in Son House's case, "Vestibule"), after another mid-nineteenth-century parlor piece, "Sebastopol." (Most modern sources trace this usage incorrectly, to an apocryphal guitar piece called "The Siege of Sebastopol.") Far from being unique to the blues world, the use of "Spanish" and "Sebastopol" for these tunings also turns up in music magazines published in the 1890s for educated white amateurs.

7. No one knows who composed these particular pieces, so it is possible that in each case the composer may have been black or white—or Cherokee—but all three share traits that place them within the black fiddle tradition: a simpler harmonic structure, more room for improvisation, and powerful rhythmic drive. Such pieces sound quite different from the tunes that have clear Scots-Irish-English roots, but there are also many pieces that fall on the borderline. The important point is that the hoedown tradition is an African-European fusion.

8. David C. Morton with Charles K. Wolfe, *DeFord Bailey: A Black Star in Early Country Music* (Knoxville: University of Tennessee Press, 1991), p. 27.

9. Stuart's band included the white Sam Sweeney, brother of the famous minstrel banjo star Joel Walker Sweeney, and a black man named Bob, the general's body servant, who played fiddle, bones, and guitar (Malone, *Singing Cowboys and Musical Mountaineers*, p. 19).

10. Interview with the author, c. 1994.

11. Neff and Connor, *Blues*, p. 12.

12. In my experience, whenever a bluesman has told me that he or his father used to play square-dance gigs, if I asked whether he worked with white musicians the answer was at least a qualified yes. Having provided examples of such mixed groups from Georgia, Kentucky, Virginia, Tennessee, and Mississippi, let me add one from Texas: The pioneering black electric guitarist Eddie Durham recalled that his father worked there as a fiddler with hillbilly bands (James Sallis, *The Guitar Players* [New York: William Morrow and Company, 1982], pp. 97–98).

13. It is occasionally suggested that Native American styles also had a place in the mix. There is little musical evidence for this, but Jim Baxter, for one, was Afro-Cherokee, so it may be a slight oversimplification to frame this discussion entirely in terms of black and white.

14. *Times Ain't Like They Used to Be: Early Rural & Popular American Music 1928–1935* (Newton, N.J.: Yazoo Video 512, 1992), video recording.

15. This survey was conducted by Kip Lornell and Roddy Moore, sponsored by Ferrum College, Roanoke, Va. Some of the relevant recordings are available on the compact disc *Virginia Traditions: Non-Blues Secular Black Music* (Global Village CD 1001).

16. Handy, *Father of the Blues*, p. 33.

17. Whites did continue to "black up" a good deal longer than blacks. It was only

in 1979 that the Society for the Preservation and Encouragement of Barber Shop Quartet Singing in America officially banned blackface performances (Abbott, "Play That Barber Shop Chord," p. 301).

18. Jesse Stone, who would go on to write the rock 'n' roll hits "Shake, Rattle and Roll" and "Money Honey," got his first taste of show business in what he called a minstrel show, a rather informal affair produced by his father and featuring family members, in Kansas (Nick Tosches, *Unsung Heroes of Rock 'n' Roll* [New York: Harmony Books, 1991], p. 13). In Massachusetts, the white percussionist John "Mr. Bones" Burrell told me about learning to play the bones for a high school minstrel show in the 1940s, and such shows were apparently common at some New England prep schools at least into the 1960s.

19. In such potentially race-sensitive markets, the record companies sometimes made conscious decisions about whose pictures got printed, and where. The black singer Carroll Clark recorded many light parlor ballads before 1920, but was told by his record company that they would print his picture only in advertisements for "coon" songs ("Records Racial Melodies as Sung by Members of the Race," *Chicago Defender*, June 4, 1921, p. 6). Along with releasing African-American artists in "white" record lines, the companies also occasionally passed white artists off for black. Records by Roy Evans, Emmett Miller, and the Allen Brothers were advertised with pictures of black singers, and one Allens record was issued in Columbia's Race catalog. The Allens brought suit, fearing that this classification would hurt their chances in white vaudeville (Charles Wolfe, "The White Man's Blues, 1922–40," *Journal of Country Music*, vol. 15, no. 3, 1993, p. 39).

20. There were very few exceptions to this rule, though there is an exuberant 1927 record of "Ain't She Sweet" by the black guitar and harmonica duo of Bobby Leecan and Robert Cooksey. Some blues scholars would also list Charley Patton's reworking of "Some of These Days" and Kokomo Arnold's of "Paddling Madeline Home," but these were so altered as to be almost unrecognizable, and cannot be considered pop covers.

21. Margaret McKee and Fred Chisenhall, *Beale Black and Blue: Life and Music on Black America's Main Street* (Baton Rouge: Louisiana State University Press, 1981), p. 195.

22. The term "musicianer" was, as far as I know, purely rural, but "songster" can also be found in period newspapers, used to refer to popular singers, with no genre implied. In the Delta, it was used routinely for blues vocalists. Rube Lacey, the Delta guitarist who taught Son House, would say, "I was a good songster in them days. . . Walter [Vincson] was a good songster. He could sing. . . Tommy [Johnson] was a good songster. Ishmon [Bracey] was a good songster" (David Evans, *Tommy Johnson* [London: November Books, 1971], p. 40). There are many cases of such vernacular terms acquiring new specificity in the hands of folklorists. For example, backwoods Southerners called all printed songsheets "ballads," because it was common for topical story-songs to be sold in this form. Because folklorists use "ballad" to mean story-song, whether printed or not, it has become standard practice for them to

write "ballet" when a rural Southerner uses the word for a songsheet, and I have even had folklorists say to me "those are ballets, not ballads," as if it were now incorrect to use the original term. Obviously, creating such a distinction is useful within the narrow context of academic folklore studies, but it is important to remember that it did not exist among ballad singers in the rural South. The same holds true for the use of "banjar" for the older, gourd-bodied banjos.

23. Stephan Michelson interviewed Thomas and recorded him with his hotel band in Shreveport in April 1974 (Stephan Michelson, personal communication with the author, 2003).

24. Tommy Johnson was not from the Delta, but from the Crystal Springs area, to the south. However, he spent time in the Delta with Patton, and much of his playing reflects this influence.

25. The Tommy Johnson–Jimmie Rodgers connection provides interesting background to the work of later bluesmen as well. Howlin' Wolf's falsetto "howl" resembles Johnson's, and is usually traced to this source, but Wolf told a different story to the blues singer John Hammond: "He said he was inspired to play by listening to Jimmie Rodgers records . . . He said, 'Yep. I wanted to yodel in the worst way, and all that I could do was make a howl'" (Jas Obrecht, ed., *Blues Guitar: The Men Who Made the Music* [San Francisco: Miller Freeman Books, 1993], p. 65).

26. From the folklorists' point of view, the eagerness of rural informants to sing pop material was a constant annoyance. For example, Alan Lomax wrote in a field notebook for his 1942 Mississippi trip: "recorded some very lovely contemporary spirituals from some 20 year old girls who wanted to sing 'Blues in the Night.'" The winnowing process by which such material was excluded must always be kept in mind when assessing the work of such collectors. We will never know how many of the inmates on Parchman Farm were singing Fats Waller hits or show tunes to their mules, since such singers would have been of no interest either to Lomax or to his peers and successors.

27. This list appears in Alan Lomax, *The Land Where the Blues Began* (New York: Dell, 1993), pp. 413–14. A few further titles appear in Work's field notes (reproduced in Gordon, *Can't Be Satisfied*, p. 5) and Lomax's original notes. The other Autry hits were: "Home on the Range," "Be Honest with Me" (mistakenly attributed to Bill Monroe), "Jingle Jangle Jingle," and "You Are My Sunshine." The other pop songs were: "Dinah," "I Ain't Got Nobody," "Wang Wang Blues," "Darkness on the Delta," "Bye Bye Blues," and two untraceable titles: "The House," and "Texaco." The blues included six originals, along with Sonny Boy Williamson's "Down South," "Sugar Mama," and "Bluebird Blues"; St. Louis Jimmy's "Going Down Slow"; Walter Davis's "13 Highway" and "Angel Child"; "County Jail Blues" (mistakenly attributed to Davis, but probably from Big Maceo); and two songs in a more clearly Mississippi style: Robert Lockwood's "Take a Little Walk with Me" and Yank Rachell's ".38 Pistol Blues."

28. McKee and Chisenhall, *Beale Black and Blue*, p. 231.

29. The other recent record was Tony Hollins's "Crawling King Snake," later covered with great success by John Lee Hooker. The Wheatstraw record was "Sweet Home Blues" b/w "Good Woman Blues" (which Lomax noted as "Sweet Woman Blues"). The Williamson was either "Bluebird Blues" or one of his many other releases on the Bluebird label. The gospel disc was "Preaching with Singing" b/w "Everybody Will Be Happy Over There," by Elder Oscar Sanders and Congregation, of Christ Temple, Muncie, Indiana.

30. Waters's accordion playing is mentioned in Gordon, *Can't Be Satisfied*, p. 19. Townsend recalls that his father played blues and sounded "something like Clifton Chenier" (Henry Townsend, as told to Bill Greensmith, *A Blues Life* [Urbana: University of Illinois Press, 1999], p. 5). The Homer Lewis information is from Evans, *Big Road Blues*, p. 194. Downriver in Louisiana, the instrument was even more popular, and Leadbelly recorded a couple of accordion tunes (Jared Snyder, "Leadbelly and His Windjammer: Examining the African American Button Accordion Tradition," *American Music*, Summer 1994; and Jared Snyder, "Squeezebox: The Legacy of the Afro-Mississippi Accordionists," *Black Music Research Journal*, vol. 17, no. 1, Spring 1997).

31. Stephen Calt, *I'd Rather Be the Devil: Skip James and the Blues* (New York: Da Capo Press, 1994), p. 3.

32. Welding, "Ramblin' Johnny Shines," p. 25.

33. David "Honeyboy" Edwards, interview in *Living Blues*, vol. 1, no. 4, Winter 1970–71, p. 20.

34. The "Bill Bailey" report is from Chris Albertson, "Bessie Smith," in Pete Weldon and Toby Byron, eds. *Bluesland* (New York: Dutton, 1991), p. 53. John Hammond Sr. wrote that when he produced Smith's last recordings in 1933, she refused to sing blues: "I can remember her now, saying: 'Nobody wants to hear blues—times is too bad.' Nothing I could say would sway her, and instead of blues she insisted on having Socks Wilson and Coot Grant write her pop-type tunes" (John Hammond, "Why Bessie Wouldn't Sing the Blues," *ABC Hootenanny*, January 1963, p. 60). Three years later, interviewed during the seventh week of her extended run at a New York nightclub, Smith was doing swing numbers, and said, "Things have changed quite a bit, and I realize that we are living in an entirely new era of entertainment" (Allan McMillan, "New York Sees Bessie Smith; Wonders Where She's Been," *Chicago Defender*, February 28, 1936, sec. 1, p. 10).

35. Chris Albertson, "Lonnie Johnson," in Weldon and Byron, *Bluesland*, pp. 42–43.

36. Weldon's group was unrelated to the Washboard Rhythm Kings who recorded in New York and New Jersey, and it went on to make a half dozen records in the next two years as the State Street Swingers. It was basically a second-string Harlem Hamfats, and recorded covers of both "Oh! Red" and Tampa Red's "When You Were a Girl of Seven." Its version of "Arlena" is a speeded-up and lyrically garbled reworking of a pop ballad previously recorded by Leroy Carr.

37. Paul and Beth Garon, *Woman with a Guitar: Memphis Minnie's Blues* (New

York: Da Capo Press, 1992), photo section, plate 42. The guitarist Willie Moore also recalled that he, Minnie, and Son House's old partner Willie Brown sometimes substituted for the W. C. Handy band at white dances in the Delta, and that their songs included "You Great Big Beautiful Doll," "Let Me Call You Sweetheart," and "What Makes You Do Me Like You Do Do Do?" (Calt and Wardlow, *King of the Delta Blues*, p. 158).

38. These performances were released only in 2002, on *Big Bill Broonzy in Concert with Graeme Bell*, Jasmine CD 3007, and *Big Bill Broonzy on Tour in Britain, 1952*, Jasmine CD 3011/2.

39. While Dodds sounds quite at home with the Louisville players, Hines recalled hearing one of the records he made with them on the radio when he was sitting with Louis Armstrong, and being so embarrassed that he denied he was the pianist. He referred to them as a "hillbilly group," mentioning them alongside Jimmie Rodgers, and one would not know from his telling that they were black, much less a popular blues group that had made a series of records with Sara Martin (Stanley Dance, *The World of Earl Hines* [New York: Charles Scribner's Sons, 1977], p. 58).

40. Carr's non-blues recordings include a 1930 pairing, "Let's Make Up and Be Friends Again" and "Let's Disagree," and 1934's "Arlena." There are also three songs—"I Know that I'll be Blue," "Don't Say Goodbye," and "Prison Cell Blues"—which start off as twelve-bar blues but finish with Tin Pan Alley pop codas, with Carr shifting his style accordingly.

41. Jim O'Neal, *Crescent City Blues* (New York: RCA Bluebird LP 5522, 1975), phonograph album notes.

42. Stephen Calt, "The Anatomy of a 'Race' Music Label: Mayo Williams and Paramount Records," in Norman Kelley, ed., *Rhythm and Business: The Political Economy of Black Music* (New York: Akashic Books, 2002), p. 93.

43. There were many "covers" of hit songs recorded during the blues era, but usually by regular studio musicians, to meet commercial demands. For example, when Josh White was recording for ARC, a label that specialized in pressing twenty-five-cent records for department store chains, he seems to have been specifically assigned to make budget covers of songs that were hits on the higher-priced labels, especially ARC's sister label, Vocalion.

44. Sykes had also recorded a "32-20 Blues" over a year before James's session, under the pseudonym Willie Kelly, and James mentions that caliber as well.

45. This expert was William Ferris, then director of the Center for the Study of Southern Culture at the University of Mississippi. He may have been oversimplifying his views to make a point, but he said that Powell and other Mississippi blues players preferred to play blues, and only broadened their repertoire for white gigs and visitors like myself. I would suggest that this view may say more about Ferris's own tastes than about those of the musicians.

4
Hollers, Moans, and "Deep Blues"

1. The derivation of ballet from folk dances was asserted by Dame Ninette de Valois, director of the Royal Ballet of England, quoted in Marshall Stearns and Jean Stearns, *Jazz Dance: The Story of American Vernacular Dance* (New York: Macmillan, 1968), p. xiv.
2. "plaintive African songs," Dena J. Epstein, *Sinful Tunes and Spirituals: Black Folk Music to the Civil War* (Urbana: University of Illinois Press, 1977), p. 72; "raised such a sound . . . into falsetto," ibid., p. 182.
3. Clarence "Tom" Ashley's "Walking Boss" is a pure work song, recast in a somewhat different rhythm, and Uncle Dave Macon's "Buddy, Won't You Roll Down the Line" has roots in a similar piece.
4. Lomax, *The Land Where the Blues Began*, p. 273.
5. Ibid., p. 273. In recent years, both Alan Lomax and his father, John, have come under attack from various writers for making their reputations and income off the music of poor people who only occasionally shared in the profits from their work. I do not want to address this question in detail at this point, especially since I do not address the many more egregious cases of exploitation by both commercial record companies and revivalist blues promoters. However, since I cite Lomax at some length, I would note that he preserved a lot of music and history of which we otherwise would be ignorant and, unlike some other folklorists and promoters of rural music, he has tended to be remembered fondly by the people he recorded, and has made all of his material freely available to the rest of us.
6. This is on the LP *Roots of the Blues* (New World Records 252). The track alternates verses of a song Lomax recorded in 1959 from a Mississippi convict named Henry Ratcliff with verses recorded by David Sapir in Senegal in 1967 from a singer named Bakari-Badji.
7. Toure sounds like Hooker not simply because they share common roots, but because he was entranced by Hooker's records and learned guitar licks off them. I see no reason to doubt him, though, when he says that what drew him to these records was their resemblance to the music he already knew as a herdsman on the upper Niger.
8. In 1942, Alan Lomax made a recording of David "Honeyboy" Edwards singing a song that began "You got to roll, just like a wagon wheel," first in free-meter holler style, then as a guitar-backed blues number (Library of Congress recording, available on *Honeyboy Edwards: Delta Bluesman*, Earwig CD 4922).
9. African-American church services have at times included a sort of semi-organized group moaning, without any regular rhythm, which shares something in common with the hollers, though in other respects it is quite different.
10. Lomax argued that the Delta style was unique: that hollers found elsewhere tended to be more organized and rhythmically regular, and more often showed the influence of British ballad styles. He recorded Delta-style hollers in other

regions, especially the Texas river country, but believed that he could always trace a Delta source. Other folklorists, such as David Evans, believe that Lomax was too narrow on this point, though agreeing that the Delta was particularly rich territory for the style. Evans adds that similar hollers have been recorded from cattle herders in Colombia and Venezuela (David Evans, personal communication with the author, 2002).

11. Hooker's "Hobo Blues," from 1949, was something of an exception. It had a solid dance rhythm, but Hooker's vocal was essentially a free-form holler. The fact that Hooker's success came in the late 1940s, and that nothing so rooted in the holler tradition had hit before this, may be due to the fact that many of his buyers were people who had been born in the South but now had been living for years in northern urban centers like Chicago and Detroit and wanted to hear some sounds from home.

12. Dr. Harry Oster was more broad-minded than some of his peers, and when he did his fieldwork in Louisiana's Angola State Penitentiary in the 1950s (samples of which are available on *Angola Prisoners' Blues*, Arhoolie CD 419), he taped a female prisoner singing Ivory Joe Hunter's hit "Since I Fell for You" while working at a laundry machine, and a group of male prisoners singing doo-wop. Even in situations that would seem to require powerfully rhythmic work songs, singers often followed their own inclinations. The New Orleans singer Lemon Nash, born in 1898, worked on the railroad as a boy, and recalled the greatest singer there to have been a man from Port Gibson, Mississippi, who sang old parlor ballads like "The Boston Burglar" in time with his hammer strokes (Lemon Nash interview, Hogan Jazz Archive, Tulane University). Had the folklorists asked, there were probably always more prison inmates who were able to sing pop covers than who knew the traditional work songs.

13. Paul Oliver, *Conversation with the Blues* (Cambridge: Cambridge University Press, 1997), p. 26.

14. Waters's first list is notable for the extent to which he associated artists with particular songs: "Lonnie Johnson was a good, nice, smooth blues singer: 'Careless Love.' And Leroy Carr's a good smooth blues singer: 'How Long,' 'Prison Bound,' and 'Rocks in my Pillow,' and on and on. Mississippi Sheiks, good blues, smooth blues singer. They would do 'Sitting On Top of the World,' 'Stop and Listen,' 'Corrina,' you know. And get down to the heavy thing, you would go into things like Son House, Charley Patton" (Margaret McKee and Fred Chisenhall, unpublished interview, published in slightly different form in McKee and Chisenhall, *Beale Black and Blue*).

15. B. B. King with David Ritz, *Blues All Around Me* (New York: Avon Books, 1996), pp. 23–24. King described Rodgers as "a yodeler who happened to be white, but who sang songs like 'Blues, How Do You Do?' He was called The Singing Brakeman, and I sang along with him." Thirty years earlier, King listed his vocal influences as the blues singer Dr. Clayton, gospel lead Samuel McCrary of the Fairfield Four, and Blind Lemon Jefferson, followed by Leroy Carr, Bumble Bee Slim, Gene Autry, Jimmie Rodgers, Peetie Wheatstraw,

Tommy McClennan, Tampa Red, and Lonnie Johnson (Keil, *Urban Blues*, p. 107).

16. The collector I cite was Richard Nevins. Aside from questions of modernity, there was a notable market for yodeling among black record buyers. Rodgers's early releases were listed in the Victor company's Race advertisements, and the white yodelers Roy Evans, Emmett Miller, and Happy Bud Harrison were all featured in *Chicago Defender* ads, the latter two as if they were black artists. Even before Rodgers hit, the black vaudeville singer Charlie Anderson made several yodeling records, and when Bessie Smith recorded a vocal imitation of a trumpet, on 1924's "Sinful Blues," it was advertised as a yodeling number. Following Rodgers's success, both the Mississippi Sheiks and Tampa Red recorded yodeling features.

17. Wallace recorded "Section Hand" in August 1925. Robeson had made his formal concert debut that April, and I assume "Water Boy" to have been one of his featured numbers because it was chosen as the first song at his debut recording session that July. As it happened, this recording was rejected, and the issued version was his third attempt, made the following January.

5

The Mississippi Delta: Life and Listening

1. Danny Barker, *A Life in Jazz*, ed. Alyn Shipton (New York: Oxford University Press, 1986), p. 71.

2. James C. Cobb, *The Most Southern Place on Earth: The Mississippi Delta and the Roots of Regional Identity* (New York: Oxford University Press, 1992), p. 114.

3. Cobb gives the case of a black coast guardsman who was arrested for vagrancy in Tchula, Mississippi, in 1931, and sentenced to work for a month on the plantation of the man who had arrested him. During the thirty-six days he remained there, he was beaten several times, and reported that sixteen or seventeen other men were being held on that plantation under the same conditions (ibid., p. 121).

4. Ibid., p. 99.

5. Lewis Jones, unpublished manuscript, on file at the Alan Lomax Archive. Since this manuscript is not available, I do not give separate page citations for the various quotations from it, but make clear in the text when I am using it as my source.

6. Cobb, *The Most Southern Place on Earth*, p. 125.

7. House, interview with Fahey et al.

8. Evans, *Big Road Blues*, p. 47.

9. Another reason was apparently a curfew in Clarksdale, the main town in the central Delta. Muddy Waters recalled: "Twelve o'clock, you better be out of there, get off the streets. That great big police come down Sunflower Street with that big cap on, man, waving that stick . . . That's why all this country stuff, people go out in the country. Friars Point'd go up to four o'clock in the

morning, sometimes all night" (McKee and Chisenhall, *Beale Black and Blue*, p. 232).

10. Several of these ages are disputed, in Miller's case by as much as a decade. I follow the majority opinion among the various sources consulted, but this is only a guide, and not authoritative.

11. Samuel G. Adams, "Changing Negro Life in the Delta" (master's thesis, Fisk University, Nashville, 1947), p. 51.

12. Ibid., p. 65.

13. Ibid., pp. 66–72.

14. I have corrected a few obvious errors, though there are other songs that I cannot identify and which may be misfiled as well. In the "older" lists, Adams put Memphis Minnie's "My Girlish Days" in the popular category, and "Walking the Floor Over You," a recent country hit for Earnest Tubb, in blues. In the "younger" lists, he put "Sitting On Top of the World" in the pop category (there was an older pop song called "I'm Sittin on Top of the World," and it is possible that this is what was intended, but I am betting on the Mississippi Sheiks' song), and "Livery Stable Blues," a jazz novelty, in the blues category. "Basin Street Blues" was also in the blues category, and I have moved it to pop, since there is not a single discographical entry for a blues singer of this era performing it. Adams had another title, "Fur Trapper Blues," in blues, but I assume this was Woody Herman's 1941 hit, "Fur Trapper's Ball." "Hell Broke Loose in Georgia," a common fiddle hoedown, was also on the blues list.

15. McClennan titled his version "Baby, Don't You Want to Go?" and Davis called his "Don't You Want to Go?" but the "Sweet Home Chicago" tag line finishes every verse, and many people must have assumed this was the title, especially if they were already vaguely familiar with Johnson's version.

16. Bill C. Malone, *Country Music U.S.A.* (Austin: University of Texas Press, 1985), pp. 32–34.

17. "Clarence Williams Backs Helen Kane Suit," *Chicago Defender*, May 12, 1934, sec. 1, p. 9.

18. Albertson, *Bessie*, pp. 51–52. He includes an extended review from the *Chicago Defender*, which describes the program as a "midnight frolic." I take the "Midnight Ramble" name from Larry Nager, *Memphis Beat: The Lives and Times of America's Musical Crossroads* (New York: St. Martin's Press, 1998), p. 43.

19. Howard Armstrong's string band had a radio spot in Knoxville, and a couple of jug bands are noted as radio acts in the *Chicago Defender* (April 2, 1932, sec. 1, p. 13, and September 16, 1933, sec. 1, p. 5). Jug bands were considered entertaining novelties, and a couple also made film shorts.

20. It is important to keep in mind that relatively few radio listeners or record buyers at this time were seeing pictures of their idols. Muddy Waters would recall: "I pictured so many people from the records. I knowed their color. I knowed their size. When I sees 'em, I was all disappointed. Charley Patton, he had that big voice. I thought the dude weighed two hundred fifty, you

know, and he's big and black, much blacker'n I am. When I seen him, he was brown-skinned and neat. I said, 'It can't be.' He's a little man, pretty, yellow-skinned" (McKee and Chisenhall, *Beale Black and Blue*, p. 235). Years later, Chuck Berry would find that many fans of "Maybelline" had assumed he was a white country singer.

21. In the 1942 Fisk–Library of Congress survey, Waters was asked what kinds of singing he liked, and responded positively to choir singing, jazz orchestra, quartets, long-meter hymns, and rally spirituals, but negatively to hillbilly songs. Presumably, Autry's music had enough jazz flavor for him, as it did for many pop fans. Waters said that he preferred black music to white, because it had "more harmony—in the blues line—white people can't play 'em."

22. McKee and Chisenhall, *Beale Black and Blue*, p. 250. Likewise, the Chicago blues master Otis Rush told me that Bill Monroe and Eddy Arnold were among his early favorites, before he heard the smooth blues of Charles Brown.

23. Welding, "Ramblin' Johnny Shines," p. 29.

24. Duchin and Kaye were "sweet" bandleaders, and both were fabulously popular, as were the sweet bands in general. This popularity endured well beyond the big band era: In 1956, Tyrone Power starred in *The Eddy Duchin Story*, and the sound-track album went to number one and stayed on the *Billboard* chart for ninety-nine weeks, making it one of the top thirty-five albums of the decade.

6
A Life Remembered

1. Peter Guralnick, *Searching for Robert Johnson* (New York: Dutton, 1989), p. 10. Johnson's birth date is subject to dispute. The records of the Indian Creek School give his age as fourteen in 1924, and as eighteen in 1927. His two marriage licenses give his age as twenty-one in February of 1929 and twenty-three on May 4, 1931. His death certificate, on August 16, 1938, gives his age as twenty-six. If his birth date was May 8, that means we have documentation for birth years of 1907, 1909, 1910, and 1912. The 1910 census does not include him among Julia's children, casting doubt on the first two dates, which leaves 1910 and 1912, so I end up back at the usually cited year of 1911, as an average if nothing else. (All dates are from Tom Freeland, "Robert Johnson: Some Witnesses to a Short Life," *Living Blues*, no. 150, March/April 2000, p. 49.)

2. Willie Coffee, interviewed in Robert Mugge, *Hellhounds on My Trail: The Afterlife of Robert Johnson* (Winstar Home Entertainment, 2000), video recording.

3. Freeland, "Robert Johnson," pp. 44–45.

4. Other guitarists have been cited over the years as Johnson's teachers, particularly Richard "Hacksaw" Harney, whom many older Delta guitarists recall as the region's all-time blues virtuoso. Johnson also seems to have learned quite

a bit from Ike Zinnerman, a guitarist who lived near his hometown of Hazle-hurst. Harney made a handful of recordings in the 1920s, and again in the 1970s. No recordings of Zinnerman exist.

5. House, interview with Fahey et al.

6. House recalled these details in 1941, when first interviewed by Alan Lomax, and would repeat them virtually verbatim in later years.

7. House, interview with Fahey et al. This is the only mention I have ever found of Johnson playing a seven-string guitar, and I wish Fahey had asked which string was added.

8. Lomax field notes.

9. Ibid.

10. Samuel Charters, *Robert Johnson* (New York: Oak Publications, 1973), p. 14.

11. Larry Hoffman, "Robert Lockwood, Jr.," *Living Blues* no. 121, June 1995, p. 15.

12. Johnny Shines, interviewed by John Earl, quoted in Guralnick, *Searching for Robert Johnson*, p. 68.

13. Guralnick, *Searching for Robert Johnson*, pp. 20–21.

14. "Robert was a very friendly person . . . you know," Peter Guralnick, *Feel Like Going Home: Portraits in Blues & Rock 'n' Roll* (New York: Vintage Books, 1981), p. 91; "He was very bashful, but very imposing," Guralnick, *Searching for Robert Johnson*, p. 55; "He never talked about himself . . . rowdy!" Neff and Connor, *Blues*, p. 56.

15. Hoffman, "Robert Lockwood, Jr.," p. 16.

16. Barlow, *Looking Up At Down*, p. 46.

17. Guralnick, *Feel Like Going Home,* pp. 91–92.

18. Guralnick, *Searching for Robert Johnson*, p. 19. (This quotation includes a section from Welding's interview with Shines. Guralnick merged various interviews to form seamless sentences and paragraphs. I have given earlier sources when I know them, but use Guralnick's pastiches as the principal citation when I cannot fully source them.)

19. "Robert was a guy . . . just ready to go," Welding, "Ramblin' Johnny Shines," p. 30; "I was just . . . running the road with him," Guralnick, *Feel Like Going Home,* pp. 91–92; "That was his personality . . . away from him," Welding, "Ramblin' Johnny Shines," p. 28; "It made it pretty tough . . . style that I liked," Guralnick, *Feel Like Going Home,* pp. 91–92; "Robert and I played . . . I wanted to learn," Neff and Connor, *Blues*, p. 56.

20. Welding, "Ramblin' Johnny Shines," p. 30.

21. Guralnick, *Searching for Robert Johnson*, p. 21.

22. "Sometimes I'd get . . . Robert started," Neff and Connor, *Blues*, p. 56; "He couldn't punch . . . you'd get it!" Welding, "Ramblin' Johnny Shines," pp. 28–29.

23. In 1942, Muddy Waters would tell Alan Lomax that his standard pay as a musician was six dollars for a duo at a juke joint, or sixteen dollars for the full band to play at a picnic (Lomax field notes).

24. Welding, "Ramblin' Johnny Shines," p. 29. The large minstrel shows were on

a similar schedule, and already by the 1890s were arranging their tours to follow harvest seasons across the South (Abbott and Seroff, *Out of Sight*, p. 108).

25. Samuel Charters, *Robert Johnson*, p. 12.
26. Welding, "Ramblin' Johnny Shines," p. 29.
27. Ibid.
28. Ibid., p. 28.
29. Obrecht, *Blues Guitar*, p. 24.
30. Johnson was also familiar with the local rural repertoire. Willie Moore told Gayle Dean Wardlow of hearing Johnson in Robinsonville around 1930 singing older, countrified songs with titles like "Captain George, Did Your Money Come," "Make Me Down a Pallet on Your Floor," "Black Gal, Whyn'cha Comb Your Head," "You Can Mistreat Me Here But You Can't When I Go Home," "President McKinley" (apparently a slide piece related to "Frankie and Johnny"), "East St. Louis Blues," and a bottleneck version of "Casey Jones" (Obrecht, *Blues Guitar*, p. 6).
31. "He did anything . . . continue to play them," Welding, "Ramblin' Johnny Shines," p. 29; "And I know . . . he made them right," Johnny Shines, interviewed in *The Search for Robert Johnson* (Sony Music Video 49113, 1992), video recording; "He could play . . . songs out of the air," Guralnick, *Searching for Robert Johnson*, p. 22, merged with Guralnick, *Feel Like Going Home*, pp. 91–92. Though polkas might seem a particularly odd choice, the blues harmonica innovator Little Walter apparently got his start playing waltzes and polkas in Chicago's Maxwell Street Market (Mike Rowe, *Chicago Breakdown* [London: Eddison Press, 1973], p. 49).
32. Obrecht, *Blues Guitar*, p. 13. Shines also recalled that, on a trip to Detroit, he, Johnson, and another musician, Calvin Frazier, got a job as gospel singers on a radio show out of Windsor, Ontario.
33. Henry Townsend, interview with Pete Welding, quoted in Guralnick, *Searching for Robert Johnson*, p. 58.
34. Welding, "Ramblin' Johnny Shines," p. 29.
35. Frank Driggs, *Robert Johnson: King of the Delta Blues Singers* (New York: Columbia LP 1654, 1961), phonograph album notes.
36. Ibid.
37. The one notable exception to this rule was Blind Boy Fuller, a Carolina guitarist who played in an old-fashioned but catchy ragtime style, and sang raunchy lyrics with smooth nonchalance that suggested a country Leroy Carr.
38. Son House, "I Can Make My Own Songs," Julius Lester, ed., *Sing Out*, vol. 15, n. 3, July 1965, p. 42.
39. Guralnick, *Searching for Robert Johnson*, pp. 39–40.
40. Ibid., pp. 40–41.
41. Ibid., p. 47, blended with Guralnick, *Feel Like Going Home*, p. 101.
42. Guralnick, *Searching for Robert Johnson*, p. 24.
43. Mugge, *Hellhounds on My Trail*.
44. Neff and Connor, *Blues*, p. 56.

45. David "Honeyboy" Edwards, interviewed by Pete Welding, *Blues Unlimited* no. 54, June 1968, pp. 10–11.
46. Welding, "Ramblin' Johnny Shines," p. 30.
47. All information about the death certificate comes from Wardlow, *Chasin' That Devil Music*, pp. 87, 92.
48. Guralnick, *Searching for Robert Johnson*, p. 50.

<div align="center">8</div>

First Sessions, Part One: Going for Some Hits

1. It is hard to define what should be called a "hit" record in this period, since sales figures are generally unavailable. However, it seems safe to assume that a song that was popular enough to be covered by several other people and spawned multiple sequels, as "Mean Mistreater Mama" did, deserves the label.
2. Johnson sings, "She's a kindhearted mama, she studies evil all the time/You well's to kill me as to have it on your mind." Carr had sung, "You're a mean mistreater and you mistreats me all the time/Now I tried to love you, swear but you won't pay that no mind." As in other such cases, the source is evident, but Johnson created something new and more interesting from it. As for the guitar work, Blackwell has frequently been cited as a major influence on Johnson's playing, and deservedly so. If I dwell on this influence less than other writers have, it is because I think that blues scholarship has spent far too much time talking about guitar techniques, considering the extent to which singers (many of them pianists) were the driving force of the blues boom. Johnson certainly learned a great deal from Blackwell's playing on Carr's records, but would have thought of them as Carr's records.
3. Johnson seems to have used a capo to raise the guitar pitch for many songs, and he may have been using one here, then removed or lowered it for the second take. It is also possible that this tonal difference is a technical glitch, and the playback speeds on the CD are not calibrated, but I am trusting that this is not the case.
4. Harney recorded a boogie guitar line in 1927 as part of the duo Pet and Can. His version was more complex than Johnson's and he did not use it as a steady accompaniment, but his claim as originator is supported by rumors that he was one of the people who taught Johnson some guitar techniques. Jefferson had recorded a still earlier version of the guitar boogie on his "Rabbit Foot Blues" in 1926, and again on his hugely popular "Matchbox Blues" in 1927.
5. The claim that Temple learned from Johnson appears in Obrecht, *Blues Guitar*, p. 8. Temple's denial is given in David Evans, *Johnnie Temple: Complete Recorded Works in Chronological Order, Vol. 1* (Austria: Document CD 5238, 1994), compact disc album notes.
6. The early reworkings of "Sweet Home Chicago" stuck with Johnson's puzzling tag line: "Do you want to go back to the land of California, to my sweet home Chicago?" Many people have wondered how a well-traveled performer could have written this line, and I have even heard the assertion that Johnson had

relatives in the tiny hamlet of Chicago, California. I would suggest that the listener simply imagine a gentle "or" between the relevant phrases.

7. As usual, this statement depends on how one defines genres. Harmonica players like DeFord Bailey and Sonny Terry made imitations of trains and hounds a basic part of their repertoires, and Blind Willie McTell, though generally classed as a bluesman, recorded plenty of "programmatic" instrumental riffs, even coming up with a guitar equivalent of billowing marijuana smoke. However, McTell tended to do these bits as part of ragtime-minstrel monologues, not in his blues songs, and the "Fox Chase" and train numbers usually lacked any blues structure.

8. I have taken Woody Mann, *The Complete Robert Johnson* (New York: Oak Publications, 1991), as my source for Johnson's guitar tunings. Some of these tunings are disputed, as when Mann says "Hell Hound on My Trail" is in open D or E, while others say it is in Skip James's trademark E minor tuning.

9. This was a common maxim, and had been the theme of a popular 1926 recording by E. W. Clayborn, "the Guitar Evangelist," titled "Your Enemy Cannot Harm You (But Watch Your Close Friend)," and also of a preaching record, "Watch Your Close Friend," recorded in 1927 by the Reverend W. M. Nix.

10. Tampa Red had already recorded an instrumental version of this melody in 1929, titled "You Got to Reap What You Sow," but my suggestion that "Things 'Bout Coming My Way" was inspired by the Sheiks' 1930 hit is supported by the fact that at the same session at which he recorded the latter song, he also cut a cover of "Stop and Listen," the Sheiks' follow-up release.

11. This stretch was beyond not only Johnson's peers in the Delta, but also generations of blues scholars, who have routinely assumed that his song was directly inspired by the Sheiks. Obviously, Johnson knew "Sitting On Top of the World"—as did almost everyone in Mississippi, black or white—but he clearly patterned his arrangement on the Tampa Red variation. This mistake exemplifies the persistence with which Mississippi bluesmen have been viewed as a world apart, rather than fitted into the wider popular music scene of their time. To reinforce this point, the Sheiks' song was itself a variation on the "How Long, How Long" melody.

12. Big Bill Broonzy, *The Bill Broonzy Story* (1960; reissued Verve 31454, 1999), compact disc recording, disc 2, track 1.

9
First Sessions, Part Two: Reaching Back

1. It has also been suggested that Johnson may have recorded only one song on Thursday because he had been hurt in an altercation with the police, as recalled by Don Law.

2. Wisconsin may seem like a strange location for a Mississippi musician to choose, but James was recording in Grafton, Wisconsin.

3. Wardlow, *Chasin' That Devil Music*, p. 15.

4. The practice of suggesting a full guitar accompaniment while in fact only beating a rhythm was employed brilliantly by Charley Patton, the most rhythmically complex artist in blues. Johnson was certainly influenced by Patton's work, though to what extent is debatable.

5. Recalled by Paul Geremia, personal communication with the author, 2002.

6. Oliver, *Conversation with the Blues*, p. 70.

7. House did compose some songs with fixed lyrical structures, but "Walking Blues" and "My Black Mama" were not among them. His two versions of the former song, recorded in 1930 and 1941, share only the title verse in common.

8. Jefferson sang this verse in "Change My Luck Blues." The Elgin metaphor was popularized in black vaudeville by the song-and-dance man Butler "String Beans" May, who in 1910 was billing himself as "The Elgin Movements Man" (Abbott and Seroff, " 'They Cert'ly Sound Good to Me,' " p. 435), and in the 1924 pop hit "Everybody Loves My Baby."

9. The "heart disease" line had been used still earlier, in Le Roy "Lasses" White's 1913 sheet-music number, "Nigger Blues" (Abbot and Seroff, " 'They Cert'ly Sound Good to Me,' " p. 411).

10. Though I hear a somewhat garbled pronunciation of "accelerate" as the word Johnson is singing, the usual transcription of this phrase is, "I can study rain" or "I been studyin' the rain," which even its proponents describe as "phonetically correct, although meaningless" (*Robert Johnson: The Complete Recordings* [New York: Sony Columbia/Legacy 64916, 1990], compact disc album notes, p. 41). Johnson's singing is not clear, and I prefer to go with what makes more sense. There is no "right" answer, and such difficulties have dogged the blues world since the 1920s. One of Charley Patton's most imitated songs was released as "Stone Pony Blues," but Son House would explain, "That's 'Storm Pony,' s-t-o-r-m. It's a fast-running horse, just like a storm coming, with a lot of wind to it and it's really getting going. That's the way the horse do. . . . If it's stone, s-t-o-n-e, like they think, a stone don't move, and you can't ride it" (House, interviewed by Fahey et al.).

10

Second Sessions: The Professional

1. David "Honeyboy" Edwards, *The World Don't Owe Me Nothing* (Chicago: Chicago Review Press, 1997), pp. 99–100. In interviews, Edwards has placed his first meeting with Johnson in Jackson, in Itta Bena, and in the northern Delta. Each time, he was quite precise about the street and circumstances. I have no reason to doubt that Edwards met Johnson, but he is an old hand at jiving blues researchers. (When Lomax met him in 1941, he was claiming to be Big Joe Williams.) In his book he boasts of his abilities as a con man, and always musters a wealth of detail to support his memories, whether or not these details match from telling to telling. *Caveat lector.*

2. The records released were, in order: "32-20 Blues" b/w "Last Fair Deal Gone

Down," "I Believe I'll Dust My Broom" b/w "Dead Shrimp Blues," and "Rambling On My Mind" b/w "Cross Road Blues."

3. Others have heard this line as "I got three legs to truck on" (or "truck home"), and I can hear the faint suggestion of a "g" that would support these interpretations, though they are logically absurd. I always heard the word as "lanes," which makes more sense.

4. Bruce Bastin established the term "Piedmont" to describe a distinct regional blues style, the ragtime-influenced playing common in the Carolinas and Georgia. By now, some writers use it for almost any blues style from east of Mississippi, and a few even throw geography out entirely and call John Hurt a Piedmont player. I stick with Bastin's usage.

5. The researcher Edward Komara has suggested that Blake's "Georgia Blues" was a likely model for Johnson's song. "Four Until Late" was actually the second piece Johnson recorded in C, but the first, "They're Red Hot," was strummed rather than picked, which gives it a very different feel.

6. In "Police Station Blues," the same song from which Johnson adapted a phrase for "Terraplane Blues," Peetie Wheatstraw sang, "If tomorrow was Sunday, today was Christmas Eve . . ." This seems to support the contention of some blues experts that "Christmas Eve" and "Christmas Day" were black slang for Saturday and Sunday, but in the context of "Hell Hound," Johnson sounds as if the time he is yearning for is a good deal further off than the weekend.

7. Guralnick, *Searching for Robert Johnson*, p. 42.

8. Welding, "Ramblin' Johnny Shines," p. 29. Lonnie Johnson was from New Orleans, not Texas. The confusion may have arisen from his frequent sessions with Texas Alexander and Victoria Spivey.

9. On one bass break in "Malted Milk," Johnson throws in a lick from Scrapper Blackwell, but other than that every note he plays in these two songs is taken directly from "Life Saver." One can pinpoint the precise record, because on the flip side, "Blue Ghost," Lonnie Johnson sang, "My windows is rattlin', my doorknob turning round and round/These haunted house blues is killing me, I feel myself sinking down," which Robert adapted for the last verse of "Malted Milk."

10. Both Adam Clayton Powell and Josh White drank cocktails of scotch in milk, and it may have been something of that sort.

11. Blues singers also made plenty of completely straightforward jokes, sometimes in quite serious songs. Leroy Carr's "I Believe I'll Make a Change," the ancestor of Johnson's "I Believe I'll Dust My Broom," ends with the couplet: "I believe, I believe I'll make a change/Gonna turn off this gas stove, I'm bound for a brand new range."

12. I cannot establish a release date for Weldon's side, but it could have been out by the time Johnson recorded, and helped inspire his song. It is worth noting in this context that "Sold My Soul to the Devil" was backed with "I've Been Tricked," a song about a "hoodoo woman" in which Weldon imitated Peetie Wheatstraw's "hoo-well-well" yodel. Weldon's Devil number was popular

enough to be covered that December by a white hillbilly band, Dave Edwards and The Alabama Boys.

13. In "Six Weeks Old Blues," Wheatstraw sang: "When I die, please bury my body low/So now, that my evil spirit, mama, now, won't hang around your door." As with other such borrowings, this may have been unconscious on Johnson's part.

14. Once again, I take Mann as my authority for the guitar tuning. The song structure, a twelve-bar blues consisting of two rhymed verse lines, then a chorus made up of a short phrase repeated twice and a long phrase to finish, was commonly used for funny songs in the "Tight Like That" mold, but Johnson gives it a quite different feel.

15. One of Henry Townsend's reminiscences of Johnson shows how this phrase was used: "He wasn't like I've heard people say—he wasn't women crazy at all. . . . All the gals were like they were to every other musician: They were breakin' down, but it didn't seem to go to his head" (Townsend, *A Blues Life*, p. 68).

16. The first take of "Traveling Riverside" was left off the *Complete Recordings* set, but appears on *King of the Delta Blues Singers*, Columbia/Legacy CD 65746.

17. Other transcribers have heard this lyric as "if I be rockin' to my head."

18. The "lemon squeeze" was apparently a popular party game, though I have no evidence that it was played in the Delta. A contemporary article headlined "'Lemon Squeeze' Is New Harlem House Rent Plan," explained that "each participant pays a small sum to test his ability at guessing the number of seeds in a lemon, with the winner supposedly to collect a sizeable total. On the surface this game sounds rather familiar, but unconventional Harlem has remedied this difficulty. For in this case the lemon is usually the shortest and plumpest person at the party. He is generally gayly clad in a hideous yellow suit which is laughingly described as an imitation of a lemon. The victims in turn go and squeeze this alleged lemon, which usually calls for a good deal of hilarity" (*Chicago Defender*, July 27, 1935, sec. 1, p. 6).

19. This sweetheart was apparently Willie Mae Powell, Honeyboy Edwards's cousin, who is interviewed in *The Search for Robert Johnson*. She recalls Johnson as "very handsome; the cutest little brown thing you ever seen in your life."

20. Arnold had sung the couplet "Lord if you see my milkcow, buddy, I said please drive her home/Says I ain't had no milk and butter, mama, lord, since my cow been gone." Johnson used the first of these lines to end his bridge verse in take one, then replaced it with a reworking of the second in take two.

II
The Legacy

1. "Sweet Home Chicago" was covered in 1939 by Tommy McClennan, as "Baby Don't You Want to Go," and then by several other players, though it be-

came a standard only after Junior Parker hit with it in 1958. "Dust My Broom" was not covered until Arthur "Big Boy" Crudup did it in 1949, and hit two years later for Elmore James, who turned it into a slide guitar workout. "Stop Breaking Down" was thoroughly rewritten by John Lee "Sonny Boy" Williamson, whose 1945 recording became the model for later bluesmen.

2. It would be as logical to classify these latter artists as soul rather than blues singers, but black fans tend to call their music blues. As for artists like B. B. King, Buddy Guy, or Robert Cray, not to mention the many white blues acts on the scene, the only times I have seen a significant number of black listeners in their audiences has been at free festivals that were easily accessible from black neighborhoods, in nice weather. Such listeners are not the sort of fans that buy records or tickets, though they may enjoy the music when it happens to be around.

<div align="center">12</div>

Jump Shouters, Smooth Trios, and Down-Home Soul

1. "'B' Not 'I' Has It Because The Latter Is Swing Not The Blues," *Chicago Defender*, February 19, 1944, sec. 1, p. 8.

2. Often called the "Petrillo ban," after AF of M president James C. Petrillo, this was a strike against the record companies, demanding that some sort of royalty arrangement be worked out to provide compensation for the use of records rather than live music on radio and in places of public entertainment. It lasted two years, until the major labels agreed to pay the union a royalty, and during this time virtually no commercial recordings were made in the United States.

3. This was a light classical piece from the sound track of a wartime film, *Dangerous Moonlight*.

4. John Chilton, *Let the Good Times Roll: The Story of Louis Jordan and His Music* (Ann Arbor: University of Michigan Press, 1994), p. 14. Other sources give divergent versions of Jordan's minstrel-show apprenticeship, but Chilton's seems most thorough.

5. This tally includes "Stone Cold Dead in the Market," a calypso duet with Ella Fitzgerald.

6. Like the R&B chart, this changed its name over the years, evolving through "Folk," "Hillbilly," and "Country & Western." Jordan's two number ones were "Ration Blues," which held the spot for three weeks, and "Is You Is or Is You Ain't (Ma' Baby)," which stayed for five.

7. Arnold Shaw, *Honkers and Shouters: The Golden Years of Rhythm & Blues* (New York: Macmillan, 1978), p. 70.

8. Ibid., p. 64.

9. Helen Oakley Dance, *Stormy Monday: The T-Bone Walker Story* (Baton Rouge: Louisiana State University Press, 1987), p. 70.

10. In 1933, the *Chicago Defender* described Cox's show as including "25 people and a red hot band" including "little Janine Carmouche, the 11-year-old

sensation, who features classic and acrobatic dancing," and "that well-known riot comedy team of Sweetie Walker and Leroy White" ("Ida Cox Goes Big in South," *Chicago Defender*, April 1, 1933, sec. 1, p. 5). A year later, the paper reported that Cox was working around Tucson, Arizona, with a company that included "a chorus of 12 girls and a 12-piece band" ("Ida Cox Breaks Up Show; Visits Coast," *Chicago Defender*, May 12, 1934, sec. 1, p. 9).

11. Billy Vera, *The Very Best of Big Joe Turner* (Rhino Records CD 72968, 1998), compact disc album notes.

12. It is common for blues historians to call this song a reworking of Glenn Miller's "In the Mood," but neither the tune nor the lyric has any overlap except those three words, and even in that case Hooker's lyric is closer to another Tin Pan Alley title, the 1935 hit "I'm in the Mood for Love."

13. Kays Gary, "Elvis Defends Low-Down Style," *Charlotte Observer*, June 27, 1956, in Peter Guralnick, *Last Train to Memphis: The Rise of Elvis Presley* (Boston: Little, Brown, 1994), p. 289.

14. It is interesting to find Joe Turner on this list. No one today would class him alongside down-home bluesmen like Waters, Wolf, and Hooker, since he was thoroughly urban and grew up singing with jazz players. And yet, his style had a rootsy feel compared to the café blues sound of Charles Brown and Dinah Washington, and his lyrics were full of lines on the order of "I'm like a Mississippi bullfrog sitting on a hollow stump."

15. *Chicago Defender*, November 3, 1951.

16. Waters would recall: "He couldn't stand my playing because he wanted me to play like Johnny Moore which I wasn't able to play the guitar like. He wanted it to be a kind of sweet blues." Quoted in Mike Rowe, "The Influence of the Mississippi Delta Style on Chicago's Post War Blues," in Robert Sacre, ed., *The Voice of the Delta: Charley Patton and the Mississippi Blues Traditions, Influences, and Comparisons* (Belgium: Presses Universitaires Liege, 1987), p. 259.

17. Walter was by no means rough or down-home in his musical tastes. He listed his favorite blues singers as John Lee "Sonny Boy" Williamson, Big Bill Broonzy, Leroy Carr, Walter Davis, and Big Maceo. Outside the blues field, he mentioned Roy Hamilton, Dakota Staton, Red Prysock, Ahmad Jamal, and George Shearing (Interview with Jacques Demetre, cited in Tony Glover et al., *Blues with a Feeling: The Little Walter Story* [New York: Routledge, 2002], p. 204).

18. Nadine Cohodas, *Spinning Blues into Gold* (New York: St. Martin's Press, 2000), p. 162.

19. Shaw, *Honkers and Shouters*, p. 299.

20. Gordon, *Can't Be Satisfied*, p. 334.

21. Wolfman Jack, with Byron Laursen, *Have Mercy!* (New York: Warner Books, 1995), pp. 143–44, 178–79.

22. Guralnick, *Feel Like Going Home*, p. 100.

23. Mark Humphreys, "Bright Lights, Big City," in Lawrence Cohn, ed., *Nothing but the Blues* (New York: Abbeville Press, 1993), p. 187.

24. O'Neal and Van Singel, *The Voice of the Blues*, pp. 329–30.

25. James Brown with Bruce Tucker, *James Brown: The Godfather of Soul* (New York: Macmillan, 1986), pp. 6, 17–18.

26. McKee and Chisenhall, *Beale Black and Blue*, p. 213.

¹³
13

The Blues Cult: Primitive Folk Art and the Roots of Rock

1. It could be argued that Bessie Smith is still in the pantheon, since her name is routinely praised by musicians and scholars alike, but the likelihood of hearing her songs covered at a present-day blues festival is relatively slim.

2. Eileen Southern, *The Music of Black Americans: A History* (New York: W.W. Norton, 1971), p. 68.

3. Robert C. Toll, *Blacking Up: The Minstrel Show in Nineteenth Century America* (New York: Oxford University Press, 1974), p. 195.

4. Abbott and Seroff, *Out of Sight*, p. 361. Such presentations reached their logical extreme in the "Black America" theme park, organized in Brooklyn's Ambrose Park in 1895 by a producer from Buffalo Bill's Wild West Show. This included "A Typical Plantation Village of 150 Cabins, 500 Southern Colored People, presenting Home Life, Folk Lore, Pastimes of Dixie . . . in Marvellously Massive Lyric Magnitude for the Millions" (ibid., pp. 391–92).

5. Southern, *The Music of Black Americans*, p. 104.

6. There were a few people already making this argument in the nineteenth century. After Antonin Dvořák made his famous statement that "the future music of [the United States] must be founded upon what are called the Negro melodies" in 1893, the African-American professor F. G. Rathbun of Virginia's Hampton Institute wrote that, while he agreed with Dvořák's basic position, he did not think that classical adaptations could improve on the "old time simplicity" of the original songs. The Hampton Folk-Lore Society published a plea that was reprinted in the African-American *Freeman* newspaper in 1894, with the heading: "Plea for Negro Folk Lore—We Must Imitate the Example of Other People's [sic] and Preserve from the Rust of Oblivion the Traditions, Habits and Sayings of our Forefathers" (Abbott and Seroff, *Out of Sight*, pp. 273, 308–9).

7. "Stagolee" is alternatively spelled "Stack O'Lee," "Stagger Lee," and so on.

8. Nat Brandt, *Harlem at War: The Black Experience in WWII* (Syracuse, N.Y.: Syracuse University Press, 1996), p. 32.

9. Albertson, *Bessie*, pp. 106–7.

10. Ibid., p. 143.

11. The novelist Fannie Hurst said that Van Vechten associated with African Americans only if they were celebrities, that he "pampered people like Leontyne Price, but he would never think of inviting a Negro elevator operator to his home" (ibid., p. 141). This reveals more about Hurst's racial attitudes than about Van Vechten's, since I would assume that neither of them were close friends with any elevator operators, black or white, while Hurst apparently

felt that there was something comparable about associating with an opera singer and an elevator operator if both were black.

12. By this period, many New Yorkers had become used to the idea that jazz could be considered a sort of American art music. Paul Whiteman had presented jazz as a modern classical form in New York's Aeolian Hall in 1924, and by the late 1930s it was no longer considered daring to have jazz concerts in formal venues. In 1937, the veteran African-American show couple Charles Johnson and Dora Dean even had a show that "introduced popular songs, did their old fashioned Cake Walk, climaxing with Truckin, Souzie Que and the Boogie Woogie that absolutely rocked Carnegie Hall" (Abbott and Seroff, *Out of Sight*, p. 163). To bring blues or gospel to such a venue, though, and to present it as Hammond did, was completely new.

13. "Big Bill Broonzy was prevailed upon . . . white audience," *From Spirituals to Swing* (Santa Monica, Calif.: Vanguard Records 169/71–2, 1999), compact disc album notes, p. 8; "primitive blues singer . . . shuffled," John Hammond with Irving Townsend, *John Hammond on Record* (New York: Summit Books, 1977), p. 158.

14. *Big Bill Broonzy* (Los Angeles: Everest Archive of Folk Music FS-213, 1967), phonograph album notes.

15. Confusingly, there were two Columbias involved in this history, though by the time of "Spirituals to Swing" they were under one roof. Johnson's records were released on the ARC and Vocalion labels, which were part of the Brunswick Record Corporation. BRC bought the Columbia Phonograph Corporation in 1934. In 1938, these combined labels were bought by the Columbia Broadcasting System (Dixon and Godrich, in Oliver et al., *Yonder Come the Blues*, pp. 308–9).

16. The association of slide guitar with the Delta came only in later years. The most influential prewar blues slide player, far and away, was Tampa Red, a Chicago-based Georgian. Red generally soloed over piano or band accompaniment, and thus set the pattern for the electric slide style. Among the early electric masters, Robert Nighthawk came straight out of Red, and even Elmore James, who is universally cited as a Robert Johnson disciple, played more Red licks. (All his slow blues come out of Red's work, including direct covers like "It Hurts Me Too" and "Anna Lee.") Muddy Waters may be the only important electric blues slide player of that generation who did not display Red's influence.

17. It may seem gratuitous to provide a definition of folk music, or to couch this definition in the past tense, but so many people now consider the term to include urban intellectuals playing their own poetic compositions that I want to make it clear that such artists would not have qualified in this category before the 1960s.

18. A striking example of this tendency comes in Lomax, *The Land Where the Blues Began*, pp. 387–94: Describing Jack Owens, a onetime neighbor of Skip James who sang a number of James's songs, Lomax does not even mention James's name, simply treating the songs as if they were Owens's own pieces.

Lomax was well aware of James, having filmed him in 1966, but thought of these songs as representative of a regional folk style and hence common property. Likewise, Lomax did not mention Tommy Johnson's name when he issued a note-for-note cover of Johnson's "Cool Drink of Water" by John Dudley, a convict at Parchman Farm, on his *Sounds of the South* album series.

19. Lomax, *The Land Where the Blues Began*, p. 13. Lomax insisted on the Jefferson-Johnson link, tracing it through an anonymous Delta player who was nicknamed "Lemon" because of his devotion to Jefferson's work, who supposedly taught Son House, who taught Johnson. Whatever the truth of this pedagogical chain, Lomax is the only person who ever noted a strong resemblance between Jefferson's and Johnson's work.

20. Waters recalled his first meeting with Lomax as follows: "He said, 'Well I came down to see Robert Johnson. I heard Robert Johnson's dead and I heard you's almost as good or just as good . . .'" It is no surprise that, given this introduction, Waters would stress his links to Johnson. Nonetheless, despite all the historians who cite Johnson as Waters's main influence, Waters was by no means consistent in confirming this impression. He always named House as his principal inspiration, and often added Johnson's name only after prompting by interviewers, or as part of a longer list. For example, in an interview with McKee and Chisenhall, an edited version of which is in their book, *Beale Black and Blue*, he began a list of his influences on guitar with "a guy named James Smith, which he's never been heard of," then mentioned House. Asked who else in the area played really well, he first mentioned Robert Nighthawk, and on further prompting added, "Robert, the two Roberts"—meaning Robert Johnson ("the number one Robert, he's passed on") and Robert Lockwood. Clearly, he admired Johnson's work, learned a couple of his songs, and was inspired by his example, but there is very little in Waters's playing or singing that would have been different without Johnson's contribution, and to classify him as Johnson's musical descendant is at best an oversimplification.

21. Howard W. Odum and Guy B. Johnson, *The Negro and His Songs: A Study of Typical Negro Songs in the South* (1925; reprint, with an introduction by Roger D. Abrahams, Hatboro, Pa.: Folklore Associates, 1964), p. 149.

22. Lomax tried to persuade Son House to come to New York, writing him in December of 1941, and again a month later, to suggest that he come up and do some concerts. However, Lomax added that no money could be provided for transportation, and "the whole thing would be a gamble for you." Lomax wanted to fix him up with a group of New York singers, who "need somebody who can make his own songs and play a good guitar, and who is experienced in Negro music." This would most likely have been the Almanac Singers, and it is curious to imagine what might have happened had House accepted the invitation. Lomax was quite insistent, writing a third time in February to say that he was urging his friends to lend House the transportation money (Lomax-House correspondence, in the American Folklife Center, Library of Congress, Washington, D.C.).

23. "Bad Nigger Makes Good Minstrel," *Life*, April 19, 1937, p. 39.

24. Charles Wolfe and Kip Lornell, *The Life and Legend of Leadbelly* (New York: HarperCollins, 1992), pp. 138, 145.

25. Brownie McGhee and Josephine Premice, in separate interviews with the author, mid-1990s.

26. A 1963 *Billboard* magazine poll of American college students listed White as the third most popular male folksinger, after Belafonte and Pete Seeger, and ahead of Bob Dylan (Ronald D. Cohen, *Rainbow Quest: The Folk Music Revival and American Society, 1940–1970* [Amherst: University of Massachusetts Press, 2002], p. 213).

27. Brownie McGhee, interview with the author, c. 1997.

28. This concert is now available on a CD titled *Freedom* (Bridge Records 9114), which includes only a small sample of the commentary. Thus, modern listeners can get a taste of the lecture style, but miss hearing the singers described as representing the "strong, peasant soul" of the Negro people. The entire presentation is on file at the American Folklife Center.

29. Rudi Blesh, *Shining Trumpets* (New York: Alfred A. Knopf, 1958), pp. 143–44. Of Holiday's "Fine and Mellow," Blesh writes: "Holiday's singing . . . seems to have, at first hearing, a dispirited and rather poignant melancholy, but beneath the surface are only artifice and insincerity. The performance is devitalized, languishing, and sentimental."

30. Ibid., p. 122.

31. This is a bit of an oversimplification. People like Martin Carthy were playing Big Bill Broonzy songs in British folk clubs, as was Davey Graham, who made a blues duet album with Alexis Korner. There were also blues fans who despised R&B, R&B fans who despised rock 'n' roll, and plenty of jazz purists. There was a good deal of overlap, though, and identification with one or another scene could vary from town to town, club to club, and moment to moment.

32. Brian Jones was never a trad purist. His idol was Charlie Parker, and he named two sons after Julian "Cannonball" Adderley. He played trad, though, because that was what a jazz musician was paid to play in suburban England.

33. The reaction of folk and jazz fans to rock 'n' roll was by no means monolithic. Blesh, in a postscript to the 1958 edition of *Shining Trumpets*, described Elvis Presley as "a young folk singer . . . [whose] records were blues of the same primitive quality . . . as archaic in form as Ma Rainey's 'Shave 'Em Dry.'" The particular records Blesh was referring to were "Heartbreak Hotel" and "Money Honey," which are a long way from folk songs, but he was not alone in noting that in some ways Presley could be considered a rather old-fashioned blues singer (Blesh, *Shining Trumpets*, p. 352).

34. This album was released by the Origin Jazz Library, a blues collector label that focused on Mississippi blues singers: OJL-1 was the first Charley Patton album, and *Really! The Country Blues* (OJL-2) included the first reissues of Tommy Johnson, Son House, Skip James, and Ishman Bracey. Representing the hardest line among country blues record collectors, OJL had a stated policy of never reissuing a Blind Lemon Jefferson cut, presumably be-

cause his overwhelming popularity had compromised the integrity of his art (Bob Groom, *The Blues Revival* [London: November Books, 1971], pp. 41, 43).

35. Booker White's name was spelled "Bukka" on the labels of his 78s, and since his rediscovery was sponsored by record collectors, this misspelling was maintained during his later career. However, there are plenty of examples of White's signature, and he always spelled his name Booker—unsurprisingly, since his full name was Booker T. Washington White.

36. Groom, *The Blues Revival*, p. 83.

37. As Mac "Dr. John" Rebennack said, with some amusement, "Cats like John Lee Hooker and Lightnin' Hopkins can play them folk clubs with an acoustic guitar and get them off. People look at them and say, 'Well, look at that old man. That's all he know.' But go down to their own stomping grounds like in Texas somewhere. They'll set up an electric guitar and scare the shit out of you" (Neff and Connor, *Blues*, p. 74).

38. Quoted in *American Folk Blues Festival, '62 to '65* (Conshohocken, Pa.: Evidence Records 26200, 1995) compact disc album notes. At least some of the artists were pleased about this. Walker would later say, "People there [in Europe] *listen*. You've got to be a showman back here. Over there first time I did the splits the fans booed! That was hard to credit, but it was all right with me. They came to hear the music" (Dance, *Stormy Monday*, p. 140).

39. Stanley Booth, *The True Adventures of the Rolling Stones* (Chicago: A Cappella Books, 2000), p. 102.

40. Hooker's "Boom Boom" did briefly cross over, reaching number sixty on the *Billboard* pop chart in 1962. By that time, he and Waters had appeared at the Newport Jazz Festival, had toured Europe, and were getting gigs on the Stateside folk scene. They were also doing a lot of interviews with blues purists, and regularly reassured such fans of their devotion to the old-fashioned acoustic Delta style. The white fans held the promise of a comfortable middle age, and neither Hooker nor Waters were fools, by a long shot.

41. Jas Obrecht, "The Keith Chronicles, Part 2: Keith, Muddy and Wolf," GuitarPlayer.com, 1992 (March 23, 2003), http://archive.guitarplayer.com/archive/artists/keith2.shtml.

42. Bruce Cook, *Listen to the Blues* (New York: Charles Scribner's Sons, 1973), p. 181.

43. The Stones also made three trips to the Chess studios, cutting two sessions there in 1964 and one in 1965, which provided them with their singles of "It's All Over Now," "Good Times, Bad Times," "Little Red Rooster," "Time Is On My Side," and the first take of "(I Can't Get No) Satisfaction," along with a couple of dozen album tracks, including the instrumental "2120 South Michigan Avenue," named for the studio's street address.

44. Palmer, *Deep Blues*, p. 261.

45. Some blues fans viewed this as betrayal, others as reinvention. Leroi Jones (now Amiri Baraka), practically the only black writer critiquing the blues scene at that time, would say of the English blues-rockers, "They take the

style (energy, general form, etc.) of black blues, country or city, and combine it with the visual image of white American noncomformity, i.e., the beatnik, and score heavily. These English boys are hipper than their white counterparts in the United States, hipper because . . . they have actually made a contemporary form, unlike most white U.S. 'Folk singers' who are content to imitate 'ancient' blues forms and older singers, arriving at a kind of popular song, at its most hideous in groups like Peter, Paul and Mary. . . . As one young poet said, 'At least the Rolling Stones come on like English crooks'" (Leroi Jones, "Apple Cores," *Down Beat*, no. 32, March 25, 1965, p. 34).

46. Nadine Cohodas, *Spinning Blues into Gold* (New York: St. Martin's Press, 2000), p. 244.

47. Eric Clapton, "Discovering Robert Johnson," in *Robert Johnson: The Complete Recordings* (New York: Sony Columbia/Legacy 64916, 1990) compact disc album notes, p. 26.

48. There are people who think that the studio portrait is not the defining picture of Robert Johnson, and instead stress the "pained" or "haunted" look in the other available picture, which seems to have been shot in a dime-store photo booth. This just reinforces a romantic illusion that is doing neither them nor Johnson any favors. What Johnson looks in the photo-booth picture is tired and drunk, and there is no question which image he would have chosen to represent himself.

14
Farther on up the Road: Wherefore and Whither the Blues

1. Paul Nelson, *The Blues Project* (New York: Elektra Records 7264, 1964) phonograph album notes.

2. At times, critics would even suggest that such musicians were selling out to a white audience. John Hammond, in an article for the *New York Times* on December 18, 1938, the week before his first "Spirituals to Swing" show, wrote that some Negro jazz bands "have made serious concessions to white taste by adding spurious showmanship to their wares and imitating the habits and tricks of the more commercially successful white orchestras." This was why he had chosen Count Basie's group, which he described as "probably the most subtle and least exhibitionistic of dance bands." This contention—that black audiences expected straight music, whereas white audiences liked cheap entertainment—has no basis in fact, but fit perfectly with the idea of "primitive" genius as opposed to polished theatricality.

3. I do not mean to suggest that a "natural" musician need not work as hard, or as carefully, as one who is recreating a foreign style, or that the result is less professional or less of a performance. What I mean by a "natural" style is one that is similar to and inextricable from the artist's style of conversation and behavior offstage.

4. An interesting view on this comes from the Mississippi-born Chicago blues pianist Lafayette Leake: "I've gotten into big arguments with people that say

these white cats can't play blues. I say they can—if they learn it. . . . I can play Chopin, and he was sure white. . . . Blues, gospel, jazz—sure that was all created by blacks. So maybe you'd rather see blacks performing it, even if the imitators do just as well. I wish I could hear Chopin himself today, but I can't. So I have to listen to people playing what he wrote. But who knows—maybe they can play it better than he could" (Neff and Connor, *Blues*, p. 122).

5. Palmer, *Deep Blues*, p. 260.

6. Stephen Calt, *The Roots of Robert Johnson* (New York: Yazoo Records 1073, no date), phonograph album notes.

7. Richard Wright, *Josh White: Southern Exposure* (New York: Keynote Records, 1941), 78 r.p.m. album notes, quoted in Elijah Wald, *Josh White: Society Blues* (Amherst: University of Massachusetts Press, 2000), p. 82.

8. The Muddy Waters performance was not, in fact, the end of that concert. In a perfect example of the standards that have often ruled the blues world since the 1960s, the evening's final, headlining performer was Roy Buchanan, the one white "star" on the program.

9. Gordon, *Can't Be Satisfied*, pp. 305–6.

<div align="center">

AFTERTHOUGHT:
SO WHAT ABOUT THE DEVIL?

</div>

1. Richard Wright, *Black Boy* (1945; reprint, New York, HarperPerennial: 1998), p. 39.

2. Wheatstraw was by no means the only singer to use devilish themes. There had been devil songs back to the days of the blues queens. Among guitarists, Lonnie Johnson recorded "Devil's Got the Blues" and "The Devil's Woman," and if there was one early blues player whose technical skills suggested the possession of supernatural powers, he was it.

3. Paul Garon argues that Bunch invented the Wheatstraw persona, which then passed into folklore. Other writers have introduced Ralph Ellison's use of a character called Peetie Wheatstraw in his book *Invisible Man* as evidence that this was a folk figure, but Garon writes that Ellison had known and occasionally played with Bunch/Wheatstraw during his youth in St. Louis. However, Garon adds that the character became popular enough that he later came across two other people using the name and satanic sobriquet (Paul Garon, *The Devil's Son-in-Law: The Story of Peetie Wheatstraw and His Songs* [London: November Books, 1971], pp. 64–65).

4. The line about going down to Louisiana had been recorded by Ida Cox in 1927's "Mojo Hand Blues," but it also reflected Waters's personal view. As he told an interviewer, "If such a thing as a mojo had've been good, you'd've had to go down to Louisiana to find one. Where we were, in the Delta, they couldn't do nothin', *I* don't think" (Palmer, *Deep Blues*, p. 97).

5. There were a handful of memorial records like "The Death of Leroy Carr," but these were commercial novelties, issued to cash in one last time on the star's reputation, and do not count as folk legends.

6. Alan Lomax, *Mister Jelly Roll* (New York: Duell, Sloan & Pearce, 1950), pp. 116–17.

7. Neff and Connor, *Blues*, p. 18.

8. Evans, *Tommy Johnson*, pp. 22–23. It may be worth considering that, while LeDell Johnson speaks of Tommy selling himself to the Devil, the actual words he quotes are "a big black man," and the story involves no sale.

9. A. O. Scott, "Hail, Ulysses, Escaped Convict," *New York Times*, December 22, 2000, sec. E, pp. 1, 30.

10. Evans, *Tommy Johnson*, p. 30.

11. Wardlow, *Chasin' That Devil Music*, pp. 196–201.

12. On 1931's "Howling Wolf Blues No. 3," a sequel to his biggest hit, J. T. "Funny Paper" Smith (The Howling Wolf) sang, "[I] get home and get blue and start howling/And the hellhound gets on my trail."

13. Sam Charters suggests that "Cross Road Blues" is indeed a spiritual or religious song, but that rather than having anything to do with myths about meeting the Devil, it is a sort of gospel blues, using the common Christian metaphor of a soul at life's crossroads (personal communication, 2002).

bibliography

ABBOTT, LYNN, AND DOUG SEROFF. *Out of Sight: The Rise of African American Popular Music, 1889–1895*. Jackson: University Press of Mississippi, 2003.

ADAMS, SAMUEL G. "Changing Negro Life in the Delta." Master's thesis, Fisk University, Nashville, 1947.

ALBERTSON, CHRIS. *Bessie*. New York: Stein and Day, 1972.

ALLEN, WILLIAM FRANCIS, CHARLES PICKARD WARE, AND LUCY MCKIM GARRISON. *Slave Songs of the United States*. New York: reprinted by Dover Publications, 1995.

BARKER, DANNY. *A Life in Jazz*, ed. Alyn Shipton. New York: Oxford University Press, 1986.

BARLOW, WILLIAM. *Looking Up At Down*. Philadelphia: Temple University Press, 1989.

BERRY, CHUCK. *The Autobiography*. New York: Harmony Books, 1987.

BLESH, RUDI. *Shining Trumpets*. New York: Alfred A. Knopf, 1958.

BOOTH, STANLEY. *The True Adventures of the Rolling Stones*. Chicago: A Cappella Books, 2000.

BRADFORD, PERRY. *Born with the Blues*. New York: Oak Publications, 1965.

BROONZY, BIG BILL, AS TOLD TO YANNICK BRUYNOGHE. *Big Bill Blues*. New York: Oak Publications, 1964.

BROWN, JAMES, WITH BRUCE TUCKER. *James Brown: The Godfather of Soul*. New York: Macmillan, 1986.

CALT, STEPHEN. *I'd Rather Be the Devil: Skip James and the Blues*. New York: Da Capo Press, 1994.

CALT, STEPHEN, AND GAYLE DEAN WARDLOW. *King of the Delta Blues: The Life and Music of Charlie Patton*. Newton, N.J.: Rock Chapel Press, 1988.

CHARTERS, SAMUEL. *The Country Blues*. London: Michael Joseph Ltd., 1960.

———. *Robert Johnson*. New York: Oak Publications, 1972.

CHILTON, JOHN. *Let the Good Times Roll: The Story of Louis Jordan and His Music*. Ann Arbor: University of Michigan Press, 1994.

COBB, JAMES C. *The Most Southern Place on Earth: The Mississippi Delta and the Roots of Regional Identity*. New York: Oxford University Press, 1992.

COHN, LAWRENCE, ED. *Nothing but the Blues*. New York: Abbeville Press, 1993.

COHODAS, NADINE. *Spinning Blues into Gold: The Chess Brothers and the Legendary Chess Records*. New York: St. Martin's Press, 2000.

COOK, BRUCE. *Listen to the Blues*. New York: Charles Scribner's Sons, 1973.

DANCE, HELEN OAKLEY. *Stormy Monday: The T-Bone Walker Story*. Baton Rouge: Louisiana State University Press, 1987.

DIXON, ROBERT, JOHN GODRICH, AND HOWARD RYE. *Blues and Gospel Records 1902–1943*. Oxford: Clarendon Press, 1997.

DIXON, ROBERT, AND JOHN GODRICH. *Recording the Blues*. New York: Stein and Day, 1970.

EDWARDS, DAVID HONEYBOY. *The World Don't Owe Me Nothing*. Chicago: Chicago Review Press, 1997.

EPSTEIN, DENA J. *Sinful Tunes and Spirituals: Black Folk Music to the Civil War*. Urbana: University of Illinois Press, 1977.

EVANS, DAVID. *Big Road Blues: Tradition and Creativity in the Folk Blues*. New York: Da Capo Press, 1982.

———. *Tommy Johnson*. London: November Books, 1971.

FAHEY, JOHN. *Charley Patton*. London: November Books, 1970.

FILENE, BENJAMIN. *Romancing the Folk*. Chapel Hill: University of North Carolina Press, 2000.

FINN, JULIO. *The Bluesman*. London: Quartet Books, 1986.

FRIEDWALD, WILL. *Jazz Singing*. New York: Da Capo Press, 1996.

GARON, PAUL. *The Devil's Son-in-Law: The Story of Peetie Wheatstraw and His Songs*. London: November Books, 1971.

GARON, PAUL, AND BETH GARON. *Woman with a Guitar: Memphis Minnie's Blues*. New York: Da Capo Press, 1992.

GILLETT, CHARLIE. *Making Tracks*. New York: Dutton, 1974.

GLOVER, TONY, SCOTT DIRKS, AND WARD GAINES. *Blues with a Feeling: The Little Walter Story*. New York: Routledge, 2002.

GORDON, ROBERT. *Can't Be Satisfied: The Life and Times of Muddy Waters*. Boston: Little, Brown, 2002.

GRACYK, TIM, WITH FRANK HOFFMANN. *Popular American Recording Pioneers: 1895–1925*. New York: Haworth Press, 2000.

GREENBERG, ALAN. *Love in Vain*. Garden City, N.Y.: Doubleday, 1983.

GROOM, BOB. *The Blues Revival*. London: November Books, 1971.

GURALNICK, PETER. *Feel Like Going Home*. New York: Vintage Books, 1981.

———. *Searching for Robert Johnson*. New York: Dutton, 1989.

HAMMOND, JOHN, WITH IRVING TOWNSEND. *John Hammond on Record*. New York: Summit Books, 1977.

HANDY, WILLIAM CHRISTOPHER. *Father of the Blues*. New York: Macmillan, 1941.

HARRIS, MICHAEL W. *The Rise of Gospel Blues*. New York: Oxford University Press, 1992.

HARRIS, SHELDON. *Blues Who's Who*. New Rochelle, N.Y.: Arlington House, 1979.

HARRISON, DAPHNE DUVAL. *Black Pearls: Blues Queens of the 1920s*. New Brunswick, N.J.: Rutgers University Press, 1990.

HASKINS, JIM. *Queen of the Blues: A Biography of Dinah Washington*. New York: William Morrow, 1987.

HEILBUT, ANTHONY. *The Gospel Sound: Good News and Bad Times*. New York: Limelight Editions, 1997.

KEIL, CHARLES. *Urban Blues*. Chicago: University of Chicago Press, 1966.

KELLEY, NORMAN, ED. *Rhythm and Business: The Political Economy of Black Music*. New York: Akashic Books, 2002.

KING, B. B., WITH DAVID RITZ. *Blues All Around Me*. New York: Avon Books, 1996.

KINGSBURY, PAUL, ED. *The Encyclopedia of Country Music*. New York: Oxford University Press, 1998.

LEADBITTER, MIKE, AND NEIL SLAVIN. *Blues Records: 1943–1966*. New York: Oak Publications, 1968.

LOMAX, ALAN. *The Land Where the Blues Began*. New York: Dell, 1993.

———. *Mister Jelly Roll*. New York: Duell, Sloan & Pearce, 1950.

MALONE, BILL C. *Country Music U.S.A.* Austin: University of Texas Press, 1985.

———. *Singing Cowboys and Musical Mountaineers*. Athens: University of Georgia Press, 1993.

MANN, WOODY. *The Complete Robert Johnson*. New York: Oak Publications, 1991.

MARKHAM, "PIGMEAT," WITH BILL LEVINSON. *Here Come the Judge!* New York: Popular Library, 1969.

MCKEE, MARGARET, AND FRED CHISENHALL. *Beale Black & Blue: Life and Music on Black America's Main Street*. Baton Rouge: Louisiana State University Press, 1981.

MILLARD, ANDRE. *America on Record: A History of Recorded Sound*. New York: Cambridge University Press, 1995.

MORTON, DAVID C., WITH CHARLES K. WOLFE. *DeFord Bailey: A Black Star in Early Country Music*. Knoxville: University of Tennessee Press, 1991.

NAGER, LARRY. *Memphis Beat: The Lives and Times of America's Musical Crossroads*. New York: St. Martin's Press, 1998.

NEFF, ROBERT, AND ANTHONY CONNOR. *Blues*. Boston: David R. Godine, 1975.

NORMAN, PHILIP. *Symphony for the Devil: The Rolling Stones Story*. New York: Simon & Schuster, 1984.

OBRECHT, JAS, ED. *Blues Guitar: The Men Who Made the Music*. San Francisco: Miller Freeman Books, 1993.

ODUM, HOWARD W., AND GUY B. JOHNSON. *The Negro and His Songs*. Hatboro, Pa.: Folklore Associates, 1964.

OLIVER, PAUL. *Blues Fell This Morning*. Cambridge, UK: Cambridge University Press, 1990.

———. *Blues Off the Record*. New York: Da Capo Press, 1984.

———. *The Blues Tradition* (formerly *Screening the Blues*). New York: Oak Publications, 1968.

———. *Conversation with the Blues*. Cambridge, UK: Cambridge University Press, 1997.

———. *Songsters and Saints: Vocal Traditions on Race Records*. Cambridge, UK: Cambridge University Press, 1984.

OLIVER, PAUL, TONY RUSSELL, ROBERT M. W. DIXON, JOHN GODRICH AND HOWARD RYE. *Yonder Come the Blues*. Cambridge, UK: Cambridge University Press, 2001.

O'NEAL, JIM, AND AMY VAN SINGEL. *The Voice of the Blues*. New York: Routledge, 2002.

PALMER, ROBERT. *Deep Blues*. New York: Viking Press, 1981.

PRICE, SAMMY. *What Do They Want? A Jazz Autobiography*. Urbana: University of Illinois Press, 1990.

ROWE, MIKE. *Chicago Breakdown*. London: Eddison Press, 1973.

RUST, BRIAN, WITH ALLEN G. DEBUS. *The Complete Entertainment Discography: From the mid-1890s to 1942*. New Rochelle, New York: Arlington House, 1973.

RUST, BRIAN. *Jazz Records 1897–1942*. Chigwell, Essex, UK: Storyville Publications, 1970.

SACRE, ROBERT, ED. *The Voice of the Delta: Charley Patton and the Mississippi Blues Traditions, Influences, and Comparisons: An International Symposium*. Presses Universitaires Liege, 1987.

SALLIS, JAMES. *The Guitar Players*. New York: William Morrow, 1982.

SANTELLI, ROBERT. *The Big Book of Blues*. New York: Penguin, 1993.

SHAW, ARNOLD. *Honkers and Shouters: The Golden Years of Rhythm & Blues*. New York: Macmillan, 1978.

SOUTHERN, EILEEN. *The Music of Black Americans: A History*. New York: W.W. Norton, 1971.

STEARNS, MARSHALL, AND JEAN STEARNS. *Jazz Dance: The Story of American Vernacular Dance*. New York: Macmillan, 1968.

STEWART-BAXTER, DERRICK. *Ma Rainey and the Classic Blues Singers*. New York: Stein and Day, 1970.

TOLL, ROBERT C. *Blacking Up: The Minstrel Show in Nineteenth Century America*. New York: Oxford University Press, 1974.

TOSCHES, NICK. *Unsung Heroes of Rock 'n' Roll*. New York: Harmony Books, 1991.

————. *Where Dead Voices Gather*. Boston: Little, Brown, 2001.

TOWNSEND, HENRY, AS TOLD TO BILL GREENSMITH. *A Blues Life*. Urbana: University of Illinois Press, 1999.

WARDLOW, GAYLE DEAN. *Chasin' That Devil Music: Searching for the Blues*. San Francisco: Miller Freeman, 1998.

WELDON, PETE, AND TOBY BYRON. *Bluesland*. New York: Dutton, 1991.

WEXLER, JERRY, AND DAVID RITZ. *Rhythm and the Blues*. New York: Knopf, 1993.

WHITBURN, JOEL. *Top 40 Country Hits*. New York: Billboard Books, 1996.

————. *Top Pop Singles, 1955–1990*. Menomonee Falls, Wisconsin: Record Research, 1991.

————. *Top R&B Singles, 1942–1995*. Menomonee Falls, Wisconsin: Record Research, 1996.

WOLFE, CHARLES, AND KIP LORNELL. *The Life and Legend of Leadbelly*. New York: HarperCollins, 1992.

WOLFMAN JACK, WITH BYRON LAURSEN. *Have Mercy!* New York: Warner Books, 1995.

WORK, JOHN W. *American Negro Songs and Spirituals*. New York: Crown Publishers, 1940.

WRIGHT, RICHARD. *Black Boy*. New York: HarperPerennial, 1998.

ZUR HEIDE, KARL GERT. *Deep South Piano: The Story of Little Brother Montgomery*. London: Studio Vista, 1970.

index

accordionists, 52, 59, 266

Acuff, Roy, 93, 99

Adams, Samuel, 86, 91–96, 98–102

aesthetics
 of black vs. white fans, 83, 217, 218,
 220–21, 248–49
 blues producers of 1930s vs. modern-
 day fans, 145
 country vs. professional, 233
 effect of, on direction of music,
 250–54, 256–59

African-American audience
 blues defined by, 7–10
 blues as women's market and, 215–16
 blues in postwar period and, 194,
 208–18
 country vs. urban styles and, 31–32,
 38, 216, 217
 end of blues as pop music for,
 218–19
 first black artist marketed to, 21
 hillbilly radio and, 96
 not charmed by poverty, 258
 older, rural music and, 10–11, 52
 race records and, 3
 reaction of, to RJ*, xvii–xviii
 singers preferred by, 21, 217
 varied musical tastes of, 98–99
 white blues fans ignore, 237–38

African-American music. *See also*
 specific artists and styles
 mainstream pop, xxiii, xxiv, 72,
 78–80
 pre-1920s, 45–52
 Southerner tradition of, 71–82
 white audiences and revival of,
 221–49

African-American musicians, 20, 34
 See also rural black artists *and*
 specific artists and styles
 early, white music overlap and, 46–52
 range of material played by, 52–62
 recording limits, 22

African influences, 5, 57, 70–73, 75–76,
 85, 141, 157
 religion and, 270–71

Aguilera, Christina, xiv

Alexander, Alger "Texas," 34, 54, 76–77,
 79, 198, 206

Allison, Mose, 4

Allman, Duane, 245

American Federation of Musicians,
 196–97

Ammons, Albert, 227

Amsterdam News, 26, 201–2

Andrews, Ed, 27

Animals, 255

antebellum South, 46–47

*RJ = Robert Johnson

Anthology of American Folk Music (6 LP set), 240
Apex Club Orchestra, 62
Apollo Theater (Harlem), 51
ARC company, 120–22, 147, 166–67, 182
"archaic" jazz, 237
Arhoolie Records, 97
Arkansas, 83
Armstrong, Howard "Louie Bluie," 53–54
Armstrong, Louis, xxiv, 29, 35, 51, 62, 68, 96, 100, 174, 188, 215, 241
Arnold, Billy Boy, 268
Arnold, Eddy, 98
Arnold, Kokomo, xiv, 42, 94, 119, 127, 133, 134–36, 138–39, 144, 146, 166, 168–69, 173, 184–85, 256
art, concept and myths of, 232–33, 239–42, 245–46, 263
Atlanta, 33, 38, 60
Atlantic records, 205
audience. *See also* African-American audience; white audience
　musicians attempt to please, 69
　shift from black to white, and effect on music, 250–56, 260–61, 264
"authenticity." *See* "realness"
Autry, Gene, xxvi, 54, 58, 59, 80, 97, 99, 101, 233

Baby Face Leroy, 208
Bailey, DeFord, 49, 96
Baker, LaVern, 206
ballads, 35, 37, 38, 224, 224
Ballard, Hank, 211
band singers, 188, 196–97
banjo, 28, 49–52, 157
　Delta, 87, 88
　supernatural skills and, 266
Barbecue Bob, 35, 79
Barber, Chris, 238–39
barbershops, 43–44
Barker, Danny, 84
Barnes, Booba, xix–xx
Barnes, George, 62
Basie, Count, 4, 37, 63, 93, 98–101, 195, 196, 205, 226, 232, 235, 227, 243

Baxter, Andrew, 48
Bayes, Norah, 18
"Beale Street Blues" (Handy), 17, 94
beat movement, 236, 237, 239–41
Bechet, Sidney, 227
Beck, Jeff, 249
Beefheart, Captain, 263
"Before Music Was Segregated," 48
Belafonte, Harry, 81, 234, 238, 239
Bennett, Tony, 98
Berlin, Irving, 65, 206
Bernard, Al, 18, 20, 27
Berry, Chuck, 6, 128, 194, 208, 210, 211, 238, 239, 244, 246–48
　Jordan's influence on, 200
Bible, 168
big bands, 98–99, 196–99, 202, 205, 206
Big Maybelle, 206
Billboard charts, 203
　"Black," 219
　"Blues," 219
　country, 200
　"Harlem Hit Parade," 195
　"Hot Soul," 219
　"pop," 199–200
　"Race" 197, 198, 202
　"Rhythm and Blues" (R&B), 203–8, 216, 219
black folk tradition
　blues as, 43
　white audience and, 222–23, 232
black migrations, 38, 80, 197–98
Black Music for White People (Hawkins album), 220
"Black Snake" cycle of songs, 34, 94
"Black Snake Moan" (Jefferson), 34, 76, 100
Black Swan records, 23
Blackwell, Scrapper, 37, 65, 131, 133, 139
Bland, Bobby "Blue," 97–98, 189, 212, 216–17, 219, 248, 258
Bland, James, 224
Blesh, Rudi, 237–38
Blind Blake, 33, 34, 35, 67, 79, 118, 157, 170–71, 200, 210
　number of recordings, 42
Bloomfield, Michael, 249

"Blue Ghost Blues" (Lonnie Johnson), 174–175
"blue note," 5, 6, 78
blues
 acoustic, modern, 256, 257
 aesthetic, and division between "pop" and "folk," 234–35
 as black pop music, early history of, 8, 9, 16–24, 36–37
 as black pop music of 1940s, 200–206
 as black pop music of 1950s and 1960s, 211–18
 as black pop music, end of, 218–19
 black to white audience shift and, xiii–iv, 218–19, 250–53
 British boom, and Rolling Stones, 238–39, 243–46, 255
 as category, artificiality of, 194, 212–13
 commercial, as grab-bag, 5–6, 71
 commercial, Lomax and, 230–31
 compared to illness, 162
 country guitarists and, 27–36
 decline of individuality in modern, 254–55
 "deep" or "true" and hollers, 81–82
 defined, 4–10, 194
 Delta life and, 83, 85, 101
 Delta prewar pop and, 87–88, 91, 92, 99–100
 Depression and, 39
 "down-home" market for, 29–35, 206–7
 early recordings, 20–42
 early live performance and, 21, 43–59
 early white artists and, 18–19, 27
 early writers on, xxiii–xxiv
 European rediscovery of, 243–45
 evolution of, folk vs. pop influences and, 32–33
 evolution of, paradox of RJ's reputation and, xv–xvi, xxiv–xxvi
 female singers and, 26–27
 first heard by blues artists on record, 58, 79
 first performed onstage, 16
 first published, 16–14
 folklorists record, 72–73

 future of, 250–64
 Hammond and Lomax rediscover, 227–34
 Harlem Renaissance and, 224
 history of, before 1920s, 46–52
 Jordan and, 199–200
 macho-satanic joking in, 177–78
 modern players of, 262–63
 older Southern black tradition and, 9, 71
 origin of, 4, 9–13
 overlap of, with jazz, 62–63, 98, 198
 as poetic form, 168
 pop and folk roots in, 32–35
 pop recording artists underemphasized, 40–42
 postwar period and, 194–219
 Presley influenced by, 207
 radio and prewar, 95–98
 R&B vs., 203–4
 recording industry segregates, 55–61
 obscure and "country," preferred by white revivalists, 240–43
 rock 'n' roll as prism for history of, 7, 220–21
 romanticism and myth of, xxiii, 8, 177, 256–58, 263–64
 rural guitarists and, 13
 searching for roots of, in contemporary Delta, xvi–xxiii
 singers dominate, 196–97, 216–17
 subcategories of, artificiality and limits of, 193, 194
 supernatural and, 178, 266–68, 270–74
 top recording stars of blues era, 40–42
 urban musicians replace country guitarists, 36–42
 variety of black musical styles and, 55–57
 white cult audience and, xiii, 220–22, 253
 white folk audience and, 81–82, 226, 234–40
 white jazz fans and, 237–39
 as women's music, in 1940s, 201–3
 working-class and, 16, 251

blues queens, 7, 13, 18, 34–35, 37
 field hollers and, 76
 jazz and, 63, 237
 postwar, 195, 201–3
 rise of black, in 1920s, 22–29
 sales of, 40
 variety of music performed by, 61
 white, in 1920s, 20, 23
 work songs and, 80–81
blues revival, xxiv, 55, 67, 69, 78, 83,
 176, 245–49
blues shouters, 198–99
"blue yodels," 80
Bobo, Mississippi, xxii
Boggs, Dock, 5, 6
boogie bass, RJ's, 187–88, 217
boogie woogie, 204, 205, 243
Booker, Jim, 48
Booze, Wee Bea, 195, 202
Borges, Jorge Luis, 220
Boyd, Eddie, 209, 210, 242
Bracey, Ishmon, 119, 272
Bradford, Perry, 21, 25, 81
Bradley, Tommie, 52
brass band concerts, 44, 88
British blues boom, 238–39, 243–46, 255
Broadway show tunes, 99
Brockman, Polk, 30–31
Bronze Buckaroo, The (film), 97
Broonzy, Big Bill, xiv, 10, 77, 202, 205
 covers of, as hits, 211
 number of recordings by, 39, 41
 versatility of, 62
 white audiences and, 81, 214,
 227–28, 231, 232, 235, 237, 238
 on writing blues lyrics, 145–46
Brown, Buster, 212
Brown, Charles, 37, 83, 183, 197, 198,
 208, 210, 211, 213
Brown, James, xxiii, 4, 6, 25, 194, 200,
 215, 218–19, 252, 274
Brown, Roy, 66
Brown, Ruth, 6, 203, 212
Brown, Sterling, 236
Brown, Walter, 93, 196
Brown, Willie, 90, 108–11, 161
Bumble Bee Slim, 39, 66, 182
 number of recordings by, 41
 RJ songs and, 131

Bunch, William. See Wheatstraw, Peetie
Butler, Jerry, 37
Butterfield, Paul, xxiv, 245

Café Society, 187
Cahill, Marie, 18–19, 21
Calloway, Cab, 64, 99, 215
camp-meeting shouts, 92
Canned Heat, xxiv
Carcassi, 46
Caribbean influence, 157, 268
Carmichael, Hoagy, 60
Carolinas, black musicians in, 60
Carolina Tarheels, 44–45
Carr, Leroy, xiv, 16, 34, 61, 96, 198,
 211, 215, 219, 230, 253, 260, 264
 disappearance of, 221
 influence of, 36–37, 40, 58, 79, 93,
 94, 98, 127, 195–97, 200, 204,
 216
 influence of, on RJ, 131–35, 144,
 173, 179, 182–84
 number of recordings by, 41
 professionalism of, 177
 reissues of, 242, 248
 variety of music played live by, 63–65
 white blues revival and, 237, 240
Carson, Fiddlin' John, 31, 33, 49, 160
Carter, Bo (Bo Chatmon), 35, 40,
 54–55, 77, 119, 146, 182
 number of recordings by, 41
Carter, Clarence, 189
Carter Family, 240
Caruso, 46
Casals, Pablo, 143, 260
Champion Race records, 52
Charles, Ray, xxiv, 6, 203, 274
 career of, and RJ, 187
 hits by, 211
 influences on, 36, 201
 musical categories and, 212
Charters, Samuel, xxiv–xxv, 234, 241–42
Chasin' That Devil Music (Wardlow),
 274
Chatmon, Bo. See Carter, Bo
Chatmon, Lonnie, 54, 77
Chess, Leonard, 210
Chess, Marshall, 212–13, 215–16
Chess Records, 210, 244, 245, 260

Chicago blues, 10, 39–40, 83, 173, 204, 208–9, 212–13, 219, 252
 "Sweet Home Chicago" as anthem of, 139
 RJ as bridge figure from Delta to, xvi
 studio groups, 39–41
 white blues revival and, 243–45
Chicago Defender, 26, 29, 35, 50–51, 96, 270, 195–96, 201–2, 208–9, 213
children's games songs, 5, 87, 129
Chopin, 251
Christian, Charlie, 200, 227, 230
Christmas records, 34
Chuck Wagon Gang, 120, 149
church songs, 92. *See also* gospel; religion
civil rights movement, 235
Civil War, 38, 48
Clapton, Eric, xxiv, 6, 244–47, 249, 256
Clark, Carroll, 31
Clark, Israel, 107–8
Clarksdale, Miss., xviii–xix, 88, 98, 99, 101, 102
class, audience for blues and, 251
classical music, 44, 46–47
"classic" jazz, 237
Clinton, George, 194
Clovers, 213
Coahoma County, 86, 88
Coasters, 212
cocktail blues, 197–98
Coffee, Willie, 107, 115, 123, 124, 275
coffeehouses, xxiii, 242
Cole, James, 52
Cole, Nat "King," 36, 66, 187, 195, 197, 200
Coleman, Ornette, 151, 260
Columbia Records, 227, 228, 230, 247
"Come Back Baby," 100
"Come On in My Kitchen" (RJ), 119, 181, 266
 influences on, 142–44, 151, 171
 recorded, 142–45, 172
 slide guitar on, 142, 143, 144, 162
Como, Perry, 98
Confessions (St. Augustine), 273
Continental Monthly, 222
Cooke, Sam, xxiii, 37, 274

"coon" songs, 51–52
Copeland, Martha, 34
"Corinna" (song), 11, 58, 211
"corner loading," 120
"corn" or "cornfield" songs, 74. *See also* field hollers
Cotten, Elizabeth, 157
Cotton, James, 213
country-and-western music, 31, 69, 73
 hits, blacks and, 92, 99, 203
"country blues"
 Charters establishes term, 242
 rediscovered by whites, 240
Country Blues, The (Charters), xxiv–xxv, 241–42
country sensibility, 25–26, 29–30, 35, 88, 160. *See also* "down-home" style; ragtime
 ragtime-blues genre and, 53
 vaudeville style vs., 34–35, 54–55
covers, bluesmen play live, 66–68
cowboy music, 97, 118
 yodeling, 54, 56, 69
Cowboy Songs and Other Frontier Ballads (John Lomax), 224
Cox, Ida, 10, 23, 28, 196
 number of recordings by, 42
 popularity of, 26, 202
Craft, Callie (wife of RJ), 110
Crayton, Pee Wee, 198
"Crazy Blues" (Mamie Smith), 17, 21–22
Cream, 245
crooners, 37, 39, 206
Crosby, Bing, xxvi, 37, 39, 53, 65, 96, 118, 235
"Cross Road Blues" (RJ), 167, 172
 lyric, 155, 156, 274–75
 recorded, 155–56
 slide guitar on, 155–56, 159
"crossroads to meet devil" concept, 271, 274–76
Crudup, Arthur "Big Boy," 138
 on blues, 218
 hits postwar, 207
 Presley covers, 207, 221
"Cruel Heated Woman Blues," 131
Crumb, R., xvii
Crump, E. H., 16

Dallas, 32, 38, 77
"Dallas Blues" (sheet music), 16, 19, 21, 32
dances
 changes in, prewar Delta, 87–88, 94–95, 102
 interracial bands and, 48–49
 lyrics and, 132
 musical styles and, 45, 60–61, 67
 rhythms, of 1940s, 196
 white vs. black tastes in, 68
 work songs and, 160
Davis, Rev. Gary, 157, 254
Davis, Jimmie, 96
Davis, Miles, 143
Davis, Sammy, 66
Davis, Tyrone, 219
Davis, Walter, 40, 58–59, 77, 93, 94, 100, 229
 covers RJ song, 139
 number of recordings by, 41
"Dead Shrimp Blues" (RJ), 154–55
"deep" blues artists, popularity of, in Mississippi, 77–78
Deep Blues (Palmer), 71, 77
Delta, 86–91
 African styles and, 76
 blues lovers picture of, 100
 Charley Patton and, 35–36
 dances, 58–59
 day-to-day soundtrack of, 101
 field hollers and, 76, 77
 ghosts of songs in, xxi–xxii
 Handy and, 8
 as home to unique strain of blues, 83–84
 interviews in, 129
 jukebox tunes in prewar, 95, 99–101
 life in prewar, xxii, 84–90, 102
 magical beliefs in, 268, 270, 271, 273–75
 music as only escape from difficult life in, xxii
 music styles and tastes in prewar, 83, 87–102
 in 1940s, 89–90, 102
 non-blues and popular music, 101
 R&B of 1950s and, 209

research in, xix–xxii, xxv
RJ and, xv–xvi, 115–16, 263
variety of musical styles and, 45–46
Delta blues
 blues artists and, 79–80, 82
 classic, vs. wide variety of emergence of, 156–58
 defined by Hammond, 229–30
 music played in Delta and, 56–59
 primitivism and, 177
 RJ's first session and, 149, 155–57
 RJ's music in context of, 126–27, 180, 187–88
 RJ's vocals and, 139
 slide style of, 144
 special conditions of region and, 83–84
Depression, 39, 83, 121, 202
DeSanto, Sugar Pie, 244
Desdumes, Mamie, 12
Detroit, 38, 219
Devil and supernatural, myths of, 265–76
"Devil Got My Woman" (James), 76, 142, 144, 171, 260
"Devil's Son-in-Law, The" (Wheatstraw), 178
Diddley, Bo, 208, 209, 243, 244
"diddley bow," 107
disco, 218
Dixon, Floyd, 198
Dixon, Willie, 90, 209, 243, 259
Dockery Plantation, 108, 156, 268
Dodds, Johnny, 63
Dodds, Julia Major (RJ's mother), 106–7
Dodds-Spencer, Charles (RJ's "father"), 106, 107
Dogg, Snoop, 218
Doggett, Bill, 211
Domino, Fats, 211–13
Dominoes, 37
Donegan, Lonnie, 238, 239, 241
"Done Sold My Soul to the Devil," 178, 265
"Don't Let Your Deal Go Down" (Carson), 160
Dorsey, Thomas "Georgia Tom," 24, 36–38, 42, 273
Dorsey, Tommy (big band), 99

double-entendre, 35, 38, 54, 146, 147
"Down Hearted Blues" (Bessie Smith),
 22–23
"down-home" sound, 210
 associated with Delta, 83
 Delta prewar jukeboxes and, 100
 early, of 1920s, 29–30, 32
 impact of, in 1940s, 188
 R&B of 1950s and, 206–18
 white folk fans and, 229, 242–43
Dre, Dr., 194
Drifters, xxiii
"Drown in My Own Tears," 211
"Drunken Hearted Man," (RJ), 175
"Dry Southern Blues," 183
Duchin, Eddy, 100, 101
Dupree, Champion Jack, 242
Dylan, Bob, xxiv, 170, 188, 227,
 245–46

Eckstine, Billy, 100, 196
Edison, Thomas, 20
Edwards, David "Honeyboy," 10, 26, 60,
 86, 231, 261
 on RJ, 123–24, 166
"Egyptians" or Gypsies, 270, 271
eight-bar blues, 37
electric "down-home" Chicago sound,
 198, 212–14, 245–46
electric guitar
 early, 62
 folk revivalists and, 242–43
 Walker and, 200, 201
electronic amplification, 38–39, 51
Ellington, Duke, 29, 45, 51, 54, 60, 64,
 67, 80, 88, 97, 99, 100, 176, 193,
 196, 260
Elliott, Missy, 194
Eminem, 215, 274
English Folksongs from the Southern
 Appalachians (Sharp), 224
Ertegun, Ahmet, 205
Estes, Sleepy John, 240, 242, 244
ethnic impersonators, 18
Europe. See also British blues boom
 folk and blues revival in, 242–44
 legend of Devil in, 270–271
Evans, David, 272
Evora, Cesaria, xiv

fiddle-and-guitar duos, 52
fiddlers, 47–49, 52, 54, 55, 58, 68, 80,
 87, 93, 266
field hollers, 71–81, 206–7
fife-and-drum music, 126, 157
Finn, Julio, 268
Fisk Jubilee Singers, 223
Fisk University–Library of Congress
 (Jones, Lomax, Adams) field
 team, 86–102, 231
"floating" couplets, 132, 135, 159
Florida, 83
Foddrell, Turner, 48
folk-blues tradition
 disappearance of, in Delta, prewar, 91
 Jefferson and, 32–33
folk fans
folk festivals, 242–44
folklorists, 6, 22–24, 223–24
 field hollers and, 72–76, 78
 Fisk study and, 86–91
 hoodoo and, 270
 pop material not recorded by, 53
 split Southern music along racial
 lines, 57
folk music, 239
 blues reconceived as, by Lomax and
 Hammond, 230–32
 disappearance of, in prewar Delta,
 91
 "pop" vs., 234–35
 in rural prewar South, 70–82
folk revival, 232–34, 238–42
Folkways Records, 241
"44 Blues," reworked as "22-20 blues,"
 67, 149
Foster, Stephen, 224
France, 238, 244
Franklin, Aretha, xxiv, 6, 194, 218, 227,
 274
Friars Point, Miss., 88–89, 180
"From Four Until Late" (RJ), 170–71,
 174
"From Spirituals to Swing" concert,
 186–87, 205, 226–29, 230, 235
Fuller, Blind Boy, 40, 41, 94, 100, 118,
 152, 182, 200, 218, 228–30
Fulson, Lowell, 83, 198
funk, 194

Gaillard, Slim, 63
Gaither, Bill, 40, 41
Gant, Cecil, 37, 197
Gates, Rev. J.M., 80
Georgia, 83
Georgia Yellowhammers, 48
Geremia, Paul, 257, 263–64
Gibbs, Georgia, 244
Gillespie, Dizzy, 193, 239
Gillum, Jazz, 40
Glenn, Lloyd, 198
Gluck, Alma, 31
"Going to Chicago," 93, 99, 102,
 196
"Going to Move to Kansas City," 94
Golden Gate Gospel Quartet, 93, 99
Goodman, Benny, 63, 98, 99, 193, 230,
 232
"Goodnight Irene," 239
"good-time jazz," 63
gospel music, 5, 24–25, 33, 37, 38, 59,
 202, 216
 Delta, 92, 93, 99
 influence of, on RJ, xvii, 160
gospel-soul fusion, 273–74
Grand Ole Opry, 47, 49, 51, 96
Green, Lil, 63, 93, 100, 202, 227
guitar(ists). See also specific musicians
 black 19th-century, 46–47
 early recordings of, 26, 28–36, 40
 early styles, 87, 157
 hillbilly influence on, 96
 prewar Delta and, 88
 RJ and, 108–10, 135
 white revivalists favor, 242, 249
Guitar Slim, 6, 211
Guralnick, Peter, xvii, 106, 107, 125,
 172
Guthrie, Woody, 231, 233
Guy, Buddy, 252, 259

Haley, Bill, 205, 213
Hammond, John, 186, 205, 226–32,
 234, 235, 241, 247
Hammond, John, Jr., 245, 276
Hampton, Lionel, 202
Handy, W. C., 3, 6, 7, 16–18, 25, 50,
 202
 Delta and, 88, 94

as Father of the Blues, 11
 covers and, 31
 ragged loner myth and, 8, 9, 19
 roots of music question and, 33
 white singers and, 20–21, 96
Harlem Hamfats, 42, 63, 152–53
Harlem Renaissance, 81, 224–24
Harlem Rides the Range (film), 97
harmonica, 96, 242
 RJ and, 109, 117–18
Harney, Hacksaw, xxi, 59, 136
Harpo, Slim, 217
Harris, Marion, 18, 20, 23, 27
Harris, R. H., 37
Harris, Wynonie, 196, 197, 199
Harrison, Wilbert, 212
Hart, Alvin Youngblood, 263
Harvey, Morton, 18
Hawkins, Erskine, 195
Hawkins, Screamin' Jay, 220
Hayes, Clifford, 27
"Heartbreak Hotel" (Presley), 194
Hee Haw, 51
Hegamin, Lucille, 21, 42
"Hell Hound on My Trail" (RJ), 267,
 274
 influences on, 150–51, 171, 172
 recorded, 171–72
 white romanticism and, 237–38
Hellhounds on My Trail: The Afterlife of
 Robert Johnson (documentary), 275
Henderson, Fletcher, 62
Henderson, Rosa, 42
Hendrix, Jimi, xxiv, 188, 243, 246, 249
Hill, Miz, xviii–xix, xxv
Hill, Z. Z., 219
hillbilly styles. See also country
 sensibility; country-and-western;
 hoedown
 black musicians and, 27, 28, 33,
 44–45, 47–53, 69, 96–98, 118
 radio and, 97–98
 record companies market, as white,
 52–53
 RJ and, 160
 white prisons and, 73
 white rediscovery of, 240
Hines, Earl, 45, 60, 63, 68, 99, 100,
 196, 198

hip-hop, 194, 219
Hite, Les, 200–201
Hodges, Johnny, 100
hoedown, 35, 45, 47, 52, 85, 93
Hogan, Carl, 200
Hogg, Smokey, 206, 208
hokum, 28, 37–38, 62, 64, 152, 203
Hokum Boys, 41, 42, 200
Holiday, Billie, 202, 203, 205, 226, 230, 237, 260
Holladay, Kenny, xvi, xvii
Holland, Justin, 46
Holman, Libby, 233
"Home on the Range" (black cowboy song) 57
"Honeymoon Blues" (RJ), 182–83
"Hoochie Coochie Man" (Waters), 204, 209, 212, 244
 Van Ronk and, 177
hoodoo or mojo, 268–71
Hooker, John Lee, xix, xxiii, 76, 78, 90, 206–9, 212, 216, 217
 revivalists and, 242–45, 257
Hopkins, Lightnin', xxiii, 136, 206–7, 242–44
Horowitz, Vladimir, 251, 255
Horton, Big Walter, 90
"Hound Dog" (Presley), 211
House, Son, xv, 9, 56, 79, 90, 118, 120, 209, 272–73
 blues history and, 126, 127
 Chicago bluesmen and, 213
 "deep" blues and, 77–78
 Delta sound and, 88, 156, 158
 early recordings of, 158, 161
 influence of, on RJ, 108–11, 130, 132, 133, 139, 150, 155, 158–59, 161–62, 172, 229
 Lomax and, 96, 231
 "Preachin' Blues" and, 161–63
 on RJ and Devil, 275
 on RJ death, 124
 on RJ record, 121
 recording method of, 176
 rediscovery of, 240, 242
Howell, Peg Leg, 33, 61
Howlin' Wolf, xix, 63, 83, 208, 209
 Delta and, 90, 113
 popularity and style of, 210, 214–15

Rolling Stones and, 245, 246
 vocal style of, 155, 217
 white audience and, 214, 244–45
"How Long—How Long Blues" (Carr), 36–38, 58, 67, 93, 94, 196
Hughes, Langston, 224, 225
Humes, Helen, 196, 243
humor, 177–78, 214, 274
Hunter, Alberta, 21–23, 27, 42, 202
Hunter, Ivory Joe, 197, 212
Hurt, Mississippi John, xxiii, 9, 10, 161, 254
 early black guitarists and, 157
 range of material of, 55, 69
 white audience and, 48, 80, 240, 242, 254–55
Hyatt, Harry Middleton, 266
hymns, 92

"I Believe I'll Dust My Broom" (RJ), 140, 147, 155
 boogie shuffle on, 136–38
 recorded, 135–38
 as standard, 138, 139, 148, 188
 Wolf sings at Newport, 214–15
"I Believe I'll Make a Change" (Carr), influence of, on RJ, 135
"If I Had Possession Over Judgment Day" (RJ), 163–65, 180, 274
"I Got the Blues" (first published blues), 16
"I Got You (I Feel Good)" (Brown), 218
"I'm a Steady Rollin' Man" (RJ), 170
Ink Spots, 37, 63, 96, 183
In Search of Robert Johnson (documentary), 276
interracial music, 46–52
 segregated by folklorists, 57
 segregated by record companies, 52–53
"In the Evening" (Carr), 37, 96, 183. See also "When the Sun Goes Down"
Isley Brothers, 246
Italian favorites, 53, 137
"It Makes a Long Time Man Feel Bad," 160
"It's Tight Like That" (Tampa Red/Georgia Tom), 36, 38, 67
"I Wonder" (hit of 1940s), 197

Jackson, Jim, 35, 40, 94
Jackson, John, 49, 96
Jackson, Lew, 34
Jackson, Mahalia, 38, 253
Jackson, Mississippi, 102, 152
Jackson, Papa Charlie, 27–28, 38, 42, 94
Jagger, Mick, 6, 215, 221, 239, 246
James, Elmore, xiv, xxiii, 79, 90, 209, 213, 239
 covers RJ song, 138, 139, 148
James, Etta, 203, 216, 258
James, Skip, xv, xxiii, 67, 90, 120, 260, 263, 272
 blues history and style of, 76–78, 126, 137, 150
 Devil songs and, 274
 influence of, on RJ, 142–44, 149–51, 171
 rediscovery of, 240, 242, 254–55
 wide repertoire of, 59–60, 69
Jaxon, Frankie "Half Pint," 38
jazz, 26, 34, 45, 54
 aesthetic of obscurity and, 241
 blues and, 5, 6, 62–63, 98, 195
 as category, 193–94
 prewar Delta and, 88, 99
 Lonnie Johnson and, 29
 white fans and, 205, 226, 236
 white pop music and, 96–97
Jefferson, Blind Lemon, xxv, 10, 26, 39, 78, 79, 94, 143, 198, 206, 210, 233, 253, 260
 early success of, 29–35, 40, 42
 field hollers and, 32–33, 76
 influence of, 79–80
 influence of, on RJ, 132, 136, 159, 183
 white rediscovery of, 231, 237, 240
Jeffries, Herb, 97
"Jelly Jelly" (Eckstine), 100, 196
jigs and reels, 47
jive style, 63, 188, 200
Joel, Billy, xiv
John, Little Willie, 218
"John Henry," 10, 224, 238
Johnson, Alec, 54–55
Johnson, Alonzo "Lonnie," xxiii, xxv, 10, 26, 94, 116, 118, 196, 262

 disappearance of, 221
 early popularity of, 28–29, 34, 41, 61–62, 77
 influence of, 79–80, 196, 200
 influence of, on RJ, 174, 178
 R&B vs. blues and, 204, 205
 style and virtuosity of, 28, 54, 61, 127, 129, 174, 177
 white revivalists and, 237, 238, 242, 244
Johnson, Big Jack, xxii
Johnson, Buddy, 100, 195
Johnson, James P., 227
Johnson, Larry, 246
Johnson, LeDell, 271–72
Johnson, Lil, 40
Johnson, Merline ("Yas Yas Girl"), 42, 62
Johnson, Noah (RJ's father), 107
Johnson, Pete, 204, 205, 227
Johnson, Robert (RJ), xiv, 98. See also specific songs
 begins recording, 119–22
 birth and early life of, 105–8
 black vs. white audience and, xxiv–xxvi, 188–89, 220, 218
 boogie shuffle and, 217
 as bridge between Delta and commercial world, xv–xvi
 Chicago bluesmen and, 213, 215
 commercial aspirations of, xiv–xv
 Complete Recordings of, xxiv, xxv–xxvi
 contemporaries of, in 1940s, 198
 as cream of large crop, 261
 death of, 123–25, 194–95, 274
 Delta during time of, 90, 91
 Delta "jukes" and, 93, 94, 115–16
 direction might have been pursued by, 186–88
 disproportionate focus on, 40
 evolution of black music and, xv, xxiv–xxvi
 first sessions, hits attempted, 131–48
 first sessions, reaching back to older influences, 149–65, 173
 folk blues revival and focus on, 247–49
 grave marker ceremony of 1991 and, xvi–xvii

guitar playing and slide playing of, 113–14, 118, 119
hip-hoppers and, 219
House and, 158
influence of, 79, 187–88
legacy of music of, 186–89
looks of, 9, 111–12
magnetism of, 117–18
marries Callie Craft, 110
meets House and Brown, 108–11
modern blues audience vs. peers and, 253, 254
modern writers on guitar playing of, 256
musical world of, 101, 102
myth of, xvi–xvii, xxv–xxvi, 8–9, 106, 188, 237–38, 258, 262–63
myth of Devil and, 266–67, 269, 270, 272, 274–76
original signature pieces of, 119
other musicians and, 154
personality of, 112–14
professionalism of, 7–8
record success and, 166–67
rediscovery of, xxiv, 228–32, 241–42
Rolling Stones and, 246
second session, 122, 166–85
Skip James and, 150–51
songwriting by, 118–19
stock arrangements of, 148
travels of, 111–17
understanding, in context of his world, 126–30
unknown until "blues revival" of 1960s, xxiv
variety of music played by, 59, 60, 118
versatility of, 127
women and, 122–24
Johnson, Tommy, xx, 63, 108, 110, 119
Delta style and, 76, 90, 126, 158
Devil and, 271–75
test pressing, 56–57
Jolson, Al, 39, 46
Jones, Brian, 239
Jones, Curtis, 42
Jones, Lewis, 86–91, 101
Jones, Ruth. See Washington, Dinah
Joplin, Janis, 6, 257

Joplin, Scott, 10
Jordan, Louis, 63, 88, 100, 101, 188, 194, 198–200, 201, 208, 218, 219, 236
jug bands, 96, 129, 238
jukeboxes, 88–89, 90, 95, 99–101
juke joints, 67, 268–70
"Juke" (Little Walter), 204, 210
"jump" combos, 197, 261

Kansas City style, 195, 196, 198–99, 204–5
Kaye, Sammy, 100, 101
Kentucky, 48, 83
Kentucky Boys, 48
Kerouac, Jack, 241
Khan, Ali Akbar, 260
Khulthoum, Oum, 5
"Kind Hearted Woman Blues" (RJ), 140, 147, 173, 175, 182
first release of, 166
recorded, 131–35
Kind of Blue (Davis), 143
King, Albert, 90, 217, 245, 254, 262
King, B. B., xiii, 5, 90, 254, 259, 264
hits, 211, 216, 219
improvisation and, 176
influences on, 28, 79–80, 200, 201
R&B vs. blues and, 204, 208
white vs. black audience and, 216, 217, 219
King, Freddie, 254, 259
King, Martin Luther, Jr., xx
King and Anderson Plantation, 91
King Cole Trio, 198
"King of Spades" (Wheatstraw), 173
King of the Delta Blues Singers (RJ album reissue 1961), xxiv, 163, 247–48
Kings of Rhythm, xix
Kingston Trio, 238, 239
Kirkland, Eddie, 258–59
Koerner, Spider John, 246
Korner, Alexis, 238–39

LaBelle, Patti, 25
Lacey, Rube, 126, 272
Lang, Eddie, 29
LaSalle, Denise, 189, 219

"Last Fair Deal Gone Down" (RJ),
160–61
Latimore, 219
LaVere, Steven, 275
Law, Don, 120–21, 122
Leadbelly, 215, 230, 232–34, 237, 238,
239, 248, 257, 261, 263
"Lead Pencil Blues" (Temple), 137
Lee, Peggy, 63, 202
Lehmann, Lilli, 225, 226
Lewis, Furry, 10, 157
Lewis, Homer, 59
Lewis, Jerry Lee, 211, 213
Lewis, Meade Lux, 227
Library of Congress. See also Fisk
University–Library of Congress
field team
Josh White concert at, 235–36
recordings of House, 158
recordings of Waters, 57–58
Life, 232
"Life Saver Blues" (Lonnie Johnson),
174–175
Liggins, Jimmie, 198
Liggins, Joe, 198
Limelighters, 239
Lippmann, Horst, 243
Lipscomb, Mance, 43, 55, 242, 261
Little Milton, 9, 66, 215–16, 217, 219
"Little Old Log Cabin in the Lane,
The," 31, 49–50
"Little Queen of Spades" (RJ), 173–75
Little Richard, 25, 211, 243, 246
Little Walter, 204, 209–10, 211
live performance, 43–69
barbershop, 43–44
blues as black, southern style and,
21–22
hillbilly styles and, 47–50, 52
interracial, 46–52
minstrel shows and, 50–52
recorded vs., 61, 67
variety of musical styles in, 44–45,
52–59
Locke, Alain, 236
Lockwood, Robert, 112–13, 122, 261
Lomax, Alan, 73, 86, 239, 252
field hollers and, 74–76
House interviews, 111

Mississippi field trip of, 57–59, 97,
231, 270
rediscovery of rural blues and,
230–36, 241
Lomax, John A., 57, 73, 224, 230, 232,
233, 235
Lombardo, Guy, xiv, 96, 196
Los Angeles, 198
Louisville, 83
Louisville Jug Band, 27, 63
"Love in Vain" (RJ), 163
recorded, 183–84
Rolling Stones cover, 246
lullabies, 92

Mabon, Willie, 209, 210
McCartney, Paul, 245
McClennan, Tommy, 93, 100, 139
McCormick, Mack, 106, 124–25, 276
McCoy, Charlie, 54–55, 63, 77, 137,
152
McCoy, Kansas Joe, 42, 54–55, 63, 77,
152, 202, 274
McDowell, Fred, 246
McGee, Sam, 96, 157
McGhee, Brownie, xiii, 48, 238, 239,
243
on going "white," 233, 234
McGhee, Kirk, 47
McGhee, Stick, 234
Macon, Uncle Dave, 49–50
McShann, Jay, 59, 93, 100, 195, 196
McTell, Blind Willie, 33, 63, 67, 118,
157
Maggio, Antonio, 16
Mahal, Taj, 246
Maid of Harlem (musical revue), 20
male performers, 27–38
"Malted Milk," (RJ), 175
March of Time (newsreel), 232
Markham, Pigmeat, 51
Martin, Dean, 207
Martin, Sara, 21, 26, 27, 40, 41
Mayall, John, 245
Mayfield, Percy, 6
"Me and the Devil" (RJ), 182, 267
devil in, 274
humor in, xvii, 177–79, 274
recorded, 175–79

"Mean Mistreater Blues," 94, 131, 133
medicine shows, 51, 55, 139, 274
Memphis, 33, 38, 62, 102, 149, 204
"Memphis Blues (Mr. Crump), The,"
 (Handy) 16–18
Memphis Jug Band, 42
Memphis Minnie, 40, 41, 63, 77, 92,
 99, 100, 134, 229, 262
 wide repertoire of, 62
Memphis Slim, 209, 242, 243
Messenger's Café jukebox titles, 99–100
Michelangelo, 262
"Midnight Hour Blues" (Carr), 37, 260
Midnight Ramble (radio show), 96
Milburn, Amos, 198, 216
"Milk Cow Blues" (Arnold), 94, 134,
 138, 145, 168–69, 173, 184–85
"Milk Cow Calf Blues" (RJ), 184–85
Miller, Aleck "Sonny Boy Williamson,"
 90, 209
 on death of RJ, 124
Miller, Glenn, 99, 196
Miller, Steve, 249
Millinder, Luckey, 197
Mills Brothers, 96, 152
Milton, John, 275
Milton, Roy, 198
minstrel shows, 11, 18–19, 28, 33, 35,
 44, 46, 50–52, 54–55, 60–61, 139,
 222, 224
Mississippi blues players. See also Delta
 blues; and specific artists
 Charley Patton and, 35–36
 Chicago sound and, 198, 209
 development of, RJ and, 126–28
 postwar era, 207
 prewar stars from, 83
 R&B hits and, 209, 211
 recordings, 119–20
Mississippi Jook Band, 126, 153
Mississippi Sheiks, xx, xxi, xxv, 34, 36,
 42, 52, 54, 94, 119, 126, 144, 146,
 229
Missouri, 83
Mitchell's Christian Singers, 227
moans. See field hollers
modernism, 17, 85, 102
 RJ and, 144, 177–78
Monroe, Bill, 48

Montgomery, Little Brother, xx, 65–66,
 79, 84, 137, 242, 269
"Moonshine Blues" (Ma Rainey), 24
Moore, Johnny, 188, 197, 209
Moore, Monette, 22
Moore, Rudy Ray, 267
Moore, Scotty, 239
Moore, Spence, 51
Moore, Whistlin' Alex, 98
Morand, Herb, 63
Morton, Jelly Roll, 12, 26, 51, 176, 237,
 268–70, 275
Mumford, Lewis, 14
musical categories, 193–94, 204–5, 208,
 212–13, 218
 invention of, 44, 56
musical versatility and variety, 44–69,
 95–101, 127, 206, 233
"My Black Mama" (House), 159
"My Blue Heaven," 98, 118
Myth of the Machine, The (Mumford),
 14

Narmour, William T., 48
Negro and His Songs, The (survey of
 black rural folk music), 231
"Negro spiritual" ensembles, 223
Nelson, Romeo, 237
Nelson, Sonny Boy. See Powell, Eugene
neo-ethnic movement, 240
Newbern, Hambone Willie, 164
Newbern, Willie, 126
New Orleans, 12–13, 29, 33, 157
New Orleans jazz
 hoodoo and, 268–69
 jazz purists ("moldy figs") and,
 193–94, 237
New Orleans Joys (album), 238
Newport Folk Festival, 254–55
 Wolf at, 214–15
New York Times, 272
Noone, Jimmy, 62
North Carolina, 83

O Brother, Where Art Thou? (movie),
 272
Oertle, Ernie, 120
"Oh! Red" (McCoy), 63, 152–53
Okeh Records, 27, 30–31, 267

Oklahoma, 83, 198
"Old Original Kokomo Blues" (Arnold), 138, 139
"Old Time" music, 31, 47, 49–50, 52, 52
Oliver, King, 26, 34, 62, 237
Oliver, Paul, 79
On the Road (Kerouac), 241
Orlando, Tony, and Dawn, 56
Ottley, Roi, 10

Paganini, 271, 275
Palmer, Robert, 71, 77
"Papa's Got a Brand New Bag" (James Brown), 194, 218
Paramount Records, 27–29, 66, 108, 143, 159
　"test pressing," variety of black "bluesmen" and, 56–57
Parchman Farm, 72, 75, 160, 161
Parker, Charlie, xxiv, 188, 193
Parker, Junior, 138, 139, 217
parlor songs, 92
Parton, Dolly, 25
"party blues," 146
patriotic anthems, 92
Patton, Charley, xiv, xv, xvii, xxv, 56, 57, 59, 79, 113, 118, 119, 143, 206, 210, 214, 215, 268, 273
　Delta or "deep" sound and, 77, 90, 102, 126, 156, 158
　House, Brown and, 108, 161
　influence of, on RJ, 160
　lyrics of, 132
　popularity of, 35–36, 40, 94, 100
　rediscovery of, 240
　showmanship of, 108
　vocal style, 155
Peer, Ralph, 31
Peetie Wheatstraw: The Devil's Son-In-Law (record and movie), 267
Pekin Theater (Chicago), 16
"Penitentiary Moan Blues" (field holler), 77
Perkins, George, 34
Pettis, Arthur, 126
Petway, Robert, 126
Phillips, Esther, 203

Phillips, Sam, 214
Phillips, Washtub Robbie, xvi
"Phonograph Blues" (RJ), 147–48
pianists, 209
　folk revival and, 242–43
　influence of, on RJ, 137
piano-guitar duos, 35–40, 61–62
Picasso, 151, 172
Pickett, Wilson, 252
Piedmont style, 170
"Pinetop's Boogie Woogie," 100, 211–12
plantation system, 84–85, 101
"Police Station Blues" (Wheatstraw), 146
Polish favorites, 53
polyrhythms, 157–58, 170
popular music "pop," 7, 58
　art vs., 243
　bluesmen as entertainers and, xv, 215, 252
　Delta prewar taste and, 87–88, 90–95, 98
　"folk" vs., 234–37, 240–42, 252
　influence of, on bluesmen , 32–33, 58, 60, 127, 129, 130, 201, 262
　played by blues artists, 52, 61–62, 64–66
　rural artists and, 52–54, 72
"popular culture," as academic discipline, 235
"postclassic jazz," 237
Powell, Eugene (Sonny Boy Nelson), xx–xxi, 68
Preachin' Blues (Up Jumped the Devil)" (RJ), 267
　House and, 161
　recorded, 161–63, 172
　rediscovered, 229, 242
Premice, Josephine, 233
Presley, Elvis, 4, 84, 134, 194, 207–8, 211, 215, 221, 239, 241, 244, 248
Price, Lloyd, 212, 252
Price, Sam, 100, 195
Pride, Charley, 69
primitive folk art
　white fans and blues as, 220–21, 227–29
prison farms, 72–75, 77, 85
Prohibition, 88

Providence Civic Center concert,
 259–60
Pruitt Twins, 26
Pullum, Joe, 94

"Queen" Elizabeth, 276

Rabbit Foot Minstrels, 199
Race records, 16, 21–42
 pop music and, 53
 rediscovery of, 3, 242
 styles not recorded by, 45, 52
 work songs and, 80–81
Rachell, Yank, 94
racism. See also stereotypes
 minstrel shows and, 51–52
 Mississippi Delta and, 84–85, 101
radio, 95–99, 101–2, 118, 197
"ragtime" (older African-American rural
 music), 5, 6, 10–11, 16, 61, 28, 33,
 85, 87, 88, 157
 RJ and, 153, 170–71
Rainey, Georgia Tom and
Rainey, Gertrude "Ma," 4, 10, 11, 28,
 94, 206, 264, 273
 influence of, 22, 37–38, 80, 199
 influences on, 76
 Jefferson and, 32–33
 names the blues, 11–12
 number of recordings by, 42
 postwar covers of, 195, 196, 211
 style and variety of, 21–26
Rainey, William "Pa," 11
Raitt, Bonnie, 197, 256
"Rambling on My Mind" (RJ), 147, 148
 recorded, 139–40
Rand, Odell, 63
rap music, 264
Ratliff, Rev. James, xvii, xxv
Real Folk Blues (Chess album reissue),
 245
Really! The Country Blues (album), 242
"realness," xiv, 7–8, 232, 233–34,
 240–41, 253–54, 258
record collectors, 236, 237
record companies
 "blues" term, applied to rural
 guitarists by, 13
 cost of discs and, 57–58

blues queens as first blues hits and,
 17–18, 21–26
Delta and, 101
Depression and bankruptcy of, 39
early accompaniments and, 26
early country male recordings by,
 27–38
emphasis on new material by, 66–68
female vs. male popularity, 26–27
greatest-of-all-time recording by,
 260–61
influence of, on musicians, 46,
 58–59, 79
limit black musicians to blues, 47,
 52–53, 56–68
live performance and, 21, 40, 44–47
male singer-guitarists and, 27–36
regional markets and, 30–31
rise of black artists and, 21–22
RJ discovered by, 119–21
stars of, of 1920s and 1930s, 39–42
urban sounds replace country
 guitar-singers and, 36–42
white blues revival and, 240–41
WW II and, 196–97
Redding, Otis, 37, 218
Red Scare, 239
Reed, Jimmy, xxiii, 3, 136, 138, 207,
 217–18, 245
"reels," 10
regional differences, 30–31, 157
Reinhardt, Django, 201
reissues, 240, 245, 247, 263
Rembrandt, 241
"rent parties," 38, 61, 67
Rhodes, Walter, 59, 94
Rhythm and Blues (R&B), 6. See also
 Billboard charts
 Carr resurfaces on, 183
 as category, 194, 208, 212
 "down-home" bluesmen and, 206–7
 hits, 199, 209–10, 211–12, 216–18
 influences on, 37
 hoodoo and, 268
 McGhee and, 234
 term becomes standard, 203–6
 Welk hit and, 97
rhythm duos, 188
Richards, Keith, 221, 239, 243–46

Rite of Spring (Stravinsky), 241
Robertson, Alec, 87
Robeson, Paul, 81, 93
Robinsonville, Miss., 107, 108, 109
Rock, Chris, 274
"Rock Island Line," 232, 238
rock 'n' roll, 6, 137, 210
 bluesmen as roots of, 220
 as category, vs. blues, 194, 208
 European blues revival and, 243
 folk music vs., 239
 RJ and, 263
 Turner and, xxiii, 199, 205
Rodgers, Jimmie, xxiv, 56, 69, 80, 94,
 96, 118, 188, 240, 244, 255,
 263
Rogers, Jimmy, 261
Rogers, Roy, 97, 239
"Roll and Tumble Blues," 164, 180
Rolling Stones, xxiv, 128, 220–21, 239,
 243–46, 252, 254, 255, 276
Romanticism, 223
 black vs. white, 9, 276
 lone black guitarist myth and, 8–9,
 12–13, 19, 248–49, 263
 obscurity and, 240–42
 RJ myth and, 263, 266
 white view of black culture and, 226,
 248–49, 257–58
Roomful of Blues, 259
Roosevelt, Theodore, 224
Ross, Lanny, 99, 101, 129
Royal Canadians, 96
Rubinstein, Arthur, 251
Ruffin, David, 37
rural black artists. *See also* country
 blues; "down-home" sound; Delta
 blues; "Old-Time" music; "ragtime"
 early echoed, 157
 folklorists and, 223, 224
 influence of Rainey on, 12
 recordings, early boom in, 31, 32
rural music, 47, 51, 54, 157
 blues boom and, 40, 42
 "folk" music in prewar South, 70–82
 "neo-ethnics," 240
 overlap of black and white, in south,
 47–52
 "songster" label and, 55–56

variety of styles and, 44–45, 54
Rushing, Jimmy, 93, 99, 195, 196, 205

"Sagefield Woman Blues" (Arnold), 135
St. Augustine, 273
St. Louis, xvi, 38, 40, 102, 116–17, 219
"St. Louis Blues" (Handy), 11, 16, 17,
 21, 58, 93, 94
Sallie Martin Singers, 202
"Salty Dog Blues," 28, 94
Santeria, 271
Satherley, Art, 120
Schulta, Arnold, 48
Scruggs, Uncle John, 49–50
sea chanteys, 73
"Section Gang Blues" (field holler), 77
"Section Hand Blues," 80–81
Seeger, Pete, 239
"See See Rider" (Rainey), xxiii, 195, 202
 hit as "C.C. Rider," 211
segregation, 48, 51–52, 204
Senegal song, 75–76
"Shake, Rattle and Roll" (Turner), xxiii,
 194, 205, 206, 211
"Shake It Baby" (Hooker), 244
Shakespeare, 241
"Shake That Thing" (Jackson), 28, 38
sharecropping, 84–85, 87
Sharp, Cecil, 224
Shaw, Arnold, 37
Shaw, Artie, 92, 99, 100
Shindig! (TV show), 245
Shines, Johnny, 261, 276
 on jukeboxes of 1930s, 99
 on RJ, 111–19, 121–24, 142, 154,
 155, 174, 266
 on styles of live performers, 45–46,
 60
 on Wolf, 214
Shining Trumpets (Blesh), 237–38
Sinatra, Frank, 62, 66, 206, 235
singer-guitarists
 early recordings of, 27–36
 Rainey paves way for, 25–26
 replaced in black pop music, 194–95
"Sissy Man Blues," 135
"Sitting on Top of the World," xxi, 94,
 144
Skiffle Bands (album), 241

slaves and slave musicians, 9–10, 46–47, 72, 86

Slave Songs of the United States (book, 1867), 223

slide guitar, 62, 142–44, 155–56, 158, 159, 162, 228

small combos, 197–98, 199

Smith, Bessie, xxiii, xxv, 5, 7, 10, 16, 20, 196, 206, 215, 254, 257, 260, 273
 death of, xviii
 early popularity of, 22–27, 30–31, 41
 Hammond and, 227, 230
 influence of, 78, 80, 204
 influences on, 25, 76
 radio and, 96
 Van Vechten and, 225–26
 variety of music sung by, 61

Smith, Clara, 23, 26, 40, 41, 76, 162, 265
 influence on RJ, 178

Smith, Funny Paper, 274

Smith, Harry, 240

Smith, Lucius, 88

Smith, Mamie, 17, 20–21, 23, 26, 27, 42, 196, 253

Smoky Mountain Boys, 99

smooth balladeers, 206

smooth trios, 197

Snow, Hank, 98, 203

songs, favorite, Fisk study, 91–95, 102

"songsters" label, 55–56

Sor, 46

soul, 6, 187, 202, 217, 218
 as category, vs. blues, 194, 212

soul shout, 37

Soul Stirrers, 37

Sousa, John Phillip, 46

South
 black and white music overlap in, 46–49
 "chitlin' circuit" in, 219
 country guitarists and, 35
 record company field trips to, 30–31, 33, 39
 white vs. blacks and nostalgia for Old, 31–32

South Carolina, 83

Southwest, 198

"Spanish Fandango," 47, 157

Speir, H. C., 66, 119–20

Spencer, Charles. *See also* Dodds-Spencer, Charles

Spencer, Robert (RJ's name on early documents), 107

Spirits of Rhythm, 152

spirituals, 92, 93, 223

Spivey, Victoria, xxv, 29, 34, 42, 76, 94
 revivalists and, 244

Springsteen, Bruce, 227

square dances, 53, 87, 88

"Stagolee" (song), xxiii, 10, 212, 224, 268

"Stardust," 35, 54, 92, 201

Stein, Gertrude, 172

stereotypes, white audience for black music and, 221–23, 225, 257

Stokes, Frank, 161

"Stones in My Passway" (RJ), 167–70

"Stop Breakin' Down Blues" (RJ), 179–81

Strachwitz, Chris, 97

street singers, 27–28, 30–33

"Street Walkin'" (Powell), xxi

string bands, 10, 46, 48, 50, 52–54, 77, 96

Stuart, Gen. J. E. B., 48

Sun Records, 214

"Sweet Home Chicago" (RJ), 93, 102, 119, 135, 140
 becomes standard, 138, 139, 188
 recorded, 138–39

swing, 61, 88, 92, 93, 193, 198

swing jive, 152, 153

Sykes, Roosevelt, xx, 41, 67, 79, 94, 149, 197, 237, 242

"Tain't Nobody's Business if I Do," 22

"Take Me Back to My Boots and Saddle" (Autry), 58, 97

Tampa Red, 41, 61, 94, 119, 129, 195, 198, 200, 204, 218
 influence of, 36, 37–38
 influence of, on RJ, 131, 144
 variety of music played by, 63–64

Tangle Eye (black convict), 75, 77

"Tangle Eye Blues" (field holler), 75

Tarriers, 239

Tartini, 271

Taylor, Eva, 22, 42, 95–96
Taylor, Koko, 259
Taylor, Little Johnny, 217
Taylor, Montana, 237
Taylor's Kentucky Boys, 48
Tedeschi, Susan, 256
Temple, Johnnie, 137, 144, 152, 274
tenant farms, 101
Tennessee, 48, 83
Tennessee Chocolate Drops, 53
tent shows, 11, 13, 25, 199
"Terraplane Blues" (RJ), xvii, 121, 155, 162, 180, 185
 as hit, 145, 166
 recorded, 145–47
 "Stones in My Passway" and, 167–69
Terry, Sonny, 227, 233, 234, 238, 239, 243
Texas, 76–77, 83, 98, 174, 195, 198
Texas Playboys, 134
Tharpe, Sister Rosetta, 93, 99, 227
"That's All Right" (Crudup), 207
"That's All Right" (Rogers), 261
"They're Red Hot" (RJ), 152–54
"Things 'Bout Coming My Way" (Tampa Red), 119, 144
32-20 Blues" (RJ), 149–52
 Skip James and, 149–51
"This Old Hammer" (work song), 81
Thomas, Henry "Ragtime Texas," 55
Thomas, Jesse, 56
Thornton, Big Mama, 206
Thorogood, George, 6
Three Blazers, 188, 197, 198
Tin Pan Alley, 7, 21, 52–53, 60–62, 64–65, 202
"Tin Pan Alley Blues," 94
"Tomorrow Night" (Lonnie Johnson), xxiii, 204, 205
Toure, Ali Farka, 76
Townsend, Henry, 59, 112, 116–19
"trad jazz" crowd, 237–39, 240, 242
"Traveling Riverside Blues" (RJ), 180–82
Travis, Merle, 48
Travis, Virginia (first wife of RJ), 108
Tucker, Bessie, 76
Turner, Big Joe, xxiii, 66, 194, 195, 196, 199, 204–6, 208, 227
Turner, Ike, xix

Tutwiler, Mississippi, 8, 16
twelve-bar blues, 6, 32, 45, 96, 194, 198, 200, 211–12, 218
 defined, 4
Tympany Five, 199, 200

urban studio blues players, 61, 77
 revivalists exclude, 242
 urban styles, RJ and, 132–33

Vallee, Rudy, 96, 129
Van Gogh, 241
Van Ronk, Dave, 177, 240, 241, 257
Van Vechten, Carl, 225–26, 234
vaudeville, 11, 13, 16, 18, 20–22, 34–35, 38, 60–61, 76, 81, 139
 "country" vs., 54–55
 supernatural and, 273–74
 work songs and, 81
Vaughan, Sarah, 213
Vaughan, Stevie Ray, 6, 219, 249, 252, 257
Victor Military Band, 17
Villon, François, 264
Vinson, Eddie "Cleanhead," 197, 198
Vocalion Records, 52, 182
Von Schmidt, Eric, 240

Waits, Tom, xiv
Walker, Ernest, 116
Walker, T-Bone, xiv, 66, 83, 188, 195, 196, 198, 219, 258, 264
 folk revivalists and, 243, 253
 influence of, 200–201, 208, 210, 215
"Walkin' Blues" (RJ), 94
 recorded, 158–59
 "Spirituals to Swing" concert and, 229
Wallace, Sippie, 23, 80–81
Waller, Fats, xxvi, 59, 72, 100
Wardlow, Gayle Dean, 150, 274
Washboard Band, 63
Washboard Rhythm Kings, 62
Washboard Sam, 40, 41, 94
Washington, Dinah (Ruth Jones), 6, 37, 188, 198, 201–3, 208, 210, 215, 258, 264
"Water Boy" (work song), 81, 93
Waters, Ethel, 21, 23, 41–42, 202, 204

Waters, Muddy, xxiii, 83, 128, 208, 217, 261, 264, 268
 Delta world and style of, 90, 91, 102, 156–57
 early Chess hits, 260
 homemade vs. professional blues and, 79
 "Hoochie Coochie Man" and, 177, 178, 204
 on House, 158
 influences on, 72, 79, 158
 Lomax and, 57–59, 86, 231
 musical categories and, 59, 97, 212
 as R&B star, 209–13, 215, 216
 on RJ, 261
 rock and, 208, 221, 244–45
 white revivalists and, 213, 238, 241, 244–45, 247, 248, 252–55, 258, 259
Watts, Charlie, 239
Weaver, Sylvester, 26, 27
Weavers, 239, 241, 248
Webb, Chick, 199
"Weed Smoker's Dream" (McCoy), 63
Weldon, Casey Bill, 62, 178, 195
Welk, Lawrence, 97
Wells, Junior, 252, 259
West Africa, 49
West Coast, 83, 197–98, 200
Western hits, 127
Wheatstraw, Peetie (William Bunch), 40, 41, 59, 63, 66, 94, 100, 116, 127, 140, 206, 262, 267
 Devil's Son-In-Law and, 267
 influence of, on RJ, 146, 170, 173, 175, 178
"When the Sun Goes Down" (Carr), 196
 "Love in Vain" and, 183–84
"When You Got a Good Friend" (RJ), 140–42
Whitburn, Joel, 216
White, Booker, 80, 242
White, Georgia, 40, 42, 62
White, Josh, 81, 134, 148, 205, 219
 Lomax and, 230
 number of recordings by, 42
 RJ and, 131, 263
 white audience and, 233–34, 238, 239, 241, 248

white audience, 81–82, 97, 213–14, 221–54
 artists play non-blues to "please," 68–69
 black artists rediscovered by, 242–47
 blues as folk form and, 226–34
 blues introduced to, 205
 categories and, 208
 demonic concept and, 266–67, 276
 down-home singers and, 211
 effect of, on music, 252–54
 guitar vs. singing and, 217
 Jordan hits of 1940s and, 199–200
 primitiveness and, 177–78, 220–21
 Reed and, 218
 RJ as bridge for, xvi, 138, 188–89
 rock fans and, 244–46
 in rural Mississippi, 11
 takes over blues stars from blacks, 219
 tastes of, vs. original audience, 27
 "trad jazz" fans, 236–39
 Wallace work song aimed at, 81
white blues musicians, 6, 245
 early, 17–22, 27, 31
 modern, 253–56
white blues researchers, 68
white country music, 27, 28, 31–32, 47, 80, 97–98
white musicians, 47, 51–52, 57
white pop music, 96
Whitter, Henry, 31
"Whole Lot of Shakin' Going On," 211–12
"Why Don't You Do Right" (McCoy), 63, 202
Wilkins, Robert, 246, 272
Williams, Big Joe, 55, 244
Williams, blues composer, 25
Williams, Clarence, 34, 63
Williams, Cootie, 197
Williams, Hank, xxiv, 98, 188, 203, 255
Williams, J. Mayo "Ink," 29, 66
Williams, Mary Lou, 99
Williams, Robert Pete, 78, 242, 261
Williamson, John Lee "Sonny Boy," 39–40, 42, 58, 59, 63, 94, 179, 244. See also Miller, Aleck
Willis, Chuck, 211

Willis, Dusty (RJ's stepfather), 107
Wills, Bob, 134
Wilson, Edith, 21
Wilson, Jackie, 6
Wilson, Teddy, 99, 226
Witherspoon, Jimmy, 183, 199, 258
W.J. (jazz piano player), 60
Wolfman Jack, 213
women. *See also* blues queens
 blues as market of, 213, 215–16
 as blues stars, 201–2
 folk traditions of black, 73
 male stars vs., 26–28
 shift to white male audience from, 251
Wooding, Sam, 23
Work, John, 11, 57, 58, 86

work songs, 5, 71, 73–74, 80–81, 92, 93, 160, 239
World War I, 38
World War II, 102, 196–98, 204
Wright, Richard, 257, 265
Wyman, Bill, 239

Yardbirds, 244
Yas Yas Girl. *See* Johnson, Merline
Yazoo Records, 64–65
"Yellow Dog Blues" (Handy), 17
"You Gonna Need Somebody When You Die" (Patton), 160
Young, Lester, xiv

Zinnerman, Ike, 110